Impressionist and Post-Impressionist Paintings

IN THE METROPOLITAN MUSEUM OF ART

Impressionist and Post-Impressionist Paintings IN THE METROPOLITAN MUSEUM OF ART

Charles S. Moffett

The Metropolitan Museum of Art
Harry N. Abrams, Inc., Publishers
NEW YORK

The publication of this volume
has been made possible by a gift
from Janice H. Levin.

PUBLISHED BY
The Metropolitan Museum of Art, New York

Bradford D. Kelleher, Publisher
John P. O'Neill, Editor in Chief
Amy Horbar, Project Coordinator
Henry von Brachel, Production Manager
Peter Oldenburg, Designer

LIBRARY OF CONGRESS CATALOGING IN PUBLICATION DATA
Metropolitan Museum of Art (New York, N.Y.)
 Impressionist and post-impressionist paintings in the Metropolitan
Museum of Art.

 Bibliography: p.
 1. Impressionism (Art)—France—Catalogs. 2. Post-impressionism
(Art)—France—Catalogs. 3. Painting, French—Catalogs. 4. Painting,
Modern—19th century—France—Catalogs. 5. Painting—New York
(N.Y.)—Catalogs. 6. Metropolitan Museum of Art (New York, N.Y.)
—Catalogs.
I. Moffett, Charles S. II. Title.
ND547.5.I4M4 1985 759.4′074′01471 82-14172
ISBN 0-87099-317-8
ISBN 0-8109-1104-3 (HNA)

The photographs for this volume were
taken by Malcolm Varon and by The
Photograph Studio, The Metropolitan
Museum of Art.

Composition by Innovative Graphics
International Ltd., New York, and
Cyber-Graphics, Inc., New York
Printed by Imprimeries Réunies Lausanne S.A.,
Lausanne, Switzerland
Bound by Mayer & Soutter S.A.,
Renens, Switzerland

Contents

FOREWORD

Impressionist and Post-Impressionist paintings, the products of the late nineteenth-century avant-garde, are loved and admired by layman and scholar alike. The wide variety of audiences to which this art consistently appeals is clearly due to its multifaceted and generally pleasing character, as well as to the many levels on which it engages the eye and the mind. Indeed, these movements may be unique in the history of art because of their universal appeal that somehow does not preclude serious inquiry, as evidenced year after year by the impressive array of books, articles, and doctoral dissertations devoted to their study. It is evident that the pleasure experienced by the average viewer is matched in intensity by the curiosity of the scholar. It is my hope that this volume will be perceived as more than just another manifestation of the wide interest in Impressionism and Post-Impressionism, because The Metropolitan Museum of Art is publishing it to answer a very real need. For the first time a large selection of the finest works of these schools in the Museum's collection is available in one volume of scholarly commentaries and superbly realized colorplates.

It should be noted that the broad appeal of these Impressionist and Post-Impressionist paintings was by no means an instantaneous phenomenon. The first Impressionist group exhibition, held in Paris in 1874, was greeted with taunts, skepticism, and more opprobrium than approval, and one should remember that the word *Impressionism* was used by a hostile critic as a derisive term in this context. The popularity enjoyed today by Degas's ballerinas, Monet's gardens, and van Gogh's sunflowers cannot be ascribed only to the appeal of agreeable and uncomplicated subject matter. If their bright, pure colors and variegated effects of light at first detain and seduce the eye, an important factor in our continuing romance with these pictures resides in our sensing that just beneath the lush and luminous surface a heroic struggle, albeit in varying degrees, is taking place, one that endows them with a latent power that is key to their lasting appeal. We are here dealing with more than merely decorative and easily comprehensible paintings. At their best these works reflect man's ineluctable search to understand nature and his place in it, and his struggles, at the highest level of consciousness, to render in visual terms his own perceptions of reality.

Impressionist and Post-Impressionist paintings are investigations of the visible world as it had never before been "seen." Furthermore, art historians have begun to demonstrate that these beautiful and deceptively "simple" pictures are part of a complex fabric of philosophical, scientific, political, and historical thought.

Monet looked afresh each time he planted his easel in a field or on a riverboat, and Cézanne's quest for the structure of space is always on the edge of every stroke of his brush, irrespective of its pleasing effect or apparent inevitability. Actually, these two artistic currents evolved rapidly and are characterized by a pluralism of styles, relatively rapid changes in formal emphasis, and a willingness to experiment that call into question the usefulness of the very words *Impressionist* and *Post-Impressionist*. Indeed, both must be thought of as "umbrella" terms for the art of the late nineteenth-century avant-garde in general; otherwise it would be impossible to explain why both Renoir and Degas are called Impressionists, and why Seurat, Cézanne, and Gauguin are labeled Post-Impressionists.

Thus, Impressionism and Post-Impressionism are more complex and more blurred as movements than is generally believed. I hope that the selection of works in this book will provide insights into the diversity of French avant-garde painting between 1860 and 1900 rather than subsume it under another discussion of various *isms*. Monet himself warned that "pictures aren't made out of doctrines." Admittedly, The Metropolitan Museum of Art's collection in this area has gaps that make it impossible to present a completely detailed synopsis of one of the richest periods in the history of French painting, but the extraordinary quality, variety, and fascinating interrelationships provided by the 126 works included in this anthology present a good alternative to a formal, exegetical examination of the two movements that, taken together, provided the crucible for the art of the twentieth century.

Philippe de Montebello
Director
The Metropolitan Museum of Art

PREFACE

This book focuses on a selection of 126 Impressionist and Post-Impressionist pictures from the Museum's collection. It begins with the work of Johan Barthold Jongkind and Eugène Boudin, two painters who, in the early 1860s, exerted a strong influence on many of the young artists who emerged in the 1870s as the practitioners of the style that we now recognize as the classic phase of Impressionism. Their keen interest in light effects and their choice of subject matter appealed to the younger artists who clearly benefited from their example.

Henri Fantin-Latour, too, is included in this book. Although he was not an Impressionist, his realist still lifes of the 1860s and 1870s reflect the impetus that gave rise to Impressionism. Indeed, he frequented the Café Guerbois, where he became friendly with Manet and his circle. His work lies at the periphery of Impressionism, but in spirit his pictures often achieve a nearly identical goal.

Edouard Manet, of course, is the father of the Impressionist movement, although he never exhibited work in the Impressionists' eight group exhibitions, which were held between 1874 and 1886. Manet preferred, instead, to show in the officially sanctioned annual Salons. He sought the approval and awards proffered by the Salon juries, which were nearly always dominated by establishment figures from the Academy and the Ecole des Beaux-Arts. Like his younger colleagues, Manet focused on subjects from modern life, and there is a formalist emphasis in his work that looked far into the future. At the Café Guerbois he was the center of gatherings that included such artists, writers, and intellectuals as Zacharie Astruc, Edmond Duranty, Théophile Silvestre, Henri Fantin-Latour, Edgar Degas, Pierre Auguste Renoir, Alfred Stevens, Paul Cézanne, Alfred Sisley, Claude Monet, Camille Pissarro, and sometimes Emile Zola. Later, after 1876, they nearly all began to frequent the Café de la Nouvelle-Athènes, but by then Impressionism was a bona fide movement, at least in name.

In subject and style Manet established the precedents that enabled such younger artists as Monet, Degas, Cézanne, Pissarro, and Sisley to strike out in an independent direction. As George Heard Hamilton observed in *Manet and His Critics,* "Manet had proclaimed his acceptance of the fundamental principle of contemporary realism as it had been defined [in 1855] by Courbet. In the manifesto distributed in his Pavillon du Réalisme, Courbet had declared that his intention had been 'to represent the customs, the ideas, the appearance of my own era according to my own ideas.'" The younger artists arrived on the scene with a variety of ideas and stylistic emphases, but most of them shared a strong interest in subjects from modern life and the desire to paint light as it actually appears rather than as one was taught to interpret it at the Ecole des Beaux-Arts. As Duranty wrote in 1876 in an essay about an exhibition that included work by Degas, Monet, Pissarro, Renoir, Sisley, and others, "The idea, the first idea, was to take away the partition separating the studio from everyday life.... It was necessary to make the painter leave his sky-lighted cell, his cloister where he was in contact with the sky alone, and to bring him out among men, into the world."

The Impressionists' eight group exhibitions were held under a variety of titles, and some of the artists, notably Degas, were unhappy with the word *Impressionist.* In actuality, the shows were forums for the work of the French avant-garde. The most famous of the many artists who exhibited work in the shows are still known as Impressionists, but many others are never included in discussions of Impressionism. The principal figures were Monet, Renoir, Degas, Cézanne, Pissarro, Sisley, Berthe Morisot, Paul Gauguin, and Georges Seurat. Gauguin and Seurat are better known as Post-Impressionists, and the inclusion of Seurat's now-famous *A Sunday on La Grande Jatte* (Art Institute of Chicago) suggests how inexactly defined the parameters of the exhibitions had become by 1886. Indeed, as early as 1879 Renoir defected to the Salon, and the next year Monet had a painting accepted there; moreover, work by neither artist was included in the last of the Impressionists' group shows, in 1886.

While the work of the orthodox Impressionists included in this book—Monet, Renoir, Degas, Pissarro, and Sisley—began to change in the early 1880s, the stylistic shifts were at first gradual and can be construed as experiments within the parameters of Impressionism. However, in the mid-1880s a group of predominantly younger artists—Seurat, Paul Signac, Vincent van Gogh, Odilon Redon, Gauguin, Henri de Toulouse-Lautrec, and Henri Rousseau (Le Douanier)—moved away from the kind of visual realism of Impressionism to an expressive use of line, form, and color. With the exception of Rousseau, these painters had their roots in Impressionism, though their work is informed by a wholly different attitude toward the goals of art. They perceived reality as more complex than the image that strikes the retina. The change in art during the three decades following the first Impressionist exhibition is easily measured by comparing Monet's *Apple Trees in Bloom* (pages 116–17) with Henri Rousseau's *The Repast of the Lion* (pages 246–47). Landscape had given way to mindscape. The range of possibilities open to an artist in the 1890s is immediately obvious when one

remembers that Gauguin's *Two Tahitian Women* (pages 206–7), Lautrec's *The Sofa* (pages 238–39), and Monet's *Rouen Cathedral* (pages 144–45) were all painted between 1892 and 1899. The fields, flowers, street scenes, and sunny days of Impressionism—all relatively uncontroversial and safe as subjects—had given way to such themes as a South Pacific paradise, the interior of a brothel, and the light-demolished facade of a cathedral.

The organization of this book is, of course, somewhat arbitrary because it is limited to the Museum's holdings. Nevertheless, the progression that begins with the pre-Impressionist Jongkind and ends with the Post-Impressionist Rousseau is a fairly accurate summary of the revolution in art that occurred between about 1860 and 1900. There are serious gaps in the collection—for example, a notable Gauguin still life, an important painting by Morisot, and a Renoir of the 1860s—but it stands as the best in the world next to that of the Louvre. Indeed, it is prodigious in its quality, which improves with each passing year.

The growth of the Metropolitan's holdings of late nineteenth-century avant-garde painting is worth summarizing, because this book reflects the aggregate taste and efforts of many individuals. Nearly all the paintings were either given or bequeathed by private collectors and not purchased by curators or directors. In 1889 Erwin Davis auspiciously inaugurated the Museum's collection of Impressionist and Post-Impressionist paintings with the gift of Manet's *Boy with a Sword* (pages 26–27) and *Woman with a Parrot* (pages 36–37), the first works by the artist to enter an American museum. However, eighteen years passed before another nineteenth-century avant-garde European painting became part of the Metropolitan's permanent collection. In 1907 Boudin's *On the Beach at Trouville* (pages 16–17) was bequeathed to the Museum, and in the same year the Metropolitan made one of its rare but significant purchases, Renoir's *Madame Georges Charpentier (Marguerite Lemonnier) and Her Children, Georgette and Paul* (pages 160–61). Six years later Cézanne's *View of the Domaine Saint-Joseph* (page 201) was bought and became the first painting by the artist to enter a public collection in the United States. Unfortunately, the arrival of the Cézanne did not mark the beginning of a succession of similarly bold purchases. Jongkind's *Honfleur* (pages 14–15) was acquired in 1916, and three years later the Museum bought drawings by Degas at one of the auctions of the contents of the artist's studio, but the first paintings by Degas arrived at the Metropolitan only in 1929, with the Bequest of Mrs. H. O. Havemeyer.

In 1915 three pictures by Monet were bequeathed to the Museum by Theodore M. Davis, and at least one of them, *Rouen Cathedral* (pages 144–45), was on view beginning that year, but the Davis estate was contested and the paintings did not actually become the property of the Metropolitan until

1930. Interestingly, paintings by Monet were on view as early as 1906, but they were on loan. The first Monet that was accessioned is *Apple Trees in Bloom* (pages 116–17), which was bequeathed to the Museum in 1926 by Mary Livingston Willard. To place the arrival of the Metropolitan's first Monet in historical perspective, one need only recall that the first of the Impressionists' group exhibitions took place fifty-two years earlier, two years after the founding of the Museum. In short, half a century later there were only a few Impressionist paintings in the collection. Nevertheless, there was sufficient interest in the city to enable the Durand-Ruel Gallery, the principal Parisian dealer in Impressionist art, to maintain an extremely profitable branch in New York. Mr. and Mrs. H. O. Havemeyer were among the gallery's best clients, and some of their pictures were destined for the Museum. For this reason, the Metropolitan probably did not feel compelled to buy works by Degas, Monet, Renoir, Cézanne, and Manet. Indeed, the Impressionist art in the Bequest of Mrs. H. O. Havemeyer—which also included old-master paintings, a large collection of pictures by Courbet as well as other nineteenth-century European paintings, prints, and drawings, and Far Eastern art—established the Metropolitan in 1929 as the most important public collection outside of France of works by Degas, Monet, Cézanne, and Manet. Mrs. Havemeyer bequeathed five Cézannes; thirteen paintings as well as numerous pastels, prints, drawings, and sixty-nine sculptures by Degas; six paintings and three pastels by Manet; eight Monets; one Pissarro; and one Renoir. But more important than its size was the quality of the bequest. It included such works as Manet's *Boating* (pages 40–41), Cézanne's *The Gulf of Marseilles Seen from L'Estaque* (pages 188–89), Monet's *La Grenouillère* (pages 112–13) and *Poplars* (pages 138–39), and Renoir's *By the Seashore* (pages 168–69).

In 1930 the three Monets bequeathed by Theodore M. Davis joined those given by Mrs. Havemeyer and Mary Livingston Willard, bringing the total to twelve. Today there are thirty-five, of which the most recently acquired is the Robert Lehman Collection's *Landscape near Zaandam* (pages 114–15). Nevertheless, none of the Museum's Monets are dated after 1908, and the collection does not include a single *Water Lilies* from either the 1903–8 series or from the group of mural-size paintings executed preparatory to the cycle that was ultimately installed in the Orangerie des Tuileries in Paris.

The Depression and World War II interrupted the growth of the collection during the 1930s and 1940s, but in 1949 William Church Osborn gave Manet's *The Spanish Singer* (pages 24–25) and Gauguin's *Two Tahitian Women* (pages 206–7). Two years later the Museum received his bequest of Pissarro's *Jallais Hill, Pontoise* (pages 84–85) and Monet's *The Beach at Sainte-Adresse* (pages 108–9), *Vétheuil in Summer*

10

(pages 128–29), and *The Manneporte, Etretat, I* (page 134). *Two Tahitian Women* was the Metropolitan's first painting by Gauguin, and *Jallais Hill, Pontoise* was its first important Pissarro. In 1951 the Gauguin was joined by another major work by the artist, *Ia Orana Maria* (pages 204–5), bequeathed by Sam A. Lewisohn.

Mr. Lewisohn's bequest included several other extremely significant Impressionist and Post-Impressionist paintings: Cézanne's *Still Life: Apples and a Pot of Primroses* (pages 184–85), Renoir's *In the Meadow* (pages 170–71), Rousseau's *The Repast of the Lion* (pages 246–47), van Gogh's *L'Arlésienne: Madame Joseph-Michel Ginoux (Marie Julien)* (pages 214–15), and Seurat's final study for *A Sunday on La Grande Jatte* (pages 224–25). That oil study was the first painting by Seurat to enter the collection, but *L'Arlésienne* was the third van Gogh. In 1949 the Museum had had the courage to purchase two: *Sunflowers* (pages 210–11) and *Cypresses* (pages 216–17). Nevertheless, the Lewisohn bequest provided the Museum with its best-known image by van Gogh as well as other Post-Impressionist paintings of the highest caliber.

Nine years later, in 1960, the Bequest of Stephen C. Clark brought the Museum another group of Impressionist and Post-Impressionist pictures that were as important as those bequeathed by Sam A. Lewisohn. Degas's *Self-Portrait* (pages 50–51) and *The Singer in Green (La Chanteuse Verte)* (pages 78–79), Renoir's *A Waitress at Duval's Restaurant* (page 157) and *Marguerite (Margot) Bérard* (pages 162–63), Seurat's extraordinary *Invitation to the Sideshow (Parade de Cirque)* (pages 226–27), and a superb group of Cézannes: *Madame Cézanne in the Conservatory* (pages 182–83), *Near the Pool at the Jas de Bouffan* (pages 186–87), *Still Life: Apples and Pears* (page 200), *Still Life with a Ginger Jar and Eggplants* (pages 196–97), and *The Cardplayers* (pages 198–99). In short, the Osborn, Lewisohn, and Clark bequests enriched the entire collection, increasing in number and significance the Museum's Post-Impressionist paintings. The base of the collection had broadened considerably, and it began to emerge clearly as the strongest one of its kind in the United States.

During the 1950s and 1960s several other important bequests were received. Of the thirty-five Monets today in the Metropolitan, five were bequeathed by Julia W. Emmons in 1956, and four others were given by Mr. and Mrs. Charles McVeigh in 1959. Twelve more entered the Museum during the same period, including the three bequeathed by William Church Osborn in 1951. In 1967 the Metropolitan acquired the only Monet that it has ever purchased, *Terrace at Sainte-Adresse* (pages 110–11). Nine of the Museum's sixteen Pissarros and seventeen of its twenty-five Renoirs were acquired by gift or bequest during the same two decades. The only Pissarro ever bought by the Museum, *Rue de l'Epicerie, Rouen* (pages 100–101), was purchased in 1960 with funds given

by Mr. and Mrs. Richard J. Bernhard. In 1964 the first paintings by Alfred Sisley to enter the collection were given by Mr. Richard Rodgers and Mr. and Mrs. Henry Ittleson, Jr. Since then, four others have been given or bequeathed. Another artist whose work entered the Museum at a relatively late date is Signac, who was first represented in the permanent collection by *View of the Port of Marseilles* (pages 230–31), a gift of Robert Lehman in 1955. Three more arrived with the Robert Lehman Collection in 1975, and the same year *The Jetty at Cassis* (pages 228–29) came with the Bequest of Joan Whitney Payson.

Large gifts and bequests tend to dominate our attention, but it is also important to point out that acquisitions of single works have often added significantly to the collection. Particularly striking examples are Mr. and Mrs. Edwin C. Vogel's gift in 1957 of Degas's *Portrait of a Lady in Gray* (pages 54–55), Mr. and Mrs. John L. Loeb's gift in 1962 of van Gogh's *Oleanders* (pages 212–13), and the purchase in 1962 of Cézanne's *Madame Cézanne in a Red Dress* (pages 194–95) with funds given by Mr. and Mrs. Henry Ittleson, Jr.

In 1967 the Bequest of Miss Adelaide Milton de Groot contributed to the extraordinary growth of the collection during the postwar decades. It included several important pictures of the 1880s and early 1890s: van Gogh's *Self-Portrait with a Straw Hat* (pages 208–9), Seurat's *The Gardener* (page 222), Monet's *Rapids on the Petite Creuse at Fresselines* (pages 136–37), and Toulouse-Lautrec's *The Englishman at the Moulin Rouge* (pages 236–37). The Toulouse-Lautrec is one of five works by the artist given or bequeathed during the 1960s and 1970s. Before 1967 the only picture by Toulouse-Lautrec in the collection was *The Sofa* (pages 238–39), which was purchased through the Rogers Fund in 1951. In 1975 Toulouse-Lautrec's *Woman in the Garden of Monsieur Forest* (pages 234–35) arrived with the Bequest of Joan Whitney Payson, which also included, among other works, Manet's *Peonies* (pages 34–35) and *The Monet Family in Their Garden* (pages 46–47), and Degas's *Portrait of Yves Gobillard-Morisot* (pages 60–61). Toulouse-Lautrec's striking portrait of René Grenier (pages 232–33) joined the collection in 1978 with the Bequest of Mary Cushing Fosburgh. Pissarro's *Barges at Pontoise* (pages 88–89) was also bequeathed by Mrs. Fosburgh, and since then two other important paintings by the artist have also been donated: *The Garden of the Tuileries on a Winter Afternoon, II* (pages 102–3), a gift in 1979 from the collection of Marshall Field III, and *Morning, An Overcast Day, Rouen* (pages 96–97), Bequest of Grégoire Tarnapol, 1979, and Gift of Alexander Tarnapol, 1980.

The gift of the Robert Lehman Collection in 1975 constituted the largest group of European paintings and drawings donated to the Museum since the Bequest of Mrs. H. O. Havemeyer in 1929. Included in the Lehman Collection are

important paintings by Monet (pages 114–15), Renoir (pages 172–75), Seurat (page 223), Signac, Sisley, Degas, Pissarro, van Gogh, Gauguin, and Cézanne that substantially broaden the range of Impressionist and Post-Impressionist art to be seen at the Metropolitan. Only four are included in this book, but all will be fully studied in the forthcoming complete catalogue of the Robert Lehman Collection.

Like the Bequest of Mrs. H. O. Havemeyer, the addition of the paintings in the Lehman Collection was an exceptional event. Nevertheless, the Museum's collection of Impressionist and Post-Impressionist paintings has grown with increasing, albeit somewhat erratic, momentum since Erwin Davis's gift of two Manets in 1889. Significant needs remain, but there is no collection of paintings that could not be improved by the addition of a particular picture. For that reason, in 1980 the Museum purchased, through the Mr. and Mrs. Richard J. Bernhard Gift, by exchange, Fantin-Latour's *Still Life with Flowers and Fruit* (pages 20–21), a painting of exceptional quality dating from the mid-1860s.

Occasional strategic purchases of this kind will continue to be made, but the Metropolitan's Impressionist and Post-Impressionist paintings will remain primarily an assemblage of collections formed by individuals with the particular likes and dislikes generally labeled taste. The Museum's collection has grown impressively because of the extraordinary generosity of these individuals and because they formed their collections by exercising taste, courage, perspicacity, and will. Their decisions were not made by committees, and their collections almost always reflect personal considerations and strong ideas about quality—elements not always typical of the decision-making processes of museum acquisitions committees. The spirit with which the Museum's benefactors collected is best expressed in the passage in Mrs. Havemeyer's *Sixteen to Sixty: Memoirs of a Collector,* wherein she described her reasons for buying Degas's *Madame Gobillard-Morisot (Yves Morisot)* (pages 62–63). After remarking that most collectors would probably have preferred a more fashionable example of Degas's work, such as the pastel of a woman in a striped dress seated on a sofa that Mary Cassatt had once found for her, she added that she prized above all his portrait of Berthe Morisot's sister: "Well! I paid a large sum for that picture and I do not regret it, not a farthing of it. I bought neither beauty nor glamour, no, nor still life, nor a great composition; nothing but art, just pure incandescent art, right out of the crucible; its author heated it over the sacred fire. It seems to me it is not a picture, not a portrait, it is an inspiration. Degas never did anything like it again. I doubt if he ever could, I doubt if *ever* any painter could do such a picture. It is forever! It is an art epoch in itself."

C.S.M.

ACKNOWLEDGMENTS

The texts for each painting were developed from the label texts written in 1979–80 by Charles S. Moffett, Curator, Department of European Paintings, and Ann M. Wagner, formerly a Research Assistant, Department of European Paintings, for the Metropolitan Museum's André Meyer Galleries. For the purposes of this book, many of the label texts were substantially rewritten and expanded by Charles S. Moffett and Charles F. Stuckey, Research Assistant, Department of European Paintings. Selected references have been included in a separate section at the back of the book.

John Pope-Hennessy, Consultative Chairman, Department of European Paintings, edited the original texts for The André Meyer Galleries and later suggested that Charles S. Moffett convert the material written for the Impressionist and Post-Impressionist sections into a text for this volume. The Museum's publisher, Bradford D. Kelleher, and its editor in chief, John P. O'Neill, enthusiastically endorsed the project.

C.S.M.

Impressionist and Post-Impressionist Paintings

IN THE METROPOLITAN MUSEUM OF ART

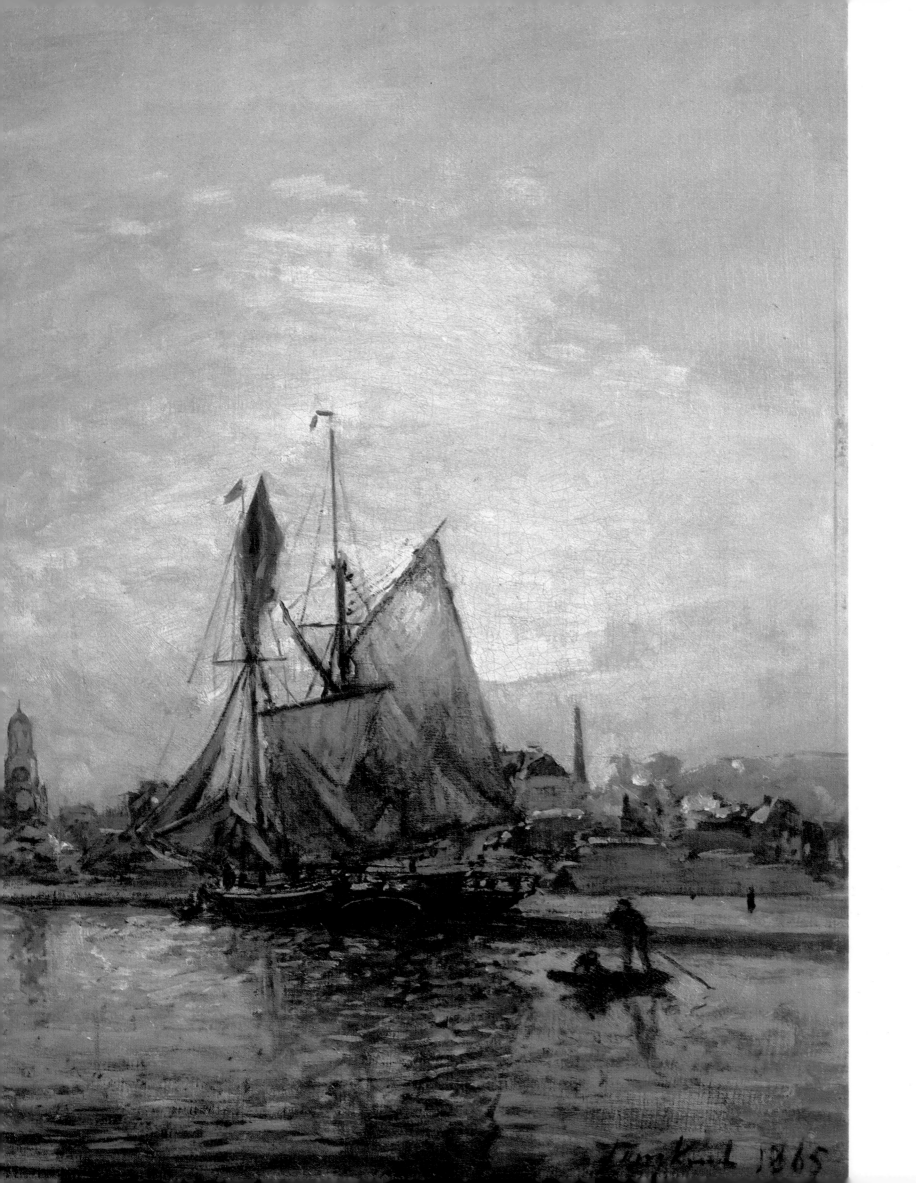

JOHAN BARTHOLD JONGKIND

Dutch, 1819–1891

Honfleur

Oil on canvas, 20½ x 32⅛ inches
Signed and dated (lower right): Jongkind 1865

IN 1846 JONGKIND left The Hague and went to Paris, where he studied with Eugène Isabey and François Picot. Through the early 1850s his work reflected the influence of Isabey. In 1853 his only source of financial support, a royal stipend, was withdrawn. As a result, his personal and professional life began to disintegrate. Two years later, drinking heavily and deeply in debt, he returned to Holland. Monet reported regretfully to Boudin, "The only marine painter we have, Jongkind, is dead to art." However, in 1860 Jongkind returned to Paris. His works during the next few years influenced the young Impressionists, especially Monet, whose harbor scenes of the 1860s may have been at least indirectly inspired by such pictures as *Honfleur*. Moreover, Jongkind's sensitive treatment of subtle light effects must have greatly appealed to the young painter. The two occasionally met in Honfleur, a town on the Channel, where both artists worked in the early and middle 1860s. This canvas was painted there in August–September 1865, during Jongkind's third visit.

Wolfe Fund, 1916
Catharine Lorillard Wolfe Collection

16.39

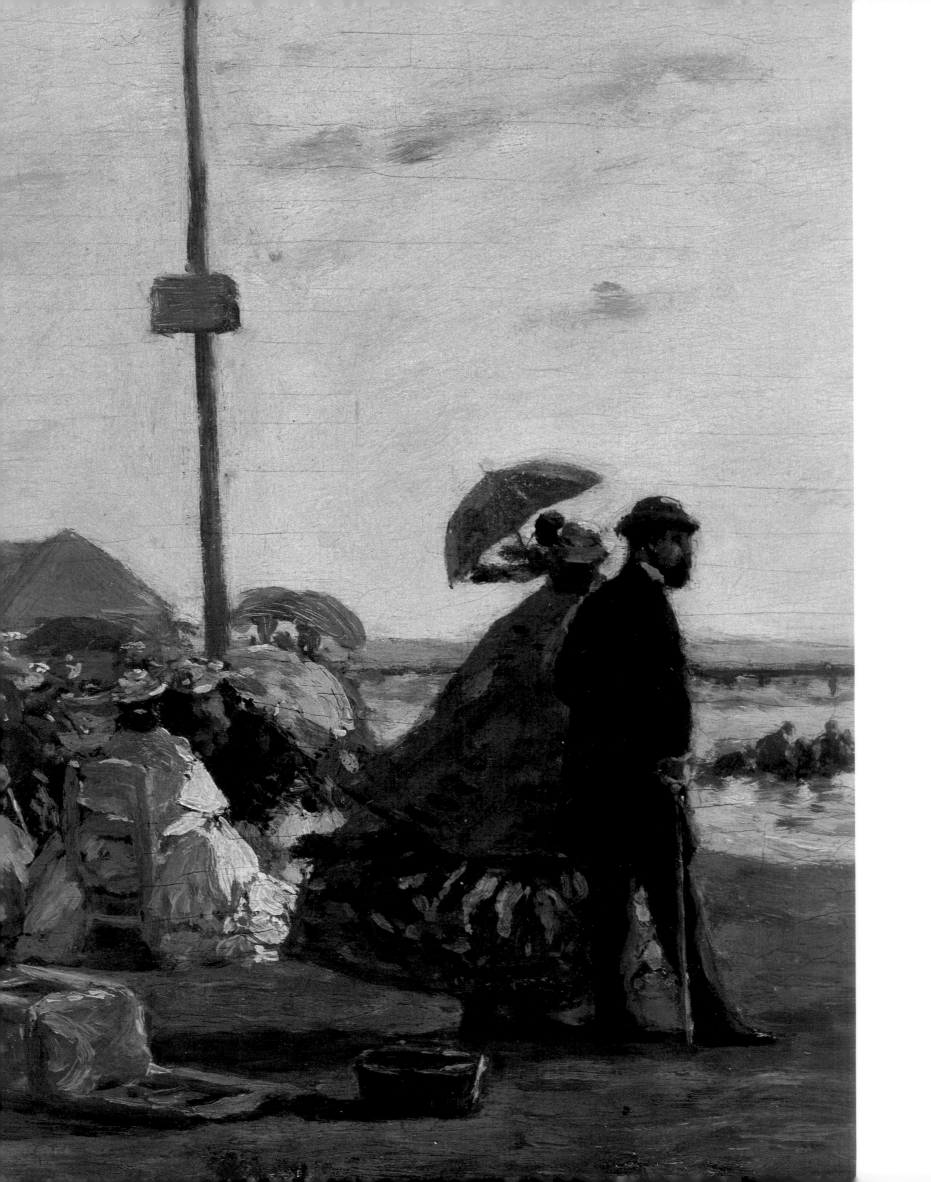

EUGENE BOUDIN

French, 1824–1898

On the Beach at Trouville

Oil on wood, 10 x 18 inches
Signed and dated (lower right): E. Boudin. 63

THIS IS AN early example of the seaside scenes for which Boudin is famous. On February 12, 1863 (the year it was painted), he wrote to a friend, "People like my little ladies on the beach very much; some hold that in them there lies a vein of gold to be exploited." In another letter he mentioned some beach scenes that were "perhaps not great art but at least a fairly honest image of the world in our time." A plein-air painter of subjects from modern life, Boudin clearly underestimated the importance of his work in the early 1860s. Although the scope of his work remained rather limited, his early achievement was revolutionary, and he had an important influence on the young Monet, to whom he gave painting lessons in 1858–59.

Bequest of Amelia B. Lazarus, 1907 07.88.4

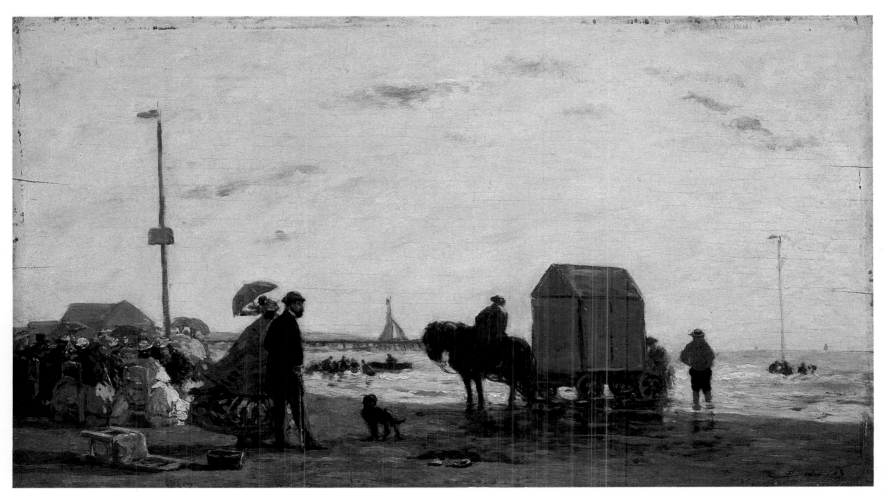

EUGENE BOUDIN

French, 1824–1898

Village by a River

Oil on wood, 14 x 23 inches
Signed (lower right): E. Boudin.

BOUDIN FREQUENTLY painted landscapes along the coast of Brittany, although his views of people on the beaches of seaside resorts in Normandy are better known (pages 16–17). The subject of this work is the village of Le Faou, west of Brest, which he visited in 1867, 1873, 1874, and 1875. *Village by a River* was probably executed during Boudin's first visit, because its broken brushwork and small, light touches resemble his handling of a view of Le Faou, sold in 1868, that was presumably painted the summer before. The short, quick brushstrokes and the flicker of light and color are easily distinguished from his earlier, simpler style. The technique he developed in the late 1860s became the basis of his work during the remainder of his career. Although Boudin is generally regarded as an artist of secondary importance, works such as *Village by a River* exemplify his importance during the early years of Impressionism. As an accomplished plein-air painter in the 1860s, his interpretation of the world through myriad quick touches of color provided an important precedent for the younger painters who banded together later as the Impressionists. Boudin's significance for the movement was officially acknowledged when they invited him to exhibit in their first group show in 1874.

Gift of Arthur J. Neumark, 1959 59.140

18

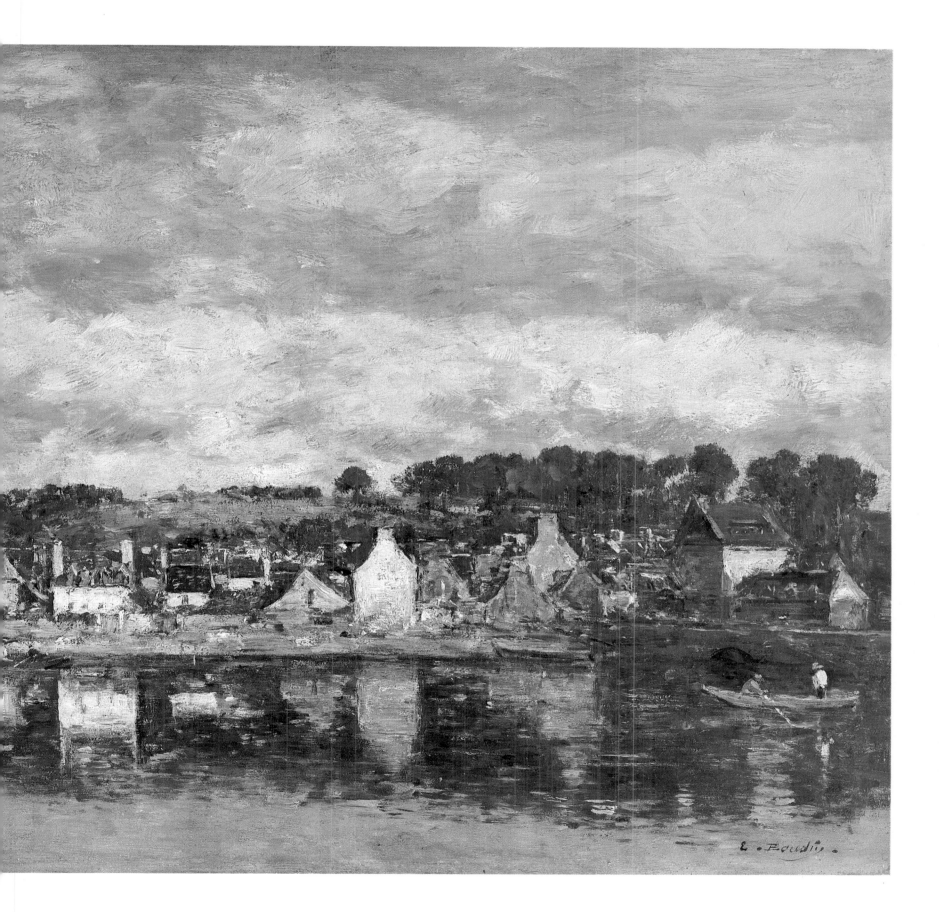

19

HENRI FANTIN-LATOUR

French, 1836–1904

Still Life with Flowers and Fruit

Oil on canvas, 28³/₄ x 23⁵/₈ inches
Signed and dated (upper left): Fantin. 1866.

IN THE EARLY years of his career, Fantin-Latour under-took a wide range of subject matter that included traditional allegory, still life, and portraiture, but he always worked in an unmistakably contemporary idiom. He was particularly successful with flower subjects, which occupied him throughout his career. Inspired by the eighteenth-century painter Chardin and by his own contemporary Courbet, he was direct and naturalistic in his approach. This painting of flowers and fruit, and several others of 1865–66, are Fantin-Latour's first major achievements as a still-life painter. They are relatively large in scale and reflect his desire to create serious compositions in a realist style that transcend mere pictures of well-rendered objects in convincing space. The special character of his work is described in the following passage written by Jacques-Emile Blanche, a painter of the next generation: "In his paintings of flowers, Fantin's drawing is sometimes beautiful and bold; it is always sure and incisive. He gives the physiognomy of the flower that he copies; it is itself and not another of the same species."

Purchase, Mr. and Mrs. Richard J. Bernhard Gift, by exchange, 1980 1980.3

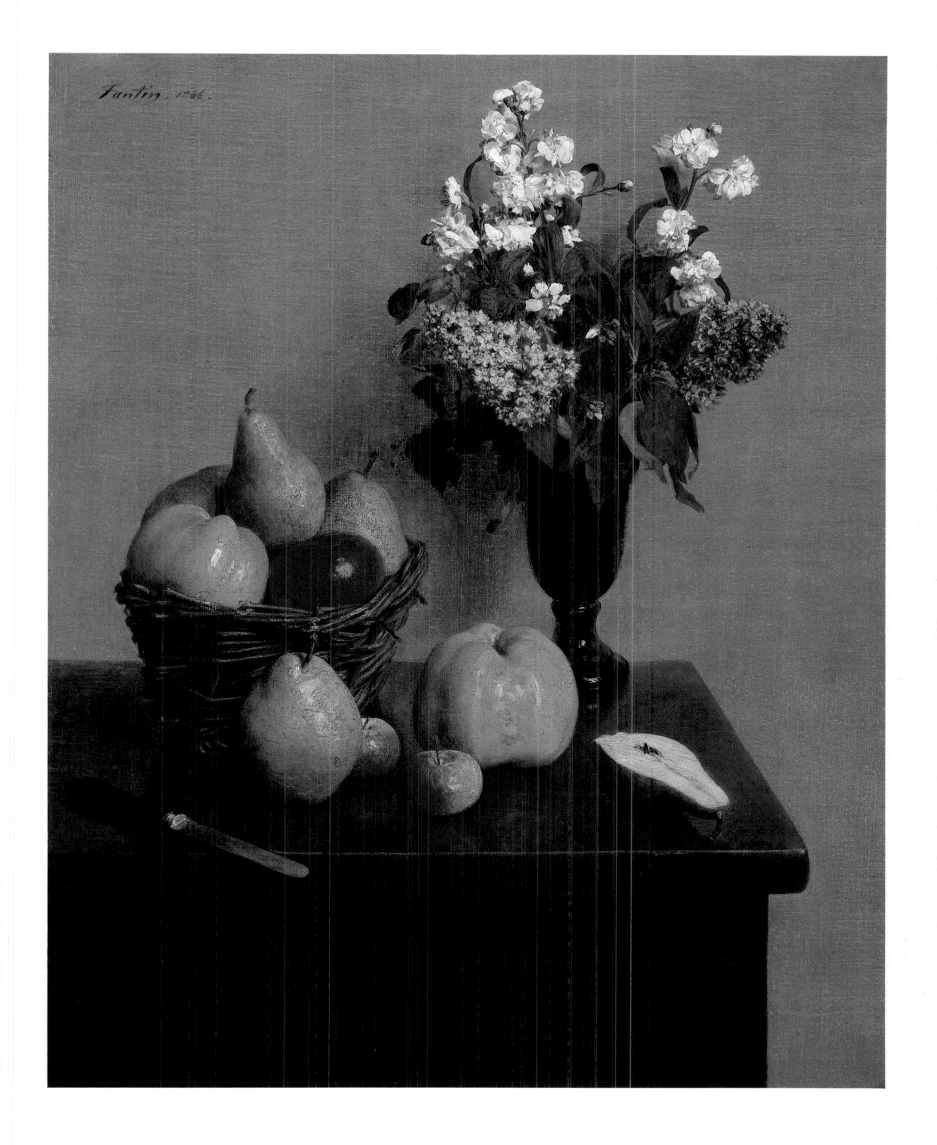

HENRI FANTIN-LATOUR

French, 1836–1904

Still Life with Pansies

Oil on canvas, 18½ x 22¼ inches
Signed and dated (upper right): Fantin. 74

MADAME FANTIN-LATOUR, in a catalogue of her husband's work, listed thirty-one compositions of flowers and fruit painted in 1874, including *Still Life with Pansies*. Among the pictures she mentioned is a study of a basket and pansies in small pots (present location unknown) that is probably similar to this painting. The branch of apples suggests that the Museum's picture was painted in the fall, but the pansies are spring flowers that were probably cultivated in a hothouse.

Still Life with Pansies is typical of Fantin-Latour's portrait-like treatment of flowers and fruit. Generally he managed to avoid the pitfalls of repetitiveness and self-imitation, but his work is characterized by a conservatism that distinguishes his pictures clearly from those of his Impressionist contemporaries. When compared to Monet's *Apples and Grapes* (pages 122–23), for example, the limitations of *Still Life with Pansies* are obvious. Fantin-Latour's vision was less vigorous and less complex than Monet's, and many of his pictures fail to challenge or engage the viewer. Nevertheless, paintings such as this one are as pleasing to the eye today as they were in 1874.

The Mr. and Mrs. Henry Ittleson, Jr. Purchase Fund, 1966　　　66.194

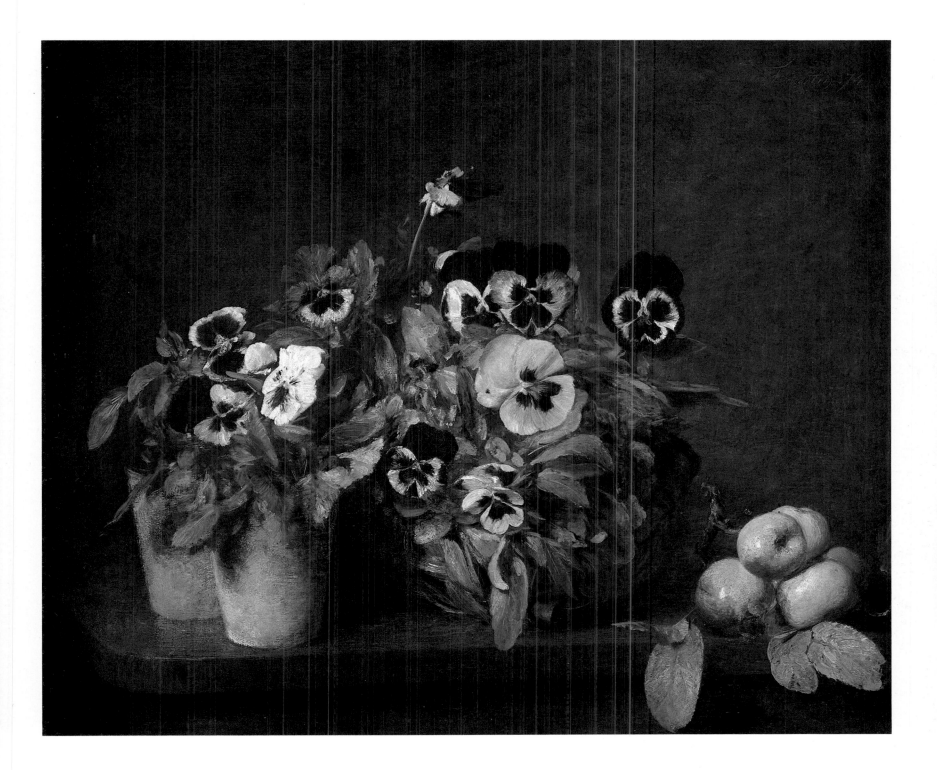

EDOUARD MANET

French, 1832–1883

The Spanish Singer

Oil on canvas, 58 x 45 inches
Signed and dated (at right, on bench): ed. Manet 1860

MANET MADE HIS public debut at the Salon of 1861 with a portrait of his parents (Louvre, Paris) and *The Spanish Singer.* Response to his pictures was gratifying. The jury awarded *The Spanish Singer* an honorable mention after it was moved from high up on a wall, where it had first been placed, to a more prominent position. Reviewing the Salon, Théophile Gautier, the respected critic for the government's *Moniteur universel,* praised Manet as a gifted realist in the tradition of Spanish painters from Velázquez to Goya. As Gautier's own essays on Spanish culture had stimulated French printmakers to flood the market with illustrations of Spanish types, the theme of Manet's picture was hardly novel. Yet, as Gautier observed, most of the illustrators romanticized their subjects, whereas Manet did not.

The Spanish Singer was also warmly admired by such younger painters as Alphonse Legros and Henri Fantin-Latour, who were among a group that visited him in his studio to convey their admiration. Such acclaim surely helped to sustain Manet's independent spirit during the next years.

Manet openly admitted his debt to the seventeenth-century Spanish masters, but he treated every detail of *The Spanish Singer* with unique finesse: the red shoulder strap that twists in the shadows, the crumpled trousers, the spent cigarette, and the soulful expression, captured after just two hours' work. Despite Manet's apparent concern for detail, however, the singer holds his guitar left-handedly though the instrument is strung for a right-handed musician, and his precarious pose would tax anyone's ability to play. By such devices Manet drew attention to the artifice involved in painting pictures that purport to be realistic transcriptions of everyday life.

Gift of William Church Osborn, 1949
49.58.2

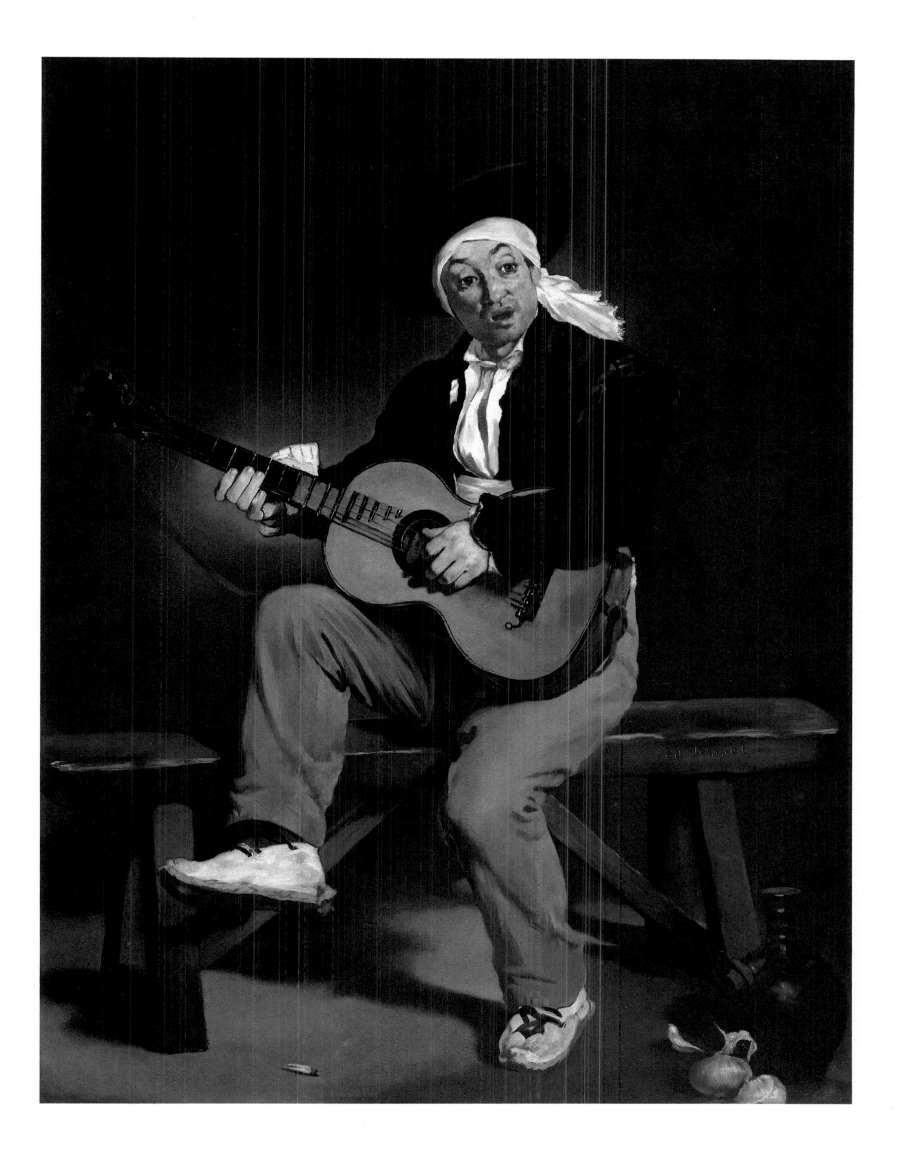

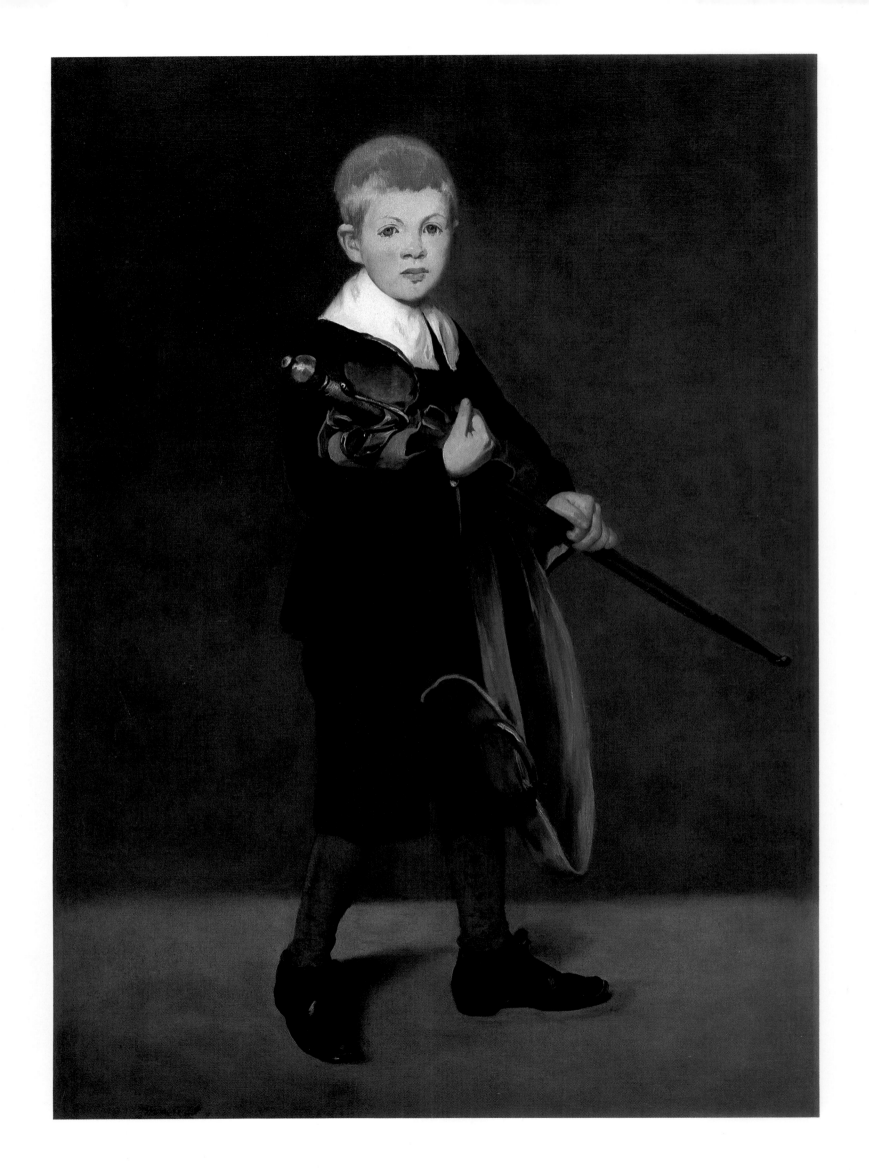

EDOUARD MANET

French, 1832–1883

Boy with a Sword

Oil on canvas, 51⅝ x 36¾ inches
Signed (lower left): Manet

ASSESSING MANET'S CAREER shortly after his death, the conservative critic Albert Wolff predicted that *Boy with a Sword* would eventually enter the Louvre and exemplify the artist at his best. However, Emile Zola, who wrote the preface to the catalogue for the memorial exhibition of Manet's works in 1884, presumed that the picture had been destroyed, since it was not included. In fact, *Boy with a Sword* had already been purchased in 1881 by the perspicacious American collector Erwin Davis, who also owned Manet's *Woman with a Parrot* (pages 36–37). When Davis donated the two pictures to the Metropolitan in 1889, they became the first of Manet's works to enter an American museum.

When interviewed later in his life, Léon Koëlla-Leenhoff, Manet's stepson, explained that he had posed for the picture in 1861, when he was about ten years old. His innocent gaze directed toward the spectator, the boy seems to be fetching a weapon for a grown-up. Manet dressed him in a seventeenth-century costume and borrowed a sword of the same period as a prop, presumably in a tribute to Velázquez and other Spanish artists whom he deeply admired. That the boy's straightforward pose, the neutral background, and the muted colors reflect the art of Spain's Golden Age was evident to most critics, who reviewed the work favorably when Manet exhibited it, on five separate occasions, during the next six years.

Gift of Erwin Davis, 1889 89.21.2

EDOUARD MANET

French, 1832–1883

Mademoiselle Victorine in the Costume of an Espada

Oil on canvas, 65 x 50¼ inches
Signed and dated (lower left): éd. Manet. / 1862

LIKE ALL THE WORKS submitted by Manet to the Salon of 1863, *Mademoiselle Victorine in the Costume of an Espada* was rejected. The severity of the jury that year was, however, countered when the government agreed to support a separate exhibition, the Salon des Refusés, where Manet's works provoked heated debate. Clearly he intended *Mademoiselle Victorine* to perplex. He chose his favorite female model, Victorine Meurent, for the picture, although women did not fight in the bullring. If it is to be understood that her gaze is directed toward a bull, she is holding her sword and cape ineffectually, and the latter, which should be red, is pink. Ignoring the premises of pictorial realism, Manet copied her pose from sixteenth- and seventeenth-century engravings, as if adherence to tradition were more important than common sense. His spoofery extended to the background of the painting. The vivid realism of the men and animals, based on etchings by Goya, is at odds with the theatrical pose of Victorine. Moreover, in terms of scale the groups of figures in the background are inconsistent with one another as well as with the principal figure. It seems beyond doubt that Manet conceived these disconcerting juxtapositions to show that enduring art is fundamentally the product of abstract harmonies of shape and color and not of convincing illusionism.

Bequest of Mrs. H. O. Havemeyer, 1929 29.100.53
H. O. Havemeyer Collection

28

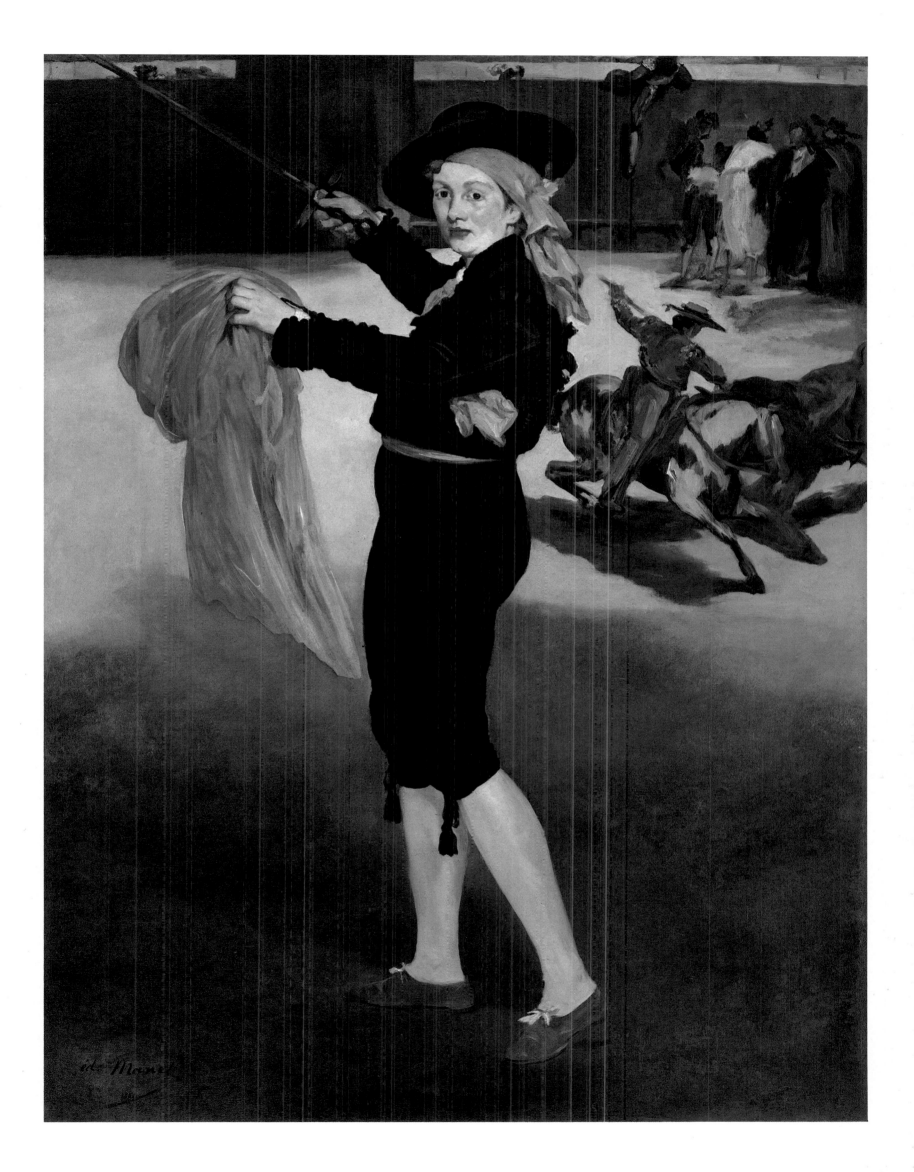

EDOUARD MANET

French, 1832–1883

Young Man
in the Costume of a Majo

Oil on canvas, 74 x 49⅛ inches
Signed and dated (lower right): éd. Manet. 1863

ACCORDING TO HIS close associates, Manet painted so many pictures with Spanish subjects because he had acquired a trunkful of Andalusian costumes that had enormous visual appeal for him. For this depiction of one of the dashing young Spaniards known as *majos,* Manet's younger brother Gustave donned the same cut-off trousers and bolero that Victorine Meurent had worn to pose for *Mademoiselle Victorine in the Costume of an Espada* (pages 28–29). Rejected by the Salon of 1863, both paintings were included in the Salon des Refusés that same year. Although Manet's robust brushwork and bold use of color were admired by most critics, some complained that the *majo* lacked psychological characterization, Manet having rendered his face and hands with no more attention than he had rendered details of the costume. In an article published early in 1867, Emile Zola countered such objections, explaining that Manet's only concern was to translate purely visual sensations into paint. "His attitude toward figure painting," contended Zola, "is like the academic attitude toward still life." Indeed, *Young Man in the Costume of a Majo* seems to have been conceived primarily as a vehicle for virtuoso painting both subtle and unrestrained. Striking in juxtaposition are the exquisitely delicate black and pastel tones of the *majo's* suit and the broadly applied red and orange stripes of the tasseled blanket draped over his arm.

Bequest of Mrs. H. O. Havemeyer, 1929 29.100.54
H. O. Havemeyer Collection

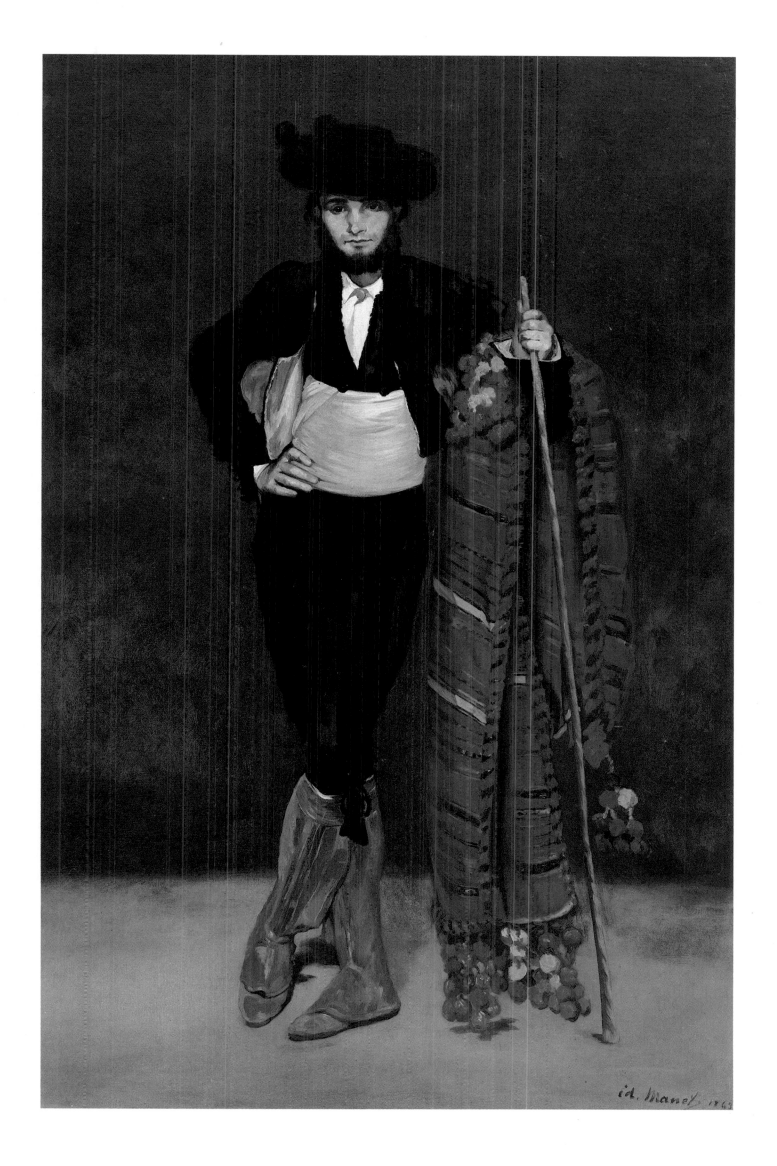

EDOUARD MANET

French, 1832–1883

The Dead Christ, with Angels

Oil on canvas, 70⅝ x 59 inches
Signed (lower left): Manet
Inscribed (lower right, on rock): évang[ile]. sel[on]. S⸋ Jean / chap[itre].
XX v. XII

MANY PROGRESSIVE mid-nineteenth-century artists, including Gustave Courbet, felt it was dishonest to paint things that could not be observed at first hand: for example, angels with wings. In fact, "Religious painting has disappeared," pronounced one critic of the Salon of 1857. Not surprisingly, Manet's *The Dead Christ, with Angels* provoked both surprise and anger when it was exhibited at the Salon of 1864.

In the passage from the Gospel of John referred to in an inscription on a rock in Manet's painting, Christ's disciples entered his tomb and found no trace of his body there, but instead two angels at the head and feet of the shroud. Recently scholars have suggested that Manet included the dead body of Christ in his picture because he had been impressed by Ernest Renan's best-selling book *La Vie de Jésus* (1863), in which the author claimed that Christ was a man, not a supernatural being. There are other anomalies in the painting: for example, Christ's wound is in his left side, and, though Baude-

laire pointed out the mistake prior to the Salon, Manet did not correct it. Nevertheless, criticism was not all adverse. Manet's advocates in the press compared his ability to paint the human figure to the skill of the Renaissance masters upon whose compositions *The Dead Christ, with Angels* is closely based.

Manet's previously exhibited works had frequently been found lacking in psychological characterization, but this Christ conveys both suffering and majesty, and the pity and sorrow of the angels are equally moving. According to Antonin Proust, his lifelong friend, Manet always wanted to depict the Crucifixion. Although that project was never realized, *The Dead Christ, with Angels* and *The Mocking of Christ* (1865, Art Institute of Chicago) indicate what enormous expressive powers the painter could bring to religious subjects.

Bequest of Mrs. H. O. Havemeyer, 1929 29.100.51
H. O. Havemeyer Collection

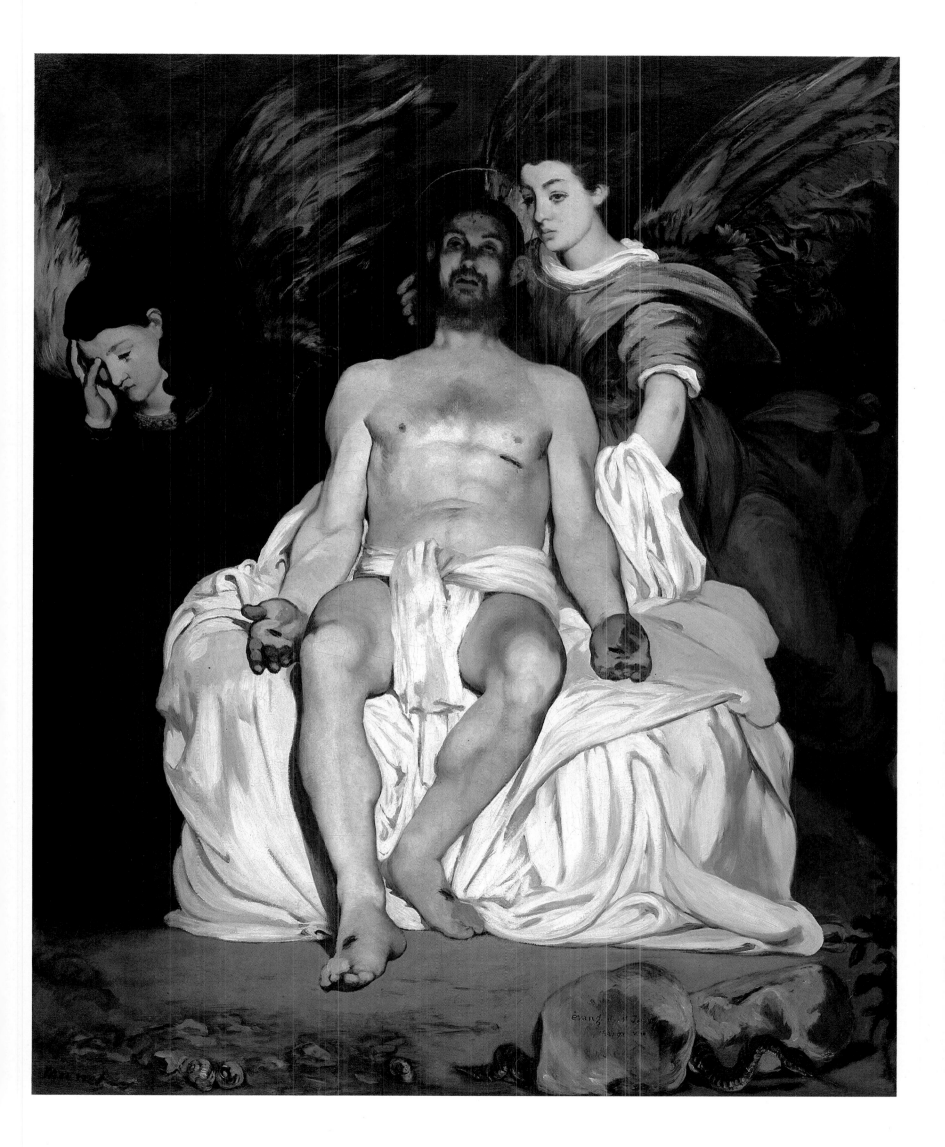

EDOUARD MANET

French, 1832–1883

Peonies

Oil on canvas, 23⅜ x 13⅞ inches

PERHAPS BECAUSE RECENT work by Courbet and Fantin-Latour had interested him in the subject, Manet painted half-a-dozen flower pictures during his summer vacation in 1864. As he would later in his career on those occasions when a still-life theme took his attention, Manet used different vases for different pictures in the series. The group of 1864 is devoted to peonies, reportedly Manet's favorite flower. Since their petals and leaves are broad, Manet could work with a relatively wide brush, and his paintings are thus more loosely rendered than many contemporary flower pieces. The delicate color of the peonies is accentuated in the Museum's example by the highly polished surface of a tabletop and by a red lacquer tray.

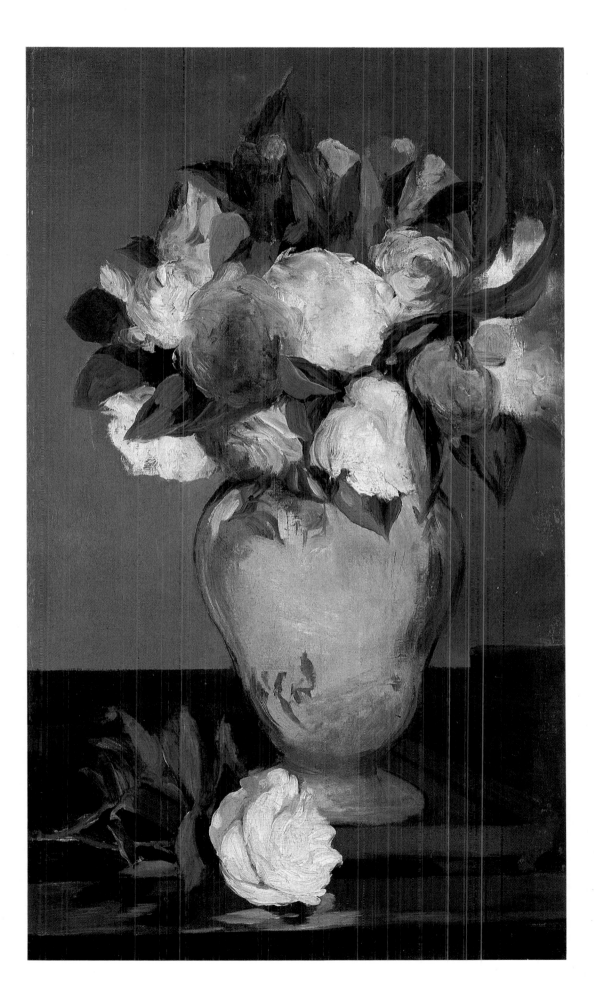

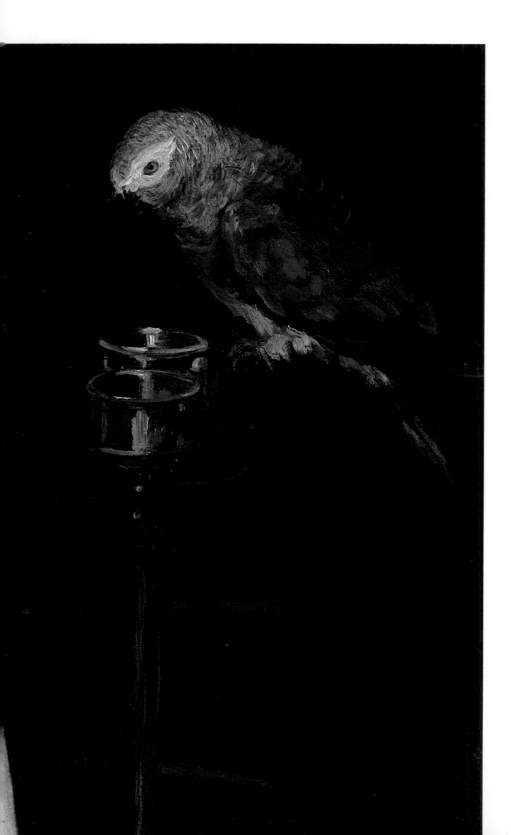

EDOUARD MANET

French, 1832–1883

Woman with a Parrot

Oil on canvas, 72⅞ x 50⅝ inches
Signed (lower left): Manet

MANET PAINTED *Woman with a Parrot* in his studio in the Rue Guyot. The model is Victorine Meurent. Given his inclination to allude to the works of other painters, it is probable that Manet conceived this picture as a comment on the controversial nude exhibited by his rival Courbet at the Salon of 1866 that is today also in the Metropolitan Museum (29.100.57). The two paintings were included in the one-artist exhibitions independently organized by Courbet and Manet for the World's Fair in Paris in the spring of 1867. Whereas Courbet's picture is explicitly sexual and filled with opulent objects of the boudoir, Manet's is discreet and spare. He may have wished to show that a truly gifted artist need work only with the simplest poses and props.

When it was exhibited for the second time, at the Salon of 1868, Théophile Gautier remarked that Manet had not bothered to place his figure in a realistic setting: "The indefinite and neutral background must have been borrowed from the wall of the studio, smeared with an olive color. If there were nothing more, it would be enough to make a beautiful picture." Yet Gautier found the painting to be without poetry or drama and, like other critics, he claimed that Manet had not fairly represented the beauty of his Titianesque model. The woman's pallor and pensive expression, however, may be intended to suggest private thoughts—perhaps of the lover whose captured monocle she fingers while absentmindedly inhaling the fragrance of a token of violets. Evidently she has only recently changed into a comfortable peignoir, for her hair is still bound up. Whether or not her lover is to be imagined as present is something that only her pet parrot will know.

The theme of a woman and her parrot-confidant has literary and pictorial antecedents. It has also been suggested that *Woman with a Parrot* is an allegory of the five senses: smell (the violets), touch and sight (the monocle), hearing (the talking bird), and taste (the orange).

Gift of Erwin Davis, 1889 89.21.3

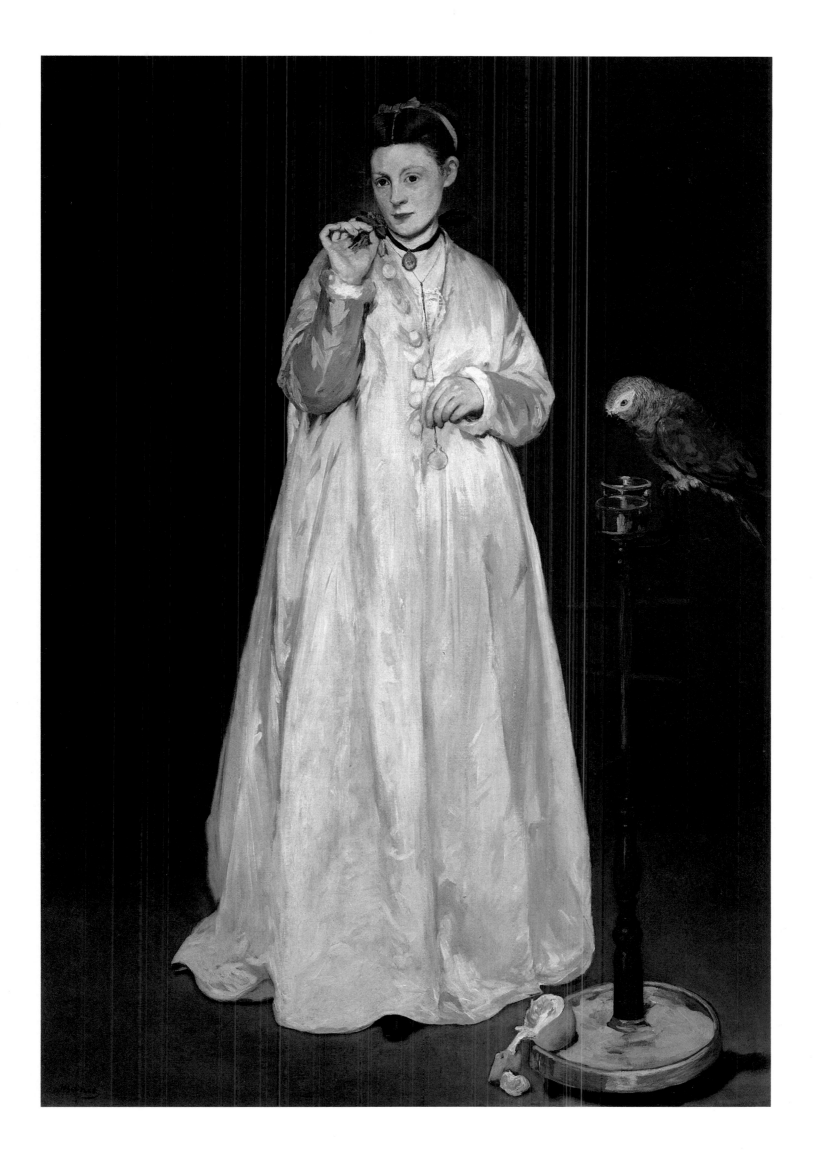

EDOUARD MANET

French, 1832–1883

Madame Edouard Manet

Oil on canvas, 39½ x 30⅞ inches

THE SITTER IS MANET'S wife, Suzanne Leenhoff, whom he painted several times after their marriage in 1863. Most of these portraits are interior scenes, but here her surroundings are undefined and she is dressed as if about to go out. The handle of an umbrella protrudes from beneath her left arm, and she seems to draw on her gloves. This picture is an excellent example of the kind of painting described by the critic Edmond Duranty in 1876: "What we need is the particular note of the modern individual, in his clothing, in the midst of his social habits, at home or in the street."

The portrait is unfinished and is therefore difficult to date, but most scholars relate it to Manet's work of the late 1860s. However, the character of the brushwork is very similar to that of a much later but also unfinished picture, *Le Clairon,* of 1882 (Wildenstein & Company, New York).

Its state provides a rare view of Manet's working method. The figure has been sketched in with thin but vigorous brushstrokes, after which Manet seems to have concentrated on the face. Technical examination has revealed that the artist scraped off and repainted the face at least twice before abandoning the portrait.

Bequest of Miss Adelaide Milton de Groot (1876–1967), 1967 67.187.81

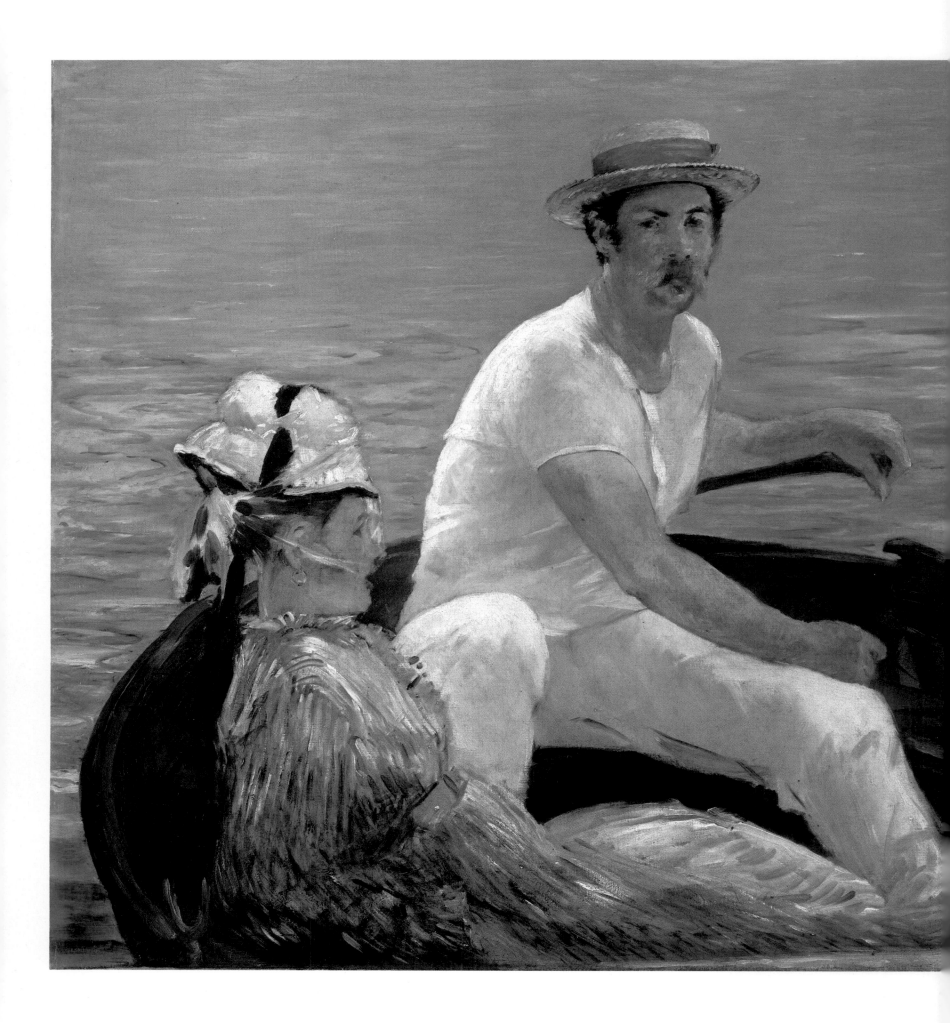

EDOUARD MANET

French, 1832–1883

Boating

Oil on canvas, 38¼ x 51¼ inches
Signed (lower right): Manet

BOATING WAS PAINTED during the summer of 1874, when Manet was working with Renoir and Monet at Argenteuil, a village on the Seine northwest of Paris. The high-keyed palette, the elevated viewpoint from which the water's surface appears to rise up as a backdrop, and the artist's decision to celebrate the everyday pleasures of the middle class are all in keeping with the Impressionist style recently developed by his younger colleagues. Despite his close association with Renoir and Monet, Manet preferred not to exhibit at their independent group shows but instead to submit his works to the official Salons, where they seemed out of place. Why they did J. K. Huysmans found easy to understand. At the Salon of 1879 he admired the unconventional visual qualities of *Boating*. "The bright blue water continues to exasperate a number of people," he wrote. "Manet has never, thank heavens, known those prejudices stupidly maintained in the academies. He paints, by abbreviations, nature as it is and as he sees it. The woman, dressed in blue, seated in a boat cut off by the frame as in certain Japanese prints, is well placed, in broad daylight, and her figure energetically stands out against the oarsman dressed in white, against the vivid blue of the water. These are indeed pictures the like of which, alas, we shall rarely find in this tedious Salon."

The identities of the sitters are uncertain, although the man may be Manet's brother-in-law, Rodolphe Leenhoff. At an early stage in the execution of the painting, his right hand held the rope to guide the sail, as X-rays and pentimenti indicate.

Bequest of Mrs. H. O. Havemeyer, 1929
H. O. Havemeyer Collection

29.100.115

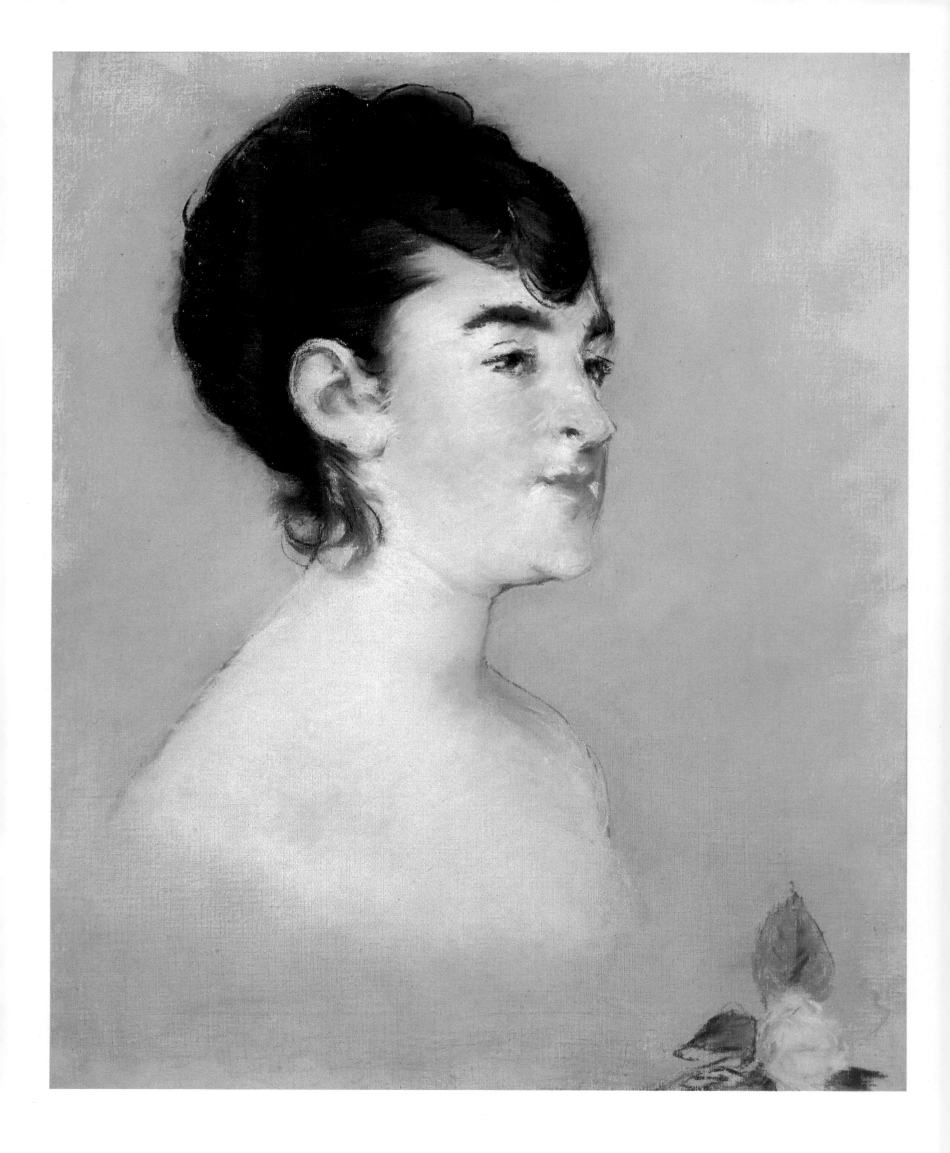

EDOUARD MANET

French, 1832–1883

Mademoiselle Isabelle Lemonnier

Pastel on canvas, 22 x 18¼ inches

BORN IN 1860, Isabelle Lemonnier was the daughter of a successful Parisian jeweler. She may have met Manet at the home of her sister Marguerite, Madame Georges Charpentier, who is the principal figure in Rencir's *Madame Georges Charpentier (Marguerite Lemonnier) and Her Children, Georgette and Paul,* of 1878 (pages 160–61).

In 1879 Manet painted the first of at least six portraits of Isabelle Lemonnier. This pastel may have been executed the same year, or perhaps in the summer of 1880, when Manet was staying at Bellevue, near Paris. Mademoiselle Lemonnier spent her summer holiday at a nearby villa, and Manet frequently sent her letters charmingly decorated with watercolor sketches.

Bequest of Mrs. H. O. Havemeyer, 1929 29.100.56
H. O. Havemeyer Collection

EDOUARD MANET

French, 1832–1883

George Moore

Pastel on canvas, 2 1 ³/₄ x 1 3 ⁷/₈ inches
Signed (lower left): Manet

A GROUP OF ARTISTS that included Manet, Degas, and Renoir brought the medium of pastel back into popularity during the final quarter of the nineteenth century. They were stimulated in large part by the enthusiastic reappraisal of Maurice Quentin de la Tour and other eighteenth-century masters of chalk drawing by the Goncourt brothers, whose *L'Art du dix-huitième siècle* began to appear in a new edition by Charpentier in 1881. The previous year the publisher had made new space in his offices available to Manet, who chose to exhibit not only recent oils but fifteen pastels.

Among them was this portrait of George Moore, the Irish writer, who had come to Paris as an art student in 1873. Later he would write memoirs that describe the Café de la Nouvelle-Athènes and its guests, among whom were members of the Impressionist group. Manet met Moore there in 1879, shortly after work in pastels had become a "passion" for him, and Moore agreed to serve as a model for a never-finished genre painting of a café (pages 48–49), as well as for this pastel portrait, a work that he reportedly found to be unflattering. Nevertheless, he obtained a photograph of the boldly executed portrait to use as the frontispiece for his book *Modern Painting* (1893).

Bequest of Mrs. H. O. Havemeyer, 1929 29.100.55
H. O. Havemeyer Collection

44

EDOUARD MANET

French, 1832–1883

The Monet Family in Their Garden

Oil on canvas, 2⊂ x 39¼ inches
Signed (lower right): Manet

THE MONTHS FOLLOWING the first of the Impression-ists' group exhibitions, in April 1874, were especially important for the development of painting in France. The Monet family settled in a house in Argenteuil that Manet had helped them find. As John Rewald has noted, "Probably no single place could be identified more closely with impressionism than Argenteuil where, at one time or another, practically all of the friends worked but where, in 1874 particularly, Monet, Renoir, and Manet went to paint.... Renoir made fre-quent visits there, once more painting at Monet's side, choosing the same motifs;...Manet himself decided to spend several weeks at Gennevilliers (where his family owned property) on the other bank of the Seine river, opposite Argenteuil."

Manet, whose example had been seminal for these younger men during the 1860s, took a greater interest now in their experiments. He paid relaxed visits to the Monet family and one day undertook this casual group portrait of Monet at work in his garden, accompanied by his wife, Camille, and their son Jean. While Manet was working Renoir arrived and painted Camille and Jean as they were posing for Manet (*Madame Monet and Her Son*, National Gallery of Art, Washington, D.C.). Caught up in the spirit of competition, Manet reportedly whis-pered to Monet in jest, "He has no talent at all, that boy! You, who are his friend, tell him please to give up painting." Renoir and Manet made presents of their canvases to their host. Monet, too, took up his brushes that day and painted Manet at work on this picture. Unfortunately his picture has been lost.

Bequest of Joan Whitney Payson, 1975 1976.201.14

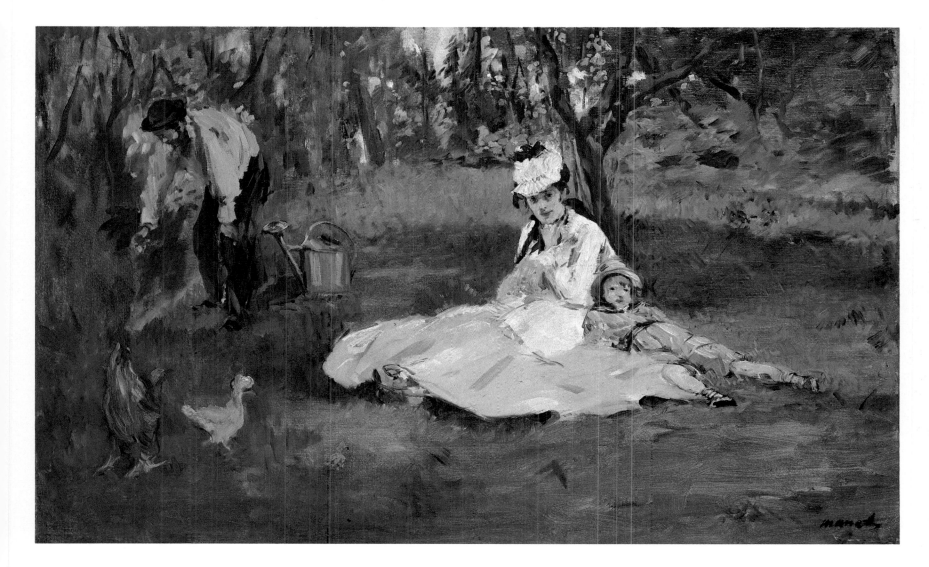

EDOUARD MANET

French, 1832–1883

George Moore (Au Café)

Oil on canvas, 25¾ x 32 inches

IN THIS UNFINISHED portrait of the writer George Moore, painted in 1879, Manet depicted the young Irishman at the popular Café de la Nouvelle-Athènes, a gathering place for artists and writers. Moore was introduced to the group at the café by the poet Stéphane Mallarmé and soon became a member of the circle that included Manet, Degas, Renoir, Monet, and Pissarro. The critic Théodore Duret later described Moore as an object of amusement for the others because of his odd manners and poor French. Moore had been a student of the academician Alexandre Cabanel but had abandoned painting for writing. Although he did not remain a member of the Nouvelle-Athènes group for long, he later wrote vividly of the café as well as of the artists and literary figures who assembled there.

Manet depicted Moore at least four times. Moore said that the artist's intention had been to paint him in a café: "He had met me in a café, and he thought he could realize his impression of me in the first surrounding he had seen me in. The portrait did not come off; ultimately it was destroyed." This picture is another that Manet never finished. However, the Museum owns a finished pastel portrait of Moore (pages 44–45) that Manet is believed to have done in 1879, shortly before Moore left Paris.

Gift of Mrs. Ralph J. Hines, 1955 55.193

49

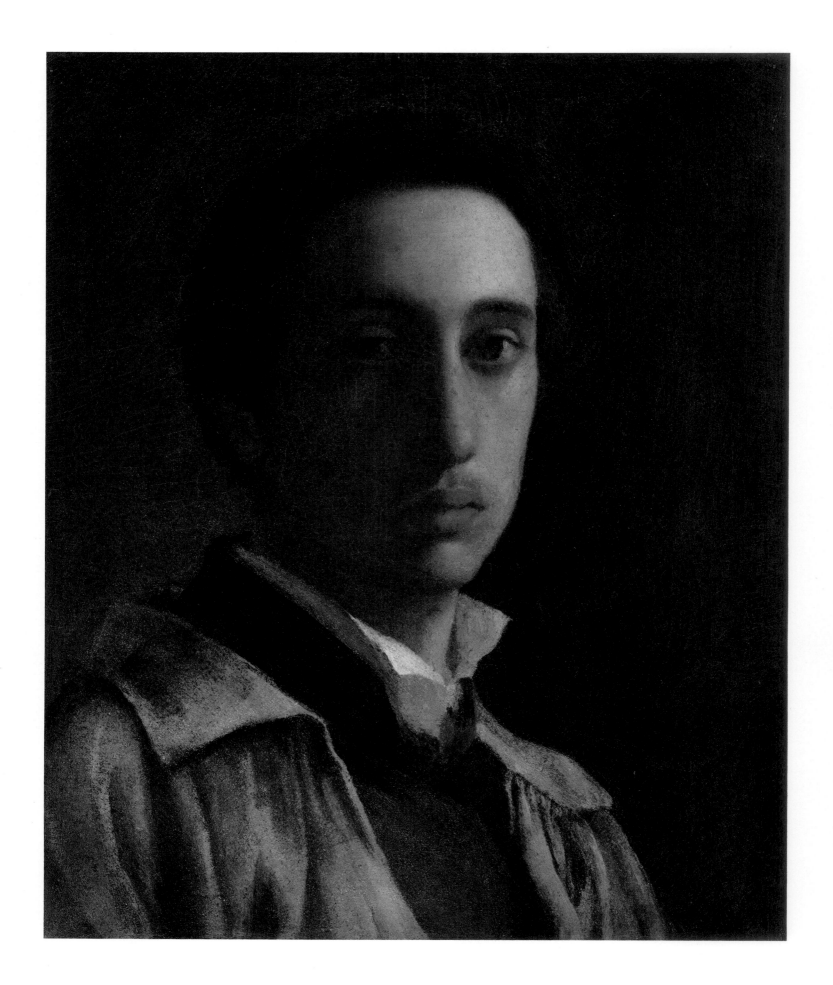

EDGAR DEGAS

French, 1834–1917

Self-Portrait

Oil on paper, mounted on canvas, 16 x 13 ½ inches

IN THE 1850s AND 1860s Degas produced numerous self-portraits in various media. This one is thought to have been painted in 1854, the year that he gave up the study of law to become an artist. The decision was difficult for the twenty-year-old Degas because he knew it would infuriate his father. According to Degas's niece, "With great sadness and no less nobility Degas left his father's home and went to live in an attic."

This work reflects Degas's acute awareness of the self-portraiture of Rembrandt, Ingres, and Delacroix. The close scrutiny, the intense introspection, and the precocious talent reflect an individual who was moody, disciplined, and demanding. Few living painters could have combined as successfully the classicism of Ingres and the romanticism of Delacroix.

Bequest of Stephen C. Clark, 1960 61.101.6

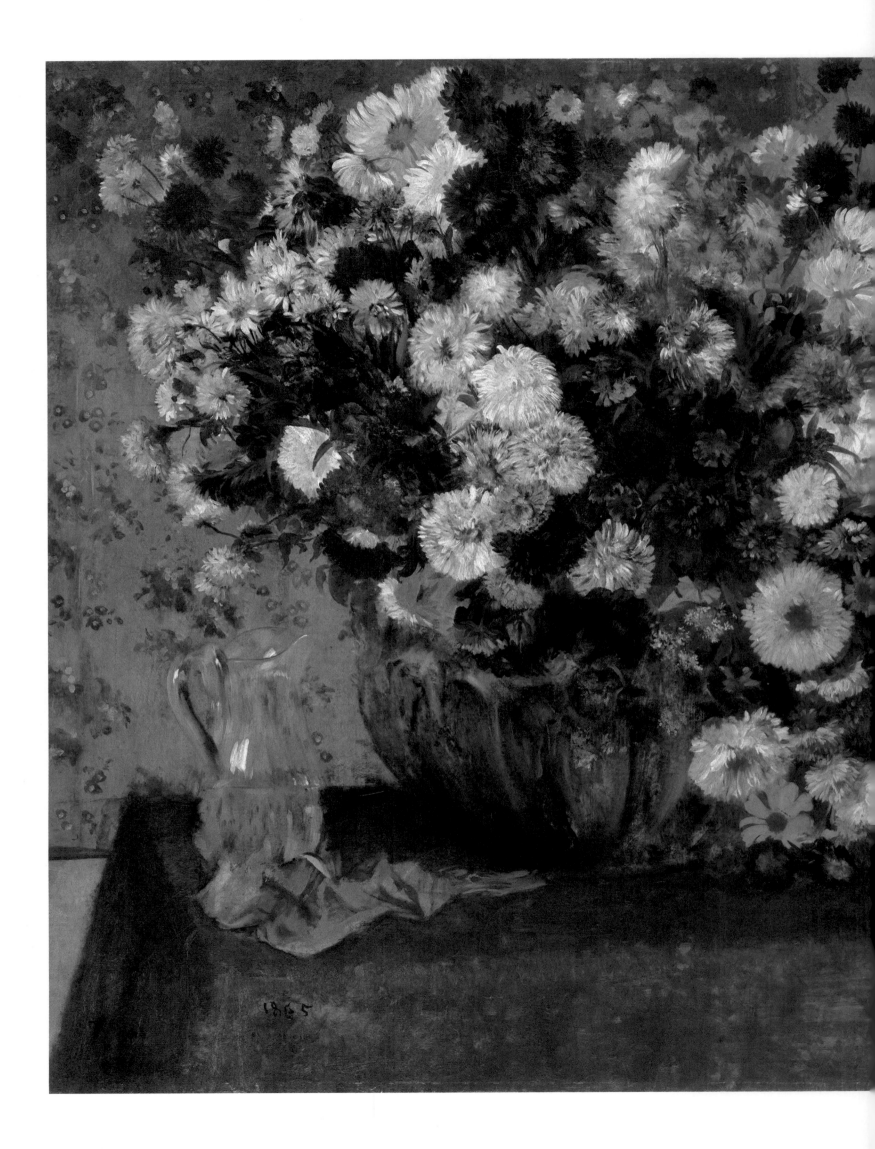

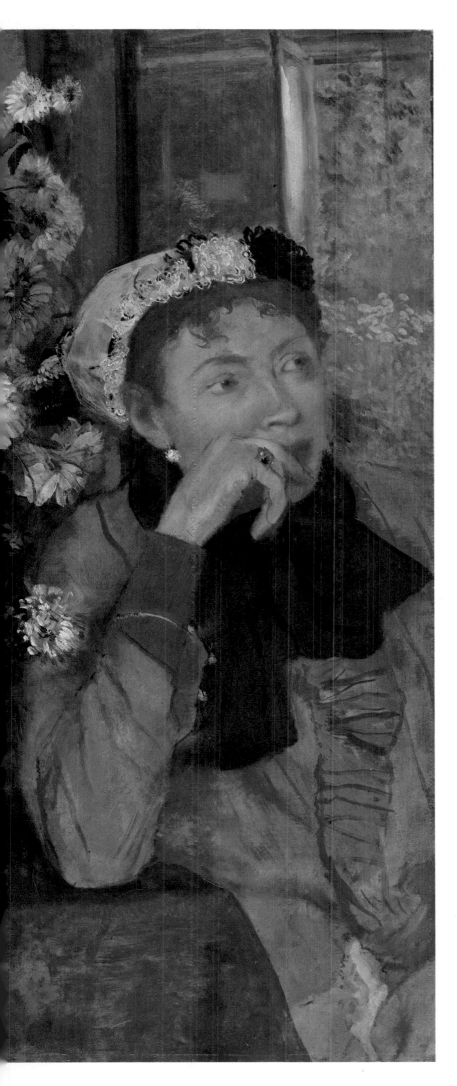

EDGAR DEGAS

French, 1834–1917

A Woman with Chrysanthemums

Oil on canvas, 29 x 36½ inches
Signed and dated (twice, lower left): D[e]gas / 18[5]8
1865 / Degas

PORTRAITS ARE AN extremely significant aspect of Degas's work, but, with a single exception, he seems never to have accepted a commission for one, and he made little effort to sell those that he did paint. Indeed, most were not formally posed, a departure from tradition. Instead, they reflect the artist's wish to depict his subjects in familiar and typical positions. Here, and in such works as *Mademoiselle Marie Dihau* (page 55), Degas observed his subject in a private and unguarded moment, but in this painting he may have relied as much on invention as on direct observation to create an image that would express the character of the unidentified sitter. Despite the compelling realism of this painting, there is strong evidence that the woman never posed next to the vase of flowers. The canvas is signed and dated twice, indicating that it results from two separate periods of activity. When completed in 1858, it was a still life of flowers that seems to have been strongly influenced by Delacroix's flower pictures of 1848–49. In 1865 Degas added the figure of the woman, for which there is a drawing (signed and dated 1865) in the Fogg Art Museum, Cambridge, Massachusetts. Moreover, X-rays and pentimenti show that her arm, right shoulder, and bodice cover blossoms that were part of the original composition—further evidence that the portrait was added to the still life at a later date. Like many of Degas's ballet pictures, *A Woman with Chrysanthemums* may thus be an assortment of observations that were brought together first in the artist's mind and then on canvas.

Bequest of Mrs. H. O. Havemeyer, 1929
H. O. Havemeyer Collection

29.100.128

53

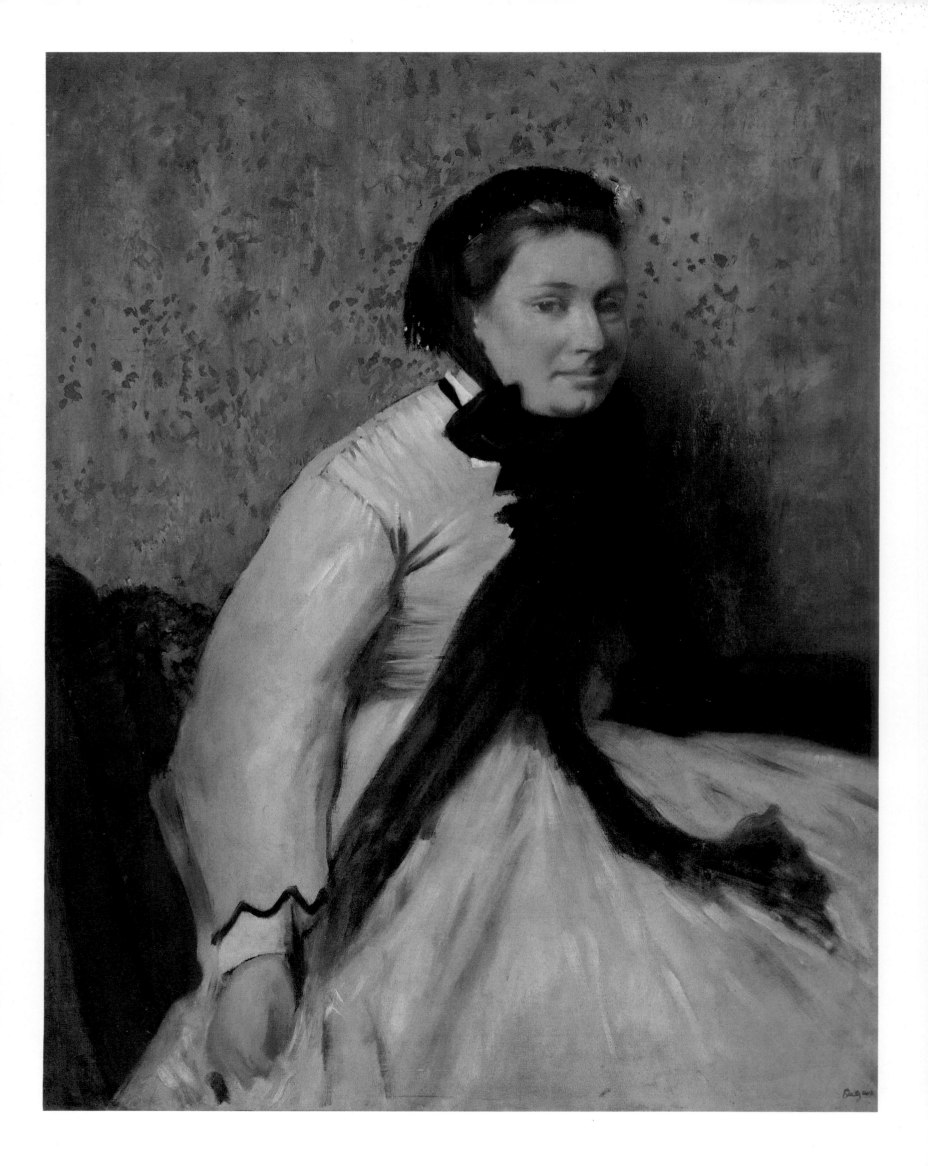

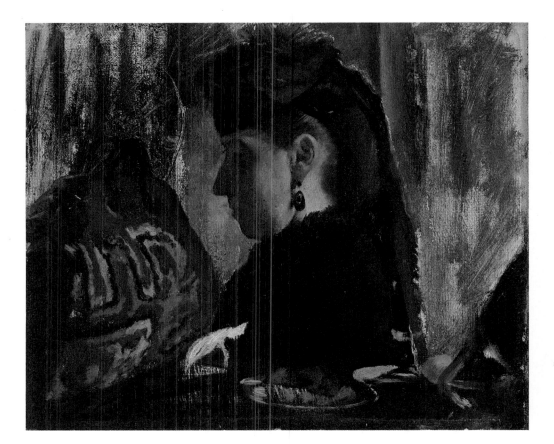

EDGAR DEGAS

French, 1834–1917

Portrait of a Lady in Gray

Oil on canvas, 36 x 28½ inches
Stamped (lower right): Degas

VARIOUS AUTHORS HAVE cited affinities between this portrait and works by Velázquez, Ingres, and Whistler, but any direct influences have been eliminated as the artist searched for the precise attitude and gestures that would reveal the character of the sitter. Here, the unidentified woman seems about to rise from the sofa. She is bonneted, ready to leave, and only partially turned toward the viewer. Her posture and imminent departure suggest an indefinable elusiveness, perhaps shyness. Her right hand, almost out of sight, grips nervously the length of scarf that she has pulled taut.

As in *A Woman with Chrysanthemums* (pages 52–53) and *Mademoiselle Marie Dihau* (above right), in this work of about 1865 Degas has achieved the kind of intimate view of an individual that is usually only possible with a camera. Interestingly, he later experimented with a camera, but none of the photographs that has survived is as successful as this painting.

The stamped signature identifies *Portrait of a Lady in Gray* as a work that was in the artist's possession when he died. It was included in the first four auctions of the contents of the artist's studio in 1918–19. All works included in the sales bear a stamped signature.

Gift of Mr. and Mrs. Edwin C. Vogel, 1957 57.171

Mademoiselle Marie Dihau

Oil on canvas, 8¾ x 10¾ inches

DEGAS'S PORTRAIT OF Marie Dihau shows the successful pianist and singer in what is probably a characteristically contemplative moment. She is seen in the Parisian restaurant Chez la Mère Lefebvre, a popular gathering place for musicians. In 1867–68, when this portrait was painted, Mademoiselle Dihau was living in Lille (where she had won a first prize at the Conservatory in 1862), when she was not in Paris working or visiting her two brothers. According to Mademoiselle Dihau's later recollection, the painting was done rapidly as a consolation gift before one of her frequent departures for Lille, which may account for the unfinished appearance of the background.

Undoubtedly Degas knew his subject well, for she and her brother Désiré belonged to a circle of musicians and cognoscenti of music that included the artist and his father. Désiré Dihau, a bassoonist in the orchestra of the Paris Opera, is depicted in Degas's *Ballet from "Robert le Diable,"* of 1872 (pages 68–69).

Bequest of Mrs. H. O. Havemeyer, 1929 29.100.182
H. O. Havemeyer Collection

55

EDGAR DEGAS

French, 1834–1917

The Collector of Prints

Oil on canvas, 20⅞ x 15¾ inches
Signed and dated (lower left): Degas / 1866

COMPARED TO HONORE DAUMIER'S images of collectors and connoisseurs, the unidentified figure depicted here seems detached and distant. Evidently he has been interrupted while seated in a gallery looking through a portfolio of prints. The single-mindedness of his endeavor is reflected in the cool, matter-of-fact glance from beneath the brim of the hat that he has not bothered to take off. Hunched over, and hidden by his hat and beard, this man reveals little about himself other than his interest in art.

Like Degas's portrait of his friend the artist Jacques Joseph Tissot, of 1866–68 (pages 58–59), and Manet's portrait of Emile Zola, of 1868 (Louvre, Paris), Degas's print collector is depicted in a setting that reflects contemporary interest in Far Eastern art. There is a T'ang horse in the vitrine to the left, and in the frame to the right, prominent among the paper and cloth miscellanea, are five Japanese woven silks that were originally used as pocketbook covers but were prized by nineteenth-century French collectors and artists for their intrinsic beauty of design.

Bequest of Mrs. H. O. Havemeyer, 1929 29.100.44
H. O. Havemeyer Collection

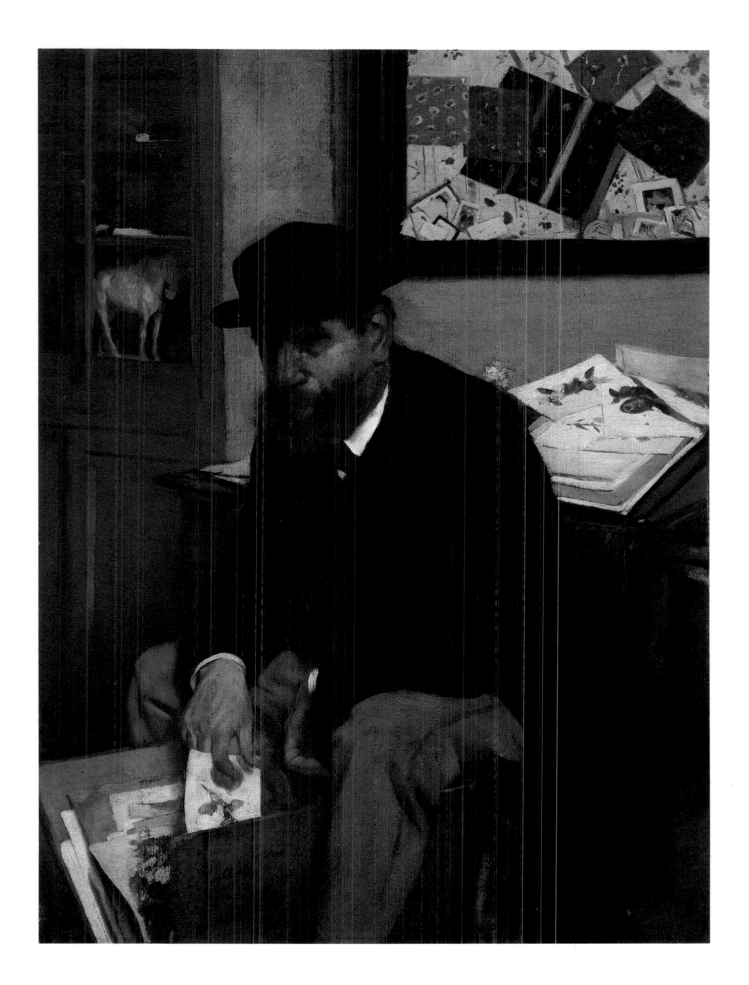

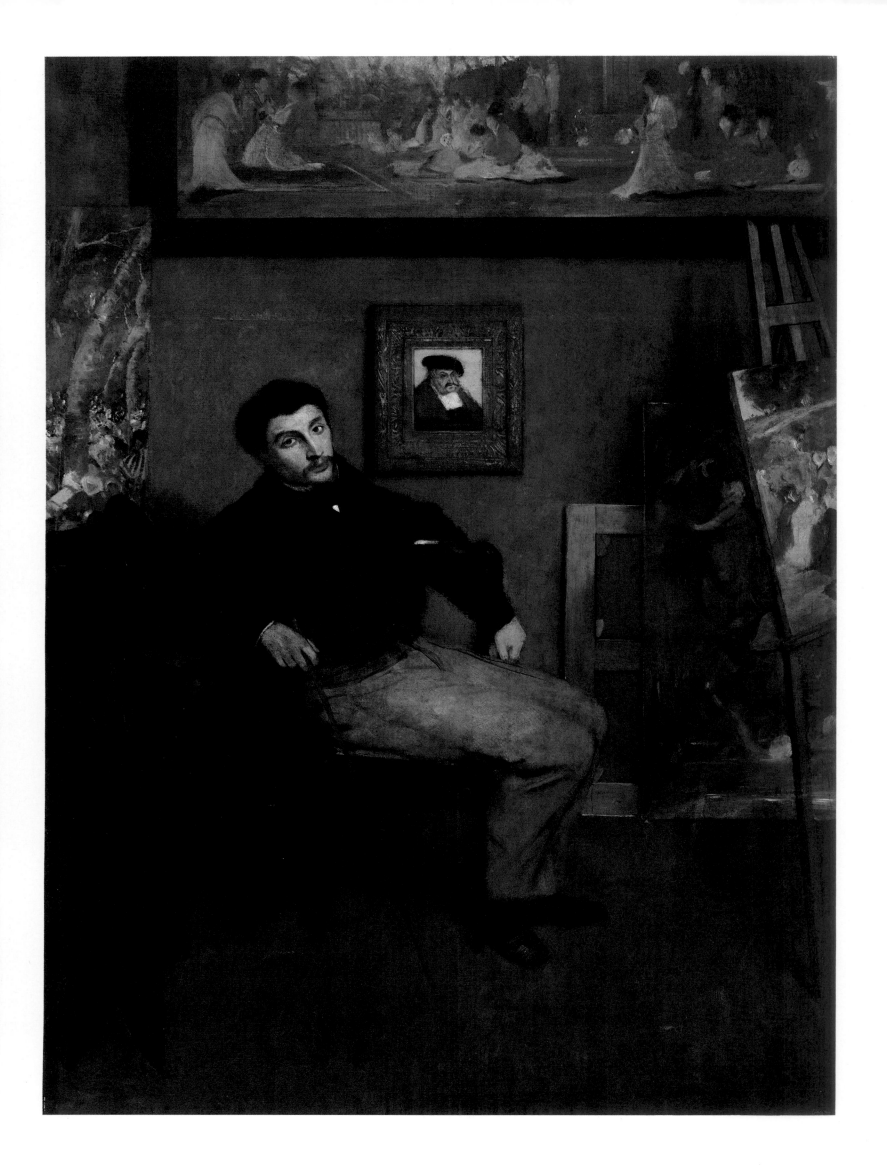

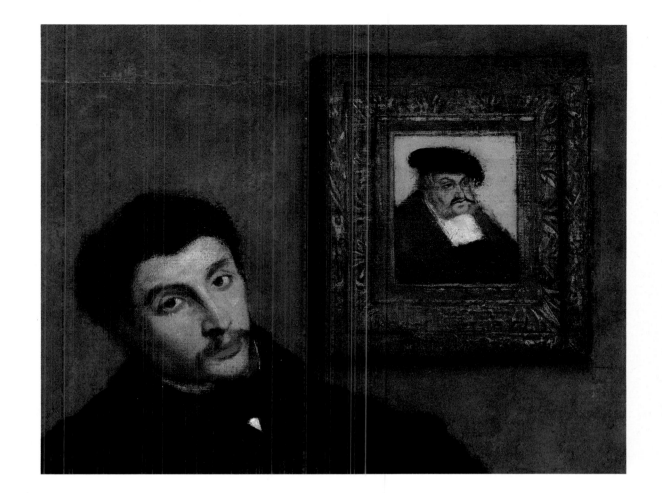

EDGAR DEGAS

French, 1834–1917

Jacques Joseph Tissot

Oil on canvas, 59⁵/₈ x 44 inches
Stamped (lower right): Degas

IN 1919, AT THE THIRD of four auctions of the contents of Degas's studio, three drawings appeared that helped to establish the identity of the sitter in this portrait as Jacques Joseph Tissot. In 1871 Tissot fled France after playing an active role in the violent political upheaval known as the Commune. He spent ten years in England, where he was known as James Tissot, and achieved great success as a painter of fashionable women in Victorian London.

In 1874 Degas wrote to Tissot in London and asked him to participate in what later became known as the first Impressionist exhibition: "Look here, my dear Tissot, no hesitations, no escape. You positively must exhibit.... The realist movement no longer needs to fight with the others; it already *is*, it *exists*, it must *show itself as something distinct,* there must be a *salon of realists.*" Tissot declined the invitation.

Degas's portrait of Tissot, of 1866–68, is often compared to the portrait of Zola that Manet painted in 1868

(Louvre, Paris). However, the portrait of Tissot is less formal and less obviously posed. Tissot, with a pointer in one hand, seems to have been interrupted while in the middle of a casual discourse on painting.

The works depicted here are, to a greater or lesser extent, improvisations on works that Degas knew well. For example, the picture to the right of Tissot's head is a portrait in the Louvre of Frederick the Great, Elector of Saxony, by the workshop of the sixteenth-century painter Lucas Cranach. This German Renaissance portrait and other paintings—old masters, contemporary European pictures, and oriental works—reflect Degas's, and presumably Tissot's, eclectic sensibility and willingness to consider the work of all periods in order to create a style both anchored in tradition and appropriate to subjects taken from modern life.

Rogers Fund, 1939

39.161

EDGAR DEGAS

French, 1834–1917

Portrait of Yves Gobillard-Morisot

Pastel on paper, 18⅞ x 11¹³/₁₆ inches
Signed (lower right): Degas

IN MAY 1869 Degas made three studies of Yves Gobillard-Morisot that were preparatory to the Museum's painting *Madame Gobillard-Morisot* (pages 62–63). Two are pencil drawings of Yves seated on a sofa. The third is this bust-length portrait. Yves's mother described the sittings for the pastel in a letter to another of her children, the Impressionist painter Berthe Morisot: "[Degas] came on Tuesday; this time he took a big sheet of paper and set to work on the head in pastel. He seemed to be doing a very pretty thing, and drew marvelously. He asked for an hour or two in the morning yesterday. He came to lunch and stayed all day; he appeared happy with what he did and was annoyed to have to tear himself away from it. He really works with ease, for all of this took place in the midst of the visits and good-byes that never ceased during these last two days" (Yves was about to depart to join her husband in Mirande).

Referring to this pastel, Berthe later wrote, "Monsieur Degas has made a sketch of Yves that I find indifferent." However, when it was exhibited at the Salon of 1870 she changed her mind and said, "[Degas's] masterpiece is the portrait of Yves in pastel."

Bequest of Joan Whitney Payson, 1975 1976.201.8

Joseph Henri Altès

Oil on canvas: original size, 9⅞ x 7⅞ inches; with added strips, 10⅝ x 8½ inches
Signed (upper left): Degas

PAINTED IN 1868, this profile view of the first flutist and concertmaster of the orchestra of the Paris Opera is one of Degas's many portraits of musicians. Altès's fine features and broad forehead suggest a man of refinement, intellect, and vision; indeed, the evocative power

of this small painting bears out one scholar's statement that "the particular gift of Degas . . . was to make a mood emerge from the paintings as if it were the sitter's." Interestingly, Degas has chosen to depict the flutist from the side not normally seen by the audience. It is, so to speak, his private side.

The composition suggests a Renaissance portrait, an association that Degas undoubtedly meant to convey. In fact, Mrs. H. O. Havemeyer, the first owner of the painting, hung the portrait of Altès between two French Renaissance portraits; in her memoirs she said she hoped to demonstrate that "the great modern held his own between those of the Renaissance."

Bequest of Mrs. H. O. Havemeyer, 1929 29.100.181
H. O. Havemeyer Collection

61

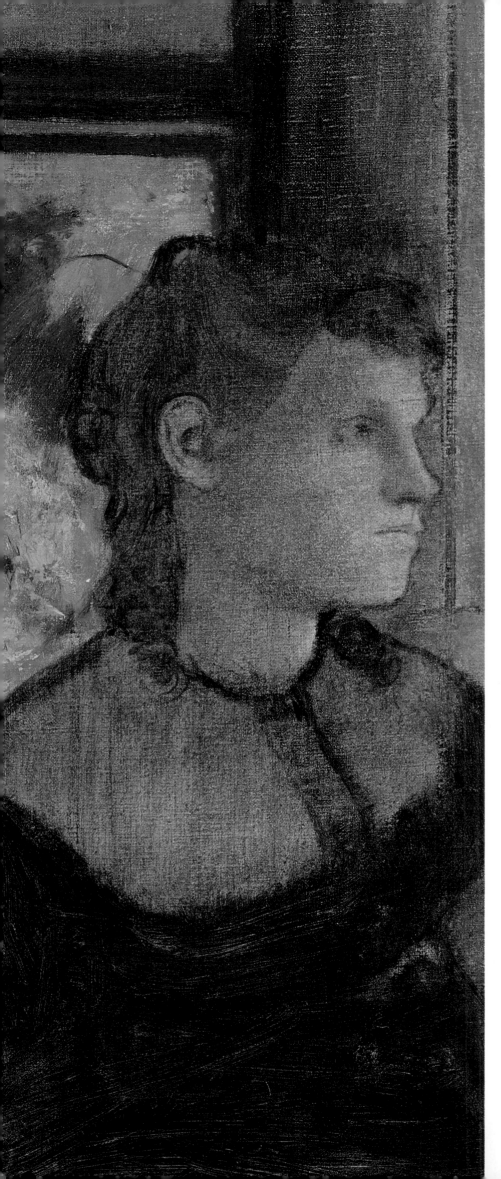

EDGAR DEGAS
French, 1834–1917

Madame Gobillard-Morisot (Yves Morisot)

Oil on canvas, 21⅜ x 25⅝ inches
Signed (lower left): Degas

DEGAS'S TWO drawings of May 1869 of Yves Gobillard-Morisot show her seated in the living room of the Morisots' home on the Rue Franklin (1984.76, 1985.48). The setting of the house was described by Yves's brother Tiburce: "This very simple house {stood} in a beautiful garden with large shade trees, to which doors on the ground gave direct access." Degas also did a bust-length portrait of Yves in pastel (pages 60–61), and sometime later he executed another drawing (Louvre, Paris). The painting probably followed in late June or early July. In both the pastel and the painting the garden is visible through the open door at the back of the room.

On May 23 the sitter's mother wrote to another of her daughters, the Impressionist painter Berthe Morisot, "Do you know that Degas is mad about Yves's face, and that he is doing a sketch of her? He is going to transfer to canvas the drawing he is doing in his sketchbook." Berthe herself was present during at least one of the sittings and provided the following account: "Monsieur Degas has made a sketch of Yves that I find indifferent; he chattered all the time he was doing it, he made fun of his friend Fantin, saying that the latter would do well to find new strength in the arms of love, because at present painting no longer suffices him. He was in a highly satirical mood; he talked to me about Puvis, and compared him to the condor at the Jardin des Plantes."

Bequest of Mrs. H. O. Havemeyer, 1929 29.100.45
H. O. Havemeyer Collection

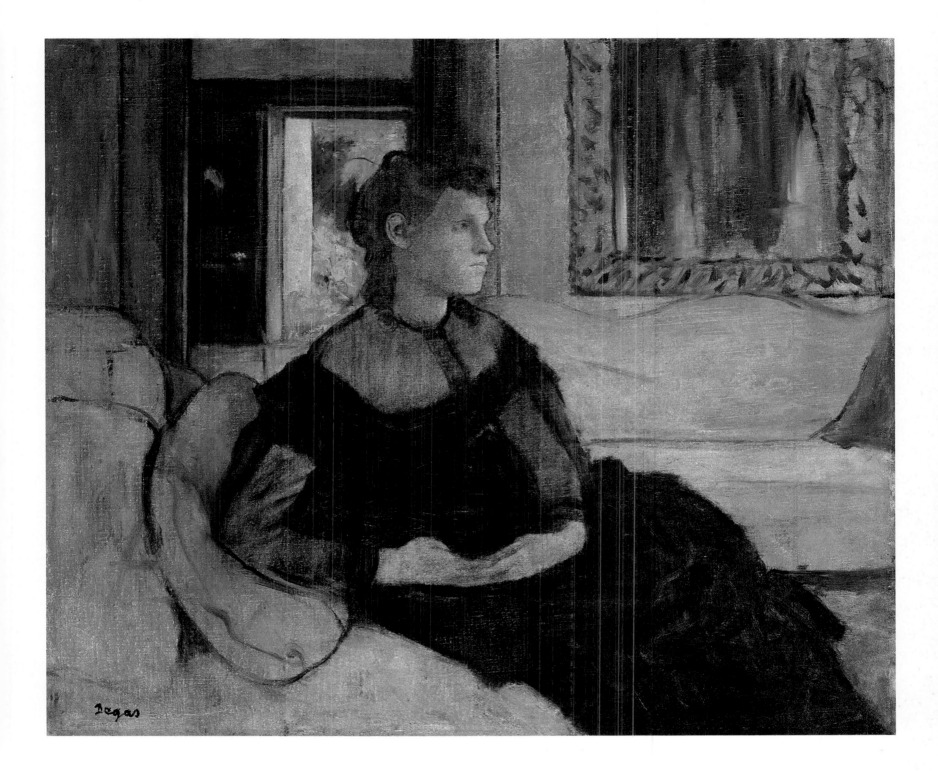

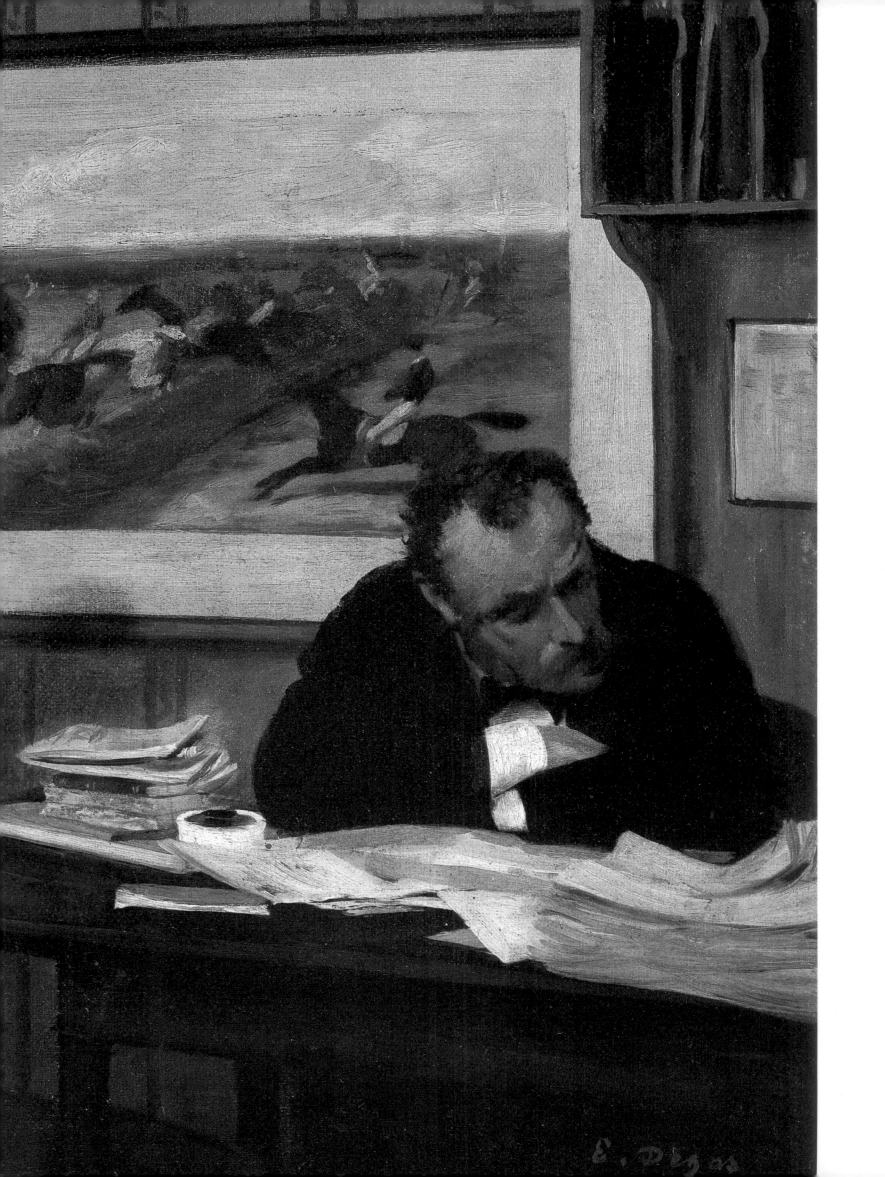

EDGAR DEGAS

French, 1834–1917

Sulking

Oil on canvas, 12¾ x 18¼ inches
Signed (lower right): E. Degas

THE SETTING OF THIS work, painted between 1869 and 1871, is possibly an office in Degas's father's bank on the Rue de la Victoire. The title is apocryphal. Originally this picture was probably known as *The Banker,* which was the title of one of six works that Degas bought back from his dealer in 1874.

Comparison with other paintings indicates that the models for the figures were Degas's friends Emma Dobigny and the critic and novelist Edmond Duranty. There is general agreement that the man seated at the desk is angry, disgusted, or annoyed, but the reason for his expression remains unexplained. The nature of the interaction between the two figures is also unclear. Possibly the painting is the result of a project that Degas proposed in a notebook of 1869: "Do expressive heads . . . a study of modern feeling . . . it is Lavater, but a more relativistic Lavater, so to speak, with symbols of today rather than the past." Lavater was an eighteenth-century Swiss who had devised a theory of analytical physiognomy through which one could interpret human character. Degas's choice of Duranty as a model may not have been accidental. In 1867 Duranty had published an essay, "On Physiognomy," in which he discussed a variety of theories of physiognomic expressiveness.

It would be understandable if in this picture Degas associated an angry or disgusted individual with his father's bank. In 1854 his father had strongly disapproved of his son's decision to become an artist, and the twenty-year-old Degas left home with little to support himself except his own determination.

Bequest of Mrs. H. O. Havemeyer, 1929
H. O. Havemeyer Collection

29.100.43

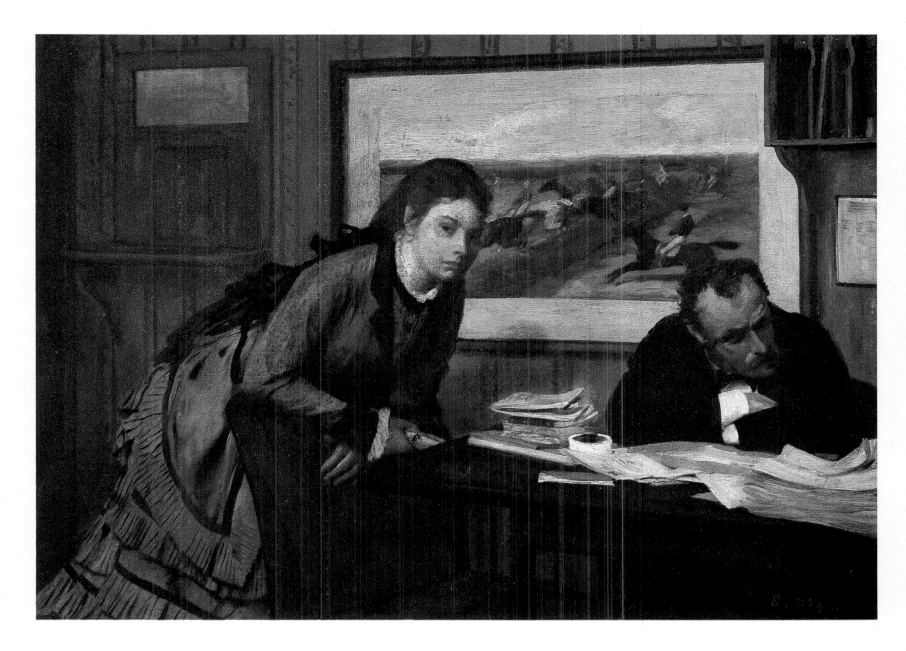

EDGAR DEGAS

French, 1834–1917

The Dancing Class

Oil on wood, 7¾ x 10⅝ inches
Signed (lower right): Degas

DEGAS'S FIRST DEPICTION of dancers rehearsing was *The Dancing Class,* which he probably painted late in 1871. Although there is visual and technical evidence that the artist made some changes in this picture while working on it (for example, the positions of the central figure and her reflection in the mirror have been altered), no preparatory drawings or studies have survived. This painting is apparently the full record of Degas's initial treatment of a subject that occupied a prominent position in his subject matter for the next thirty-five years.

The Dancing Class is also important as Degas's first essay in the orchestration of groups in an interior. It is very likely that the composition is a product of the artist's imagination, because in a letter (unfortunately undated) to a friend, in which he asked for a pass to observe the dance examinations at the Opera, Degas admitted that he had painted dance classes without ever having attended one: "I have painted so many dance examinations without having seen one that I feel a little ashamed."

Bequest of Mrs. H. O. Havemeyer, 1929 29.100.184
H. O. Havemeyer Collection

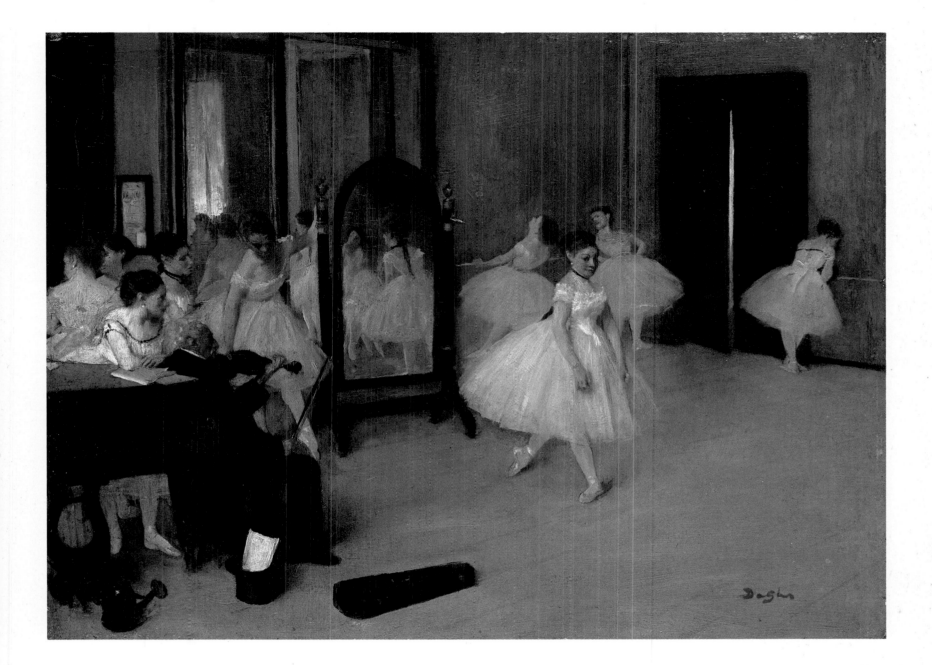

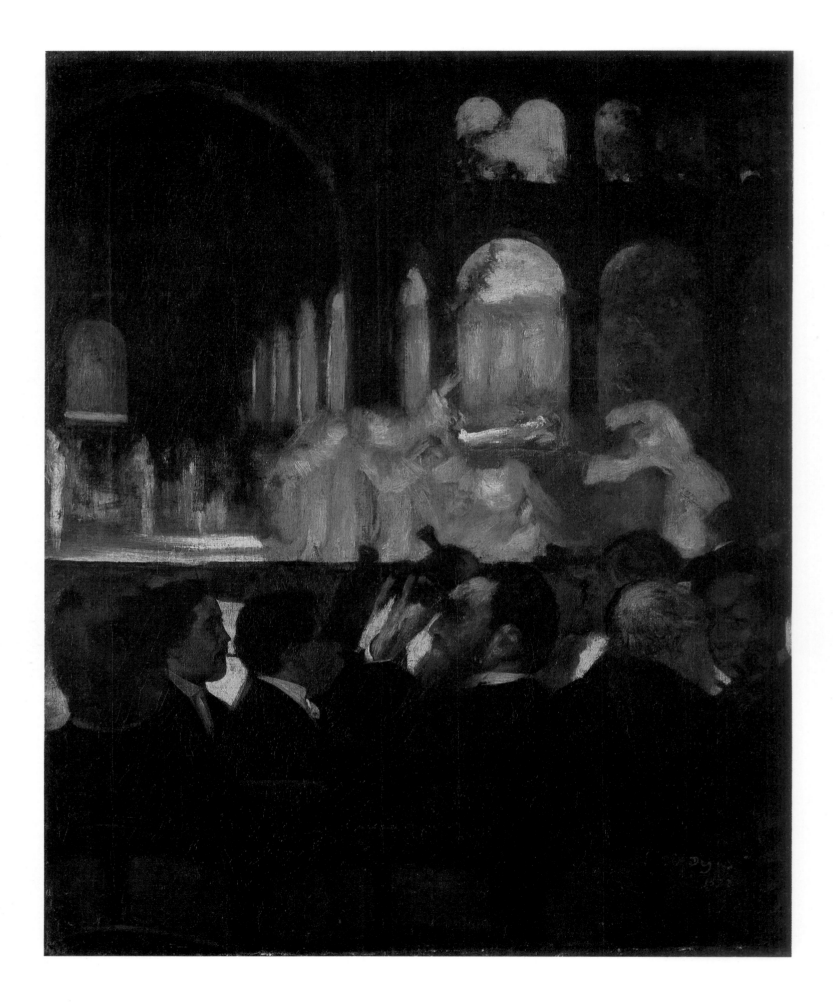

EDGAR DEGAS

French, 1834–1917

The Ballet from "Robert le Diable"

Oil on canvas, 26 x 21 3/8 inches
Signed and dated (lower right): Degas / 1872

THE SUBJECT OF THIS painting was probably inspired by the 1871 production of Meyerbeer's first French opera, *Robert le Diable,* which had been popular since its premiere in 1831. The ballet scene—during which the ghosts of a convent of nuns rise from their graves and dance through a cloister—must have fascinated Degas because of its extraordinary lighting effects. Indeed, one of his notebooks contains the following entry about the picture: "In the recession of the arcades the moonlight barely touches the columns—on the ground the effect is rosier and warmer than I have made it. Vaults black, arches indefinite. The panel of footlights is reflected by the lamps (?)."

The figure in the audience holding the opera glasses is Degas's friend the collector Albert Hecht, who is believed to have been the first owner of the painting. The second figure from the left is also identifiable. He is the bassoonist Désiré Dihau, whom Degas painted on several occasions (for example, he appears in *The Orchestra of the Paris Opera,* 1868–69, Louvre, Paris). Degas also painted two portraits of Dihau's sister Marie, one of which is in the Museum's collection (page 55).

The Ballet from "Robert le Diable" was probably influenced by depictions of theater subjects by Honoré Daumier and Adolf von Menzel. Degas admired the work of Daumier, and he is known to have copied a work by Menzel.

A horizontal version of *The Ballet from "Robert le Diable,"* dated 1876, is in the Victoria and Albert Museum (Ionides Collection), London. There are also drawings for the dancing nuns in the collection of the Victoria and Albert.

Bequest of Mrs. H. O. Havemeyer, 1929
H. O. Havemeyer Collection

29.100.552

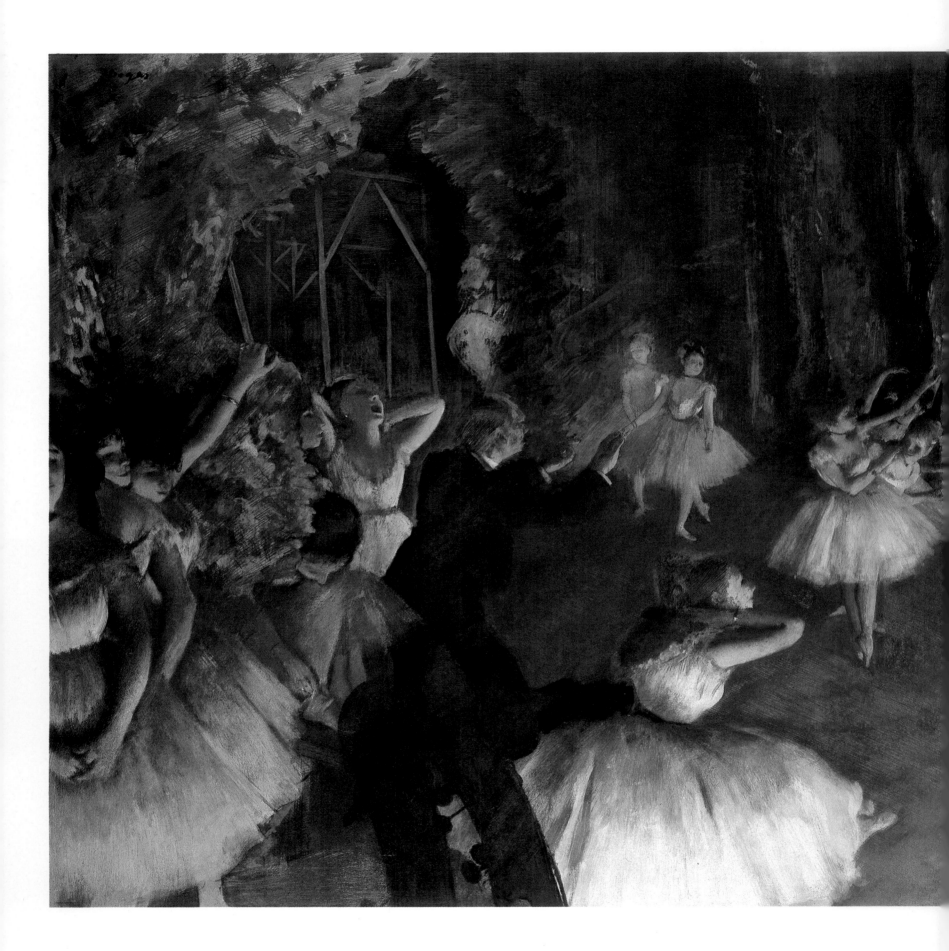

EDGAR DEGAS

French, 1834–1917

The Rehearsal
of the Ballet on the Stage

Oil colors freely mixed with turpentine, with traces of
watercolor and oil paint over pen-and-ink drawing on paper,
mounted on canvas, 21³/₈ x 28³/₄ inches
Signed (upper left): Degas

THIS PAINTING OF ABOUT 1873 is one of two very
similar versions of the same composition in the Mu-
seum's collection. The other is *The Rehearsal on the Stage*
(29.100.39), of 1873–74. Another work, the Louvre's
Répétition de Ballet sur la Scène, of 1874, presents a third,
somewhat different variation on the subject, but techni-
cal evidence suggests that the Louvre's picture was,
during one phase of its evolution, very similar to the two
in the Metropolitan.

The Rehearsal of the Ballet on the Stage began as a
pen-and-ink drawing that Degas submitted to the *Il-
lustrated London News* for publication in 1873. The draw-
ing was rejected because it was not considered suitable
for the Victorian reading public. This image was created
by working over the original drawing with a combina-
tion of *peinture à l'essence* (oil colors thinned with turpen-
tine), oil paint, and watercolor.

The Rehearsal of the Ballet on the Stage and *The Rehearsal
on the Stage* were part of a group of rehearsal pictures that
Degas made in 1873–74. There are numerous drawings
and studies for the Metropolitan's two pictures and for
the example in the Louvre. In addition, there is a
painting in the collection of the Courtauld Institute,
London, that contains figures directly related to the
performers at the front of the stage in all three versions.

Gift of Horace Havemeyer, 1929 29.160.26
H. O. Havemeyer Collection

EDGAR DEGAS

French, 1834–1917

A Woman Ironing

Oil on canvas, 21³⁄₈ x 15 ½ inches
Signed (lower left): Degas

A WOMAN IRONING of 1874 is one of Degas's many depictions of laundresses done between 1869 and 1902. Several authors have suggested a connection between them and the descriptions of laundresses in Edmond de Goncourt's novel *Manette Salomon* (1867), but Degas's pictures have none of the social implications of de Goncourt's book or any other naturalist novel. Moreover, Degas's works always rise above the picturesque concerns of genre painting and the issues of poverty and class struggle implicit in Daumier's treatment of the subject.

Degas's primary motive for painting laundresses at work is suggested in a passage from de Goncourt's *Journal.* In an entry dated February 13, 1874, he described Degas's fascination with the repertory of skilled, specialized movements of laundresses, which he related,

at least by implication, to the artist's fascination with dancers: "Yesterday I spent the afternoon in the studio of a painter named Degas. . . . And Degas placed before our eyes [pictures of] laundresses. . . while speaking their language and explaining to us technically the downward pressing and circular strokes of the iron, etc. etc. Next [pictures of] dancers file by. . . . The painter shows you his pictures, from time to time adding to his explanation by mimicking a choreographic development, by imitating, in the language of the dancers, one of their arabesques—and it is really very amusing to see him, his arms curved, mixing with the dancing master's aesthetics the aesthetics of the artist."

Bequest of Mrs. H. O. Havemeyer, 1929 29.100.46
H. O. Havemeyer Collection

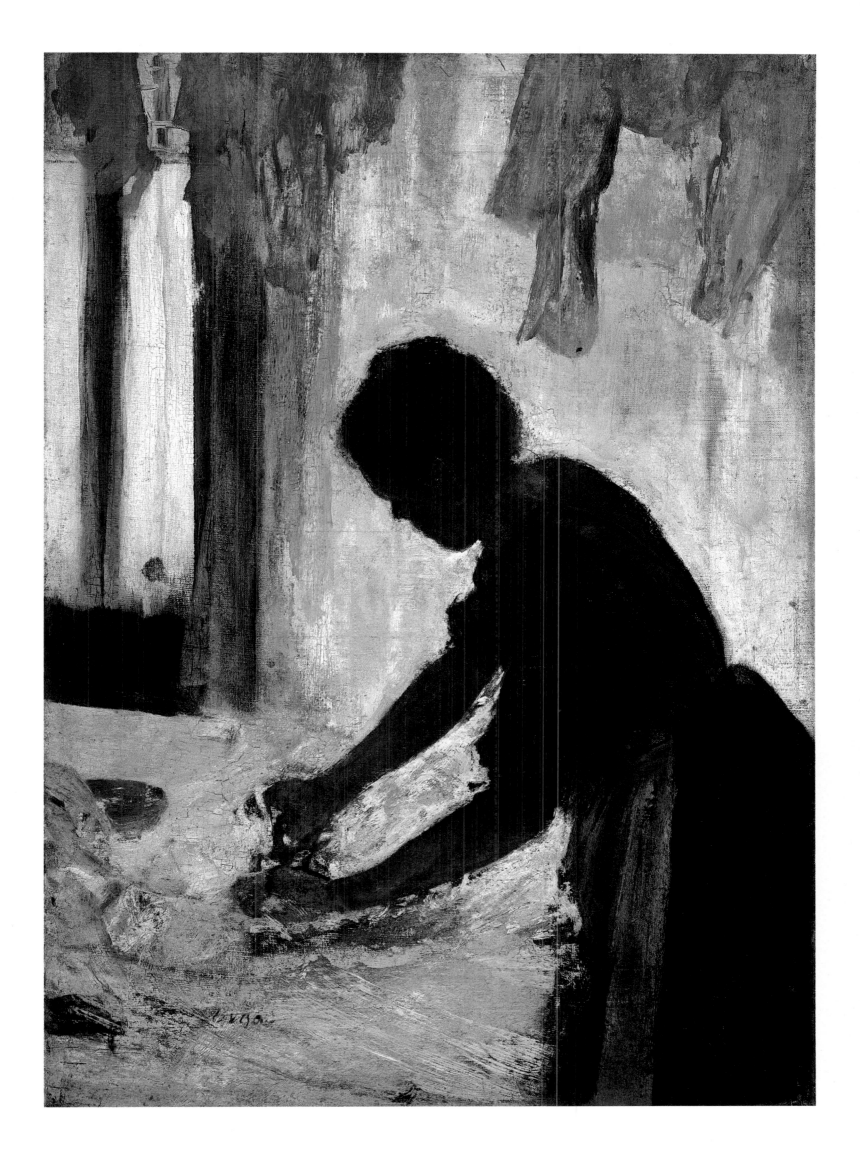

EDGAR DEGAS

French, 1834–1917

Dancers Practicing at the Bar

Oil colors freely mixed with turpentine, on canvas,
29³/₄ x 32 inches
Signed (at left): Degas

ALTHOUGH *Dancers Practicing at the Bar* has a casually realistic appearance, Degas's fascination with form and structure is reflected in the analogy between the watering can (used to lay the dust on the studio floor) and the dancer at the right. The handle on the side imitates her left arm, the handle at the top mimics her head, and the spout approximates her right arm and raised leg. Compositional devices such as this bear out the artist's famous remark, "I assure you that no art was ever less spontaneous than mine. What I do is the result of reflection and study of the great masters; of inspiration, spontaneity, temperament . . . I know nothing."

At one point Degas apparently had reservations about the visual pun and asked his friend Henri Rouart, the owner of the picture, if he would allow him to paint out the watering can. Knowing that Degas sometimes ruined works by making too many revisions, Rouart refused to allow him to take back the picture. A story that it was padlocked to the wall to prevent the artist from taking it away was dismissed as apocryphal by Rouart's son.

As in *The Rehearsal of the Ballet on the Stage* (pages 70–71), the medium of *Dancers Practicing at the Bar* is *peinture à l'essence.* The technique permits a thin, fluid application of paint and leaves a mat, pastel-like surface when it dries. There exists a *peinture à l'essence* sketch on paper of the two dancers, a pastel variant of the dancer at the right, and several drawings related to the figures and the composition.

Bequest of Mrs. H. O. Havemeyer, 1929 29.100.34
H. O. Havemeyer Collection

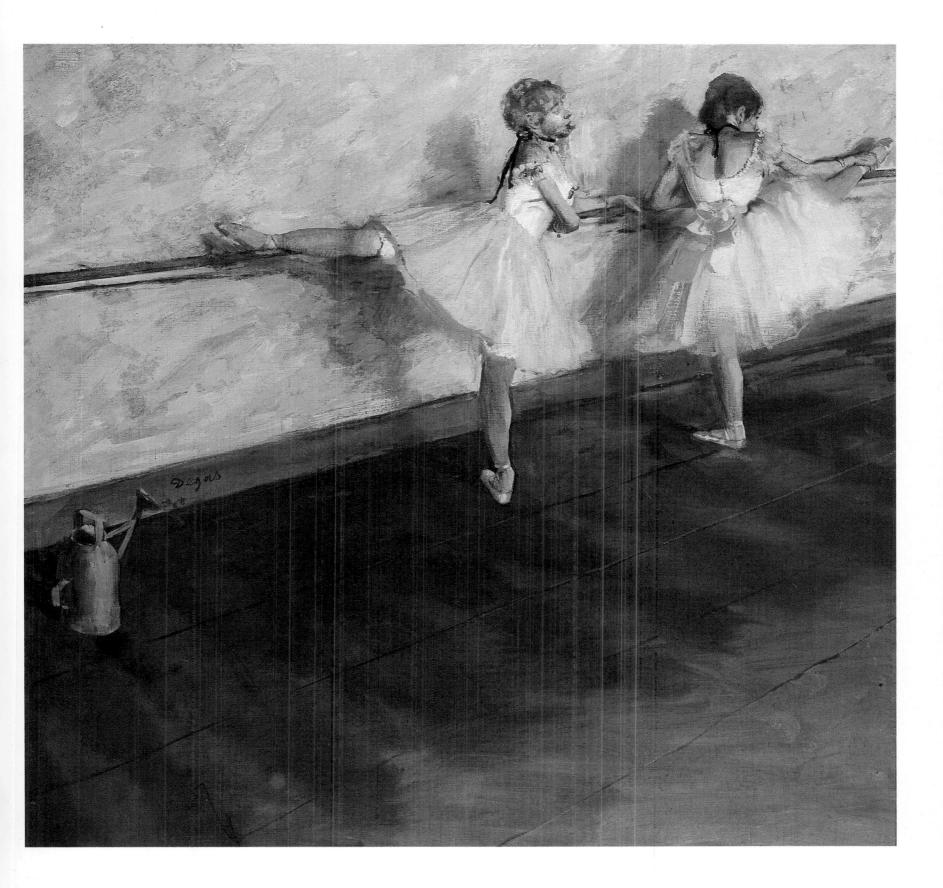

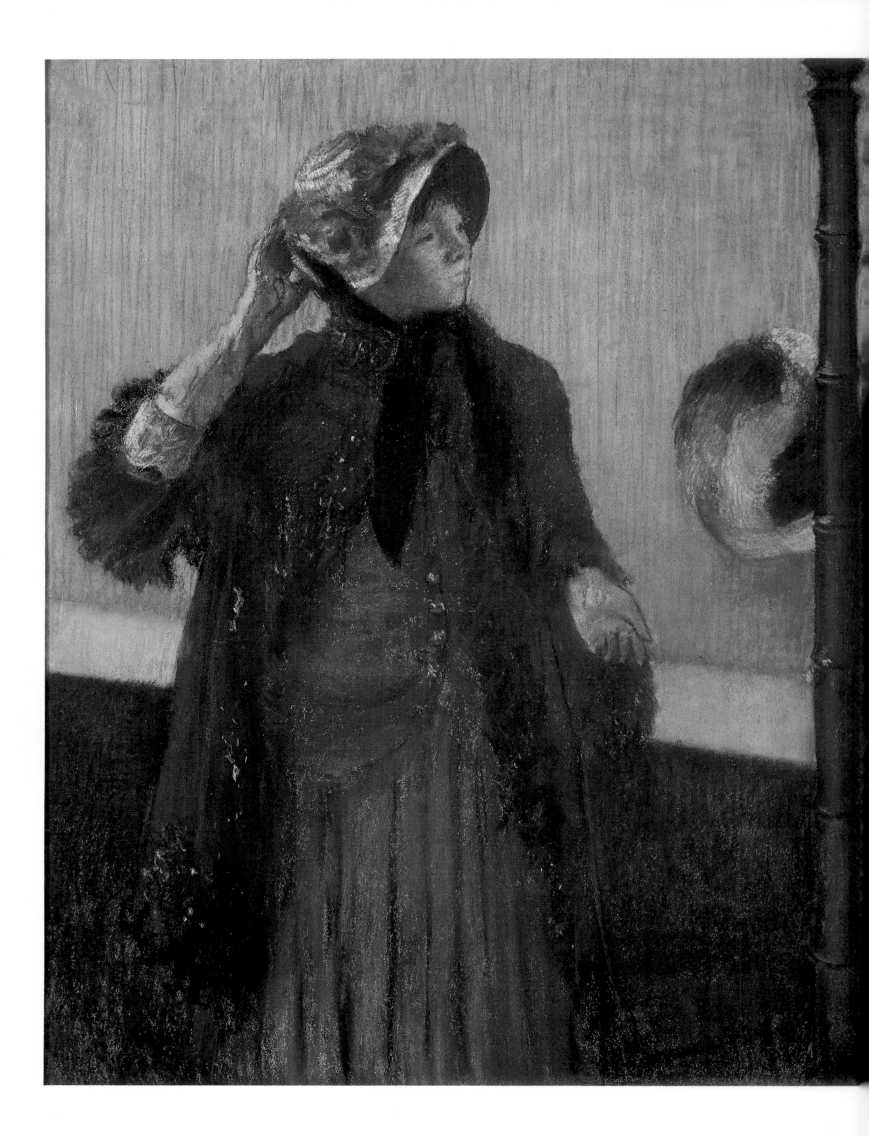

EDGAR DEGAS

French, 1834–1917

At the Milliner's

Pastel on paper, 30 x 34 inches
Signed and dated (upper right): 1882 / Degas

IN 1882 DEGAS produced several pastels of women trying on hats. Customers in various poses are seen regarding themselves in mirrors, while shopgirls stand nearby ready to perform what might be called a milliner's manual of arms. The gestures and postures are less precise than those of a ballerina or a laundress, but they are nevertheless similarly codifiable and demonstrable. These movements belong to the unconscious urban choreography that gives life much of its structure. The subject was as consciously "modern" as Degas's studies of café singers or laundresses. The Irish author George Moore wrote that the customer in *At the Milliner's* was "as typical of the nineteenth century as Fragonard ladies are of the court of Louis XV."

The painter Mary Cassatt may have posed for this pastel. Degas is said to have frequently accompanied his women friends on such errands and later to have turned what he saw into pictures.

Bequest of Mrs. H. O. Havemeyer, 1929 29.100.38
H. O. Havemeyer Collection

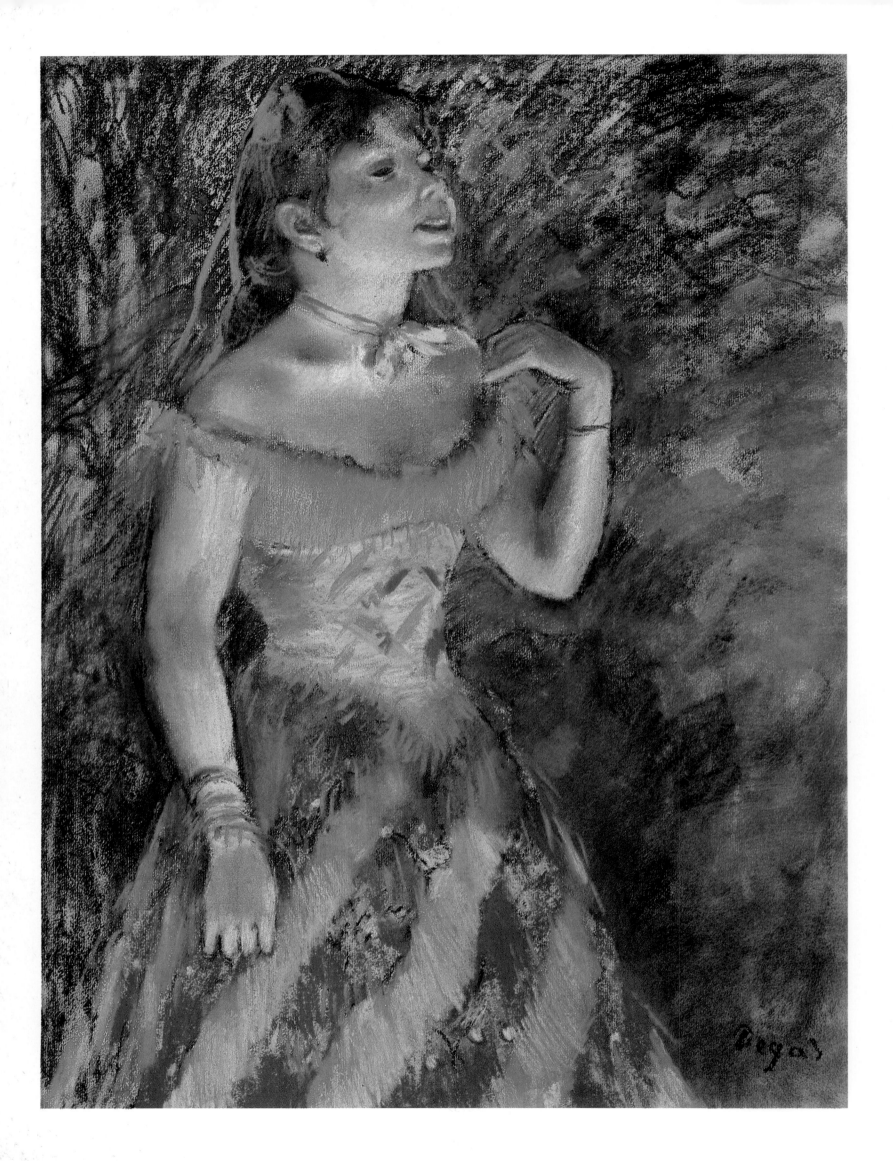

EDGAR DEGAS

French, 1834–1917

The Singer in Green (La Chanteuse Verte)

Pastel on paper, 23¾ x 18¼ inches
Signed (lower right): Degas

THE SINGER DEPICTED in this work performs in a *café concert,* one of the music halls that were a primary source of entertainment in nineteenth-century Paris. She is the mid-1880s' equivalent of a pop singer or a nightclub entertainer. The strong colors of her costume result from the exaggerating effects of the footlights. In Degas's many pictures of *café-concert* entertainers, as in his depictions of dancers both on and off stage, he shows an interest in the technical aspects of art. Here, for example, he has chosen a subject that depends heavily on a variety of artificial effects: costume, music, gesture, and stage lighting. *The Singer in Green,* executed about 1885, also reflects the artist's interests in subjects from contemporary urban life and in activities requiring expert knowledge and specialized training, such as those performed by dancers, jockeys, and laundresses. Like so many of Degas's pictures, this work focuses on the dialogue between art and the process of art, a subject that fascinated the artist throughout his career.

Bequest of Stephen C. Clark, 1960 61.101.7

79

EDGAR DEGAS

French, 1834–1917

The Bather

Pastel on paper, 22 x 18¾ inches
Signed (upper left): Degas

DEGAS'S MANY IMAGES of women climbing into or out of a bathtub form a significant subgroup within the broad category of bathing subjects that he executed during the 1880s and 1890s. Evidently he first used the pose depicted in this example in a pastel of 1883 that once belonged to the art dealer Ambroise Vollard. *The Bather* belongs to a group of pastels, drawings, monotypes, and one painting that are usually dated about 1890. The softness of the execution and the vertically striated application of the pastel relate them to a number of pictures by the artist of the late 1880s.

The ordinariness of the model, her ungainly pose, and the banality of the subject neutralize the erotic element. We tend to regard this picture as a work of art *per se* rather than an illustration of a particular theme. Like Monet's Haystacks of 1888–91, the subject seems less important than the artist's interpretation of it. The exaggerations and simplifications create rhythms and juxtapositions of color that fascinate us because of their pictorial and formal qualities. The theme is less important than the variations and impositions; Degas, not the subject, predicates our interest in these images.

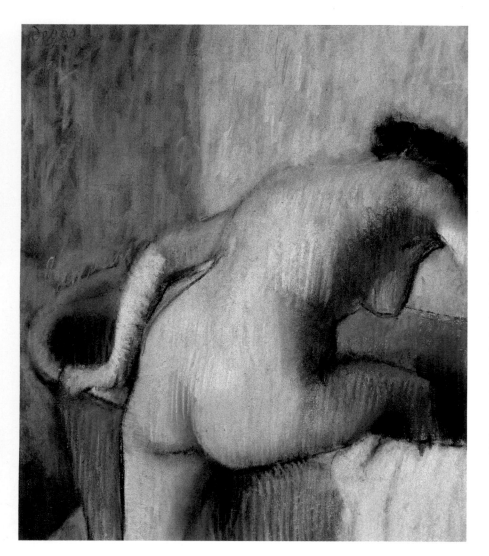

A Woman Having Her Hair Combed

Pastel on paper, 29⅛ x 23⅞ inches
Signed (lower left): degas

THIS IS ONE OF ten pastels that Degas exhibited in 1886 at the eighth and last of the Impressionists' group exhibitions. In the catalogue he described them as "a series of nudes of women bathing, washing, drying themselves . . . combing their hair and having it combed." This work, dated about 1885, is the only one among Degas's pastels of the mid-1880s that fits the last phrase of the description exactly. Intimate yet impersonal, the scene seems to have been glimpsed through a keyhole, an effect that Degas consciously sought: "Hitherto . . . the nude has always been represented in poses which presuppose an audience, but these women of mine are honest, simple folk, unconcerned by any other interests than those involved in their physical condition. . . . It is as if you looked through a keyhole."

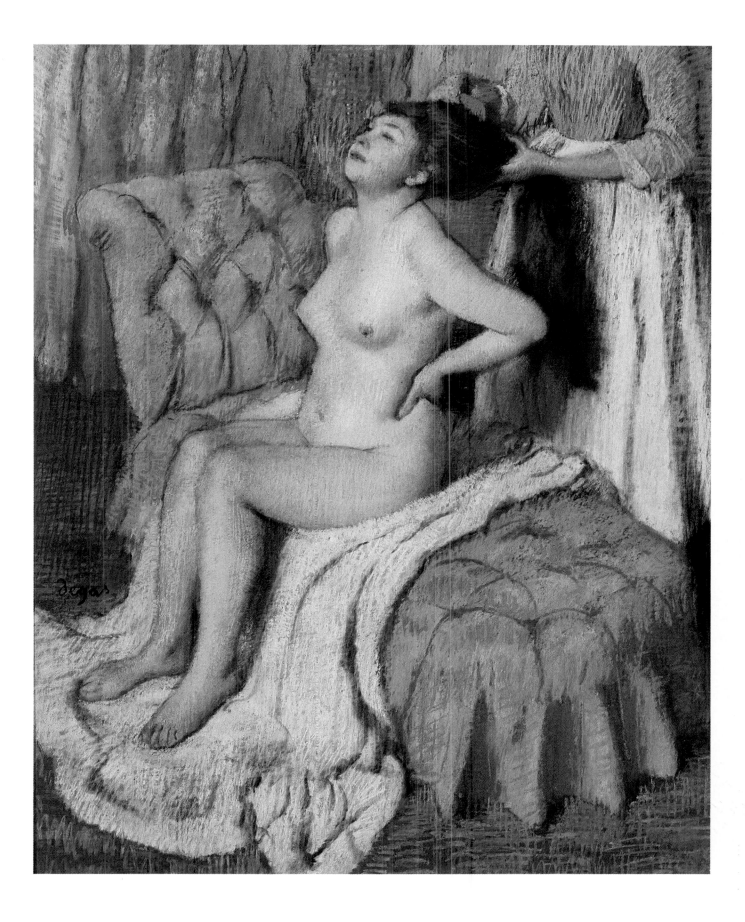

EDGAR DEGAS

French, 1834–1917

Dancers, Pink and Green

Oil on canvas, 32⅜ x 29¾ inches
Signed (lower right): Degas

DANCERS, PINK AND GREEN, of about 1880, is signif-
icant as a late work in which Degas tried to imitate in
paint the effects that he was able to achieve in pastel,
especially the exaggerated effects of such pastels of the
1880s as the Museum's *Singer in Green* (pages 78–79).
Moreover, the broader treatment of form and the looser
handling of paint indicate a growing concern with the
formal elements of painting—color, surface, and tex-
ture. The subject is increasingly a means to explore
aesthetic interests that have begun to outweigh illusion-
istic concerns. It is an interesting coincidence that at
about the time that *Dancers, Pink and Green* was painted,
Maurice Denis published his famous statement, "Re-
member that a painting—before it is a battlehorse, a
nude woman, or some anecdote—is essentially a flat
surface covered with colors assembled in a certain or-
der." There is another version of this painting in
the Louvre, *Danseuses Bleues,* of about 1890.

Bequest of Mrs. H. O. Havemeyer, 1929 29.100.42
H. O. Havemeyer Collection

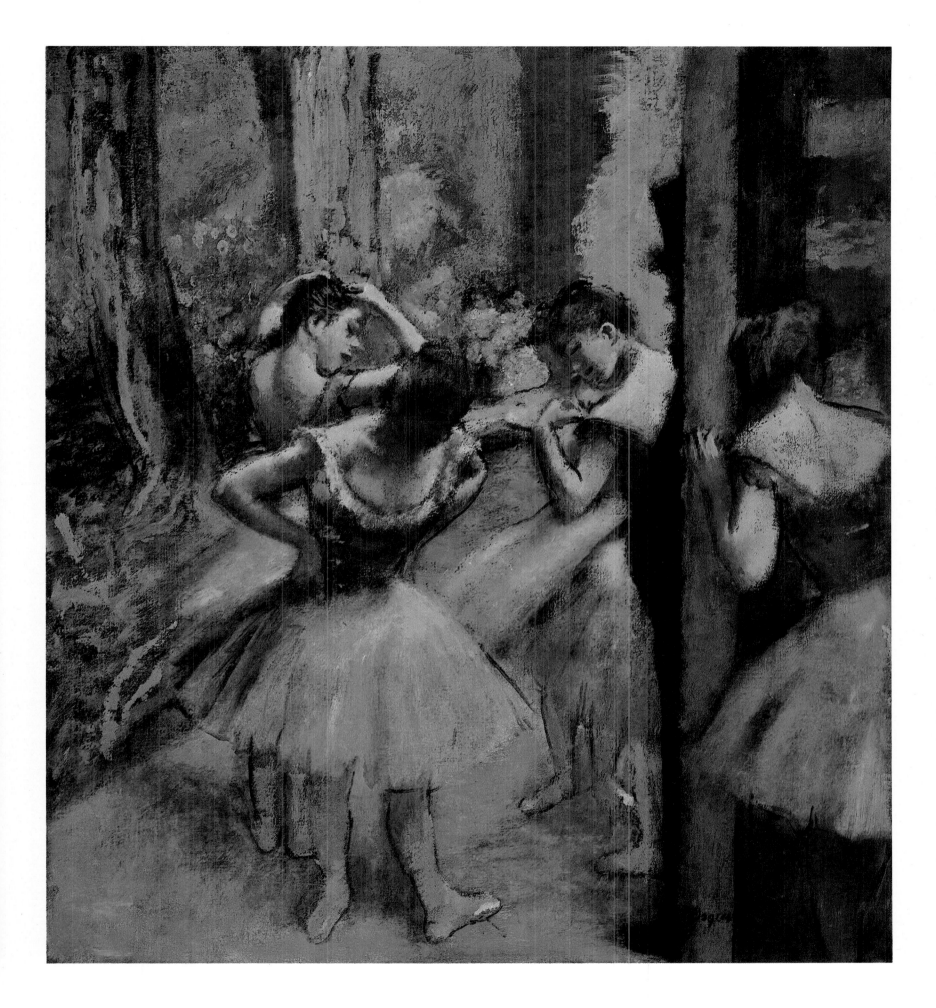

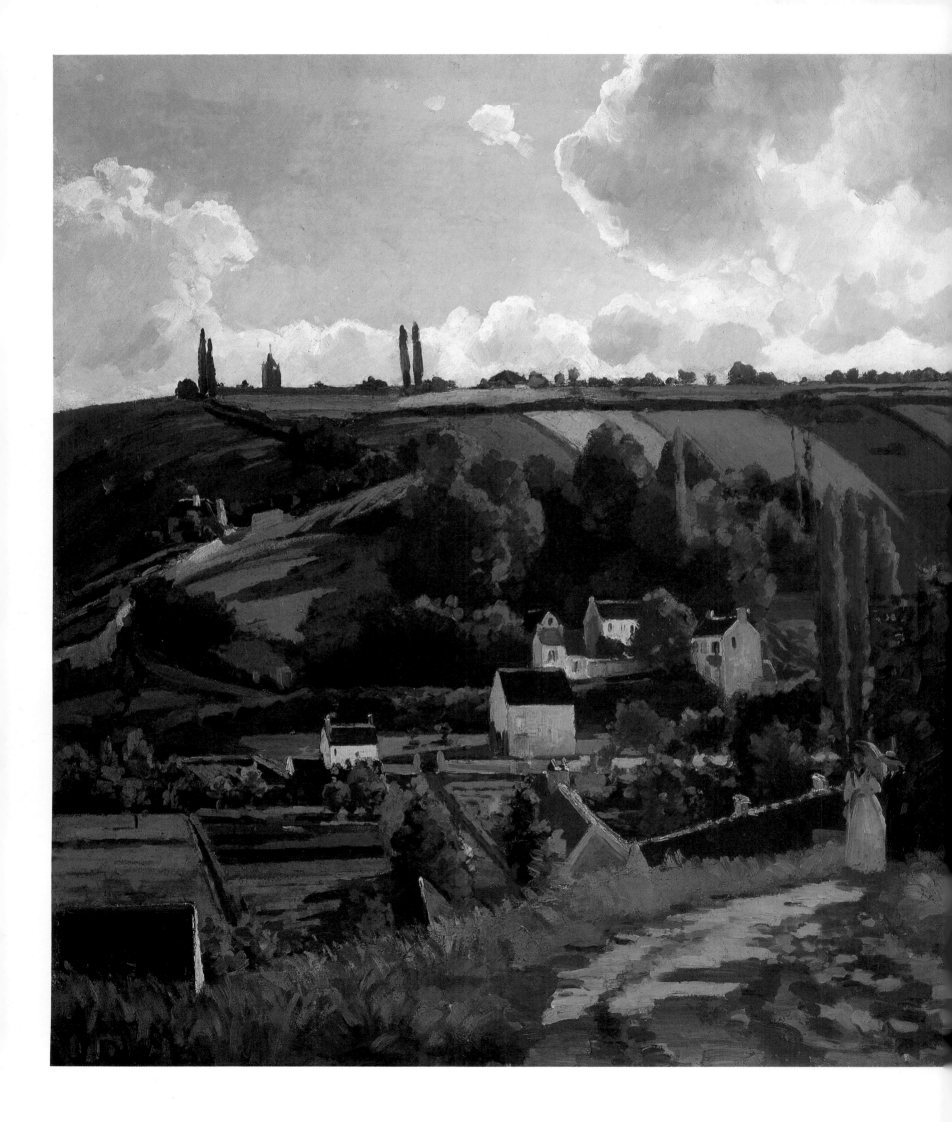

CAMILLE PISSARRO

French, 1830–1903

Jallais Hill, Pontoise

Oil on canvas, 34 1/4 x 45 1/4 inches
Signed and dated (lower right): C. Pissarro / 1867

IN 1866 PISSARRO moved to Pontoise, northwest of Paris, where he lived until 1869. The lanes, farm buildings, hillsides, and plowed and planted fields of this hilly village on the Oise provided the subject matter for a group of firmly structured landscapes that are among his most important early works. Their strong brushstrokes and broad, flat areas of color owe much to the example of Courbet and Manet, whose work was on view in large, much discussed exhibitions in Paris.

Jallais Hill, Pontoise was exhibited in the Salon of 1868 with another landscape by Pissarro, probably *Hillsides of l'Hermitage, Pontoise,* painted about 1867 (Solomon R. Guggenheim Museum, New York). Even though Pissarro's two pictures were hung high, and were therefore difficult to see, Emile Zola praised them in an article in *L'Evénement illustré* that was devoted entirely to a discussion of Pissarro's work. He especially admired *Jallais Hill, Pontoise:* "I prefer perhaps ... the Côte du Jallais.... There is the modern countryside. One feels that man has passed, turning and cutting the earth.... And this valley, this hillside embody a simplicity and heroic freedom. Nothing could be so banal were it not so great. From ordinary reality the painter's temperament has produced a rare poem of life and strength."

Although this is a pre-Impressionist work, it has many Impressionist characteristics. For example, the clear light reveals little precise detail, and the broad treatment of the grass, the figures, the road, and the foliage in the foreground foreshadows the Impressionists' interest in the generalized appearance of things that the critic Louis Leroy scorned in his review of their first group exhibition in 1874. Furthermore, Pissarro apparently included *Jallais Hill, Pontoise* in the sixth Impressionist group exhibition, in 1881.

Bequest of William Church Osborn, 1951 51.30.2

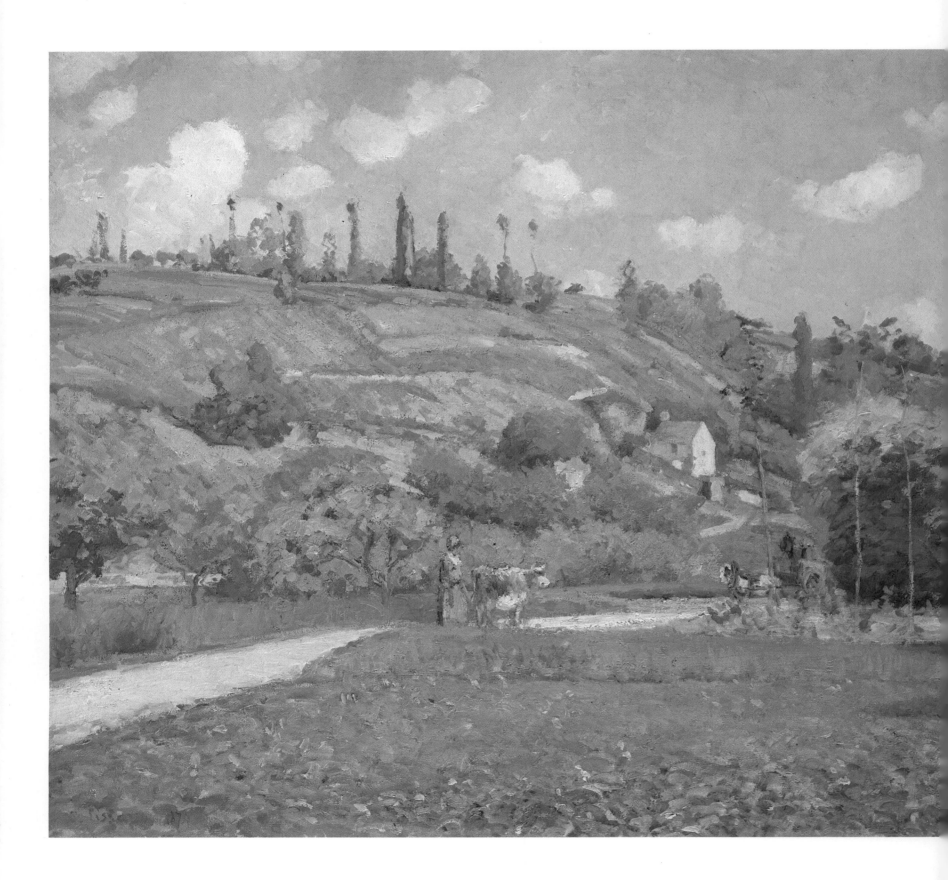

86

CAMILLE PISSARRO

French, 1830–1903

A Cowherd
on the Route du Chou, Pontoise

Oil on canvas, 21⅝ x 36¼ inches
Signed and dated (lower left): C. Pissarro. 1874

AFTER LEAVING PONTOISE in 1869, Pissarro lived in Louveciennes until the outbreak of the Franco-Prussian War in 1870, when he fled to Brittany and then to England. In London he often worked with Monet, and the two artists continued to influence each other after the war. In 1872 Pissarro returned to Pontoise and settled at 26 Rue de l'Hermitage.

A Cowherd on the Route du Chou, Pontoise was painted in 1874, the year of the Impressionists' first group exhibition. It shows the transformation that had taken place in Pissarro's art since the late 1860s. By comparison with *Jallais Hill, Pontoise* (pages 84–85), the brushstrokes are short and small, and the palette has been narrowed largely to a range of soft greens and blues. Although the painting has the appearance of a spontaneously conceived plein-air work, examination reveals a carefully constructed composition for which there were probably several preliminary drawings and studies. Moreover, the landscape is perceived as a place in which peasants live and work. Here Pissarro's concern with color and light is in balance with his increasingly strong interest in what the critic Georges Lecomte later called "inner essences of peasant life" ("des essences intimes de la vie agreste").

Gift of Edna H. Sachs, 1956 56.182

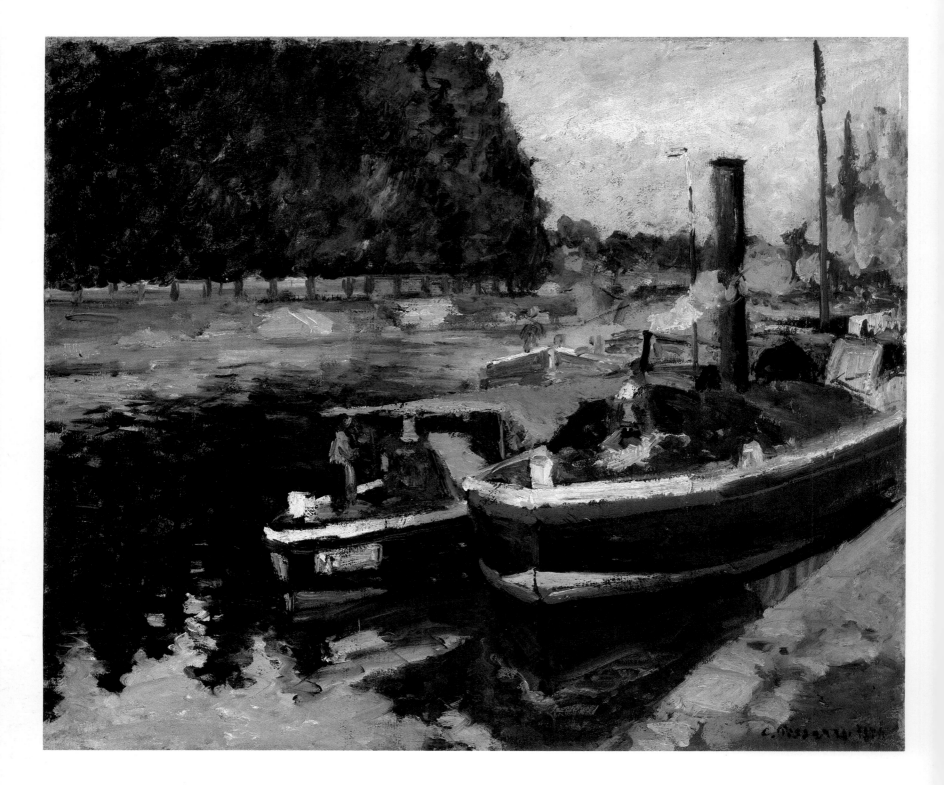

88

CAMILLE PISSARRO

French, 1830–1903

Barges at Pontoise

Oil on canvas, 18⅛ x 21⅝ inches
Signed and dated (lower right): C. Pissarro. 1876

HERE PISSARRO FOCUSES on the steam-powered barges that carried freight on rivers and canals throughout France during the nineteenth century. Although the steam engine was replaced long ago by the internal combustion engine, barge traffic is still a significant means of freight transportation in France. Today similarly moored barges can be seen along the quays of Paris.

Of the six views of barges and factories along the banks of the Oise that Pissarro painted in 1876, this is stylistically the boldest. Each of the brushstrokes serves a descriptive function but attention to detail is minimal.

For example, the figure on the bow of the boat is just recognizable, and the reflections in the water are barely intelligible. Only two years earlier the critic Louis Leroy, in a review of the first Impressionist group exhibition, derided similarly painted works as undisciplined and meretricious. Indeed, the vigorously applied strokes of orange on the hulls of the barges would probably have horrified him as much as the "palette scrapings placed uniformly on a dirty canvas" that he complained of in Pissarro's work in 1874.

Bequest of Mary Cushing Fosburgh, 1978 1979.135.16

CAMILLE PISSARRO

French, 1830–1903

La Mère Larchevêque

Oil on canvas, 28¾ x 23¼ inches
Signed and dated (upper left): C. Pissarro 80

DURING THE SECOND half of the nineteenth century, artists as different as Bouguereau and van Gogh painted solitary French peasant women, and the results nearly always reflect the artists' own political, social, and philosophical beliefs. Pissarro was no exception. The sitter in this picture was one of his neighbors in Pontoise, and the artist clearly appreciated her solid, unpretentious appearance as much as Renoir admired the unaffected manners of the young Parisian waitress at Duval's Restaurant (page 157). However, *La Mère Larchevêque* can also be compared to Ingres's famous portrait of the wealthy businessman and journalist Louis-François Bertin in the Louvre, a painting so expressive of early nineteenth-century middle-class values that Manet called it "the Buddha of the bourgeoisie." Pissarro's peasant woman also seems to typify a class and a way of life: that of the French peasantry during the early years of the Third Republic. Her still, contained pose emphasizes the solidity of her body and seems to assign her a monumental permanence that challenges the rapid industrialization and modernization of the French countryside during the 1870s and 1880s.

Gift of Mr. and Mrs. Nate B. Spingold, 1956 56.184.1

CAMILLE PISSARRO

French, 1830–1903

Two Young Peasant Women

Oil on canvas, 35¼ x 45⅞ inches
Signed and dated (lower right): C. Pissarro. 1892

PISSARRO BEGAN WORK on this painting, one of his largest, during the summer of 1891. It was completed by mid-January 1892, in time to be included the following month in a large exhibition of the artist's work organized by Joseph Durand-Ruel. Unlike earlier shows, this was a critical and financial success. Many of the fifty paintings were sold, but Pissarro kept this canvas and gave it to his wife.

Against the sharply tilting background of an open field near his house in Eragny, Pissarro placed the figures of two young field laborers. Their simple, monumental forms and reserved expressions give them a heroic quality that is part of the painting's message. Pissarro, a confirmed anarchist, opposed the spread of capitalism and the urbanization and industrialization of French society. Pissarro's peasants seem to be untroubled, happy people who work harmoniously in landscapes ripe with the bountiful results of their labor. Indeed, as Richard Brettell indicated recently, Pissarro's mature ideas about rural life grew out of his reading of such anarchist philosophers as Prince Kropotkin. Pissarro believed that inevitably all people would return to the country for at least part of each year to share the pleasures of agricultural work. As in this picture, his peasants are not exhausted by their labors but seem to contemplate the profound rhythm that directs their lives.

Gift of Mr. and Mrs. Charles Wrightsman, 1973 1973.311.5

CAMILLE PISSARRO

French, 1830–1903

Poplars, Eragny

Oil on canvas, 36½ x 25½ inches
Signed and dated (lower right): C. Pissarro. 95.

THE COMPOSITION OF *Poplars, Eragny* is very different from that of Monet's *Poplars* of 1891 (pages 138–39). Pissarro was attracted by the lyrical character of the subject, Monet by its formal and inherently decorative qualities. Also, the trees in Monet's painting were planted at equal intervals along the riverbank, while those in Pissarro's painting seem to be random and natural elements in the landscape. Painted during the summer of 1895, this canvas shows a corner of Pissarro's garden in Eragny, where he had a residence from 1884 until his death.

The figure in the background is a reminder of Pissarro's lifelong interest in French peasant life. However, like the artist's other late landscapes, it was painted from a window in his studio. Apparently Pissarro saw nineteenth-century rural France as a kind of Arcadia that was best left untouched by the Industrial Revolution. The artist's celebration of this aspect of French life may seem a confirmed anarchist's stubborn refusal to come to terms with modern existence in the 1890s, but it is more likely an affirmation of a way of life that peacefully coexisted with that of cities such as Paris and Rouen (pages 96–103).

Poplars, Eragny was among the group of works that Pissarro sold to Durand-Ruel on November 22, 1895. The dealer included it in the major exhibition of the artist's work that he held in the spring of 1896.

Bequest of Miss Adelaide Milton de Groot (1876–1967), 1967 67.187.93

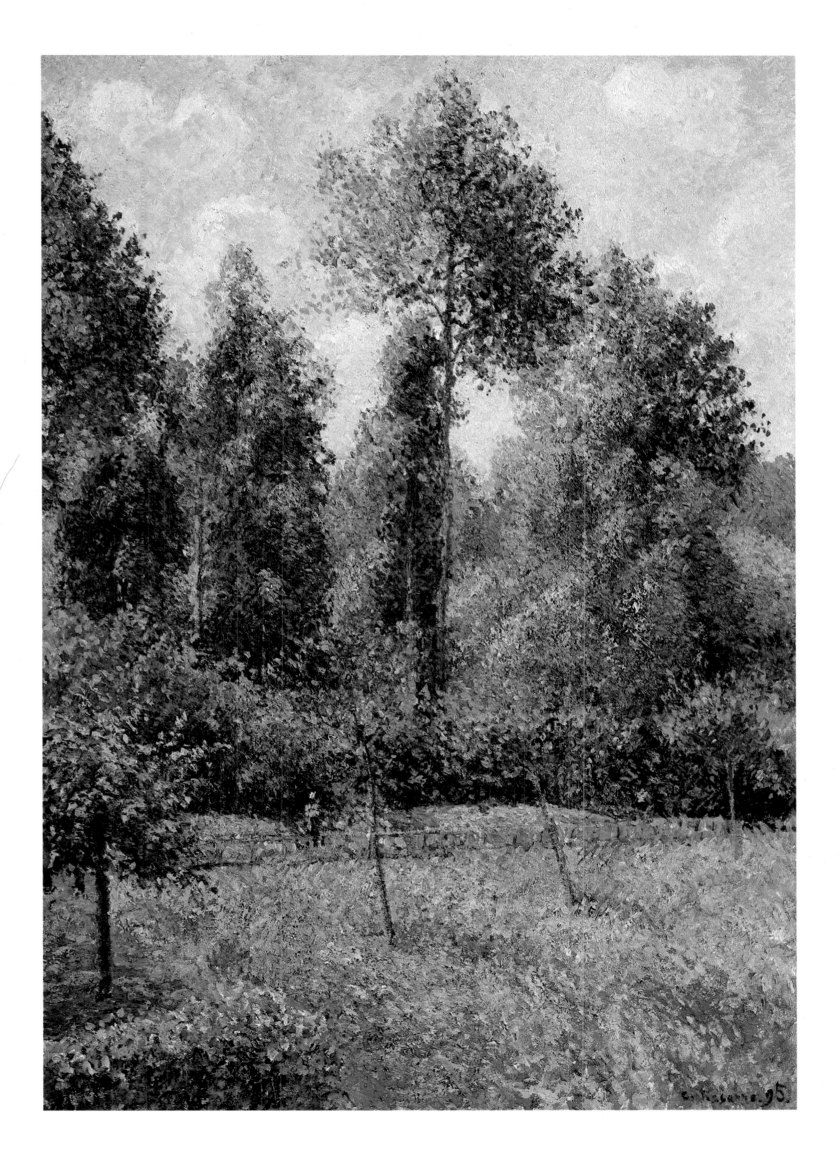

CAMILLE PISSARRO

French, 1830–1903

Morning, an Overcast Day, Rouen

Oil on canvas, 21⅜ x 25⅝ inches
Signed and dated (lower right): C. Pissarro. 96

IN HIS LATER years Pissarro developed an eye ailment that gradually prevented him from working outside. As a result, many of his city views of the 1890s and early 1900s were painted from the windows of hotel rooms in Rouen and Paris (pages 98–99, 102–3). From January to April 1896 and again from September to November of that year he was in Rouen, where, according to his letters, he became especially interested in the "motif of the iron bridge on a rainy day, with much traffic, carriages, pedestrians, workers on the quays, boats, smoke, mist in the distance, the whole scene fraught with animation and life." This painting is one of a group whose subject is the Boieldieu Bridge, or Grand Pont, which Pissarro painted from a room in the Hôtel d'Angleterre. Its title (*Matin, Temps Gris, Rouen*) is thought to be Pissarro's own; it reflects his continuing interest in the kind of veracity associated with Impressionism during the 1870s and with Neo-Impressionism during the 1880s. However, the vapor from the steamboat in the foreground and the smoke from the chimney of the gasworks in the background suggest an enthusiasm for industrialization and the rise of the modern city that is lacking in the artist's earlier work, in which he tended to emphasize the values of rural life and an agrarian society.

Bequest of Grégoire Tarnopol, 1979, and Gift of Alexander Tarnopol, 1980
1980.21.1

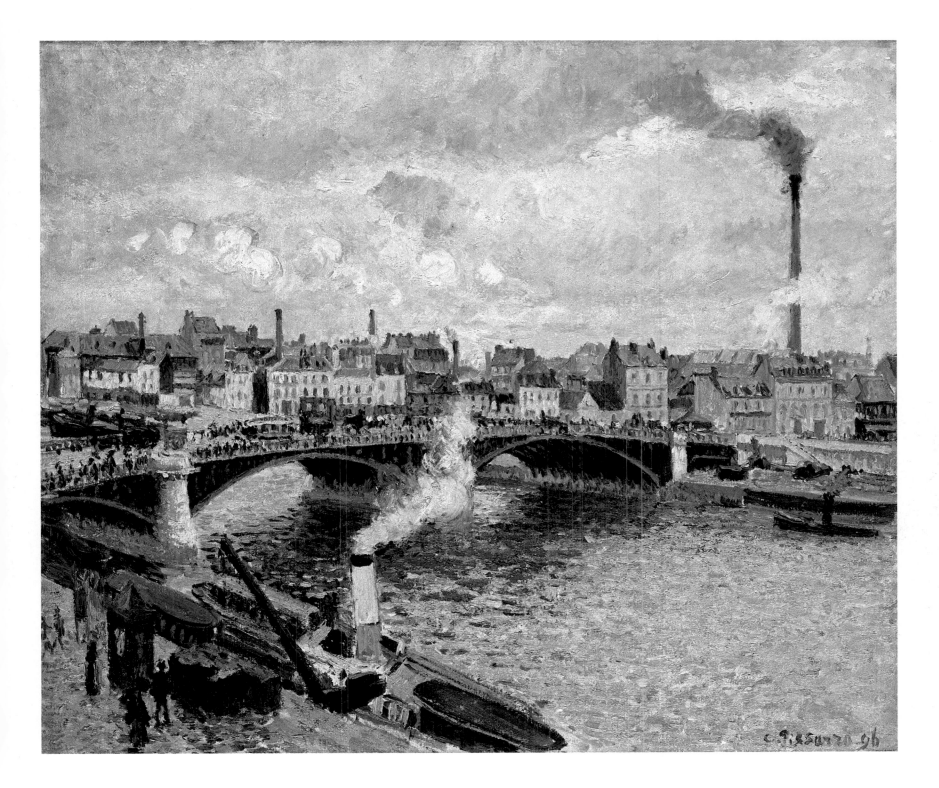

CAMILLE PISSARRO

French, 1830–1903

The Boulevard Montmartre on a Winter Morning

Oil on canvas, 25 ½ x 32 inches
Signed and dated (lower left): C. Pissarro. 97.

IN FEBRUARY 1897 Pissarro arrived in Paris from Eragny and took a room in the Grand Hôtel de Russie overlooking the Boulevard Montmartre. In a letter to his son Lucien he said he thought his dealer would be interested in a series of paintings of the boulevard at different times of day and during a variety of atmospheric conditions. Both Pissarro and Durand-Ruel had admired Monet's Haystacks (pages 140–41) and Poplars (pages 138–39) when they were shown at the gallery in 1891 and 1892, respectively. The strong critical and commercial success of Monet's series probably encouraged Pissarro to pursue a similar course.

The Boulevard Montmartre paintings were executed during the early months of 1897 and are frequently mentioned in the artist's letters during February and March. Like the individual works in Monet's series, all are slightly different in detail and point of view. Stylistically, however, these paintings recall the classic phase of Impressionism in the 1870s.

Gift of Katrin S. Vietor, in loving memory of Ernest G. Vietor, 1960 60.174

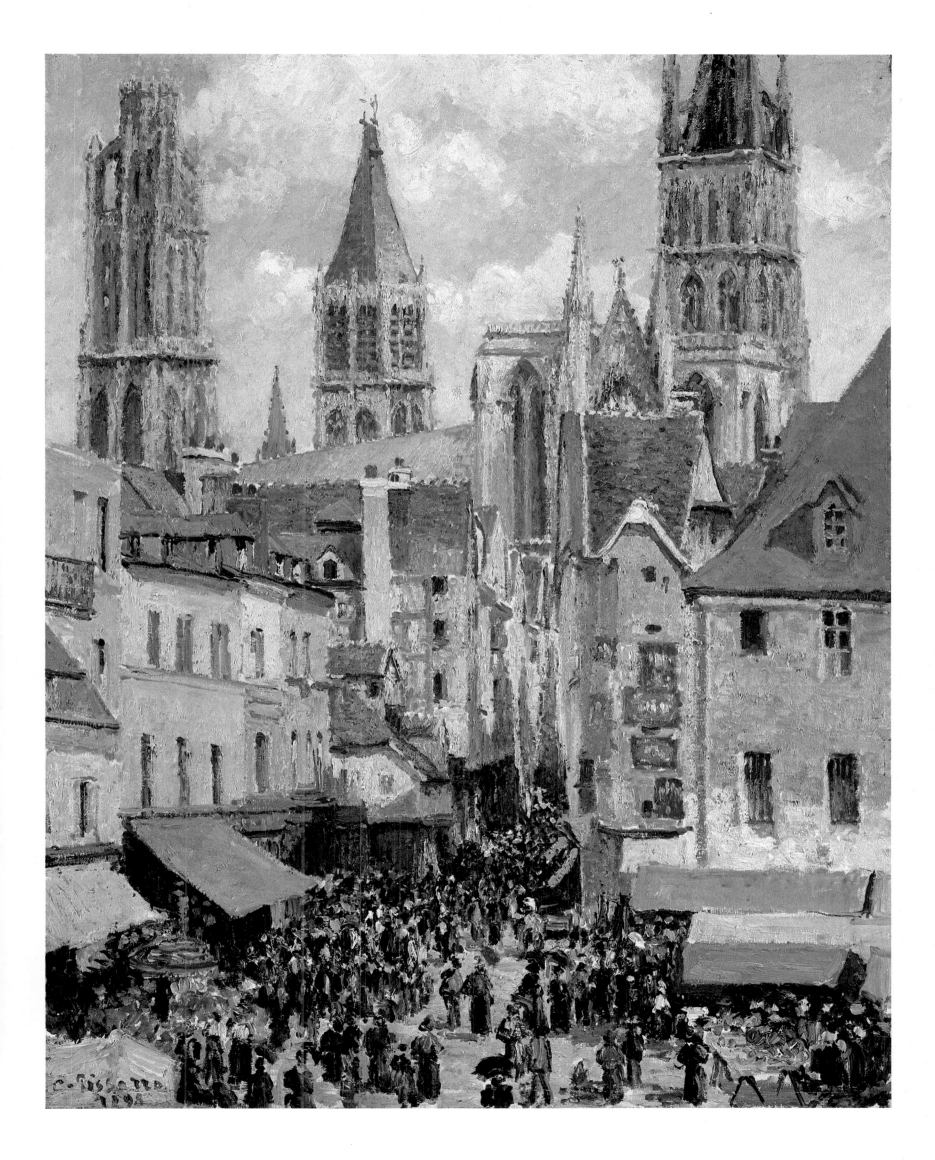

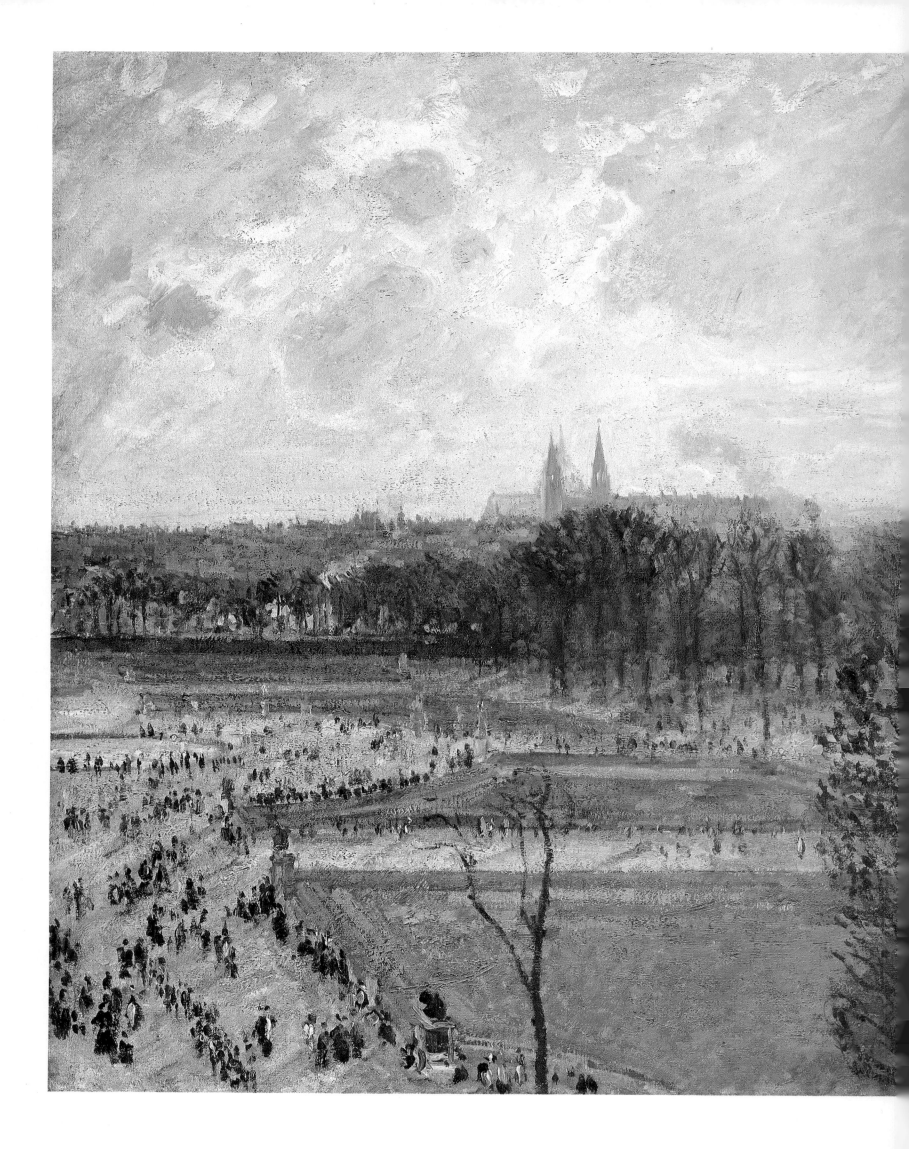

CAMILLE PISSARRO

French, 1830–1903

The Garden of the Tuileries on a Winter Afternoon, II

Oil on canvas, 28⅞ x 36⅜ inches
Signed and dated (lower right): C. Pissarro. 99

ON DECEMBER 4, 1898, Pissarro wrote from Paris that he had "engaged an apartment at 204 Rue de Rivoli, facing the Tuileries, with a superb view of the Garden, the Louvre to the left, in the background the houses on the quays behind the trees, to the right the Dôme des Invalides, the steeples of Ste. Clothilde behind the solid mass of chestnut trees. It is very beautiful. I shall paint a fine series." He painted five views of the Tuileries Gardens that are very similar to this one, and eight looking east toward the Louvre. Pissarro worked on all fourteen canvases simultaneously and recorded his progress in letters to his son Lucien. In late May he sent eleven to his dealer, Durand-Ruel. The artist noted in his letters that the paintings were generally well liked, and the following year he rented the same apartment and executed a second group of fourteen paintings.

The scene remained more or less the same in the six views of the Tuileries, permitting Pissarro to concentrate on changes in light and atmosphere. In contrast to Monet's series of the 1890s, in which exaggerations and simplifications reflect the artist's subjective experience of nature, these pictures differ in mood because of objectively recorded changes in atmospheric conditions and time of day. The naturalist-realist element in Pissarro's work remained as strong at the end of his career as it had been at the beginning. Pissarro also continued to affirm the importance of the human presence in a landscape, whether the solitary figure in *Poplars, Eragny* (pages 94–95) or the citizens of Paris out for a stroll on a late afternoon in winter.

Gift from the Collection of Marshall Field III, 1979 1979.414

CLAUDE MONET

French, 1840–1926

The Green Wave

Oil on canvas, 19⅛ x 25½ inches
Signed and dated (lower right): Cl. Monet 65

THIS PRECOCIOUS WORK was probably painted in the fall of 1865, when Monet was working in Trouville with Boudin, Charles Daubigny, and Courbet. Monet admired the work of Courbet during this period, but in *The Green Wave* the influence of Manet is far more evident. The handling of paint and the composition, especially the high horizon line, are clearly indebted to Manet's two depictions of American warships, *The "Kearsarge" at Boulogne* (private collection) and *The Battle of the "Kearsarge" and the "Alabama"* (Philadelphia Museum of Art), which had been exhibited in Paris the previous year. Even before painting *The Green Wave,* Monet had made two seascapes so dependent on the style of Manet that the older artist complained of plagiarism.

Bequest of Mrs. H. O. Havemeyer, 1929 29.100.111
H. O. Havemeyer Collection

CLAUDE MONET

French, 1840–1926

The Bodmer Oak, Fontainebleau Forest

Oil on canvas, 37⅞ x 50⅞ inches
Signed (lower right): Claude Monet.

MONET FIRST VISITED the forest of Fontainebleau in the spring of 1863. He stayed in the village of Chailly, about half a mile from Barbizon. He returned for another visit in the spring of 1864, and in April 1865 he moved to Chailly for a year. *The Bodmer Oak* depicts a subject that had long been popular among the group of painters known as the Barbizon School, who lived and worked in the neighboring village. The tree was a particularly favorite subject of Karl Bodmer, who had exhibited a painting of it in the Salon of 1850.

This work is one of at least five paintings of 1865 that anticipate Monet's project for *Le Déjeuner sur l'Herbe (The Luncheon on the Grass),* an immense painting, nearly fifteen feet high and over nineteen feet wide, that now survives in the form of two fragments, in the Louvre and the Eknayan Collection, Paris. *The Bodmer Oak* was probably done when Monet was searching for a suitable landscape setting for the large painting. Unlike his other forest scenes of this period, it is quite similar in composition to a finished sketch (Pushkin Museum of Fine Arts, Moscow) that Monet made in 1866 for *Le Déjeuner sur l'Herbe.* Although *The Bodmer Oak* is not directly related to *Le Déjeuner sur l'Herbe,* and its size and finish establish it as an independent project, it seems clearly to have been a preliminary step toward formally beginning the life-size picnic scene.

Gift of Sam Salz and Bequest of Julia W. Emmons, by exchange, 1964 64.210

106

CLAUDE MONET

French, 1840–1926

The Beach at Sainte-Adresse

Oil on canvas, 29⅝ x 40 inches
Signed (lower left): Claude Monet

MONET SPENT THE summer of 1867 with an aunt in Sainte-Adresse, a small town just north of Le Havre on the Channel coast. On June 25 he wrote to his friend the painter Frédéric Bazille that he was working on about twenty pictures. One of them was probably *The Beach at Sainte-Adresse:* "Among the seascapes, I am doing the regattas of Le Havre with many figures on the beach and the outer harbor covered with small sails." He also asked his friend to send 100 to 150 francs to help with expenses that included those of Camille Doncieux, who was pregnant with his child, and whom he had been forced to leave in Paris in order to save money.

In its composition this canvas is not as ambitious as the Museum's *Terrace at Sainte-Adresse* (pages 110–11), also painted in 1867, but it reflects Monet's growing fascination with color and light. Note, for example, the variety of blues and greens in the water, the blue shadows behind the figures in the left foreground, and the different blues on the hull of the boat on the beach. These effects indicate a strong interest in specific visual and atmospheric conditions that is in marked contrast to the idealized, formulaic approach of painters trained at the Ecole des Beaux-Arts, where pure landscape was considered beneath the dignity of a serious artist.

The brushstrokes used for the figures in the middle ground are also noteworthy. They are quite similar to those that Louis Leroy called "black tongue-lickings" in his satiric review of the first Impressionist exhibition, in 1874. In short, by 1867 Monet had already evolved the chief characteristics of the style that was finally given a name seven years later: Impressionism.

Bequest of William Church Osborn, 1951 51.30.4

CLAUDE MONET

French, 1840–1926

Terrace at Sainte-Adresse

Oil on canvas, 38⅝ x 51⅛ inches
Signed (lower right): Claude Monet

AMONG THE WORKS Monet painted at Sainte-Adresse during the summer of 1867 were *The Beach at Sainte-Adresse* (pages 108–9) and *Terrace at Sainte-Adresse.* On June 25 he reported to Bazille that all was well: "I have been here for fifteen days, happy and as well as can be expected. Everyone is charming and admires every stroke of my brush." Undoubtedly his admirers included the figures depicted in this painting: the artist's cousin Jeanne Marguerite Lecadre, standing beside an unidentified gentleman in the middle ground, and Monet's aunt, Madame Lecadre, and his father, Adolphe, seated in the foreground.

By choosing an elevated vantage point and composing his picture within horizontal areas of relatively similar size, Monet emphasized the two-dimensionality of the painting. The three horizontal zones seem to rise parallel to the picture plane instead of receding into clearly defined space. The flags, especially the tricolor on the right, may be a witty analogy to the composition. The subtle tension between illusionism and the two-dimensionality of the surface remained an important characteristic of Monet's style throughout his career.

In 1920 Monet himself recalled the avant-garde character of *Terrace at Sainte-Adresse,* as the art dealer René Gimpel recorded in his diary after visiting the artist in Giverny: "Monet showed us a photograph of one of his canvases, which represents his father looking at the sea . . . he pointed out to us that on each side of the composition there is a pole with a flag and that, at that time, this composition was considered very daring."

Purchased with special contributions and purchase funds given or bequeathed by friends of the Museum, 1967 67.241

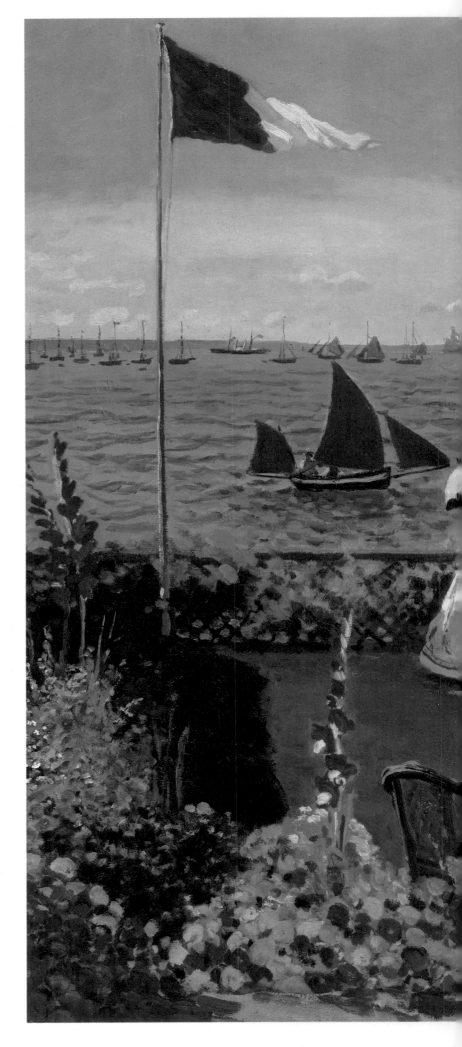

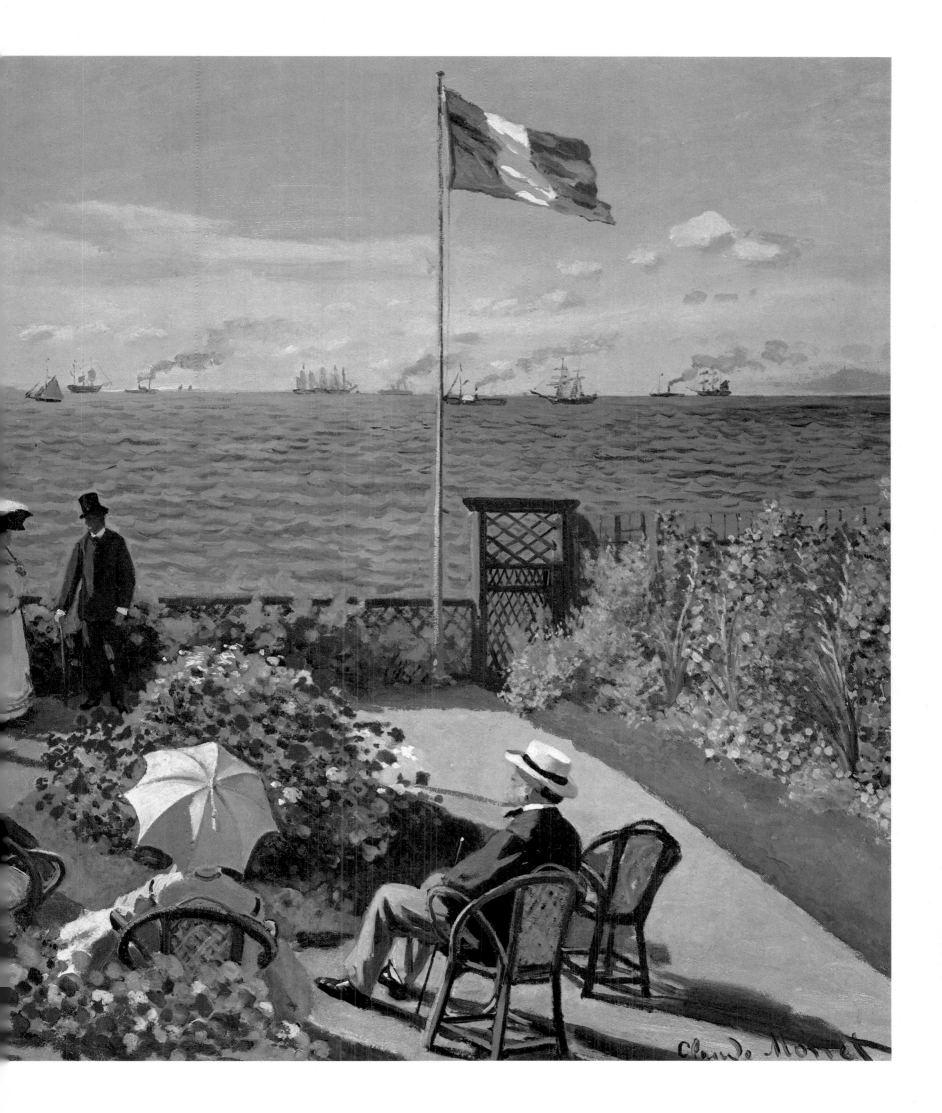

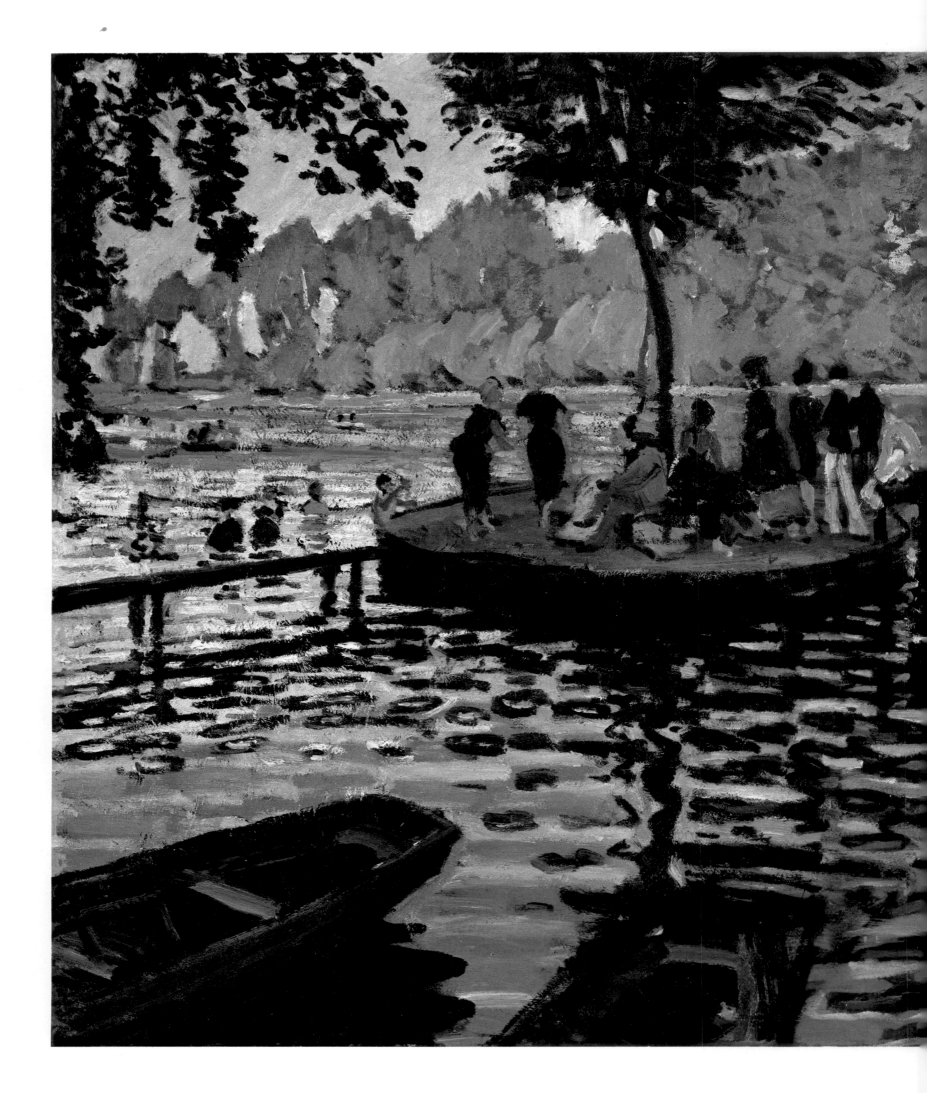

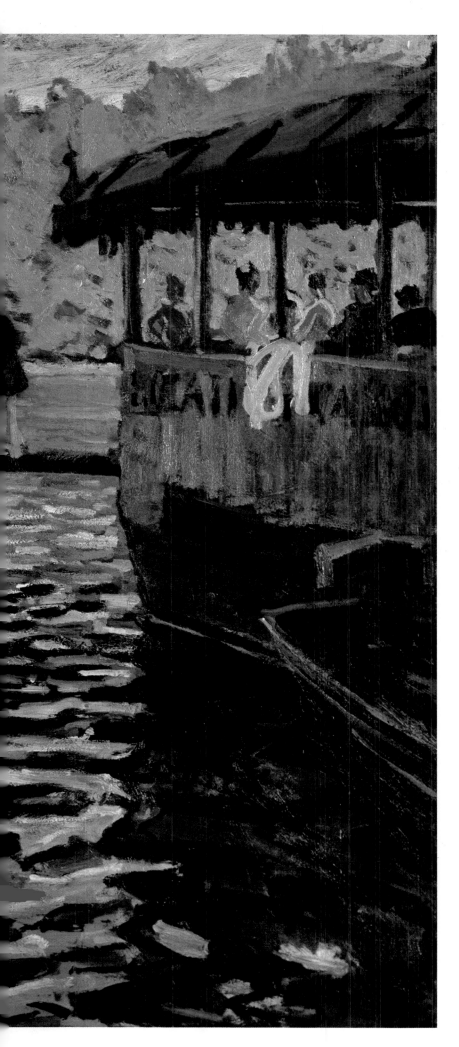

CLAUDE MONET

French, 1840–1926

La Grenouillère

Oil on canvas, 29⅜ x 39¼ inches
Signed (lower right): Claude Monet

IN 1869, WHEN this picture was painted, Monet and Renoir were living near one another in Saint-Michel, a few miles west of Paris. They often visited La Grenouillère, a swimming spot with a boat rental and a café on the Seine. On September 25 Monet wrote to Bazille, "I do have a dream, a painting, the baths of La Grenouillère for which I've done a few bad rough sketches, but it is a dream. Renoir, who has just spent two months here, also wants to do this painting."

There are actually six known paintings of the subject, separable into three pairs by each of the two artists. This example and the one by Renoir in the Nationalmuseum, Stockholm, are nearly identical in composition. They were undoubtedly painted side by side.

Pursuing interests earlier defined in *Terrace at Sainte-Adresse* (pages 110–11), Monet concentrated on repetitive elements—the ripples in the water, foliage, boats, and the human figure—to weave a fabric of brushstrokes that, although emphatically brushstrokes, retain a strong descriptive quality. X-rays and pentimenti reveal that Monet changed the positions of the boats in the foreground, an indication that in the late 1860s his interests already transcended the limitations suggested by Cézanne's famous remark, "Monet is only an eye, but, my God, what an eye!"

Bequest of Mrs. H. O. Havemeyer, 1929
H. O. Havemeyer Collection

29.100.112

CLAUDE MONET

French, 1840–1926

Landscape near Zaandam

Oil on canvas, 17¹⁵⁄₁₆ x 26⅜ inches
Signed and dated (lower left): Claude Monet. 72

MONET SPENT THE Franco-Prussian War, from the fall
of 1870 to the summer of 1871, in England, but when
hostilities ended he did not return directly to France.
Instead, he went to Zaandam, a town in Holland to the
north of Amsterdam. It has been suggested that he was
encouraged to do so by Paul Durand-Ruel, whom he had
met in London. Indeed, in September 1872 the dealer
bought six of the twenty-four works that Monet painted
along the picturesque waterways of Zaandam. At that
time few people shared Durand-Ruel's confidence in the
young artist.

Monet was particularly attracted by views across the
Zaan River and the canals in the area. In several in-
stances he selected a vantage point that permitted him
to include a great deal of reflection imagery. Much of the
excitement in these paintings results from the delicate
interplay between the appearance of the three-dimen-
sional world and its muted, gently distorted image
mirrored on the rippling water. In subject and handling
these works foreshadow many of Monet's views along the
Seine at Argenteuil, pictures that are synonymous with
Impressionism during the early and mid-1870s.

In Paris, Monet's Zaandam pictures were admired by
his colleagues. In a letter to a friend, Eugène Boudin
wrote, "[Monet] has brought back some very beautiful
studies from Holland and I believe that he is called to
take one of the leading places in our school."

From a position just beyond the last house on the left
in this painting, Monet painted a view looking in the
opposite direction (private collection).

Robert Lehman Collection, 1975 1975.1.196

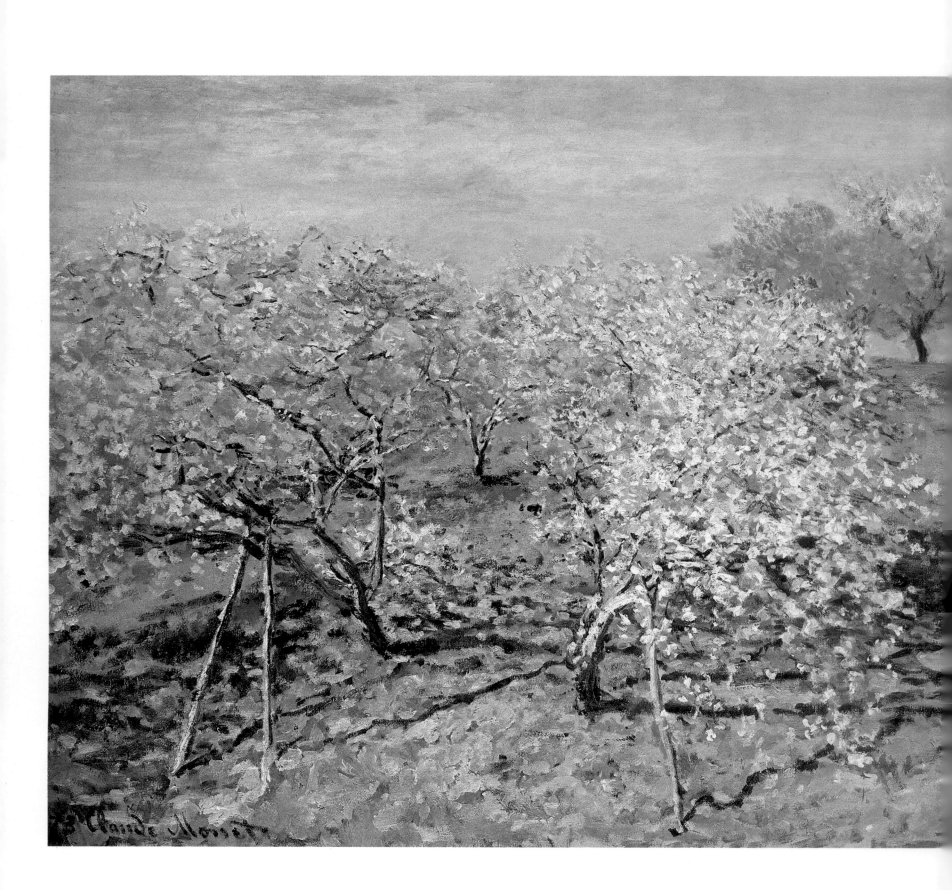

116

CLAUDE MONET

French, 1840–1926

Apple Trees in Bloom

Oil on canvas, 24½ x 39⅝ inches
Signed and dated (lower left): 73 Claude Monet·

THIS WORK WAS painted in Argenteuil, a village on the Seine northwest of Paris. In the early 1870s Argenteuil was a favorite gathering place for the Impressionists. Monet, Manet, Sisley, Renoir, and Gustave Caillebotte worked there at various times between 1871 and 1878.

Apple Trees in Bloom was painted during the classic period of Impressionism, in the early and mid-1870s. The pastel colors of spring and the clear light provided Monet with a pretext for an almost purely chromatic interpretation of nature. Indeed, he later advised another painter, "Try to forget what objects you have before you, a tree, a house, a field, or whatever. Merely think, here is a little square of blue, here an oblong of pink, here a streak of yellow, and paint it just as it looks to you, the exact color and shape, until it gives you your own impression of the scene before you."

Pissarro painted a similar picture the previous year, *Orchard in Bloom, Louveciennes* (National Gallery of Art, Washington, D.C.).

Bequest of Mary Livingston Willard, 1926 26.186.1

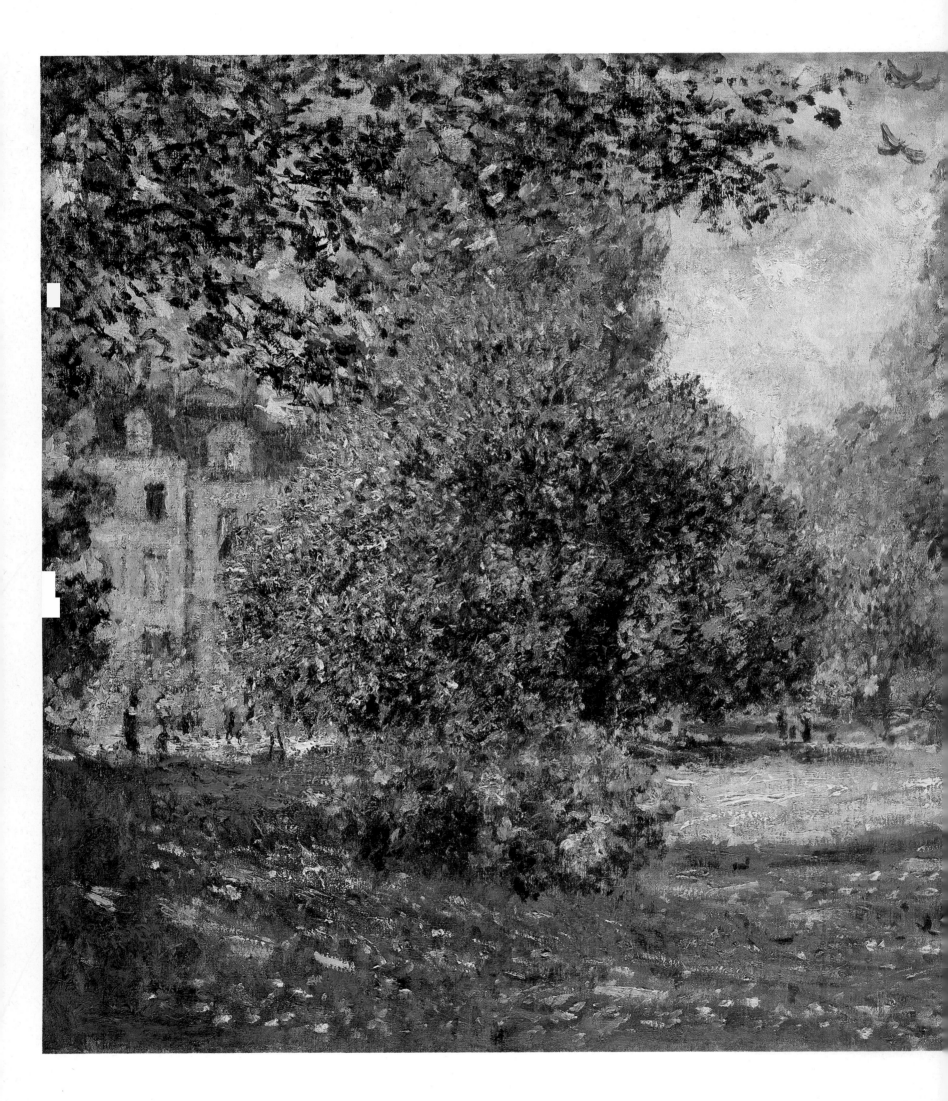

CLAUDE MONET

French, 1840–1926

The Parc Monceau, Paris

Oil on canvas, 23½ x 32½ inches
Signed and dated (lower right): Claude Monet 76

IN THE SPRING OF 1876 Monet painted three views of the Parc Monceau. Situated on the Boulevard de Courcelles in the eighth *arrondissement* of Paris and surrounded by fashionable town houses, the park was planned in the form of an English garden after designs made by Carmontelle, a French artist and writer, for Philippe d'Orléans in the late eighteenth century.

This painting relies on a compositional device that Monet used at various times throughout his career. He positioned his easel in order to focus on a contained area; in this case the space is delineated by the vegetation at the sides and the houses in the background. The best-known examples of this kind of composition are the paintings of the Gare Saint-Lazare that Monet did in 1876–77. As William Seitz has remarked, "It should go without saying that he did not choose a subject or a vantage point at random, and that while the choice was being made a pictorial solution was already forming in his mind."

In 1878 Monet returned to the Parc Monceau and twice painted a view looking toward the buildings visible at the left in this painting. One of them, *Parisians Enjoying the Parc Monceau*, is illustrated on page 121.

Bequest of Loula D. Lasker, New York City, 1961 59.206

CLAUDE MONET

French, 1840–1926

Parisians Enjoying the Parc Monceau

Oil on canvas, 28⅝ x 21⅜ inches
Signed and dated (lower right): Claude Monet 78·

THIS IS ONE of two very similar views of the Parc
Monceau that Monet painted in 1878. Comparison with
an earlier painting of the same subject (pages 118–19)
shows that the artist has turned in a new direction. The
disposition of light and shade in the foreground, the
patterns of the leaves, and the broad contours beginning
to develop in areas of strong contrast suggest that in
1878 Monet had already begun to experiment with the
boldly two-dimensional motifs that would characterize
his work in the 1880s and 1890s.

The cheerfulness of this scene contrasts vividly with
the poverty that was very much part of Monet's life in
1878. Indeed, the second half of the 1870s was a very
difficult period for Monet. Impressionism was under
attack, his second son was born amid dire financial dis-
tress, and his wife's health was rapidly deteriorating.

The Mr. and Mrs. Henry Ittleson, Jr. Purchase Fund, 1959 59.142

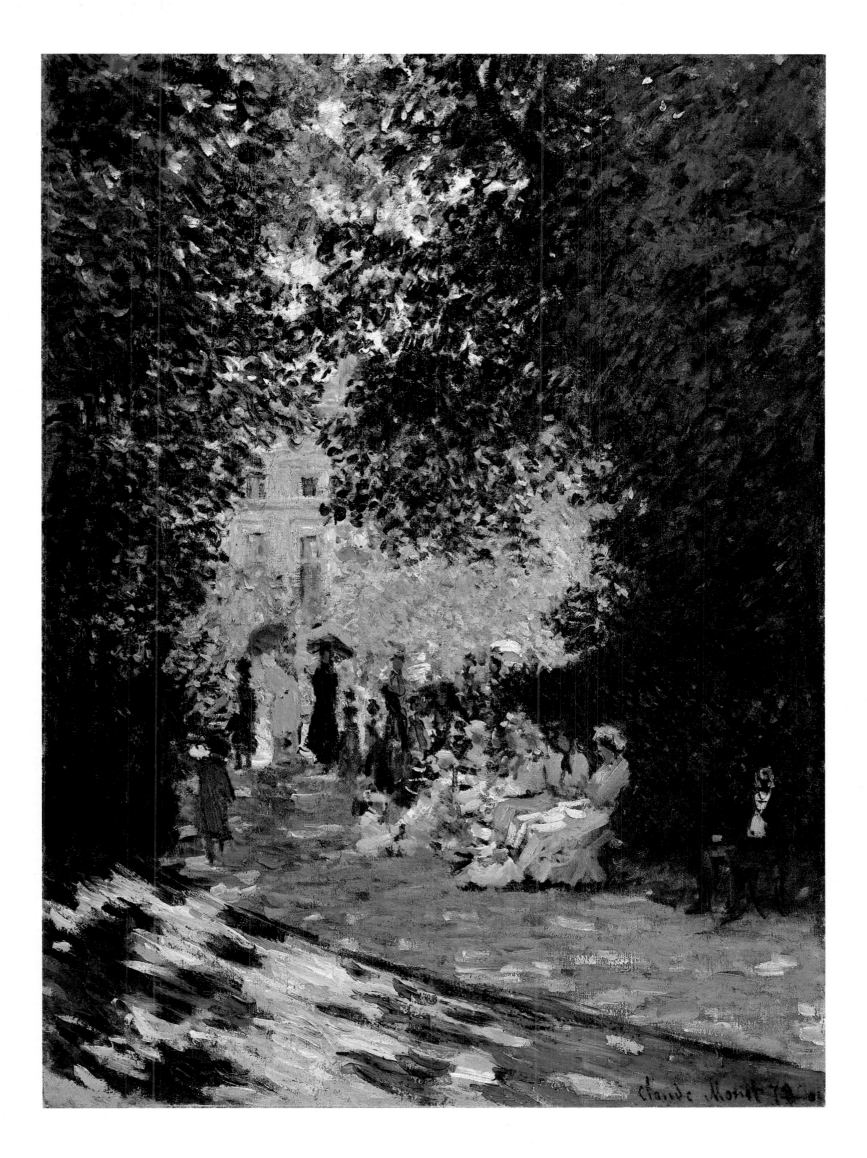

CLAUDE MONET

French, 1840–1926

Apples and Grapes

Oil on canvas, 26⅝ x 35¼ inches
Signed (upper right): Claude Monet

IN LATE NOVEMBER 1879 Marthe Hoschedé, who later became one of Monet's stepdaughters, mentioned in a letter that he was working on still lifes, and she specifically referred to a painting of fruit. During late 1879 and early 1880 the artist probably painted three pictures of apples and grapes in a basket. This example and another, in the Kimbell Art Museum, Fort Worth, depict the same table and basket of fruit. The basket was used again, but with a different arrangement of fruit, for *Still Life: Apples and Grapes,* dated 1880, in the Art Institute of Chicago.

The solidly modeled forms of the fruit suggest the influence of Courbet, who had had a great impact on Monet in the 1860s. Monet seems also to have been aware of the still lifes of fruit that Fantin-Latour painted in the 1860s and 1870s. The artist's emphasis on shape, form, and mass suggests a growing dissatisfaction with the feathery lyricism of classic Impressionism.

Gift of Henry R. Luce, 1957

57.183

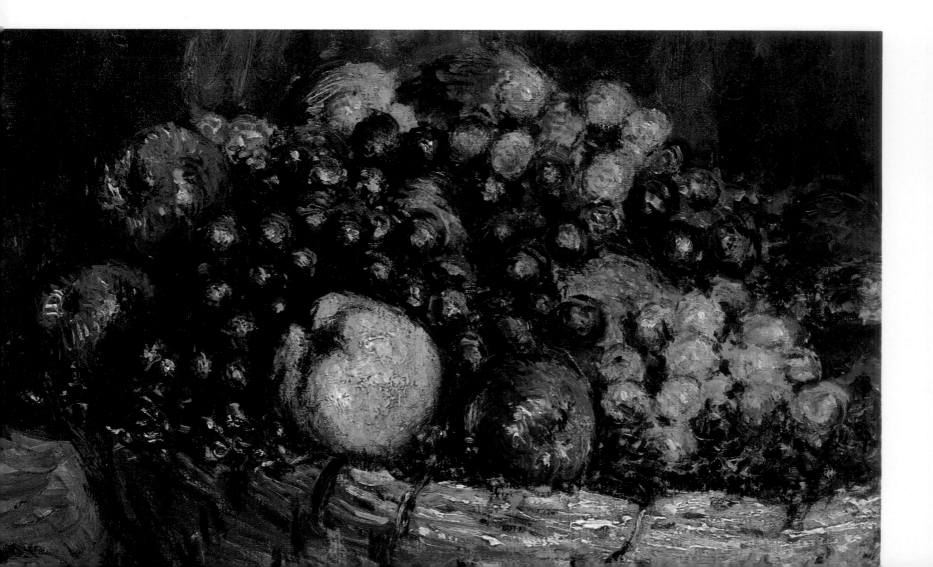

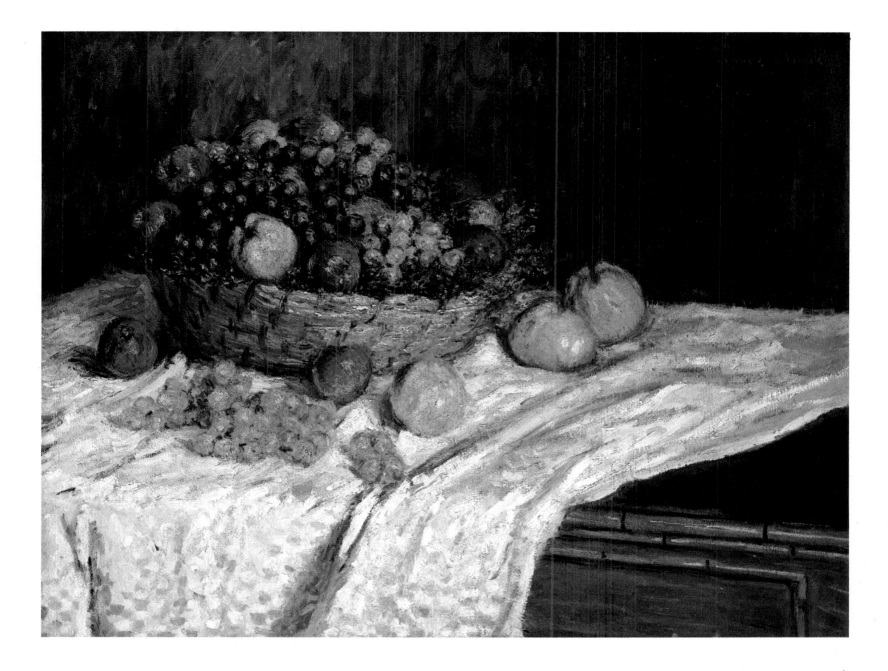

CLAUDE MONET

French, 1840–1926

Path in the Ile Saint-Martin, Vétheuil

Oil on canvas, 31½ x 23¾ inches
Signed and dated (lower left): 1880 Claude Monet

FROM APRIL 1878 until November 1881 Monet lived in Vétheuil, a village on the Seine about twenty-five miles northwest of Paris. In September of the year following his arrival, his wife, Camille, died after a long illness, but he continued to paint the surrounding landscape almost without interruption. During the summer of 1880 he painted twenty-six views of the area around Vétheuil. Six were done on the Ile Saint-Martin, one of the many nearby islands in the Seine. In this example the town of Vétheuil is visible in the background.

A variety of formal problems engaged the artist's attention during this period. In this picture, rapid, flickering brushstrokes create a strong pattern in the foreground that diminishes the illusion of space and emphasizes the abstract character of the painted surface.

There is another version of this picture in a private collection in Switzerland. In 1881 Monet returned to the site and again painted the view twice.

Bequest of Julia W. Emmons, 1956 56.135.1

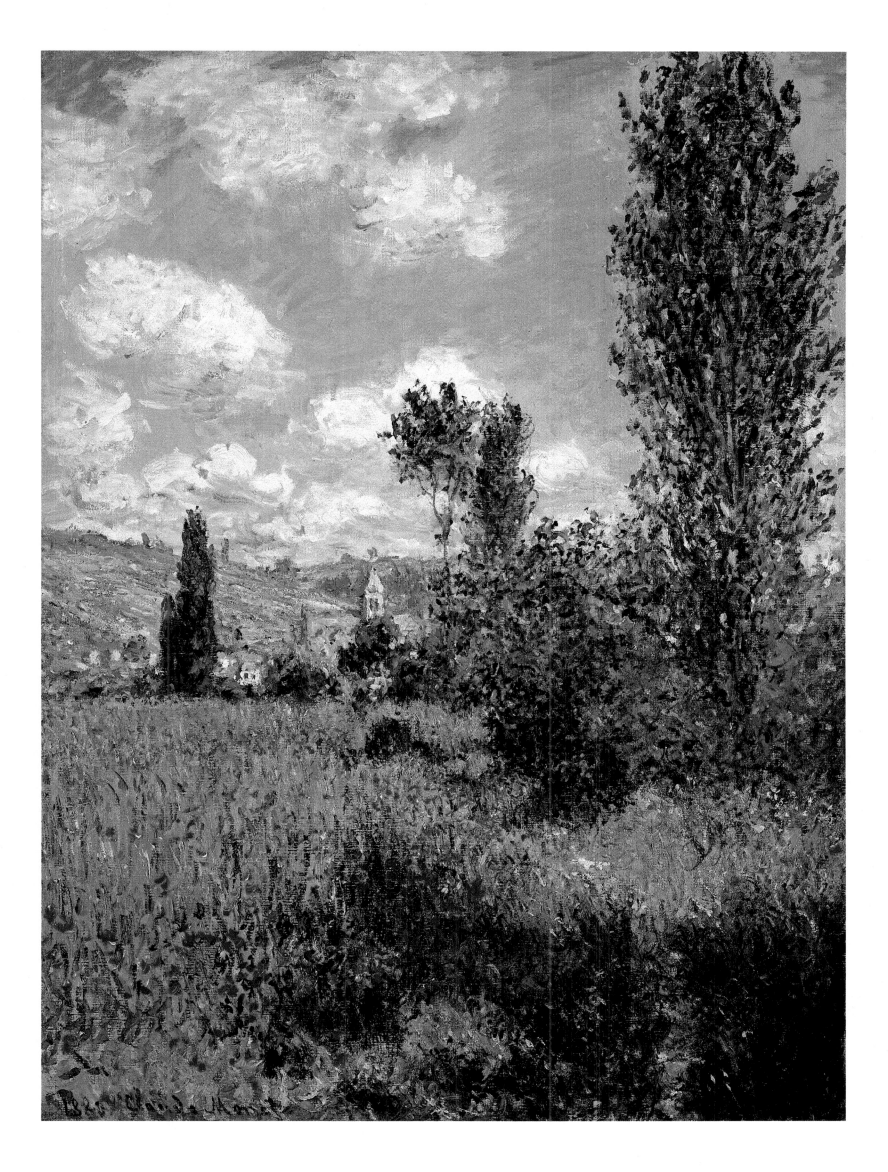

CLAUDE MONET

French, 1840–1926

The Seine at Vétheuil

Oil on canvas, 23¾ x 39½ inches
Signed and dated (lower right): Claude Monet 1880

THE REDUCED RANGE of the palette, the markedly linear character of the composition, and the prominence of the brushstrokes in this canvas dated 1880 are indicative of a change in the character of Monet's work. Increasingly dissatisfied with the limitations of orthodox Impressionism, Monet began to experiment with a variety of brushstrokes and types of composition. The change is largely a function of his emphasis on the elements of painting itself: stroke, palette, surface, and structure. Technical issues began to dominate the interest in color and light that had been the focus of most of his work in the 1870s. In *The Seine at Vétheuil* the sweeping curve of the riverbank is typical of the inherently strong, relatively simple shapes that began to appear in Monet's work in the early 1880s. In composition it foreshadows the many views of the coast of Normandy that he painted during the 1880s and 1890s.

Bequest of Theodore M. Davis, 1915
Theodore M. Davis Collection

30.95.271

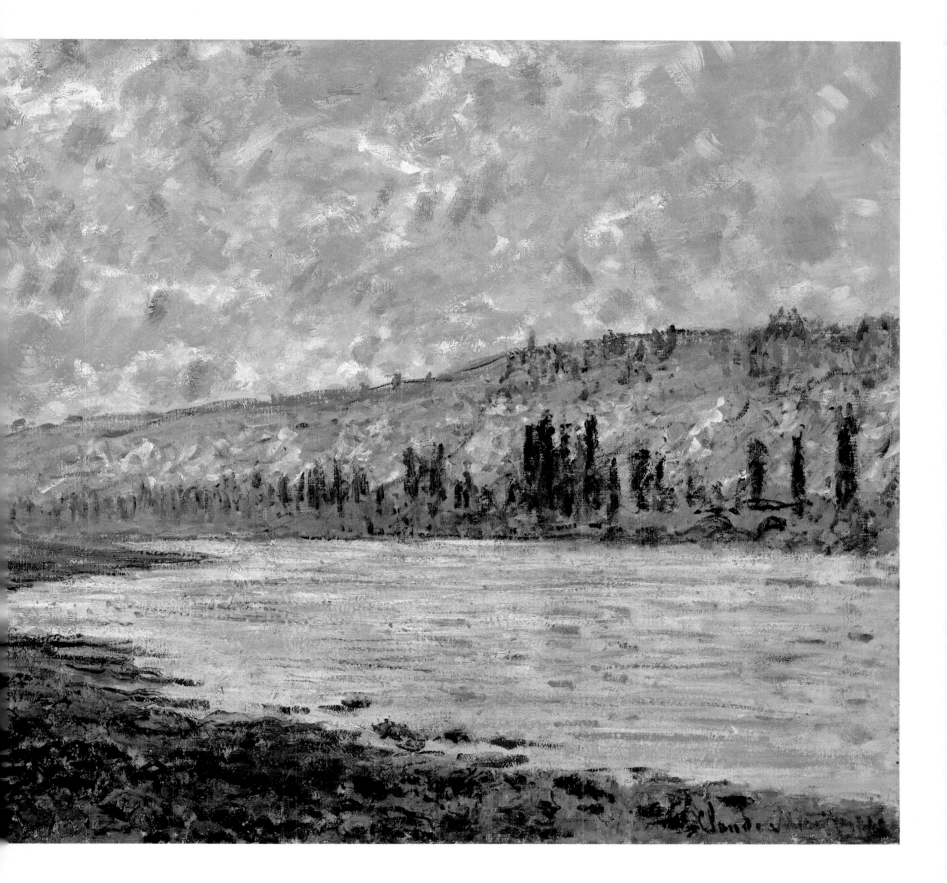

CLAUDE MONET

French, 1840–1926

Vétheuil in Summer

Oil on canvas, 23⅝ x 39¼ inches
Signed and dated (lower right): Claude Monet 1880

IN THIS VIEW OF Vétheuil, painted from the opposite side of the Seine during the summer of 1880, the flicker of individual brushstrokes reflects Monet's concern with recording as accurately as possible sensations of color and light. Ironically, his desire to transcribe the actual experience of color and light resulted in paintings with an increasingly abstract character. Indeed, the imagery nearly dissolves in the myriad touches of paint.

Vétheuil in Summer was painted two or three months after the fifth Impressionist exhibition, held in April 1880. Monet, Renoir, Sisley, and Cézanne did not participate in the show, an indication of the deep divisions that had emerged within the group. Monet and Renoir chose instead to submit work to the Salon (one painting by Monet and two by Renoir were accepted). Both painters were motivated largely by the need for financial reward that often resulted from official recognition. The Impressionists' group exhibitions continued until 1886, but they had evidently served their purpose by 1880. Paintings such as *Vétheuil in Summer* indicate that Monet's defection to the Salon did not result in a more conservative approach to painting, but rather that the criteria of the Salon jury had changed to accommodate the avant-garde.

Bequest of William Church Osborn, 1951 51.30.3

CLAUDE MONET
French, 1840–1926

Sunflowers

Oil on canvas, 39¾ x 32 inches
Signed and dated (upper right): Claude Monet 81

IN 1881 MONET painted four views of the steps descending to the garden behind his house in Vétheuil. In each of the paintings there are sunflowers growing on both sides of the steps. The blossoms in this still life must have come directly from the garden; they were probably cut on a day when bad weather had made it impossible for Monet to work outside.

In 1882 *Sunflowers* was included in the seventh Impressionist exhibition. Four years later it was shown at the National Academy of Design, New York, thus becoming one of the first Impressionist paintings exhibited in the United States.

Although van Gogh's depictions of sunflowers are better known, the Dutch artist claimed to prefer this painting to his own. In a letter of December 1888 to his brother, van Gogh wrote, "Gauguin was telling me the other day that he had seen a picture by Claude Monet of sunflowers in a large Japanese vase, very fine, but—he likes mine better. I don't agree."

Bequest of Mrs. H. O. Havemeyer, 1929 29.100.107
H. O. Havemeyer Collection

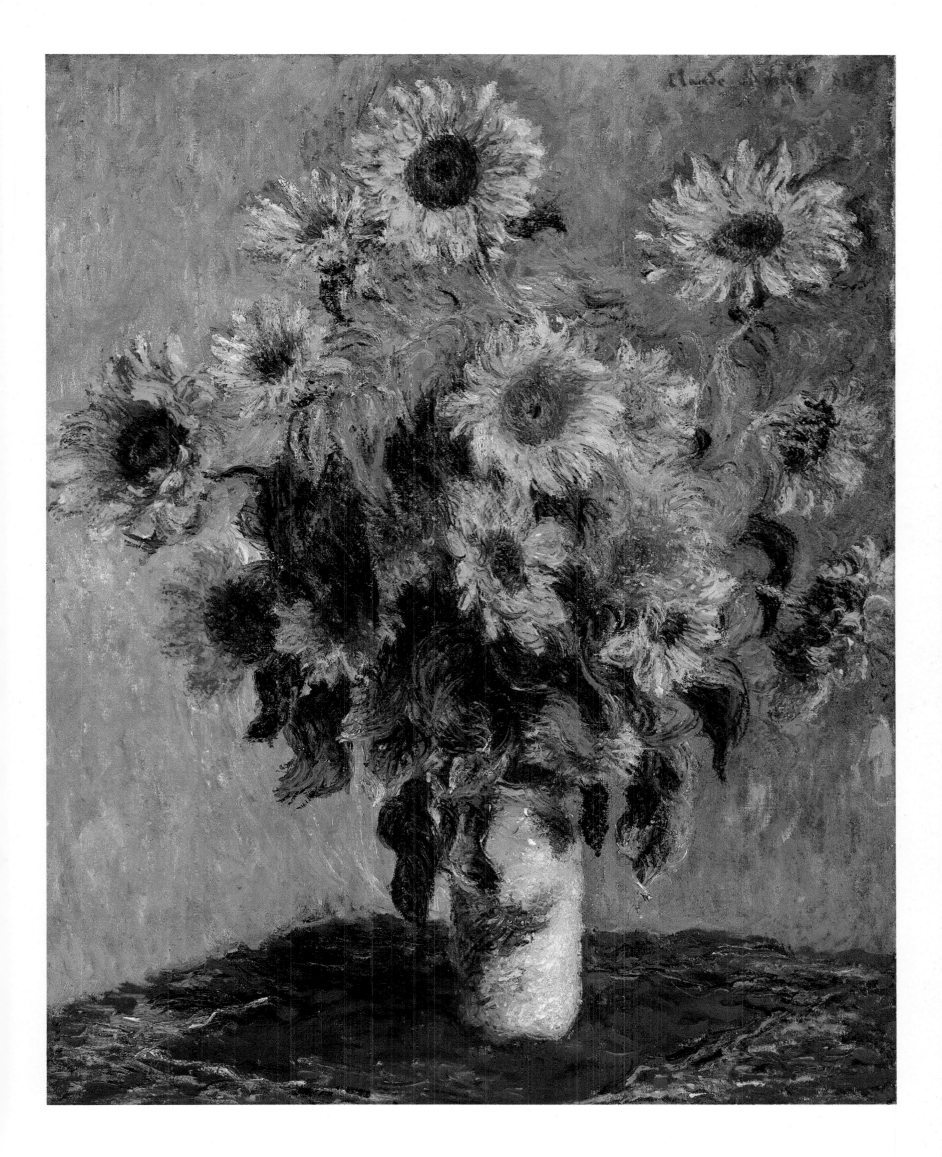

CLAUDE MONET

French, 1840–1926

Chrysanthemums

Oil on canvas, 39½ x 32¼ inches
Signed and dated (lower left): Claude Monet 82

BETWEEN 1858 AND 1882 Monet painted forty-nine still lifes, twenty-one of flowers. For the artist, flower painting was an enterprise that combined his interests in gardening and painting. The relationship between the two assumed a far more important role after he moved to Giverny in 1883.

Chrysanthemums is very likely one of the large still lifes that Monet mentioned in a letter to his dealer in the fall of 1882. It was painted either in the town of Poissy, northwest of Paris, where Monet lived from December 1881 until April 1883, or in Pourville, the village on the Channel coast where he spent the summer of 1882. Like his *Sunflowers* of 1881 (pages 130–31), it was probably painted when poor weather had driven the artist indoors. Both pictures are investigations of a limited range of harmonies, but each also exploits color, rhythm, surface, and touch to the fullest extent. Painted at a time when Monet had become dissatisfied with the tenets of Impressionism, such pictures are as much pretexts for a display of technical virtuosity as they are vehicles for the study of color and light that is generally associated with the Impressionist movement.

Bequest of Mrs. H. O. Havemeyer, 1929 29.100.106
H. O. Havemeyer Collection

132

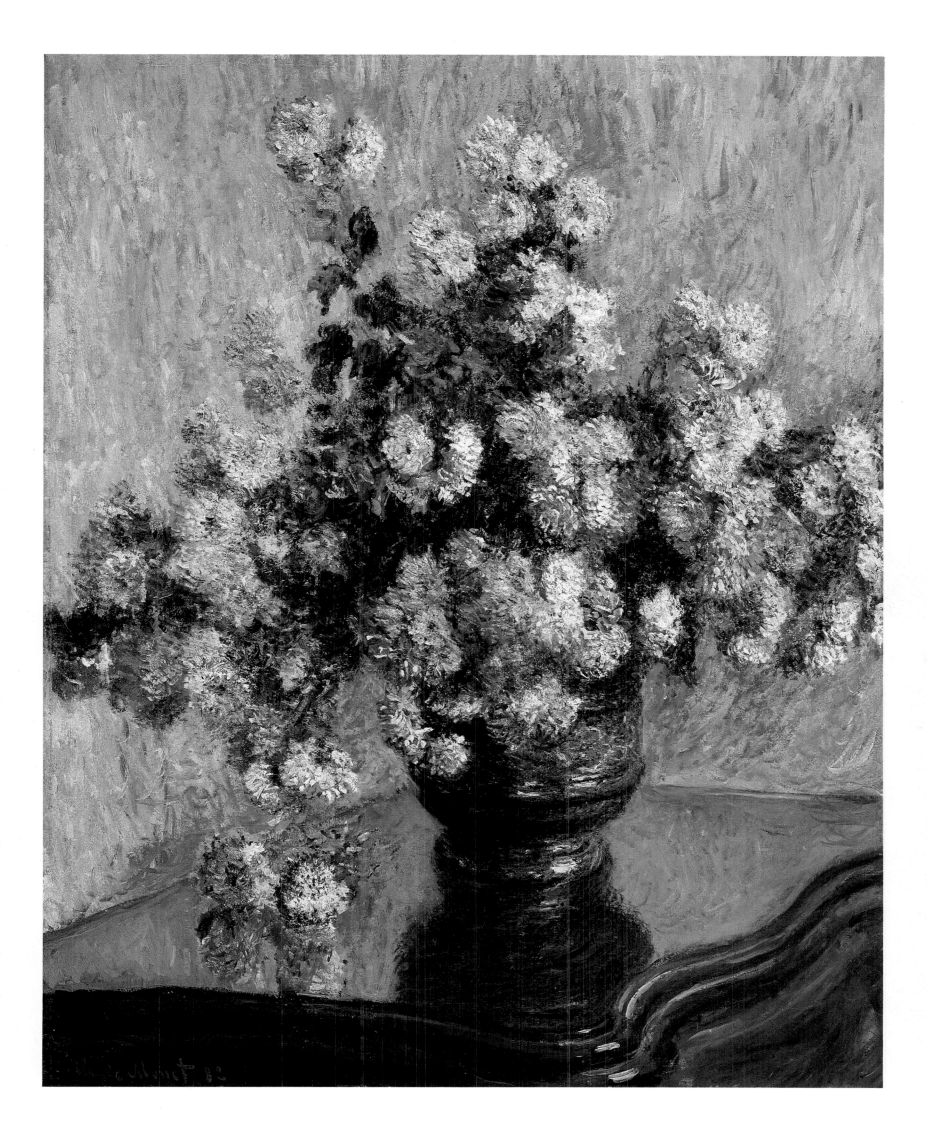

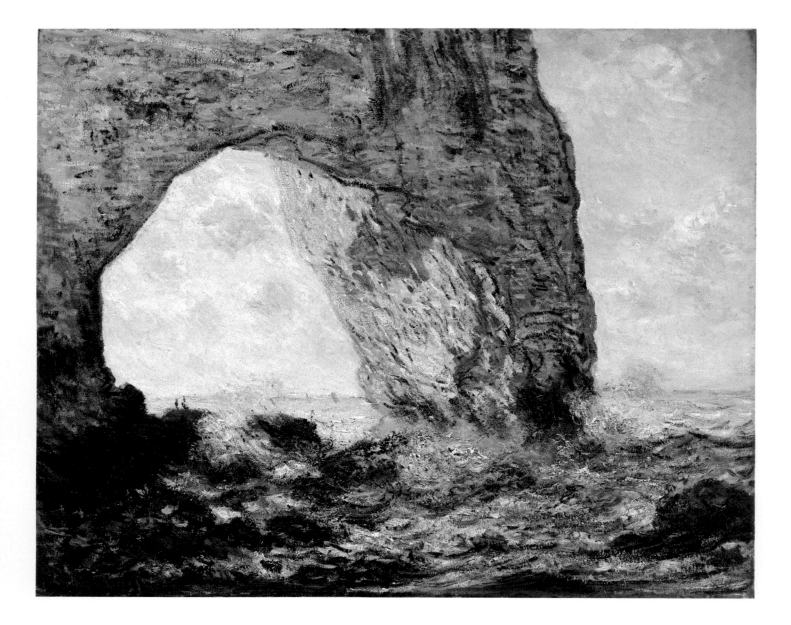

CLAUDE MONET

French, 1840–1926

The Manneporte, Etretat, I

Oil on canvas, 25¾ x 32 inches
Signed and dated (lower left): Claude Monet 83

MONET SPENT THE first three weeks of February 1883 in Etretat, a fishing village and resort northeast of Le Havre on the Channel coast. He painted eighteen views of the beach and the three extraordinary rock formations in the area: the Porte d'Aval, the Porte d'Amont, and the Manneporte. Three years later Guy de Maupassant reported that in Etretat Monet worked on several canvases at a time in order to depict changes in light and atmospheric conditions.

The sunlight that strikes the Manneporte has an especially dematerializing effect that permitted the artist to interpret the cliff almost exclusively in terms of color and luminosity. Most nineteenth-century visitors were attracted to the rock as an extraordinary natural phenomenon, as many surviving photographs made for sale to tourists attest. Monet, however, conveys little sense of the Manneporte as a natural wonder, concentrating instead on his own changing perception of it at different times of day. The nature of Monet's interests at Etretat is made apparent by comparing his with other artists' views of the area, such as those by Boudin.

Bequest of William Church Osborn, 1951

51.30.5

The Manneporte, Etretat, II

Oil on canvas, 32 x 25³/₄ inches
Signed and dated (lower left): Claude Monet 86

THE SUBJECT OF this painting is the same dramatically arched projection in the cliff at Etretat that is illustrated on the facing page. Monet painted it six times from this angle: twice during each of three visits to Etretat in 1883, 1885, and 1886.

The differences between the two pictures are too pronounced to have resulted from changes in light and atmospheric conditions alone. This work reflects the brightening of Monet's palette that followed his trip to the Riviera late in 1883. Furthermore, we know that by this time Monet had become less interested in working directly from nature, because in a letter to his dealer he reported that he continued to refine the Etretat paintings in his studio at Giverny. Equally important, in these pictures the artist's subjective response began to play a more important role. Monet's tendency to interpret and exaggerate his observations grew during the 1880s as he concentrated increasingly on painting groups of works with a single theme. In many ways the paintings of the Manneporte anticipate the Rouen Cathedral series of 1894, in which light is also reflected from an enormous stone surface (pages 144–45).

Bequest of Lizzie P. Bliss, 1931 31.67.11

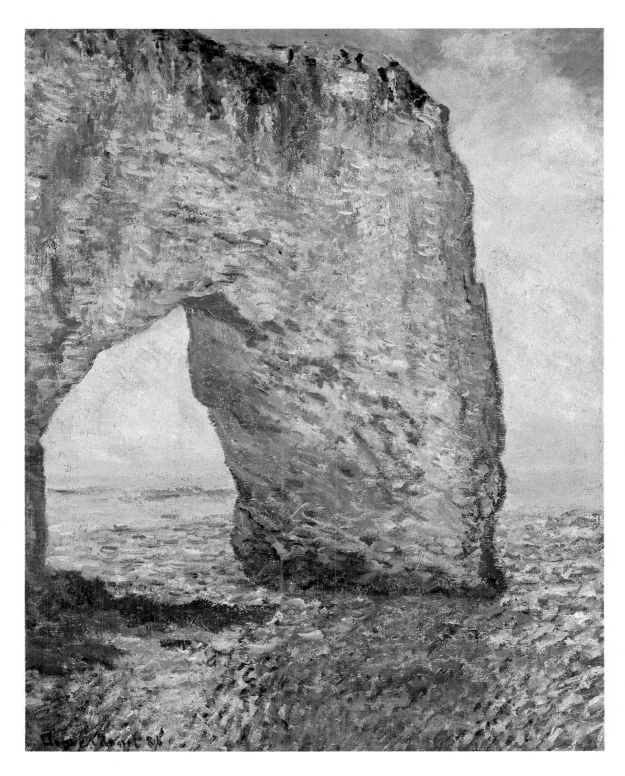

CLAUDE MONET

French, 1840–1926

Rapids on the Petite Creuse at Fresselines

Oil on canvas, 25¾ x 36⅛ inches
Signed and dated (lower left): Claude Monet 89

MONET FIRST VISITED Fresselines, a small village in the *département* of Creuse, during the second half of February 1889. He was invited initially in June 1888 by a poet and musician, Maurice Rollinat, who had extended the invitation through a mutual friend, Gustave Geffroy, the influential critic who later became Monet's biographer, but the trip was postponed until the winter. After the visit Monet returned to his home in Giverny, but by March 6 he was back in Fresselines. During the next ten weeks he painted at least twenty-three works depicting the area around the confluence of two rivers, the Petite Creuse and the Grande Creuse.

This is one of two nearly identical paintings of the shallow rapids near the confluence. The other is in a private collection. Monet positioned his easel on the steep bank of the ravine through which the Petite Creuse flows. The raised vantage point permitted him to look down onto the subject, and the resulting ambiguous space produces a strong two-dimensional effect. This is one of a number of canvases from the late 1880s that explore ideas that Monet pursued more fully later. The artist's viewpoint, the subject, and even the purples and greens recur in many of his pictures after 1900.

Bequest of Miss Adelaide Milton de Groot (1876–1967), 1967 67.187.88

CLAUDE MONET

French, 1840–1926

Poplars

Oil on canvas, 32¼ x 32⅛ inches
Signed and dated (lower left): Claude Monet 91

DURING THE SUMMER and fall of 1891 Monet painted a series of works depicting poplars along the banks of the Epte River, about a mile from his house in Giverny. Completion of the series was temporarily threatened when the village of Limetz, on the opposite side of the Epte from Giverny, decided to sell the trees at auction. In order to finish the series Monet made a financial arrangement with a local lumber merchant, who purchased the trees and allowed them to stand until the artist had completed his work.

Some of the Poplars were painted from the banks of the river; others, such as this example, were painted from a boat. According to Lilla Cabot Perry, an American who spent the summers of 1889–1909 in Giverny, Monet used a specially outfitted boat: "The Poplars series . . . were painted from a broad-bottomed boat fitted up with grooves to hold a number of canvases. He told me that in one of his Poplars the effect lasted only seven minutes, or until the sunlight left a certain leaf, when he took out the next canvas and worked on that."

Monet first exhibited the Poplars, like the Haystacks, as a series. In 1892 fifteen were shown by themselves in two small rooms at the Durand-Ruel Gallery in Paris. They were well received, but opinions differed as to their aim. Some critics praised them for naturalism, others admired their abstract and decorative qualities.

Bequest of Mrs. H. O. Havemeyer, 1929 29.100.110
H. O. Havemeyer Collection

CLAUDE MONET

French, 1840–1926

Haystacks in Snow

Oil on canvas, 25¾ x 36¼ inches
Signed and dated (lower left): Claude Monet 91

HAYSTACKS APPEAR frequently in nineteenth-century French paintings—usually as incidental elements. However, from 1888 until 1891 Monet made haystacks the principal subject of a group of canvases. Several stood in a field across the road from his house in Giverny, and he painted them at different times of day throughout the year. Although he had executed multiple versions of a single subject before, the Haystacks were the first group that he exhibited as a series.

During an interview with the duc de Trévise in 1920, Monet said that he had been forced to work on a number of canvases at the same time because of the rapidly changing light. At first he thought that two would be sufficient, but as the light shifted he had to send his stepdaughter back to the house again and again for additional canvases. The emphasis on naturalism implicit in Monet's concern with changing light is, however, somewhat deceptive. For example, the simplifications, exaggerations, and marked sense of mood in this picture suggest a strong element of subjectivity, at which Monet himself hinted in a conversation with a Dutch critic, Willem Byvanck, during the course of the 1891 exhibition of fifteen Haystacks at the Durand-Ruel Gallery in Paris.

Bequest of Mrs. H. O. Havemeyer, 1929 29.100.109
H. O. Havemeyer Collection.

CLAUDE MONET

French, 1840–1926

The Thaw (La Débâcle)

Oil on canvas, 26 x 39½ inches
Signed and dated (lower right): Claude Monet 93

DURING THE WINTER of 1892–93 Monet painted eight views of the Seine near Bennecourt, a river village a few miles southeast of Giverny. Six of the eight are identical in composition to *The Thaw*. In this series of paintings Monet was able to explore the subtlest variations in color and mood that resulted from the changing light. The heavy atmosphere in combination with the reflective surfaces of snow, ice, and water provided the artist with a wide range of the lightest blues, greens, grays, and mauves. The truest whites in the painting are unpainted areas of the prepared ground of the canvas.

Monet's first paintings of ice floes on the Seine were done in Vétheuil in 1879–80. Both the Vétheuil and the Bennecourt series foreshadow Monet's early series of Water Lilies (1903–8).

Bequest of Mrs. H. O. Havemeyer, 1929 29.100.108
H. O. Havemeyer Collection

143

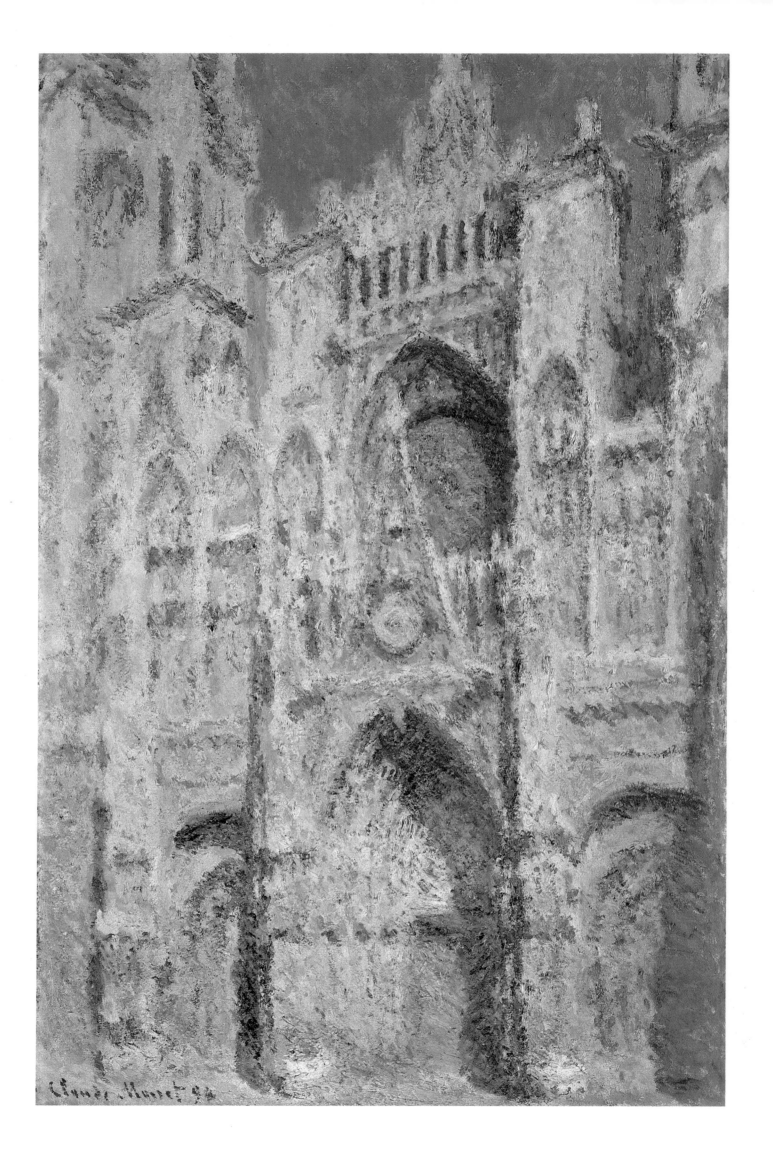

CLAUDE MONET

French, 1840–1926

Rouen Cathedral

Oil on canvas, 39¼ x 25⅞ inches
Signed and dated (lower left): Claude Monet 94

DURING FEBRUARY–APRIL 1892 and February–March 1893, Monet produced more than thirty views of Rouen Cathedral. Twenty-seven finished paintings, one unfinished painting, and one sketch depict the facade alone. Painted from the second stories of 23 Place de la Cathédrale (1892) and 81 Rue Grand-Pont (1893), they constitute the group known as the Rouen Cathedral series. The Museum's example is one of nine that show the church from the Place de la Cathédrale.

Twenty-four works in the series are signed and dated 1894, one is signed and dated 1893, and two are signed but not dated. All were probably finished later in the artist's studio in Giverny, where they were worked on together and interrelated. In 1895 twenty were exhibited as a series at the Durand-Ruel Gallery in Paris. They sold rapidly for 15,000 francs apiece, an extremely high price at that time. The Metropolitan Museum's example was included in the gallery's exhibition, where it was titled *Le Portail (Soleil) {The Portal (Sunlight)}*. The significance of these works has been interpreted by George Heard Hamilton: "The twenty moments represented by the twenty views of Rouen are less views of the cathedral (one alone would have been sufficient for that), less even twenty moments in the going and coming of the light (which is an insignificant situation), than twenty episodes in Monet's private, perceptual life. They are twenty episodes in the history of his consciousness, and in thus substituting 'the laws of subjective experience for those of objective experience' he revealed a new psychic rather than physical reality."

Bequest of Theodore M. Davis, 1915
Theodore M. Davis Collection

30.95.250

CLAUDE MONET

French, 1840–1926

Morning on the Seine near Giverny

Oil on canvas, 32⅛ x 36⅝ inches
Signed and dated (lower left): Claude Monet 97

THE MORNING ON THE SEINE series was begun in 1896 but not completed until the following year because of inclement weather. The pictures were painted from a boat that Monet had converted into a floating studio. For an extended period he rose before dawn and reached his boat before sunrise in order to observe and paint the changing effects of light as the sun came up.

The critic Gustave Geffroy wrote in 1898 that work on the series began only after a patient search for a particular kind of composition: "Monet wandered among the meadows, under the light shade of the poplars. He went up and down the river in his boat, skirting the islands, searching deliberately and with infinite care for views suited to his sense of order, form, horizon line, play of light, shadows, and color." Another critic,

Maurice Guillemot, visited Monet's studio in 1897, at a time when the Mornings on the Seine were lined up on easels to be completed together as a series. Although work in the open air remained an important aspect of Monet's painting, it was now part of a more complex procedure.

Eighteen Mornings on the Seine were shown as a series in an exhibition of sixty-one paintings at the Georges Petit Gallery in 1898. One was dated 1896, and the others were all dated 1897. In subject, and in Monet's emphasis on the imagery of reflections, the series anticipates the Water Lilies paintings to which he soon turned his attention.

Bequest of Julia W. Emmons, 1956 56.135.4

146

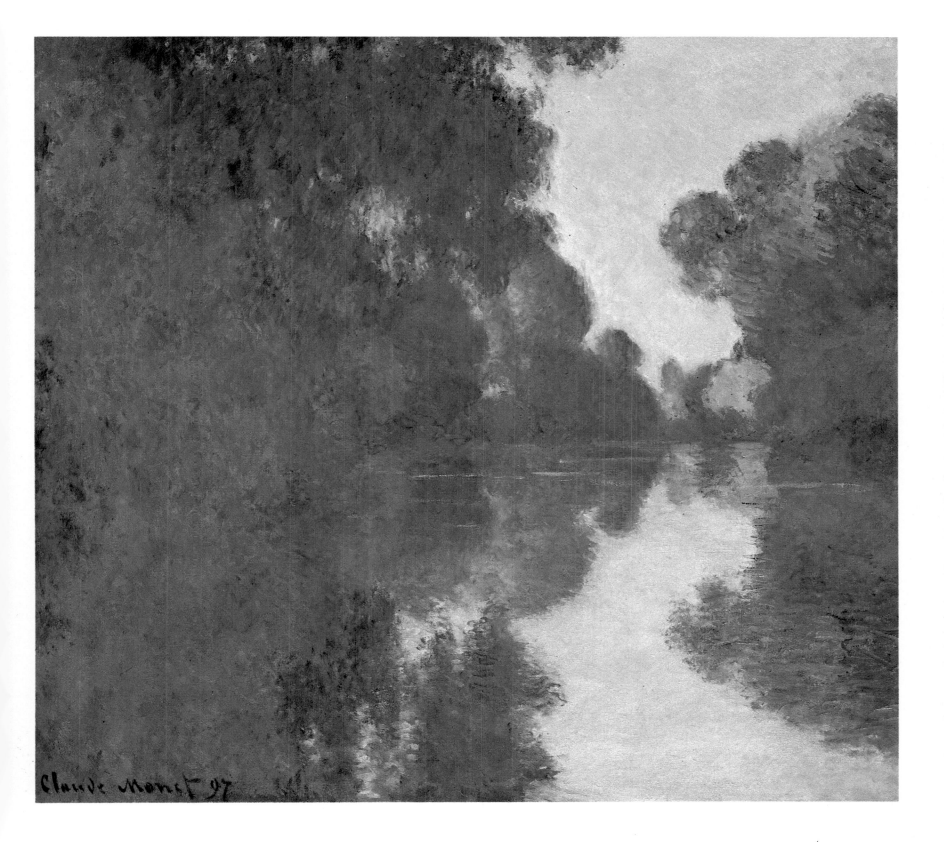

Claude Monet 97

CLAUDE MONET

French, 1840–1926

Bridge over a Pool of Water Lilies

Oil on canvas, 36½ x 29 inches
Signed and dated (lower right): Claude Monet / 99

IN 1893 MONET BOUGHT a small piece of land just across the railroad tracks (now a road) that bordered one side of his property in Giverny. The newly acquired plot included a small pond that was fed by a nearby stream. In the mid-1890s he built an arched footbridge on the axis of the main garden path in front of his house. It was probably modeled on a bridge depicted in one of the many Japanese prints in his collection.

In 1899–1900 Monet painted a series of at least seventeen views of the footbridge and the pond. In 1900 thirteen of them were included in an exhibition of twenty-six paintings by the artist at the Durand-Ruel Gallery in Paris.

Monet later purchased more property adjacent to the pond, which he expanded and refined. In the 1920s he again used the Japanese footbridge as the central motif in an extended series of paintings.

Bequest of Mrs. H. O. Havemeyer, 1929 29.100.113
H. O. Havemeyer Collection

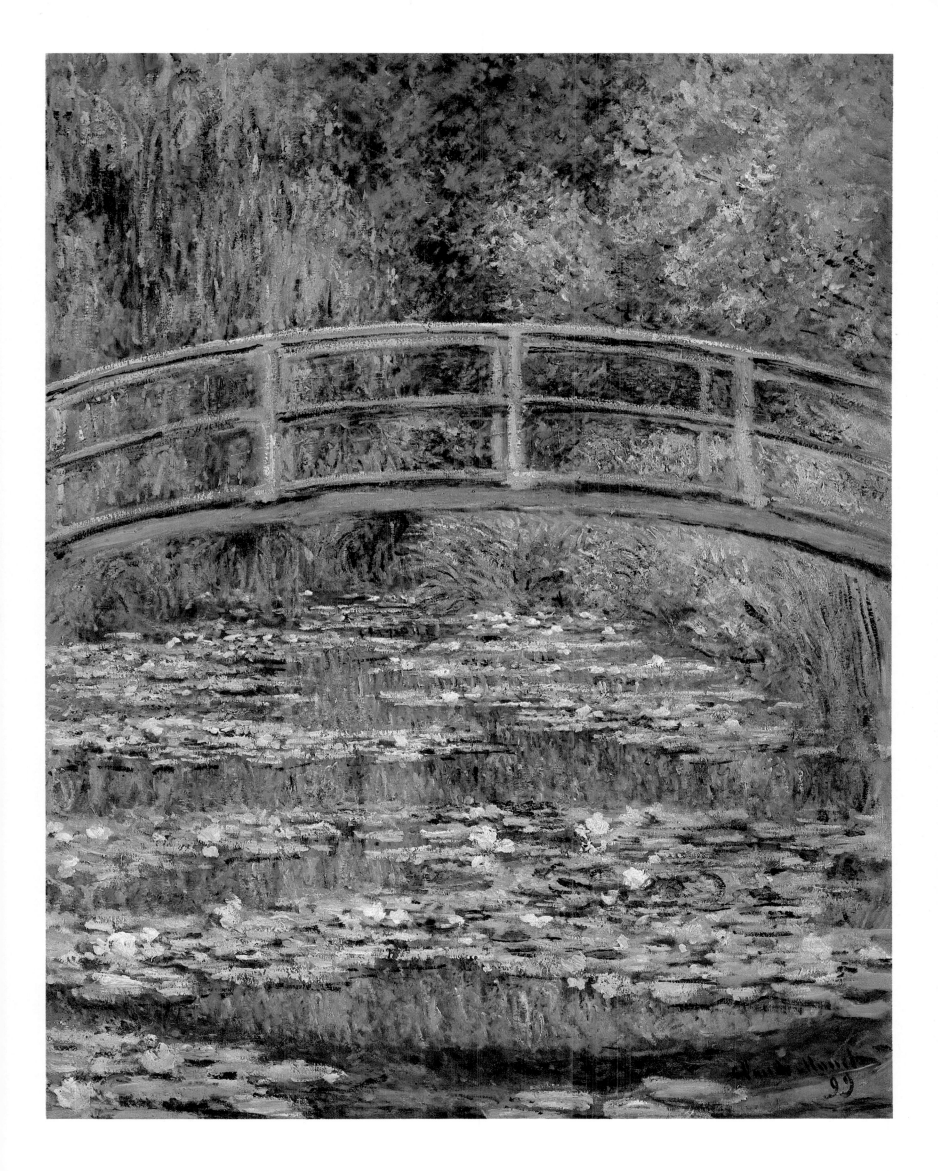

CLAUDE MONET

French, 1840–1926

The Houses of Parliament

Oil on canvas, 32 x 36⅜ inches
Signed and dated (lower left): Claude Monet 1903

MONET FIRST PAINTED views of the Thames in 1870–71, the year that he spent in England in order to escape the Franco-Prussian War. Two decades later he visited London briefly and wrote to his dealer, Paul Durand-Ruel, that he wanted to work there again. However, he did not return until the fall of 1899, when he began the so-called Thames series, a large group of works comprising views of Waterloo Bridge, Charing Cross Bridge, and the Houses of Parliament. The views of the two bridges were painted from the window and balcony of Monet's fifth-floor room at the Hotel Savoy; the Houses of Parliament were painted from Saint Thomas's Hospital directly across the river.

In London Monet reportedly worked on as many as ninety canvases. When the light changed he put one canvas aside and turned his attention to another until the light changed again. In November Monet returned to Giverny, but in February 1900, back in London, he continued to work on the Thames series until early April. In his studio in Giverny he worked on the paintings until at least 1903, when he wrote Durand-Ruel, "I cannot send you a single canvas of London . . . it is indispensable to have them all before me, and to tell the truth not one is definitely finished. I develop them all together." In May 1904 thirty-seven were exhibited at the Durand-Ruel Gallery in Paris.

Bequest of Julia W. Emmons, 1956

56.135.6

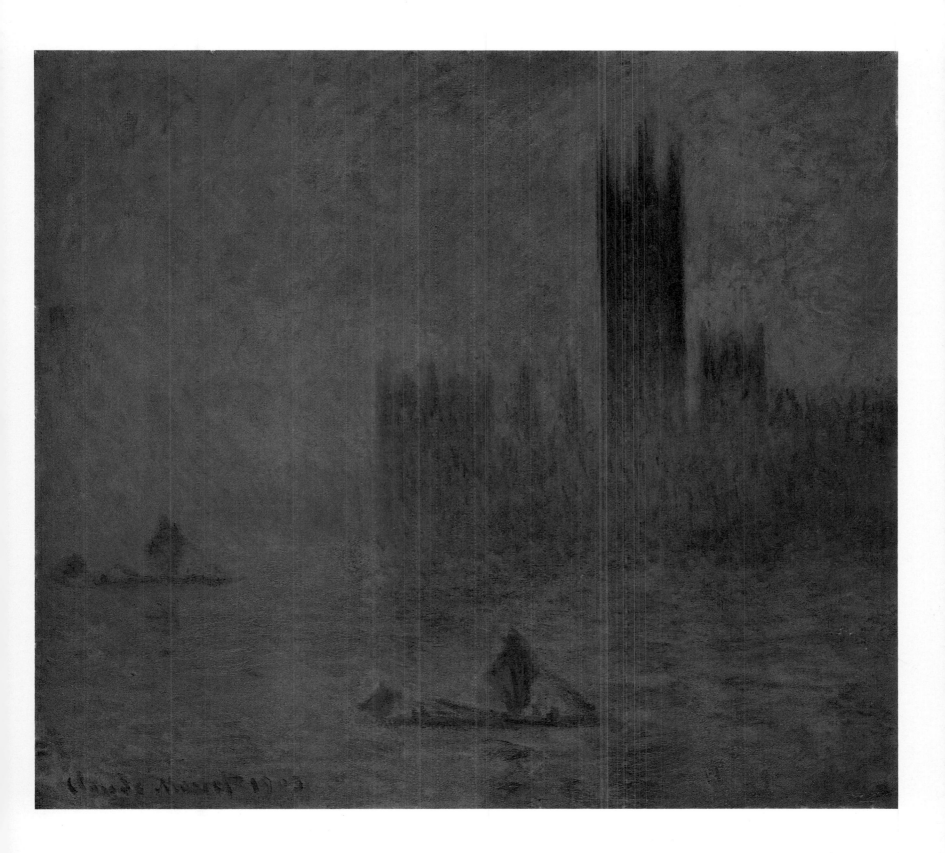

ALFRED SISLEY

British, 1839–1899

The Bridge at Villeneuve-la-Garenne

Oil on canvas, 19½ x 25¾ inches
Signed and dated (lower left): Sisley. 1872

WHEN CHARLES GLEYRE retired from teaching in
1864, several of his students, including Sisley, Monet,
and Renoir, continued to work together. In the absence
of conventional instruction, they turned their energies
increasingly to painting landscapes out-of-doors in the
countryside around Paris—as had the members of the
so-called Barbizon School a generation earlier. On occa-
sion the young artists even painted side by side, and
apparently the experience encouraged Sisley to move
beyond his early style, which reflects the influence of
Camille Corot and Charles Daubigny, and to adopt the
fundamentals of what would come to be known as
Impressionism. Those fundamentals are already evident
in *The Bridge at Villeneuve-la-Garenne:* the informal com-
position, the high-keyed, chalky color applied in short
strokes that mimic the effects of sparkling light, and the
unpretentious subject matter. Unquestionably one of
Sisley's masterpieces, this painting in effect celebrates
all the little villages, byways, and bridges that are the
soul of France. To capture that was the ultimate goal for
Sisley, as it had been for the preceding generation of
itinerant landscape painters.

Gift of Mr. and Mrs. Henry Ittleson, Jr., 1964 64.287

152

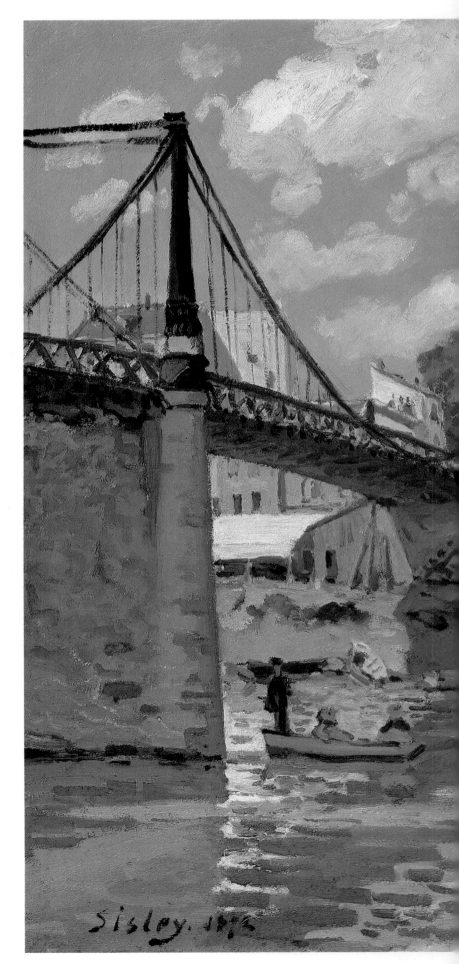

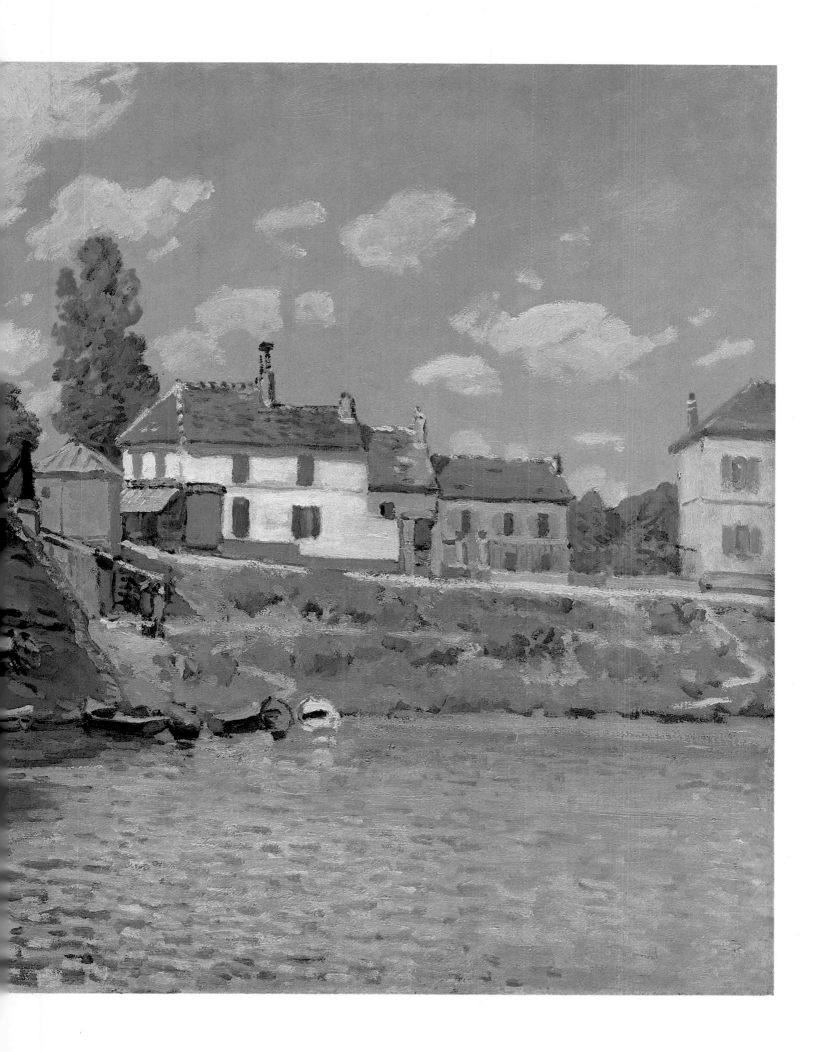

ALFRED SISLEY

British, 1839–1899

View of Marly-le-Roi from Coeur-Volant

Oil on canvas, 25¾ x 36⅜ inches
Signed and dated (lower right): Sisley. 76

TRADITIONALLY TITLED *View of Louveciennes,* this painting was recently identified by historians in that small French town as a panoramic view of a neighboring village, Marly-le-Roi, where Sisley was living in 1876. He executed two similar views during the winter of 1876, and in all three pictures the steeple of the church of Saint-Vigor rises above the houses in the background. To paint this view, Sisley set up his easel in a garden on the property of Robert Le Lubez in the hamlet of Coeur-Volant. Le Lubez was a noted amateur singer and patron of composers, two of the most famous of whom were Gounod and Saint-Saëns.

The interpretation of the visible world almost exclusively in terms of color and light and the use of rapidly applied, loose touches of paint are typical of the classic phase of Impressionism, during the mid-1870s. In 1876 Sisley's style was quite close to that of Monet. Indeed, this picture seems to combine the stylistic characteristics of the paintings of the Parc Monceau by Monet illustrated on pages 118–19 and 121.

Bequest of Miss Adelaide Milton de Groot (1876–1967), 1967 67.187.103

PIERRE AUGUSTE RENOIR

French, 1841–1919

A Road in Louveciennes

Oil on canvas, 15 x 18¼ inches
Signed (lower right): Renoir

THE PAINT HANDLING indicates that *A Road in Louveciennes* was executed about 1870, a date that is supported by the figures' style of dress. Recently the site has been identified as the village of Louveciennes, where Renoir's parents had a summer house. Pissarro lived and worked in the village in 1869–70, and he painted a view of the same road (National Gallery, London). His seems to have been painted in the spring, whereas Renoir's appears to have been done at the height of summer.

The idyllic mood and the dominant blue and green tonalities reflect Renoir's admiration for French eighteenth-century landscape, but the lively and varied brushwork is unmistakably that of Renoir in the early 1870s: tiny dabs and dashes for the foliage in the middle ground, but somewhat longer flourishes in the foreground; sweeping, viscous strokes for the path crossed with shadows; thinner, more regularly placed strokes of white and blue for the sky; and a few bold streaks of impasto for the clouds. Almost certainly executed out-of-doors, the picture is in effect drawn directly with paint. Four years later such works were derisively labeled "Impressionist," but by the time Louis Leroy coined the term the movement was already a *fait accompli*.

Bequest of Emma A. Sheafer, 1973
The Lesley and Emma Sheafer Collection

1974.356.32

A Waitress at
Duval's Restaurant

Oil on canvas, 39½ x 28⅛ inches
Signed (lower left): Renoir.

EDMOND RENOIR WROTE in 1879 that his brother was committed to art rooted in actual experience rather than contrived with the assistance of professional models wearing costumes. For this picture, painted about 1875, Renoir depicted a waitress whom he had met in one of several Parisian restaurants established by a butcher named Duval. Evidently he asked her to come to his studio to pose in her uniform, just as she looked while working. As he explained in a different context, "I like painting best when it looks eternal without boasting about it: an everyday eternity, revealed on the street corner: a servant-girl pausing a moment as she scours a saucepan, and becoming a Juno on Olympus."

The simplicity of Renoir's composition is as innovative as his attitude toward the model. Her form stands out clearly against four regularly shaped zones of muted color. The informal pose and Renoir's direct, seemingly spontaneous technique are characteristic of the kind of work that the critic Edmond Duranty described in his essay "The New Painting," written in 1876 upon the occasion of an exhibition at the Durand-Ruel Gallery that included work by Renoir, Degas, Monet, Morisot, Bazille, Sisley, and others "Farewell to the human body treated like a vase with a decorative, swinging curve; farewell to the uniform monotony of the framework, the flayed figure jutting out beneath the nude; what we need is the particular note of the modern individual, in his clothing, in the midst of his social habits, at home or in the street."

PIERRE AUGUSTE RENOIR

French, 1841–1919

Young Girl in a Pink and Black Hat

Oil on canvas, 16 x 12¾ inches
Signed (lower left): Renoir

IN THE 1890s Renoir executed several bust-length paintings of stylish young women in modish hats that are very different from the pictures of women in millinery shops done in the 1880s by Degas (pages 76–77). Degas's underlying concern was the similarity between aspects of everyday life and the technical and artificial elements of art, but Renoir's interest was limited principally to images of attractive young women. In addition, he seems to have relished sentiments such as those evoked in this painting by the nape of the girl's neck, the curves of black velvet and ostrich feathers, and rustling ribbons. Clearly a strong erotic element interweaves with Renoir's characteristic *joie de vivre* and his celebration of youth, beauty, color, and light. Despite the artist's emphasis on superficial qualities, pictures such as *Young Girl in a Pink and Black Hat* have always proven extremely popular. Renoir's hedonistic vision is evidently as enduring in its appeal as the analytical, intellectual, and aesthetic approach of Degas.

Gift of Kathryn B. Miller, 1964 64.150

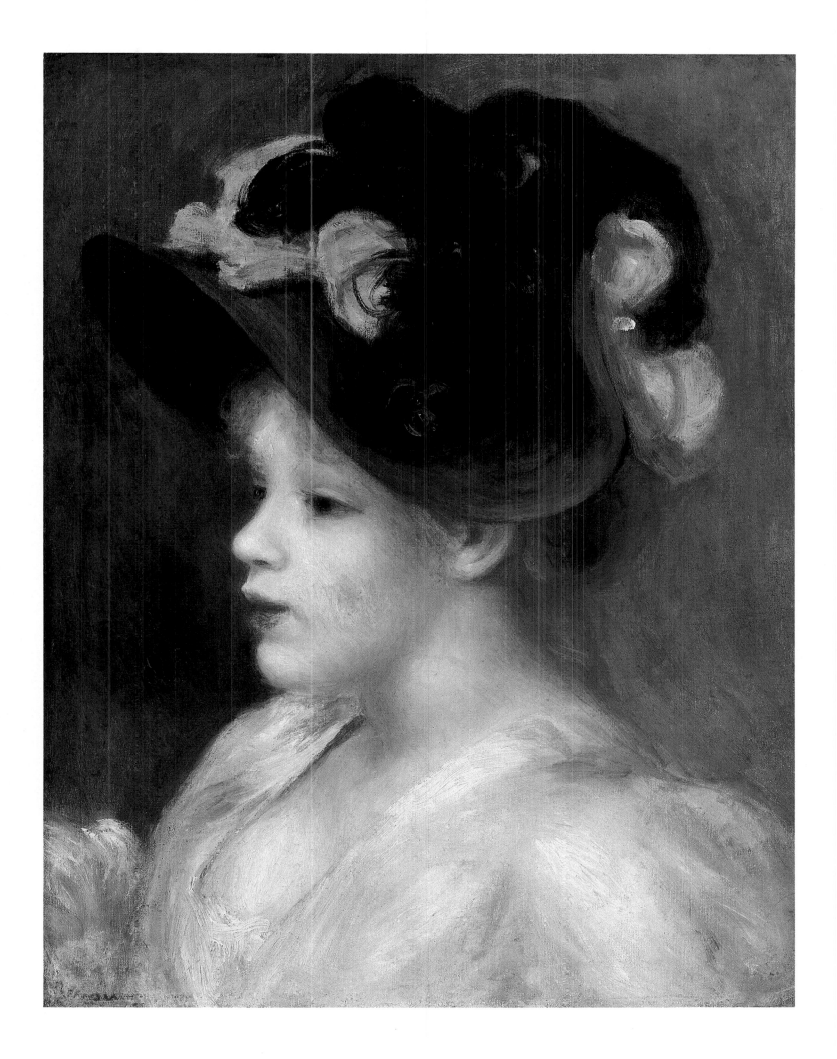

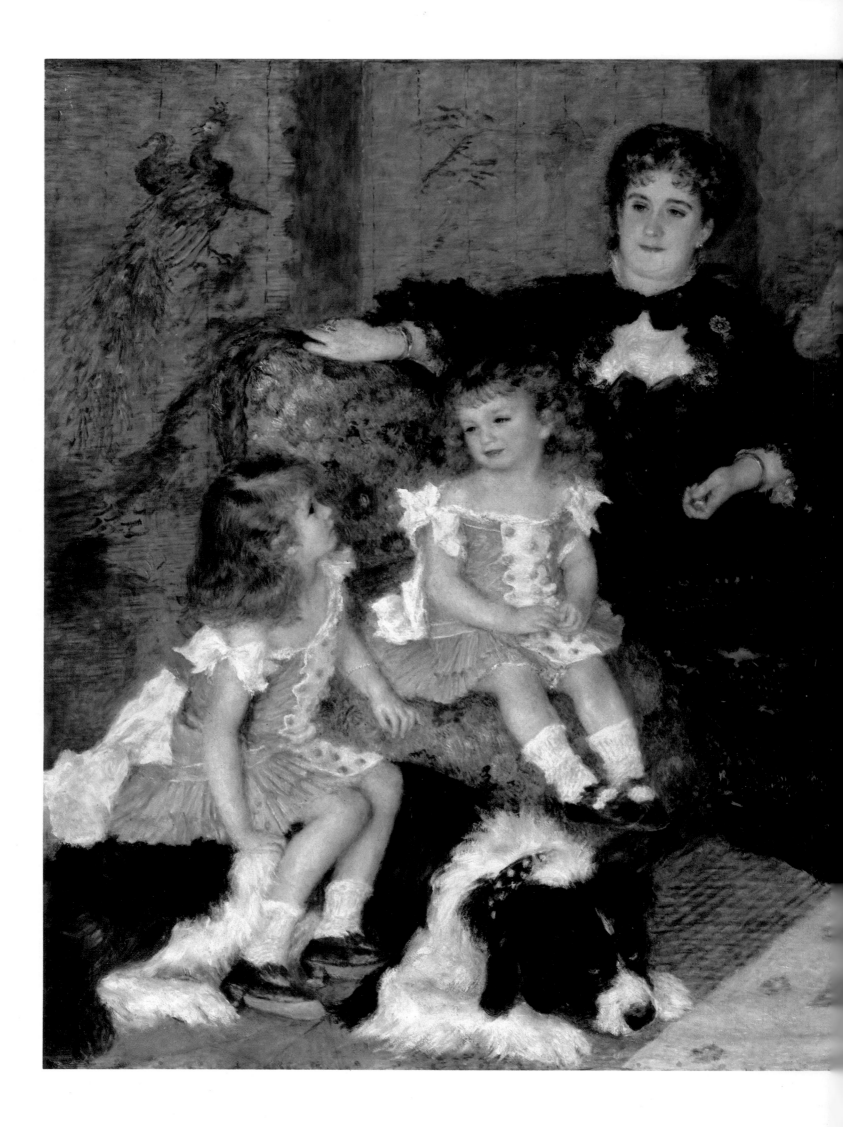

PIERRE AUGUSTE RENOIR

French, 1841–1919

Madame Georges Charpentier (Marguerite Lemonnier) and Her Children, Georgette and Paul

Oil on canvas, 60½ x 74⅞ inches
Signed and dated (lower right): Renoir. 78.

GEORGES CHARPENTIER, the well-to-do publisher of the Goncourts, Zola, and Maupassant, introduced himself to Renoir in 1876, having purchased one of the artist's paintings at auction the year before. Charpentier and his wife entertained political, literary, and artistic notables on Friday evenings, and they welcomed Renoir to these gatherings. He was paid handsomely to paint this stunning family group portrait, which so pleased Madame Charpentier that she exerted her influence to have it prominently displayed at the Salon of 1879.

During the sittings she wore an exquisite black gown designed by Worth, and its sweeping skirt dominates the scene, set in the Charpentiers' red-and-gold Japanese-style drawing room. Next to her is her three-year-old son, Paul; her six-year-old daughter, Georgette, is seated comfortably on the docile Newfoundland dog, Porto. The children wear matching blue outfits with white butterfly bows at the shoulders. Like their mother, they seem as exquisite as the exotic birds that decorate the painted Japanese blinds that serve as a backdrop.

Though Renoir conveys the opulent ease of his subjects' lives, he made no attempt to capture their personalities. Consequently, his portrait of this stylish family is closer in spirit to works by Rubens and Fragonard that he admired than to the penetrating character portraits of his colleague Degas. Far more elaborately detailed than Renoir's other works of the 1870s, this painting marks the beginning of an important shift away from the classic Impressionist style, with which the artist had made his reputation only a few years before.

Wolfe Fund, 1907 07.122
Catharine Lorillard Wolfe Collection

PIERRE AUGUSTE RENOIR

French, 1841–1919

Marguerite (Margot) Bérard

Oil on canvas, 16⅛ x 12¾ inches
Signed and dated (upper left): Renoir 79.

MARGOT BERARD (1874–1956) was the daughter of
Paul Bérard, an ambassador in the French diplomatic
corps, who met Renoir through Georges and Marguerite
Charpentier (see pages 160–61). Beginning in the late
1870s Renoir was often a guest of the Bérards at their
country home in Wargemont, on the Normandy coast.
During his visits he painted members of the family and
executed several decorative pictures for their house
(pages 166–67).

According to the sitter's nephew, this sensitive and
direct portrait was painted shortly after Renoir encoun-
tered Margot in tears. She was running from her house
after a difficult lesson with her German tutor. Since
the painter borrowed the picture in 1886 to send to an
important exhibition in Brussels, he apparently consid-
ered it to be among his best.

Bequest of Stephen C. Clark, 1960 61.101.15

162

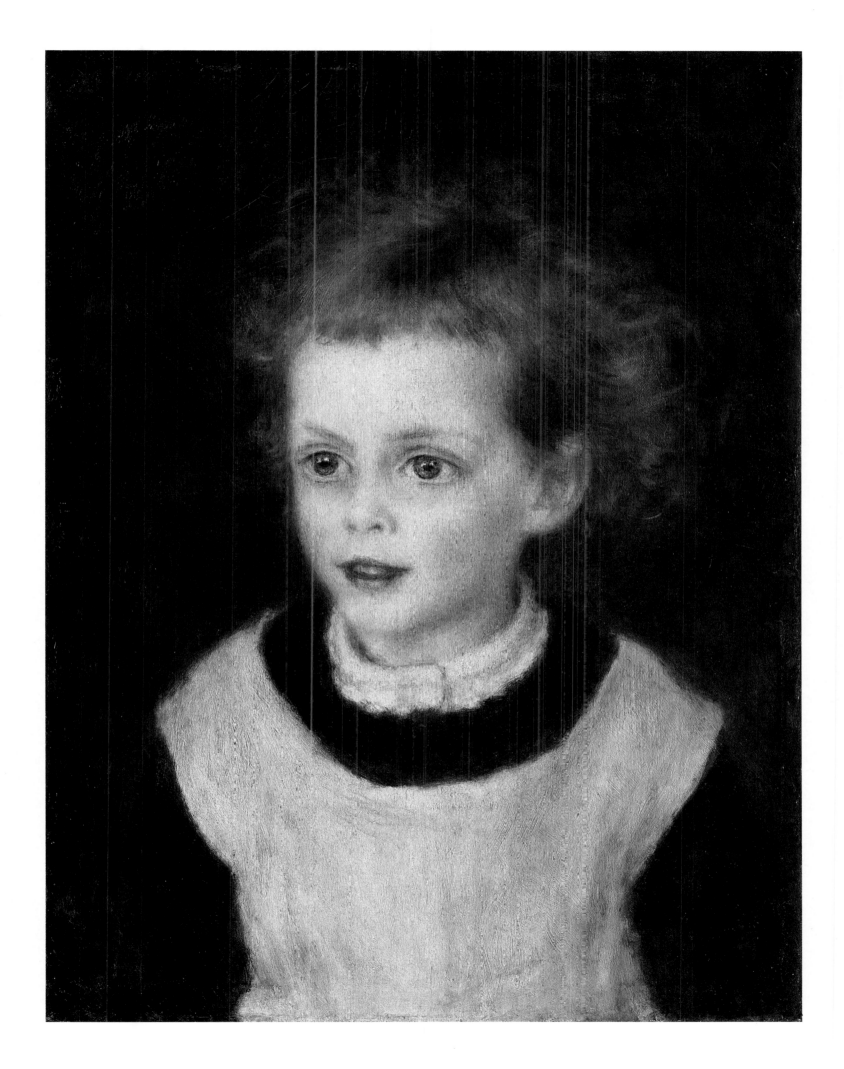

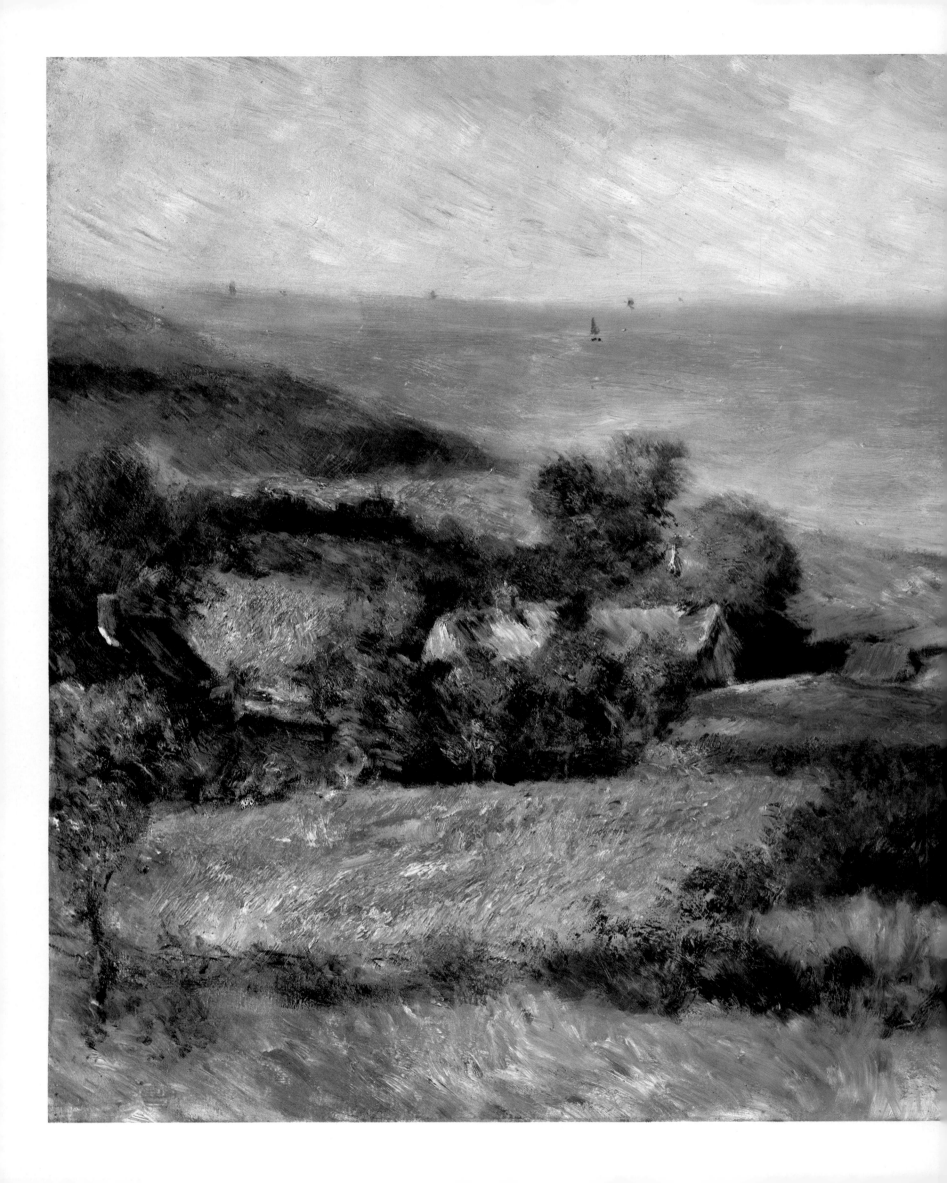

PIERRE AUGUSTE RENOIR

French, 1841–1919

View of the Seacoast
near Wargemont in Normandy

Oil on canvas, 19⅞ x 24½ inches
Signed and dated (lower right): Renoir. 80.

WHILE A GUEST AT the country house of Paul Bérard, Renoir was captivated by the seaside views. This area of the Channel coast, notable for its steep cliffs and weather-swept panoramas, also attracted Monet during the 1880s (see pages 134–35).

Renoir painted this scene out-of-doors, working quickly and broadly to capture the landscape's salient features before the lighting conditions changed. As in many classic Impressionist works by Renoir and Monet, the surface is relatively rough. Seen from a few steps away, however, the summary passages vividly suggest the dazzling play of light on grassy slopes and the vast expanse of sea stretching beyond.

Bequest of Julia W. Emmons, 1956 56.135.7

165

PIERRE AUGUSTE RENOIR

French, 1841–1919

Still Life with Peaches and Grapes

Oil on canvas, 21¼ x 25⅝ inches
Signed and dated (lower left): Renoir. 81.

WHILE VISITING THE Bérard family at Wargemont in the summer of 1881 Renoir painted two still lifes, almost identical in format, that show the family's faïence jardiniere piled with peaches. Records indicate that Bérard purchased this picture before the end of the year. The second is illustrated on the facing page.

During the late 1870s and early 1880s, both Renoir and Monet applied the bright palette and feathery brushwork they had developed for painting landscapes out-of-doors to decoratively arranged still-life motifs. This picture is exquisitely simple in conception. The composition consists essentially of two equal horizontal bands created by the white tablecloth and a deep blue background. The artist softened the stark juxtaposition of colors by combing the tablecloth with violet shadows and raking the background with white highlights. The two colors are combined again in the jardiniere, a white dish articulated with decorative blue borders. Set against the orchestrated blues and whites, the reds and yellows of the peaches appear especially vibrant.

The Mr. and Mrs. Henry Ittleson, Jr. Purchase Fund, 1956 56.218

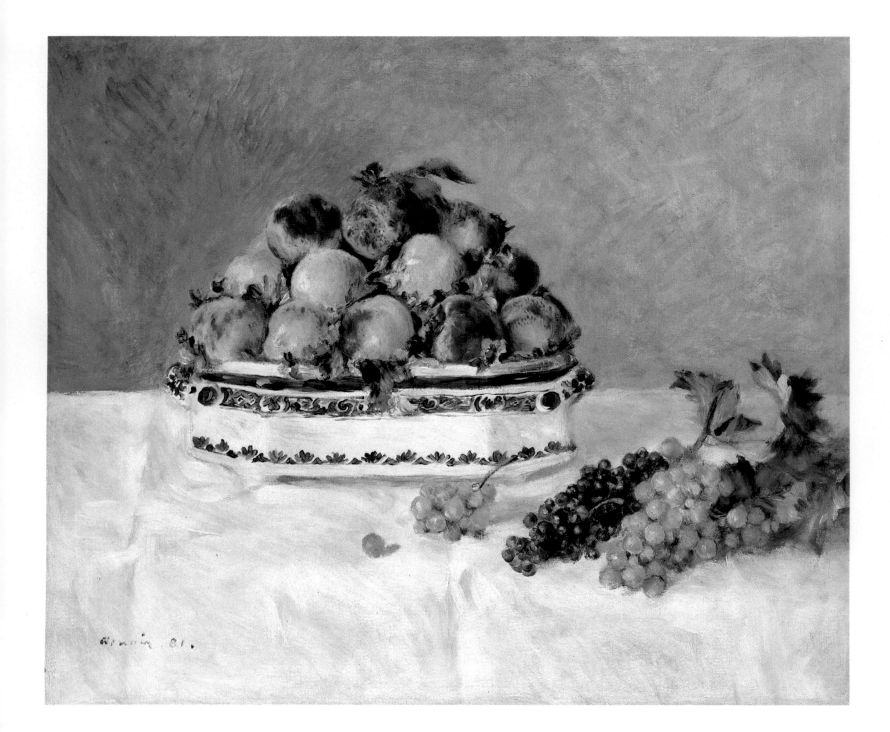

Still Life with Peaches

Oil on canvas, 21 x 25 ½ inches
Signed and dated (lower right): Renoir. 81.

STILL LIFE WITH PEACHES AND GRAPES (facing page) concentrates on the interplay of the blue and white tones in the Bérards' ardiniere and its setting; this painting, in a related fashion, focuses on the interrelationships of the red, yellow, and green of the fruit and the gold, emerald, vermilion, and red of the richly patterned wallpaper. The slightly different positioning of the jardiniere in the two paintings suggests that the pictures were conceived independently, not as pendants or even as first and second versions of the same subject. Nevertheless, it seems clear that Renoir painted them at about the same time with the idea of investigating the decorative and formal possibilities offered by different but similarly limited ranges of color.

Bequest of Stephen C. Clark, 1960 61.101.12

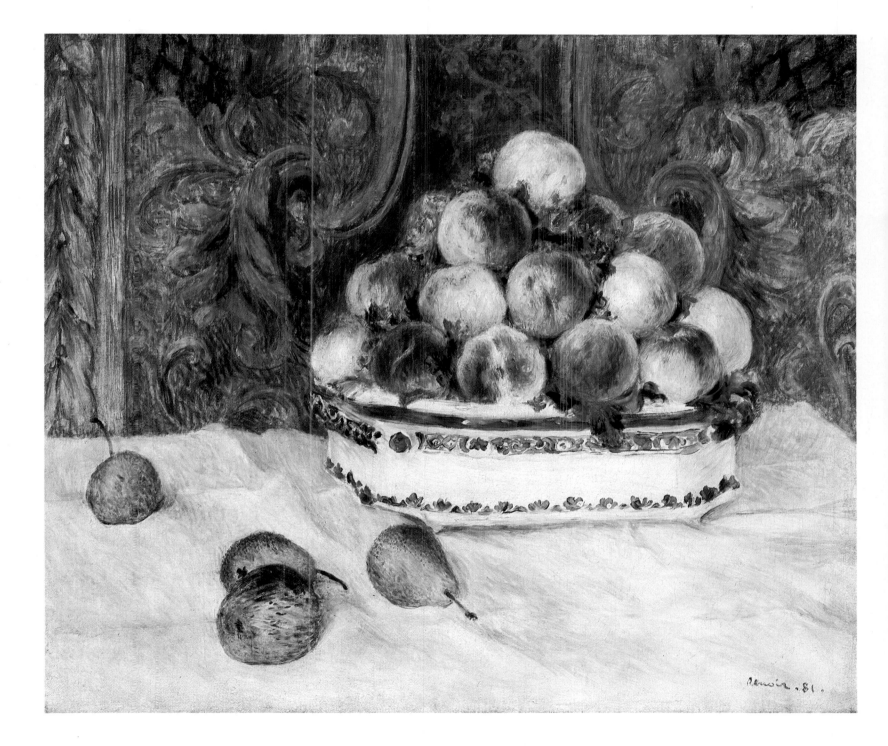

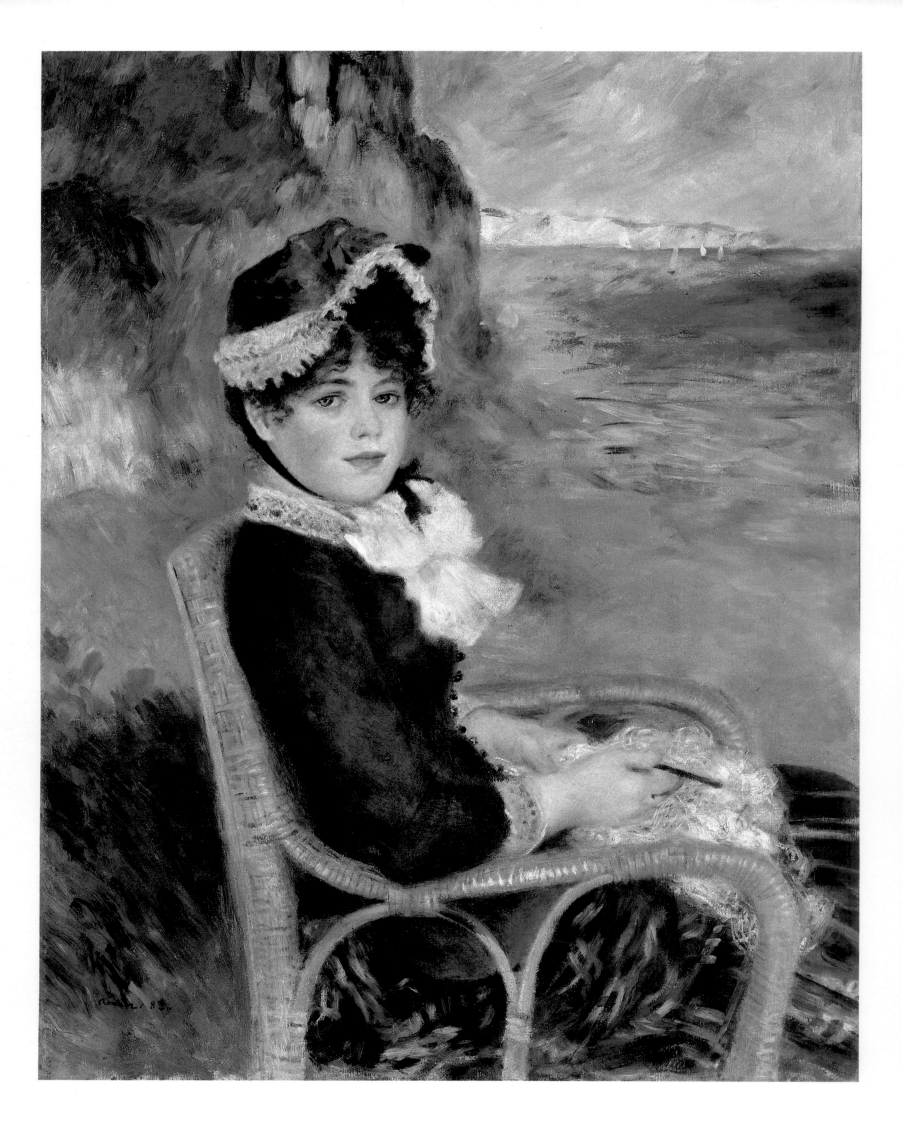

PIERRE AUGUSTE RENOIR

French, 1841–1919

By the Seashore

Oil on canvas, 35¼ x 28½ inches
Signed and dated (lower left): Renoir. 83.

DURING THE 1860s many incipient Impressionists "dreamed," as Emile Zola remarked, of painting the figure in full sunlight. Renoir pursued that goal more energetically than the others during the 1870s. He concentrated especially on bathers and painted several large canvases depicting figures seen against the Normandy seashore at Wargemont, where he began to summer in 1879. After a trip to Italy in 1881–82, Renoir consciously changed his style. His palette began to reflect the muted pastel colors of frescoes and his figures the grandeur and simplicity of those in Raphael's mythological compositions. Noting that Raphael had not worked out-of-doors yet had studied sunlight, Renoir resolved "not to bother any more with the small details that extinguish rather than kindle the sun."

This new attitude is apparent in the loosely rendered background of *By the Seashore,* probably painted on the Channel island of Guernsey in 1883. The white, blue, and ocher tones of the coast and sea are in perfect harmony with the colors of the sitter's lace-trimmed bonnet and jacket, her frothy jabot, and the wicker chair. Yet because Renoir rendered these details and the face so carefully, the figure and the background do not entirely integrate. Indeed, Renoir may have painted the young woman first, subsequently adding the view of the shoreline as background decoration. Such was his custom frequently during the 1880s and 1890s: in many works monumental, fully modeled figures are set against diffused, theatrical vistas reminiscent of Italian frescoes or of the idyllic landscape settings of Antoine Watteau's *fêtes champêtres.* As Renoir wrote from Guernsey, "One would believe oneself [to be] much more in a landscape by Watteau than in reality."

Bequest of Mrs. H. O. Havemeyer, 1929 29.100.125
H. O. Havemeyer Collection

169

PIERRE AUGUSTE RENOIR

French, 1841–1919

In the Meadow

Oil on canvas, 32 x 25¾ inches
Signed (lower left): Renoir.

ABOUT 1890 RENOIR was introduced to the two un-identified girls in this painting, one of half-a-dozen works for which they posed together in the same dresses. The blond and brunette models lean together in song at the piano (pages 174–75), read a book (Barnes Foundation, Merion, Pennsylvania), or, in this painting, admire flowers that they have picked. With their cooperation, Renoir was able to return to a theme that had attracted him in the 1870s, when he painted pairs of young women at the theater or in cafés. Whether considered as intimate genre scenes or as double portraits, all these pictures celebrate youthful innocence.

For this out-of-doors scene Renoir used long, curving strokes of very thin paint, creating a background that hardly seems substantial. It recalls the decorative, predominantly blue and green landscape settings favored by the eighteenth-century French artists whom Renoir admired. Similarly, Renoir took poetic license with actual physical appearances in order to suggest a world pervaded by the goodness of nature. As the artist's son explained in reference to a related work, "The blossom of the linden tree and the bee sipping honey from it follow the same rhythm as the blood circulating under the skin of the young girl sitting in the grass."

Bequest of Sam A. Lewisohn, 1951 51.112.4

170

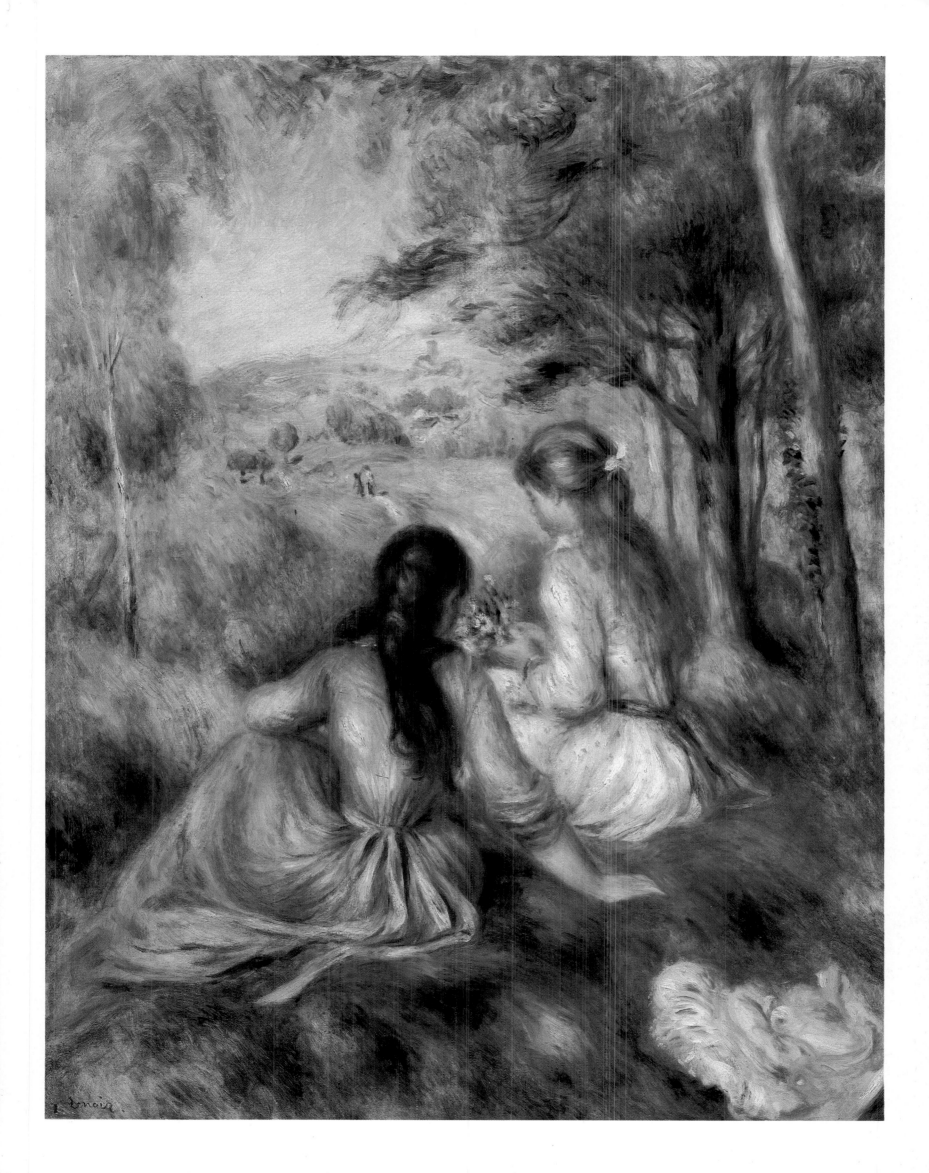

PIERRE AUGUSTE RENOIR

French, 1841–1919

Young Girl Bathing

Oil on canvas, 32 x 25 ½ inches
Signed and dated (lower left): Renoir. 92.

LIKE COURBET AND DEGAS, Renoir was committed to art based upon modern life and the classical tradition of the nude. Inspired by the frescoes of Raphael and other Italian masters that he saw on a trip to Italy in 1881–82, Renoir devoted himself increasingly to the nude during the following years. Most often he placed his models in outdoor settings, such as beaches and secluded poolside glades. Seemingly observed unawares, these bathers bear similarities to those evoked by Renoir's friend Stéphane Mallarmé in his poems. Although they have been compared to the mythological nudes painted by his contemporary Puvis de Chavannes, Renoir's bathers embody neither Puvis's allegorical intentions nor his desire to re-create in a modern idiom the effects of Renaissance fresco painting.

The blond model who posed for this picture also appears in *In the Meadow* (pages 170–71) and *Two Young Girls at the Piano* (pages 174–75). Evidently Renoir painted her in his studio and then added the loosely brushed background from his imagination. For a closely related version of *Young Girl Bathing* executed at the same time, he used a different background representing seashore cliffs (Durand-Ruel Collection, Paris).

Robert Lehman Collection, 1975 1975.1.199

172

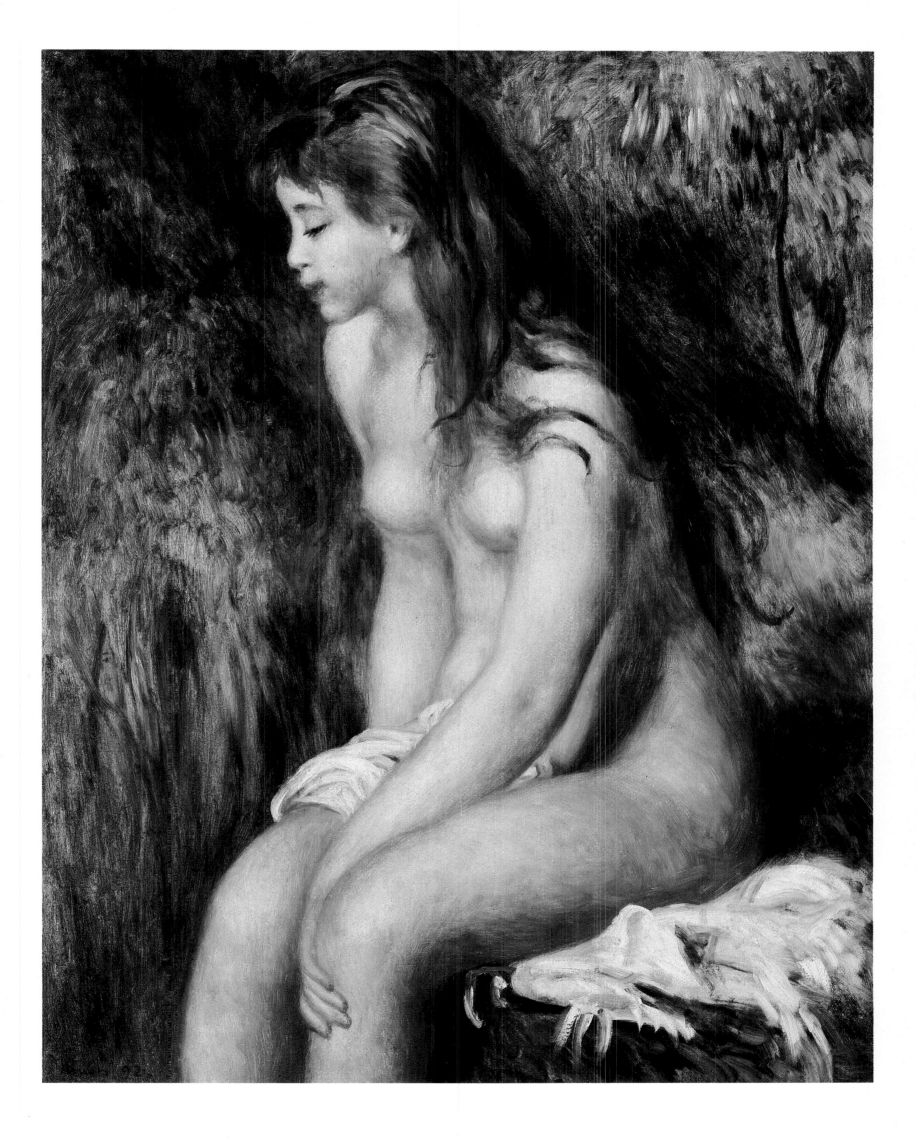

PIERRE AUGUSTE RENOIR

French, 1841–1919

Two Young Girls at the Piano

Oil on canvas, 44 x 34 inches
Signed and dated (lower left): Renoir. 92

RENOIR PAINTED SEVERAL versions of *Two Young Girls at the Piano,* and he used the models who had posed for *In the Meadow* (pages 170–71). The version believed to be the first (Louvre, Paris) was purchased immediately by the state for its museum of contemporary art in the Luxembourg Palace. In this picture he slightly altered the position of the standing model's left arm as well as the placement of the sheet music on the chair in the foreground. In addition, he changed the color of the curtains and placed a different vase on top of the piano. Three other variations exist in oil, one in pastel. Such related works, painted on commission from dealers and collectors and referred to as *répétitions,* should not be confused with the serial variations on single motifs that Monet and Pissarro executed. Their works were often exhibited as groups that were meant to be seen together; Renoir's variations on a single theme were not.

However, Renoir, too, realized that originality in art did not depend wholly upon the invention of compositions. As his son explained, "He told me one day that he regretted not having painted the same picture—he meant the same subject—all his life. In that way he would have been able to devote himself entirely to what constituted creation in his painting: the relation between form and color, which has infinite variation in a single motif, and which can better be grasped when there is no further need to concentrate on the motif."

Renoir treated the subject of a woman at a piano on several different occasions, beginning in 1875. Evidently the theme appealed to him, as it did also to James Whistler, Manet, Degas, Jacques Joseph Tissot, and Toulouse-Lautrec, all of whom were no doubt aware of contemporary investigations in creating through line and color the equivalents of musical harmonies.

Robert Lehman Collection, 1975 1975.1.201

174

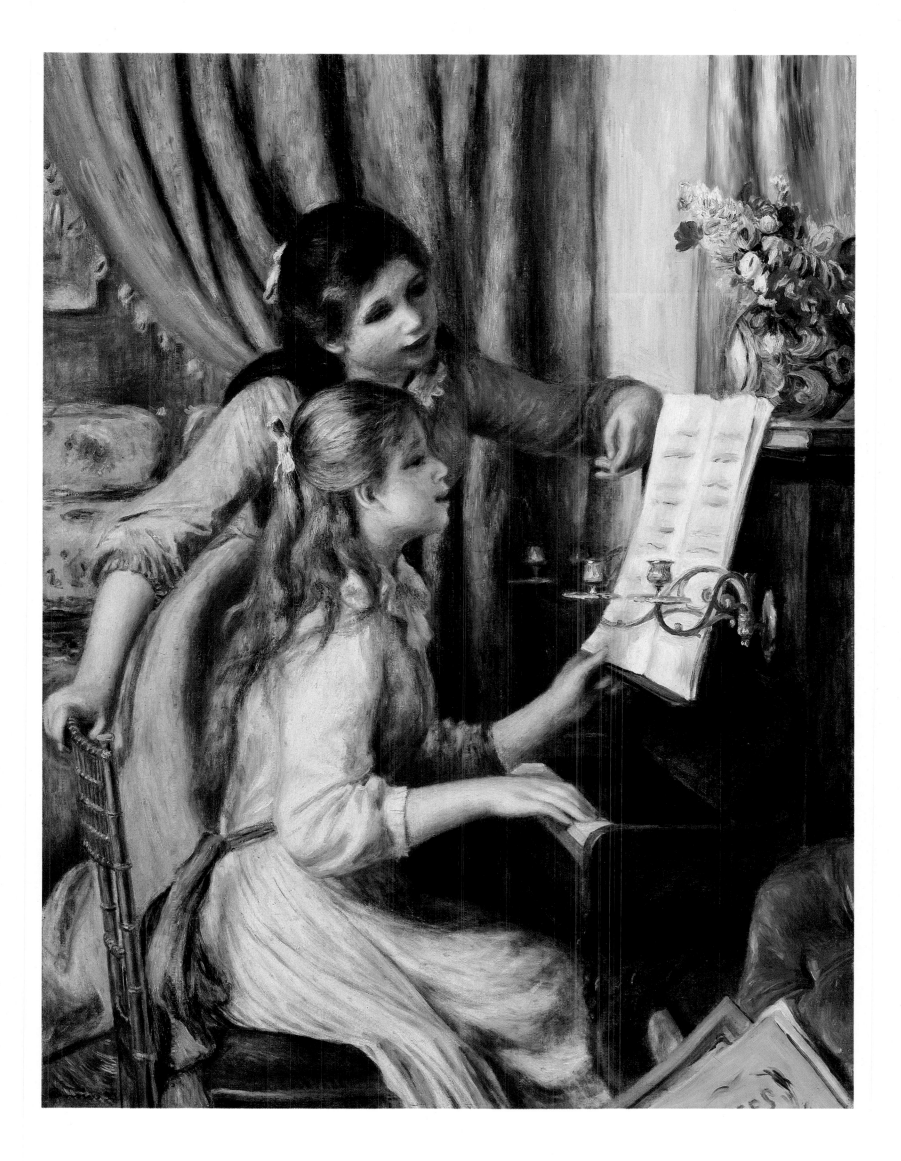

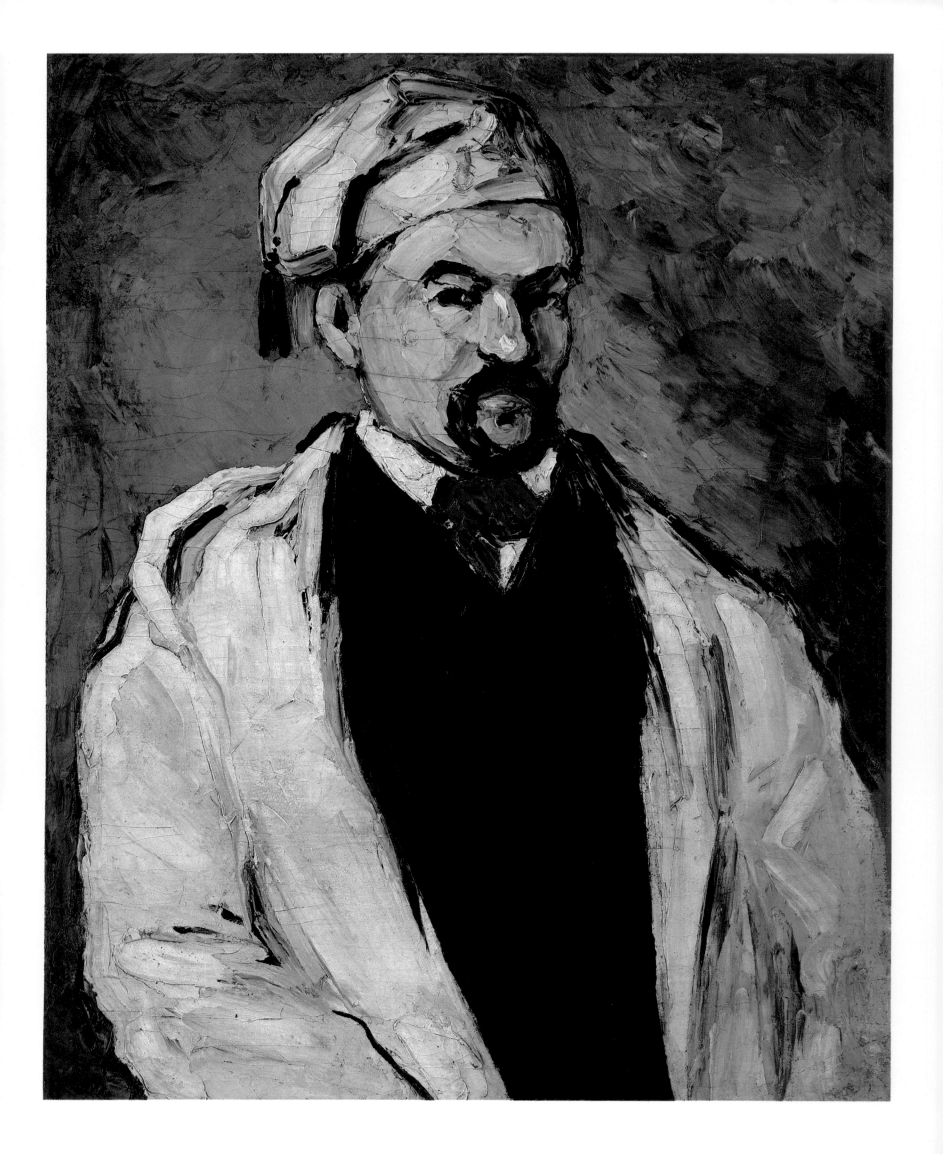

PAUL CEZANNE

French, 1829–1906

Dominique Aubert (Uncle Dominic)

Oil on canvas, 31 3/3 x 25 1/4 inches

DURING THE AUTUMN of 1866 Cézanne lived at his family's home, the Jas de Bouffan, near the town of Aix-en-Provence. Recently returned from Paris, where all the works he had submitted to the Salon that spring had been rejected, the twenty-seven-year-old artist seems to have become still more defiant of conventional standards of taste in art. *Couiliarde*—a coarse term that might be translated as vigorous or bold—is how he described his peculiar style, characterized by somber colors applied in thick impasto with a palette knife.

At the Jas de Bouffan Cézanne undertook a group of portraits for which friends and family members were enlisted to pose. His mother's younger brother Dominique Aubert sat for several, each completed in an afternoon. Because they were executed so quickly and with such thick paints, these pictures have all subse-

quently developed cracks. Aubert wears a variety of costumes in these portraits: a cowled monk's robe, a barrister's hat, a turban, and—in the Museum's picture—a soft tasseled cap presumably of the sort worn by local peasants. Whether Cézanne had collected the various hats over the years, or whether they belonged to his father (a hatmaker) or to the sitter is unknown. While Aubert sat in enforced stillness he was teased mercilessly by Cézanne's friend the painter Antoine Guillemet. We must be grateful for his patience, for from our perspective these portraits are among the most extraordinary pictures produced in the 1860s. More daringly than any of his colleagues, Cézanne discarded conventions of "finish" in these works that are virtually sculpted in paint.

Wolfe Fund, 1951, from the Museum of Modern Art, Lillie P. Bliss Collection
53.140.1

PAUL CEZANNE

French, 1839–1906

Bathers

Oil on canvas, 15 x 18⅛ inches

LIKE DEGAS AND RENOIR, Cézanne admired classical and Renaissance treatments of the nude and sought to continue that tradition in his own work. According to Maurice Denis, Cézanne once said that he had wanted to "do Poussin over again entirely from nature." However, since he worked slowly and was uncomfortable with female models, from the mid-1870s to the end of his life he concentrated on imaginary scenes in sylvan settings. In selecting the figures for these pictures, Cézanne, like Manet, often consulted works by old masters. Manet adapted the figures for modern settings, but Cézanne seldom indicated whether his bathers should be understood as subjects from modern life or classically inspired idylls similar in spirit to the decorative allegories of Puvis de Chavannes. In this painting, for example, only the roads parallel to the riverbanks—perhaps towpaths for barges—suggest that the figures may not be wood nymphs at ease beneath a Mediterranean sky.

This work of 1875–76 is one of Cézanne's first paintings of bathers. The parallel diagonal brushstrokes so evident here were later refined and became a key component of his style. The bold form that they take in this picture is typical of the artist's work in the mid-1870s. However, the bright, high-keyed palette was relatively short-lived, although the penchant for blue and green so prominent in this painting is characteristic of much of Cézanne's later work as well.

Bequest of Joan Whitney Payson, 1975 1976.201.12

PAUL CEZANNE

French, 1839–1906

Still Life

Oil on canvas, 23⅞ x 29 inches

CEZANNE'S STILL LIFES departed from tradition in two significant ways. Whereas most artists arranged and painted the objects in a still life as we might encounter them in our daily lives, Cézanne concentrated on the priorities of an artist's studio rather than on the utilitarian, symbolic, or material character of the objects depicted. As Meyer Schapiro has written, "Cézanne preserves a characteristic meditativeness and detachment from desire. His tendency coincides with what philosophers have defined as the aesthetic attitude in general: the experience of the qualities of things without regard to their use or cause or consequence." Furthermore, painters almost always used neutral backgrounds for still lifes, but in many works Cézanne introduced patterned backgrounds, such as wallpaper, suggesting that his own ideas about pictorial composition were related to the abstract principles of decorative art.

This is one of five still lifes and two figure paintings of about 1877 in which Cézanne used a variation of the wallpaper pattern seen here; it is one of twelve paintings in which he chose a wallpaper pattern with a geometric motif for the background. The suggestion of stability in the composition results entirely from Cézanne's manipulation of shapes and colors. The V-shape that results from the broken pattern, for example, is echoed in the drapery hanging over the front of the table. The lines of the V in the drapery continue and complete the lower part of a diamond composed of four sections of the wallpaper design. A pervasive geometric pattern can be sensed, and it evokes a delicate pictorial harmony among objects that might otherwise seem to be arranged with no underlying purpose.

Bequest of Mrs. H. O. Havemeyer, 1929
H. O. Havemeyer Collection

29.100.66

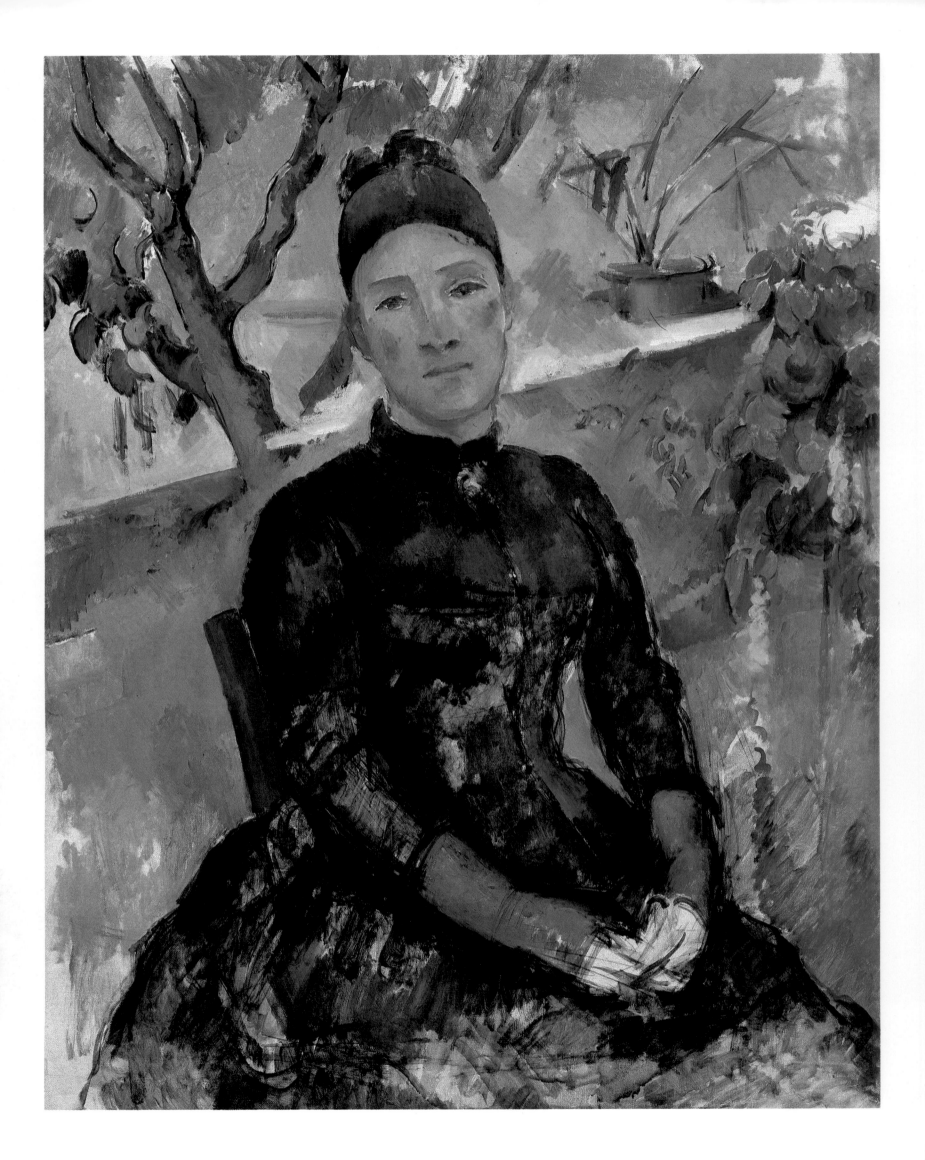

PAUL CEZANNE

French, 1839–1906

Madame Cézanne in the Conservatory

Oil on canvas, 36¼ x 28¾ inches

HORTENSE FIQUET MET Cézanne in Paris in the late 1860s and bore him a son in 1872, fourteen years before they married. She is said to have been a lively, talkative woman, although in Cézanne's numerous pictures of her she appears impassive. Judging from complaints by other sitters that Cézanne was a tyrant who forced his models to remain motionless during long sessions, often dozens of them, Hortense's expression probably indicates resignation to tedium.

This unfinished portrait, of 1891, offers a clue to Cézanne's working methods at that time. After indicating the contours of objects, he put down broad areas of a single tone with relatively diluted, transparent paint and then applied increasingly opaque colors. Though he may have developed color relationships as he proceeded, Cézanne had determined this picture's compositional interrelationships at the outset. The diagonals of the garden wall and the fruit tree, for example, cradle the tilted oval of the head and integrate the figure with the background.

Bequest of Stephen C. Clark, 1960

61.101.2

PAUL CEZANNE

French, 1835–1906

Still Life:
Apples and a Pot of Primroses

Oil on canvas, 28¾ x 36⅜ inches

MONET, AN ARDENT gardener, once owned this painting of fruit and a pot of Chinese primroses. In 1925 he lent it to an exhibition at the Musée des Arts Décoratifs, Paris. At that time it was said to have been painted in 1886. It has also been dated as early as 1880 and as late as 1894. Controversy about the date results in part from what has been called the "quiet, almost static quality" of the painting. The pattern of leaves against the background is unusual in Cézanne's work, as is the highly finished surface. But, with the exception of the primrose, the objects in the picture appear frequently in the artist's still lifes: the scalloped table, the cloth pinched up in sculptural folds, and the apples nestled in isolated groups. When Cézanne visited Monet at Giverny in 1894, he met the critic Gustave Geffroy, to whom he explained in reference to his still lifes that he wanted to astonish Paris with an apple. He never did so during his lifetime, for his works were always considered unacceptable by Salon juries.

Bequest of Sam A. Lewisohn, 1951

51.112.1

PAUL CEZANNE

French, 1839–1906

Near the Pool at the Jas de Bouffan

Oil on canvas, 25 ½ x 31 ⅞ inches

IN 1859 CEZANNE's father bought the Jas de Bouffan ("Abode of the Winds"), an estate that included an eighteenth-century house, a landscaped park, and several acres of farmland. Cézanne regarded it as his home until 1899, when it had to be sold after his mother's death.

During the late 1880s Cézanne painted several pictures of a road on the estate that was bordered with evenly spaced chestnut trees. Visible at the right in this picture, it led from the back of the house to the gardens. Near the railing dividing the two areas was a collecting pool and a washing trough, the low stone structures behind the trees. The pool was flanked with waterspout sculptures of lions, one of which is shown here from behind.

61.101.5

186

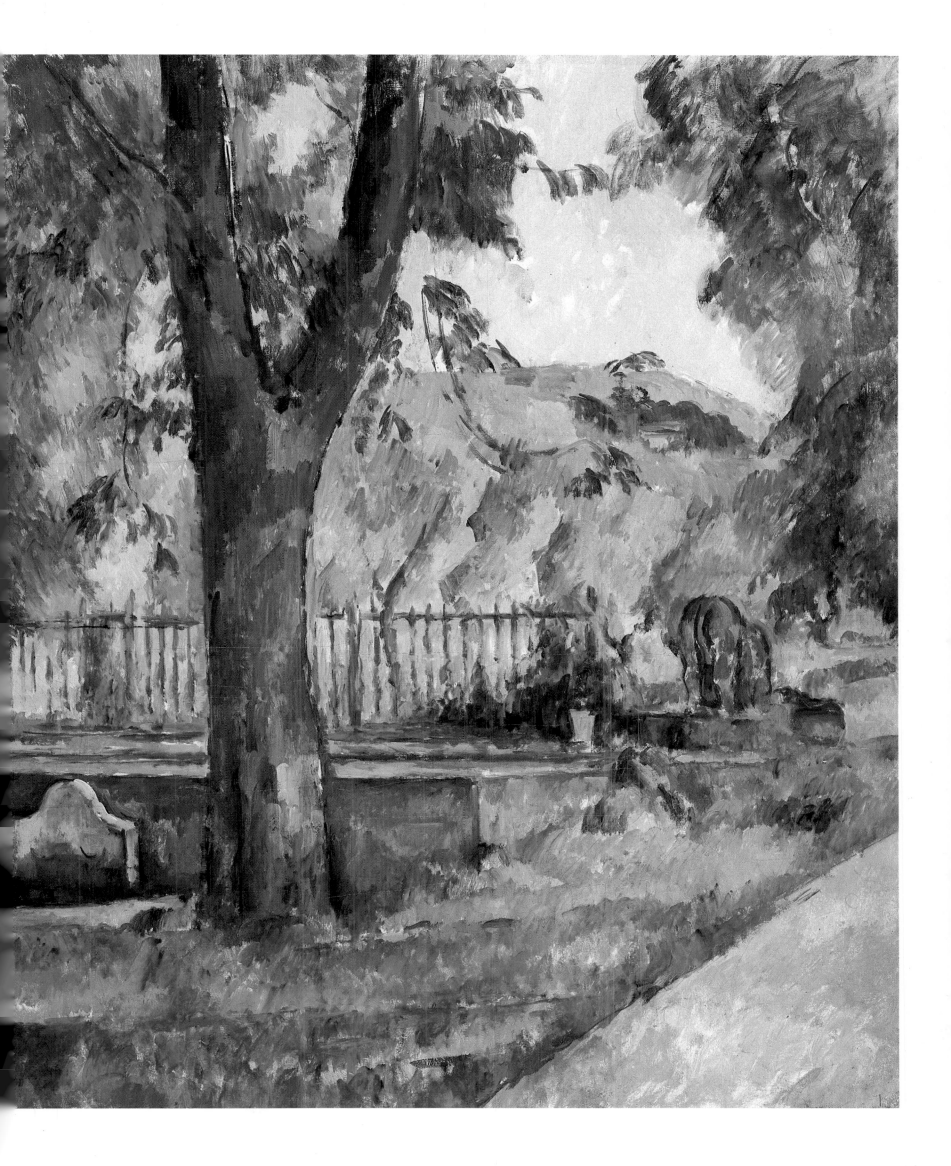

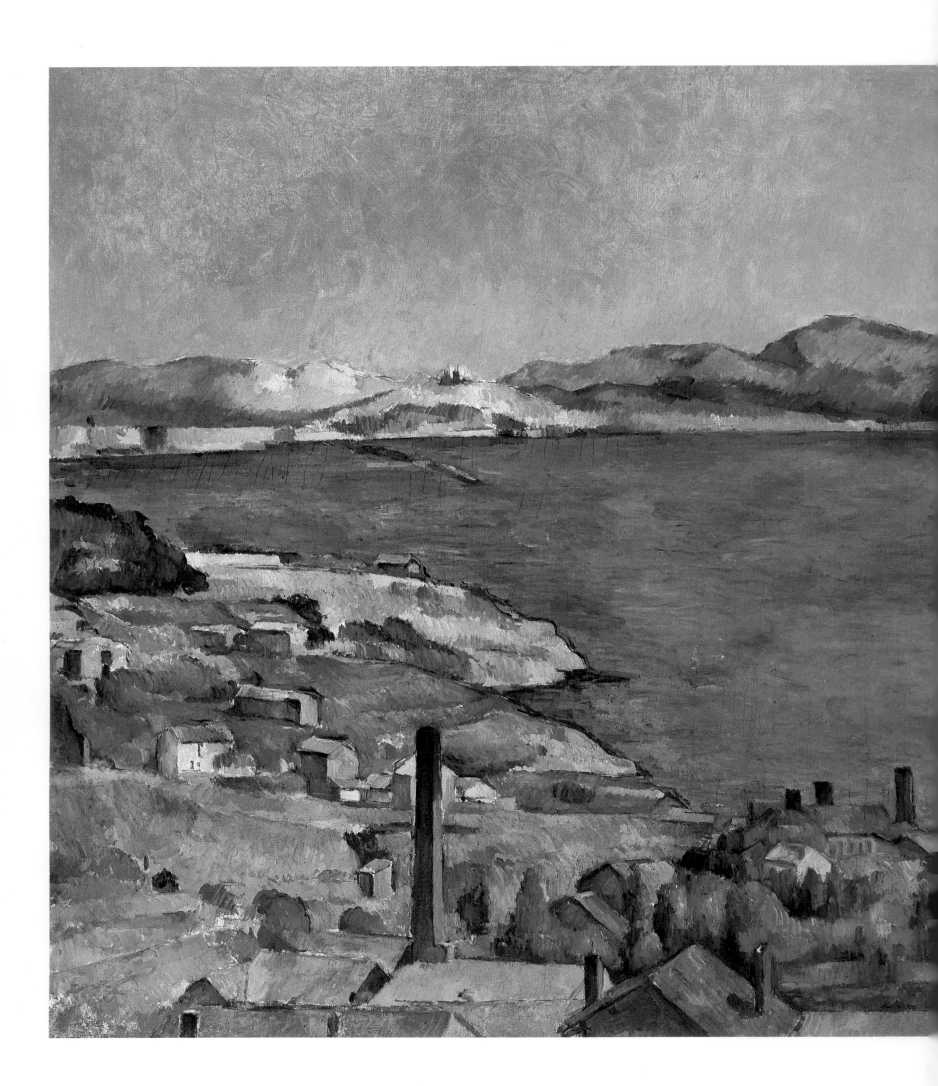

PAUL CEZANNE
French, 1839–1906

The Gulf of Marseilles Seen from L'Estaque

Oil on canvas, 28¾ x 39½ inches

DISENCHANTED WITH the competitive atmosphere of the Parisian art world, Cézanne preferred to work in his native Provence, where several carefully selected landscape motifs engaged his attention. One was a panoramic view from the town of L'Estaque toward a low range of mountains across the Gulf of Marseilles. In the summer of 1876 he described his fascination with this view in a letter to Pissarro: "It's like a playing card. Red roofs over the blue sea. . . . The sun is so terrific here that it seems to me as if the objects were silhouetted not only in black and white, but in blue, red, brown and violet. I may be mistaken, but this seems to me to be the opposite of modeling."

In the early 1880s Cézanne returned to L'Estaque and executed more than a dozen closely related pictures of the view. Pissarro and Monet independently adopted similar working methods. Their primary purpose, however, was to record transient effects of light, whereas Cézanne was interested in the variations in composition that resulted when he changed his vantage point or slightly shifted his angle of vision. This picture is the most complex of three paintings made from the same position. (The other two are in the Louvre, Paris, and the Art Institute of Chicago.) In all three Cézanne contrasted the closely packed geometric forms of reddish buildings in the foreground with the more scattered and irregularly shaped mountains that appear blue in the distance. The composition is intriguing, for from the elevated position scale is distorted, and the nearby buildings seem comparable to the mountains in size.

Bequest of Mrs. H. O. Havemeyer, 1929 29.100.67
H. O. Havemeyer Collection

PAUL CEZANNE

French, 1839–1906

Gardanne

Oil on canvas, 31 ½ x 25 ¼ inches

CEZANNE PAINTED IN Gardanne, a hill town near Aix-en-Provence, during the autumn of 1885 and throughout most of the next year. Many of his compositions of this period, and particularly the views of Gardanne, develop outward from the center, becoming less dense toward the edge of the canvas; in his works of the late 1880s, on the other hand, a formal balance is sustained over the entire field of vision. A similar development is observable in the Analytic Cubist paintings of Braque and Picasso. Indeed, Cézanne's tendencies to interpret form through facet and to restrict his palette underscore the importance of such works as *Gardanne* as forerunners of Cubism.

Cézanne painted two other views of Gardanne: a horizontal picture (Barnes Foundation, Merion, Pennsylvania), observed from a closer point of vantage; and a vertical picture (Brooklyn Museum), depicting the hill town from the opposite direction.

Gift of Dr. and Mrs. Franz H. Hirschland, 1957 57.181

PAUL CEZANNE

French, 1839–1906

Mont Sainte-Victoire

Oil on canvas, 25¾ x 32⅛ inches

DURING A JOURNEY to Marseilles in the spring of 1878, Cézanne noticed "a stunning motif... Ste Victoire and the rocks that dominate Beaurecueil," but not until the late 1880s did he address the subject. Four pictures, including this one, were painted from a hill at Bellevue, where Cézanne's brother-in-law Maxime Conil had an estate that overlooked the Arc River valley, with Mont Sainte-Victoire in the background. In these works Cézanne studied the distant mountain's silhouette in its relationship to his immediate surroundings—in particular, to a group of pines. Their tall, thin trunks and vivid green crowns serve as foils to the indistinct mass of the mountain.

During the next decade Mont Sainte-Victoire became Cézanne's favorite landscape motif, but in later pictures he virtually eliminated contrasts between foreground and background, stressing instead the mountain's dominance over the surrounding countryside.

Bequest of Mrs. H. O. Havemeyer, 1929 29.100.64
H. O. Havemeyer Collection

192

PAUL CEZANNE

French, 1839–1906

Madame Cézanne in a Red Dress

Oil on canvas, 45⅞ x 35¼ inches

THIS IS ONE OF twenty-seven portraits by Cézanne of his wife, Hortense Fiquet. It was painted about 1890 in the artist's house on the Quai d'Anjou, Paris. Cézanne's paintings of his wife are compositional studies based on the figure rather than portraits in the conventional sense. In this work she does not sit comfortably in her chair but tilts to the right, echoing the axis of the fire tongs on the left and the curtain on the right. The left side of the chair back bows slightly as if responding to the curve of her right arm, and the pattern of the upholstery merges almost imperceptibly with the fabric of her dress. Moreover, the flower that she holds in her hand seems neither more nor less real than those in the curtain at the right side of the painting. The reflection of a similar curtain is visible in the rectangular shape on the wall that we might not otherwise recognize as a mirror. The displaced image in the mirror is in keeping with the spatial dislocations evident in the artist's interpretation of the scene as a whole. For example, the molding behind the chair and the adjacent mantelpiece are drawn from different vantage points, combining two disparate perspective systems, and the molding itself is aligned slightly differently on either side of the chair. Even the two sides of Madame Cézanne's face, especially her eyes, are treated differently. Meyer Schapiro's description of Cézanne's *Portrait of Gustave Geffroy* (René Lecomte Collection, Paris) seems pertinent in this context: "The painting is a rare union of the realistic vision of a piece of space, seen directly in all its accidents of richness of detail, with a powerful, probing, rigorous effort to adjust all that is seen in a coherent balanced structure with its own vitality and attraction. The whole looks intensely contrived and intensely natural. We pass often from the artifice of composed forms to the chaos of a crowded room, and from the latter we are soon brought back to the imposing order invented by the artist; the oscillation is permanent."

The Mr. and Mrs. Henry Ittleson, Jr. Purchase Fund, 1962 62.45

194

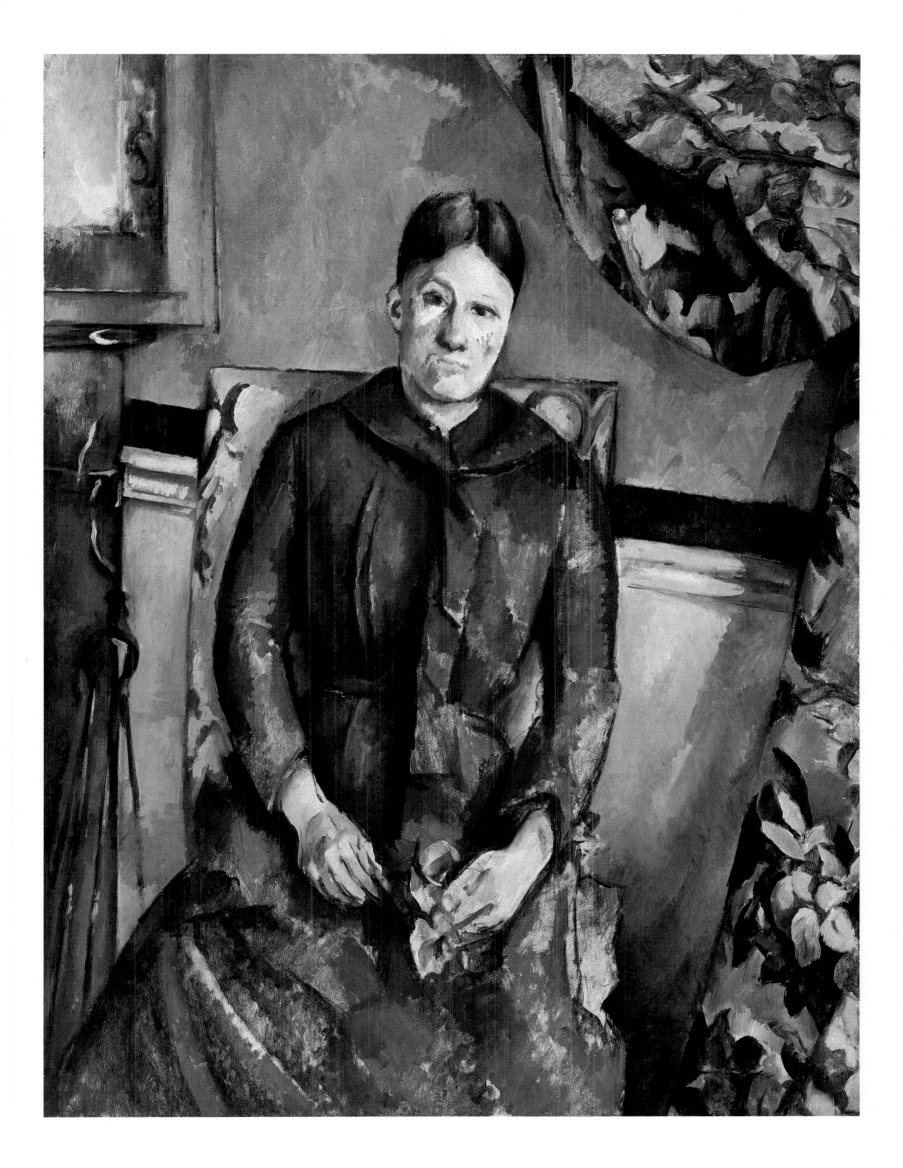

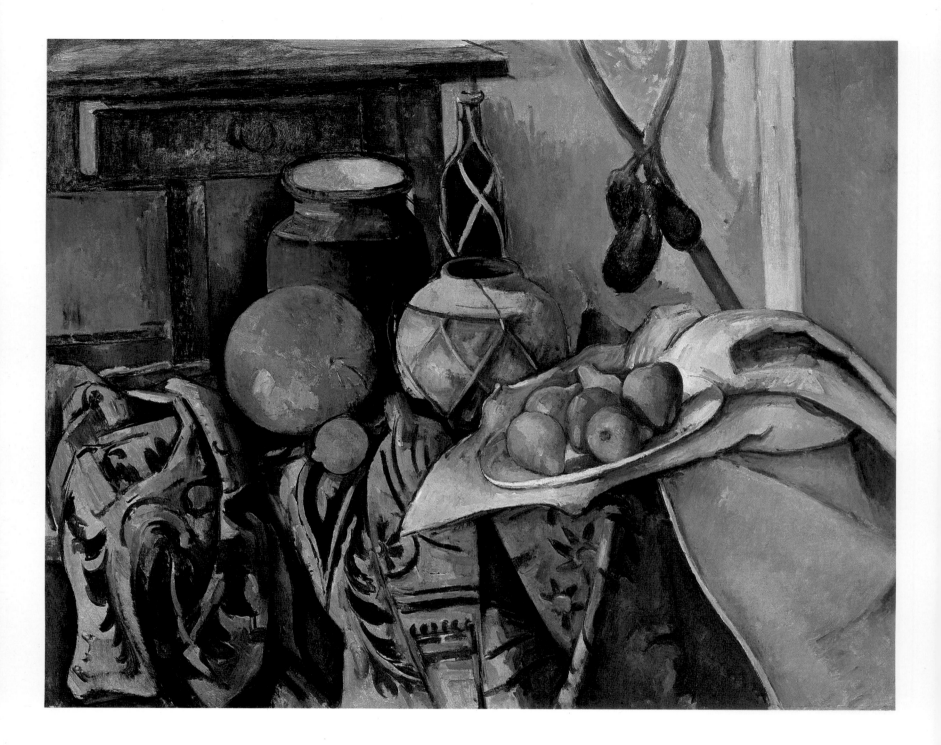

196

PAUL CEZANNE

French, 1835–1906

Still Life with a Ginger Jar and Eggplants

Oil on canvas, 28½ x 36 inches

ABOUT 1890 CEZANNE added several objects to the repertory of items that he kept in his studio to use in still lifes. The new objects included the heavy blue curtain decorated in a bold abstract floral pattern, the dark wine bottle with raffia lacing, and the round ginger jar, also bound in raffia, that appear in this painting. These were combined with such things as the green crockery jar and the table, visible in a number of earlier works.

The ginger jar appears in four paintings executed between 1890 and 1894. The compositions of these and Cézanne's other still lifes of the early 1890s are more elaborate than those of earlier pictures. Almost every shape and contour in this work is interrupted by another that overlaps it. The pattern of the fabric is itself broken by folds and creases that result in new shapes and rhythms as integral to the composition as those created by the disposition of the three-dimensional objects. Indeed, the composition is predicated upon pictorial needs rather than the demands of ordinary logic and vision. Even the artist's vantage point changes to suit the picture: the height of the table in the background indicates that the arrangement is set very close to the floor, but the objects in the foreground do not seem to be observed from an unusually high vantage point. As Meyer Schapiro has noted, the origins of abstract art lie in such works: 'Freely and subtly introduced . . . parallel lines, connectives, contacts, and breaks which help to unite in a common pattern elements that represent things lying in the different planes of depth. . . . These devices are the starting point of later abstract art, which proceeds from the constructive function of Cézanne's stroke, more than from his color.'

PAUL CEZANNE

French, 1839–1906

The Cardplayers

Oil on canvas, 25¾ x 32¼ inches

THE MAJORITY OF Cézanne's works are either land-scapes, still lifes, or portraits. In 1890, however, he undertook this ambitious genre scene of peasants play-ing cards, possibly in emulation of Mathieu Le Nain, whose painting of the same subject was on view in the museum at Aix. The subject continued to engross Cézanne, and during the next years he painted five versions of the scene, as well as numerous oil studies and drawings for individual figures.

On stylistic grounds, the largest picture (Barnes Foundation, Merion, Pennsylvania) is thought to be the earliest, the Museum's painting the next. As he pared away extraneous details in each successive version, Cézanne's psychological characterization of the event became more penetrating. In the last three (Courtauld Institute, London; Louvre, Paris; private collection, Stockholm) Cézanne dispensed with everything except the figures of two players starkly confronting one another across the table.

From the beginning, Cézanne emphasized the som-ber concentration of the participants. Expression and even personality have been suppressed by their interest in the cards. The pyramidal forms of the players can be compared to the apples turned in different directions in Cézanne's tabletop still lifes. Yet their bulk and weight suggest the seriousness of the game, the mute suspense of which intrigues the slimmer standing figure, whose intense scrutiny must have mirrored Cézanne's own as he analyzed the scene before him from his easel.

Bequest of Stephen C. Clark, 1960 61.101.1

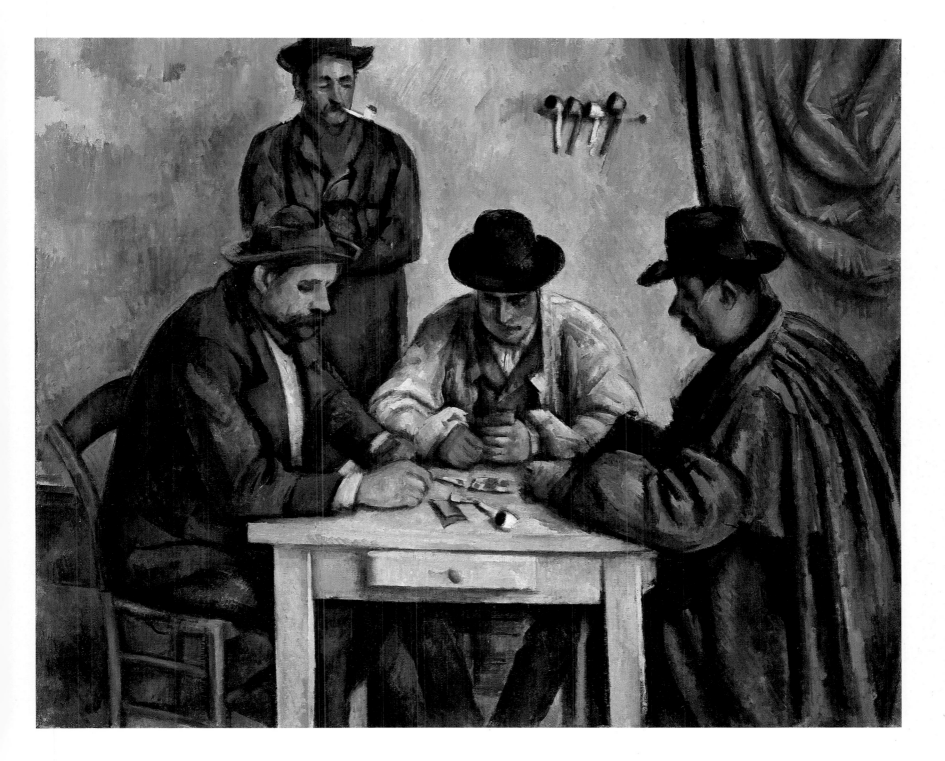

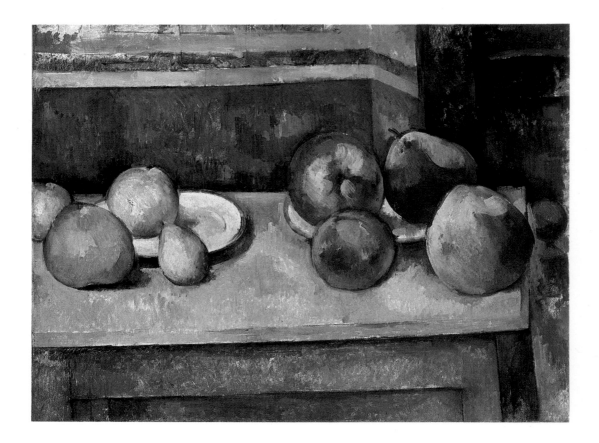

PAUL CEZANNE

French, 1839–1906

Still Life: Apples and Pears

Oil on canvas, 17⅝ x 23⅛ inches

IN CEZANNE'S STILL LIFES mundane objects are the starting point for complex meditations about mass and space. Traces of a previous pictorial idea visible at far right suggest that this picture of 1885–87 was never entirely resolved. Nevertheless it exemplifies the artist's analytical approach to representation. Rejecting the limitations of one-point perspective, Cézanne shifted his point of view from side to side. He observed the table at eye level from the front and again from slightly to the right, but he viewed the tabletop from slightly above.

These shifts in perspective with regard to the table are comparable to the varied spatial orientations of the pieces of fruit resting on it. Tilted this way and that, the pears as a group offer the multiple points of view usually associated with three-dimensional volumes experienced in the round, like sculpture. Sculptural mass is further suggested by the relationship between the table and the corner of the room seen behind. The banded wall that changes direction echoes the shape of the table like a cast shadow, suggesting a counterpoint of solid and void, light and dark, straight and askew. Every object seems to twist, as if to break loose from the flat surface. This twisting draws attention to the crux of Cézanne's art, the relationship between three-dimensional reality and two-dimensional representation.

Bequest of Stephen C. Clark, 1960

61.101.3

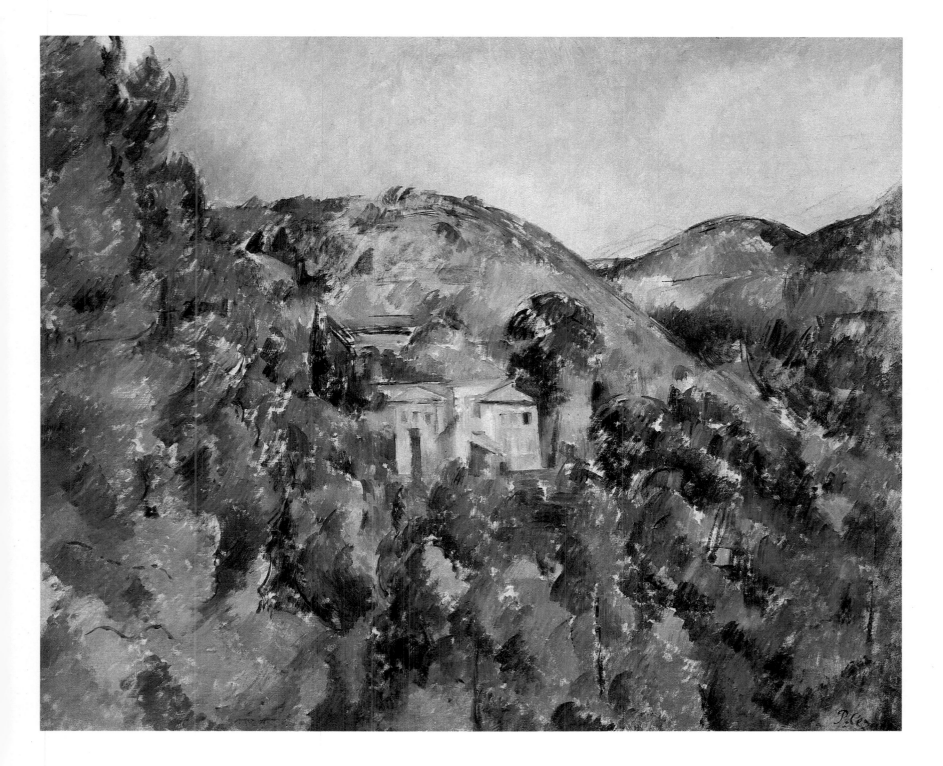

View of the Domaine Saint-Joseph

Oil on canvas, 25⅝ x 32 inches
Signed (lower right): P. Cézanne

DESPITE THE MANY areas of canvas left bare, this landscape is one of the few paintings that Cézanne signed and thereby certified as "finished." It was the first of his works to enter an American museum; the Metropolitan acquired it from the historic Armory Show in 1913. Its price was higher than that of any other work included in the exhibition.

Painted in 1887, according to the testimony of Cézanne's son, the picture is a view of an estate owned by the Jesuits until 1901, when they were expelled by the state. The property was situated on a hill known locally as the Colline des Pauvres, on the road between Aix-en-Provence and the village of Le Tholonet. Cézanne found many of his favorite landscape motifs, including the Château Noir, along this same road.

Wolfe Fund, 1913
Catharine Lorillard Wolfe Collection

13.66

PAUL CEZANNE

French, 1839–1906

Rocks in the Forest

Oil on canvas, 28⅞ x 36⅜ inches

WHEN LIONELLO VENTURI catalogued Cézanne's works in 1936, he called this painting simply *Rocks,* and speculated that it might have been painted in the forest of Fontainebleau, a mecca for landscape artists since the 1830s. It has subsequently been suggested that the picture was painted near Aix, but scholars who have combed the countryside there have failed to identify this motif. The thinly applied layers of paint that give this picture a lustrous fullness are typical of Cézanne in the mid-1890s, when he applied certain watercolor techniques to his oils. He is known to have made working trips to Fontainebleau at this time, as he had since the late 1870s and as he would continue to do until 1904. Yet two oils, both early, are apparently all that has survived from these campaigns, except possibly *Rocks in the Forest.*

Meyer Schapiro, who described this as a "somber passionate painting...saturated by the catastrophic mood," also compared it to an extraordinary passage in Flaubert's novel of 1848, *L'Education sentimentale:* "The light...subdued in the foreground planes as if at sundown, cast in the distance violet vapors, a white luminosity....The rocks filled the entire landscape,... cubic like houses, flat like slabs of cut stone, supporting each other, overhanging in confusion, like the unrecognizable and monstrous ruins of some vanished city. But the fury of their chaos makes one think rather of volcanos, deluges and great forgotten cataclysms." Flaubert's scene is set in the forest of Fontainebleau; the mood is that of Cézanne's haunting landscape.

Bequest of Mrs. H. O. Havemeyer, 1929 29.100.194
H. O. Havemeyer Collection

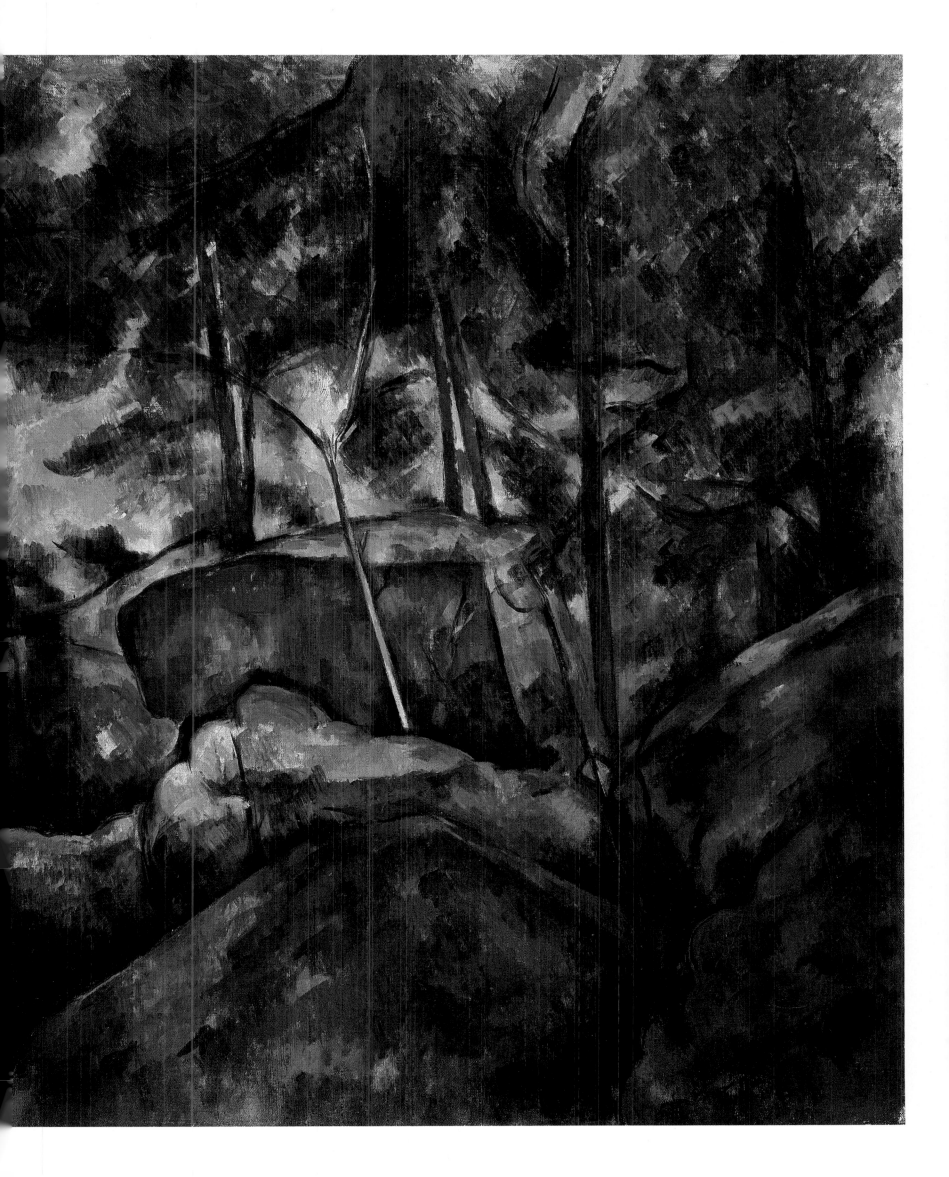

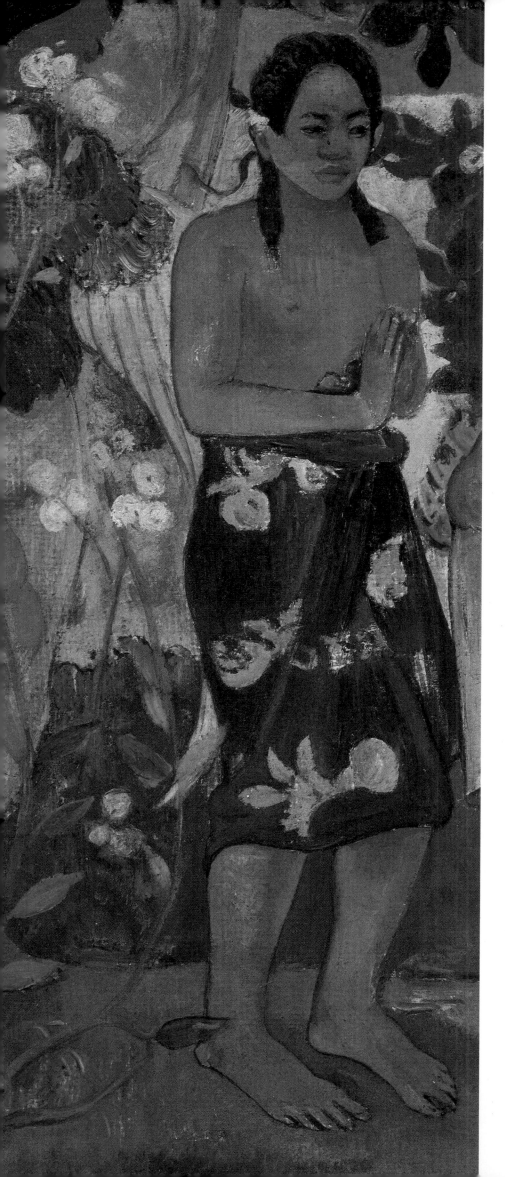

PAUL GAUGUIN

French, 1848–1903

Ia Orana Maria

Oil on canvas, 44¾ x 34½ inches
Signed and dated (lower right): P Gauguin 91
Inscribed (lower left): IA ORANA MARIA

A SAILOR BETWEEN the ages of seventeen and twenty, Gauguin began a successful career as a stockbroker in 1872. During the next eleven years he was also an enthusiastic amateur painter. Although one of his pictures was accepted by the Salon jury in 1876, he did not devote himself entirely to art until 1883. In 1887 Gauguin visited Panama and Martinique, his first trip to the tropics since his youth, and in 1891 he made his first trip to Tahiti in search of an unspoiled paradise, a kind of Polynesian Garden of Eden.

Ia Orana Maria is the most important picture that Gauguin painted during his first trip to the South Pacific, from 1891 to 1893. The title is native dialect that translates, "I hail thee, Mary," the angel Gabriel's first words to the Virgin Mary at the Annunciation. In a letter written in the spring of 1892, Gauguin described the painting to his friend Daniel de Monfreid: "An angel with yellow wings who points out to two Tahitian women the figures of Mary and Jesus, also Tahitians. Nudes dressed in pareus, a kind of flowered cotton which is wrapped as one likes around the waist. In the background somber mountains and blooming trees. A dark purple road and an emerald green foreground. To the left some bananas. I am rather pleased with it."

The religious symbolism of *Ia Orana Maria* is linked to that of Gauguin's earlier Breton canvases, in which he used the vernacular art and customs of Brittany to express Christian themes. Here, the only elements that he has taken from traditional representations of the Annunciation are the angel, the salutation, and the halos around the heads of the Mother and Child. Everything else in the picture is rendered in Tahitian idiom, except the composition, which Gauguin adapted from a bas-relief in the Javanese temple of Barabudur. He had a photograph of the bas-relief with him in Tahiti.

Bequest of Sam A. Lewisohn, 1951 51.112.2

204

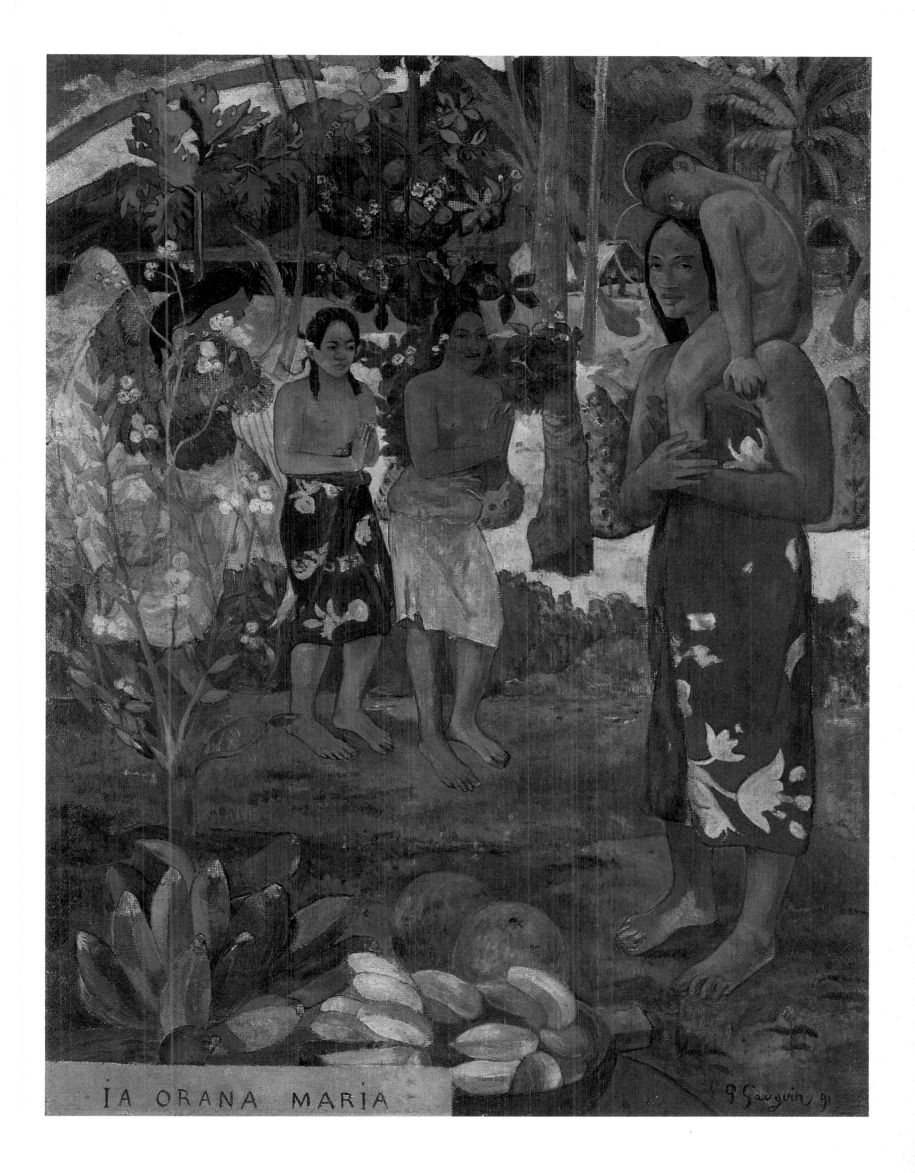

IA ORANA MARIA P Gauguin 91

VINCENT VAN GOGH

Dutch, 1853–1890

The Potato Peeler

Oil on canvas, 16 x 12½ inches

THE POTATO PEELER, painted in February–March 1885, is typical of the work that culminated in van Gogh's first important painting, *The Potato Eaters,* finished in September–October 1885 (Rijksmuseum Vincent van Gogh, Amsterdam). Although the image in the Metropolitan's picture is not directly related to any of the figures in the final version of *The Potato Eaters,* it resembles the figure at the extreme right of the first sketch, made in February–March 1885 (Rijksmuseum Vincent van Gogh, Amsterdam).

The blockiness and apparent crudeness of the figure reflect a goal that van Gogh had been striving to achieve since 1883: "The figure essentially simplified with intentional neglect of those details which do not belong to the real character and are only accidental." His remarks made in April 1885 about his progress on *The Potato Eaters* are equally applicable to *The Potato Peeler:* "All winter long I have had the threads of this tissue in my hands, and I have searched for the ultimate pattern; and though it has become a tissue of rough, coarse aspect, nevertheless the threads have been chosen carefully and according to certain rules. And it might prove to be a real *peasant picture. I know it is.* But he who prefers to see the peasants in their Sunday best may do as he likes. I personally am convinced that I get better results by painting them in their roughness than by giving them a conventional charm."

Bequest of Miss Adelaide Milton de Groot (1876–1967), 1967 67.187.70b

Self-Portrait with a Straw Hat

Oil on canvas, 16 x 12½ inches

SELF-PORTRAIT WITH A STRAW HAT was probably painted toward the end of van Gogh's two-year stay in Paris, from March 1886 to February 1888, not long before he departed to live and work in the Provençal city of Arles. The palette and directional brushstrokes are evidence of the influence of Divisionism, especially as represented by the work of Seurat and Signac. Nevertheless, van Gogh has clearly mastered the Neo-Impressionist current in his painting. This self-portrait reflects the bold temperament of the individual who in December 1885 wrote to his brother, "I prefer painting people's eyes to cathedrals, for there is something in the eyes that is not in the cathedral, however solemn and imposing the latter may be—a human soul, be it that of a poor streetwalker, is more interesting to me." Further insight into the remarkable vitality of *Self-Portrait with a Straw Hat* is provided by van Gogh's comment in August 1888, "It is true that at moments, when I am in a good mood, I think that what is alive in art, and eternally alive, is in the first place the painter and in the second place the picture."

Bequest of Miss Adelaide Milton de Groot (1876–1967), 1967 67.187.70a

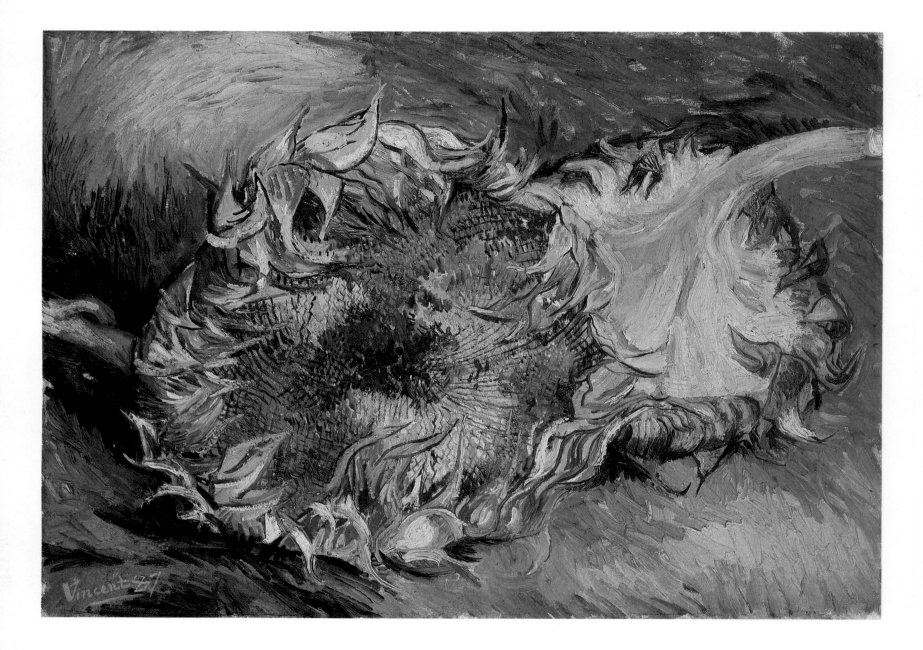

VINCENT VAN GOGH

Dutch, 1853–1890

Sunflowers

Oil on canvas, 17 x 24 inches
Signed and dated (lower left): Vincent 87

THIS IS ONE OF three paintings of sunflowers that van Gogh made in Paris late in the summer of 1887. The Museum's version and the one in the Kunstmuseum, Bern, Switzerland, depict two sunflowers; the example in the Rijksmuseum Kröller-Müller, Otterlo, the Netherlands, shows four. All are horizontal in format and are signed and dated 1887. In addition, there is a sketch for the Museum's painting in the Rijksmuseum Vincent van Gogh, Amsterdam. Van Gogh's fascination with sunflowers culminated in 1888 with the series Sunflowers, which he painted to decorate his studio in Arles.

By late in the summer of 1887, van Gogh's incipient pantheism had begun to manifest itself in a preference for natural forms that suggest an underlying universal force. The flamelike petals and the patterned faces of sunflowers attracted him for the same reasons that undulating cypresses and olive trees were to appeal to him two years later in Saint-Rémy. He had already started to seek in nature the easily exaggerated forms that fulfilled his growing need for an expressive pictorial vocabulary.

Rogers Fund, 1949 49.41

Vincent '87

VINCENT VAN GOGH
Dutch, 1853–1890

Oleanders

Oil on canvas, 23³/₄ x 29 inches
Inscribed (lower left, on cover of book):
EMILE ZOLA / LA joie de / VIVRE; (lower left,
on spine of book): La joie de / vivre / Emile / Zola

AFTER HIS ARRIVAL in Arles in February 1888, van Gogh increasingly favored subjects that are inherently expressive, such as oleanders, sunflowers (pages 210–11), cypresses (pages 216–17), images of cultivation, and the star-filled evening sky. In this work of August–September 1888, the artist placed Emile Zola's novel *La Joie de vivre* on the table in front of the flowers and thereby provided a key to the metaphorical significance, or what he called the "symbolic language," of the subject. In a letter to his brother written during the last week of September 1888, he elaborated on the meaning that the oleanders held for him: "...raving mad; the blasted things are flowering so riotously that they will catch locomotor ataxia. They are loaded with fresh flowers, and quantities of faded flowers as well, and their green is continually renewing itself in fresh, strong shoots, apparently inexhaustibly." Van Gogh saw the oleander as a symbol of fervent generation and regeneration, the driving procreative forces of the cycle of life. Images with similar associations attracted him throughout his career, but especially during his Arles, Saint-Rémy, and Auvers periods (February 1888–July 1890). Van Gogh's visionary pantheism permitted him, like William Blake, "To see the world in a grain of sand/And a heaven in a wild flower."

Gift of Mr. and Mrs. John L. Loeb, 1962 62.24

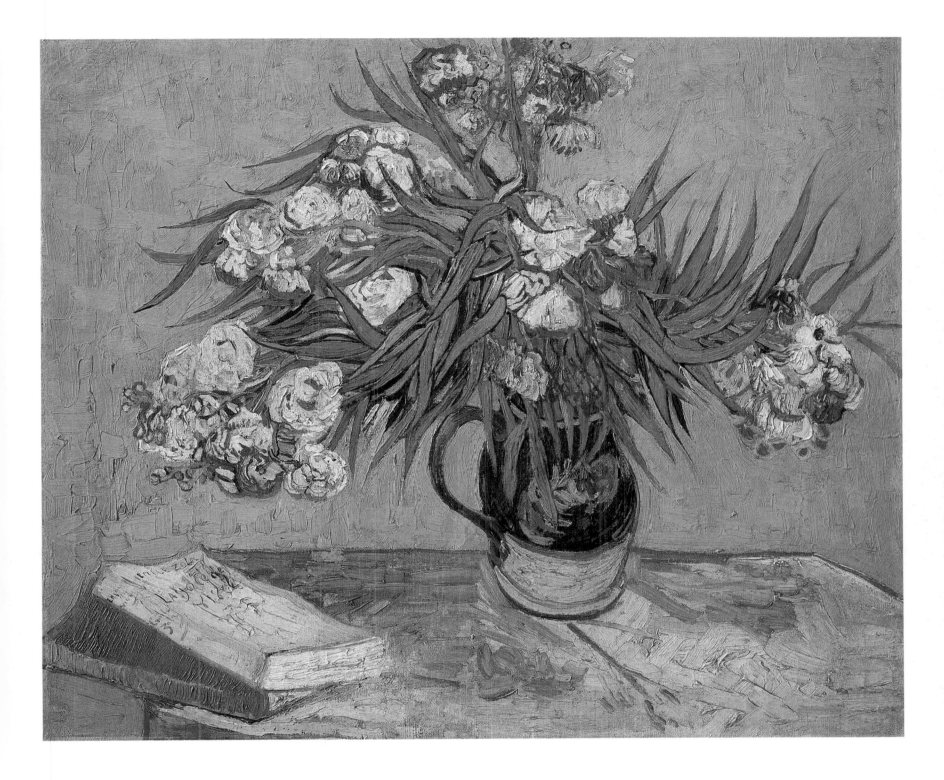

VINCENT VAN GOGH

Dutch, 1853–1890

L'Arlésienne: Madame Joseph-Michel Ginoux (Marie Julien)

Oil on canvas, 36 x 29 inches

THIS IS ONE OF the most beautiful portraits that van Gogh painted during the fourteen months (February 1888 to May 1889) he spent in Arles. It was executed with exceptional speed, as the artist reported to his brother in a letter written during the week of November 11, 1888: "I have an Arlésienne at last, a figure (size 30 canvas) slashed on in an hour, background pale citron, the face gray, the clothes black, black, black, with perfectly raw Prussian blue. She is leaning on a green table, seated in an armchair of orange wood."

L'Arlésienne was painted during the two-month period that Gauguin spent with van Gogh in Arles, from late October through late December 1888. The two artists reportedly cajoled the reluctant *patronne* of the Café de la Gare into posing by inviting her to have coffee with them. While van Gogh painted and Gauguin drew, the latter is said to have mollified the sitter by constantly repeating, "Madame Ginoux, Madame Ginoux, your portrait will be placed in the Louvre in Paris." Coincidentally, another version—apparently a variant of this portrait—was given to the Louvre in 1944.

The large areas of a single color and the bold contours of the figure reflect the influence of Japanese prints and medieval cloisonné enamel technique. Van Gogh's highly abstract use of line and color was undoubtedly approved of by Gauguin, who, with their mutual friend Emile Bernard, advocated such syntheses of form and color, in contrast to the empiricism of Impressionism.

Bequest of Sam A. Lewisohn, 1951 51.112.3

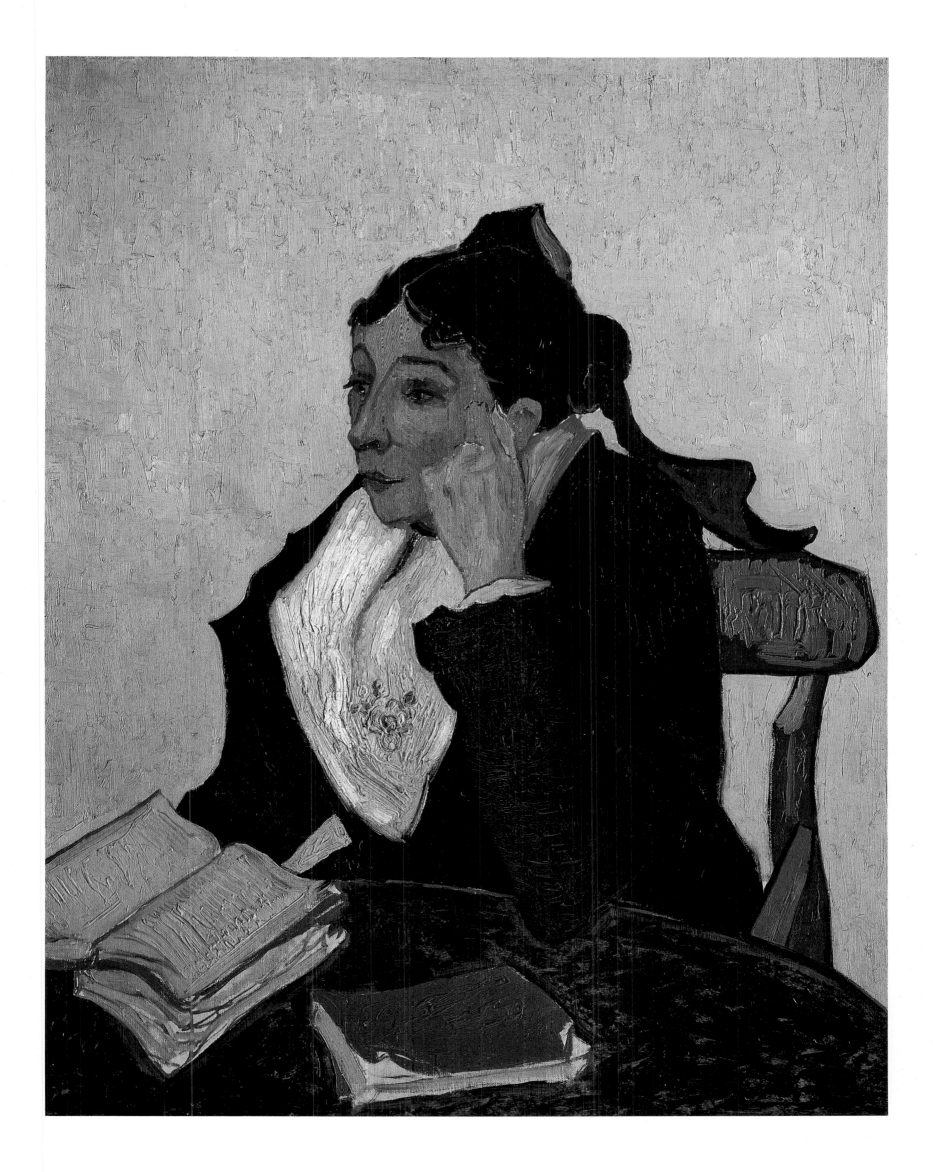

VINCENT VAN GOGH

Dutch, 1853–1890

Cypresses

Oil on canvas, 36¾ x 29⅛ inches

VAN GOGH PAINTED *Cypresses* in June 1889, not long after the beginning of his year-long voluntary confinement at the Asylum of Saint Paul in Saint-Rémy. On June 25 the artist wrote to his brother and reported that he was working on two paintings of cypresses. He included a cursory drawing of the Museum's painting in his text and remarked, "I think that of the two canvases of cypresses, the one that I am making this sketch of will be the best." The cypress represented a kind of perfect natural architecture in van Gogh's canon of pantheism: "It is as beautiful of line and proportion as an Egyptian obelisk." Olive trees and cypresses embodied what van Gogh called "symbolic language," though he never explained exactly what he meant. We only know that he related the trees to sunflowers, which he once said symbolized gratitude: "The cypresses are always occupying my thoughts, I should like to make something of them like the canvases of sunflowers" (June 25, 1889); and, "When I had done the sunflowers, I looked for the contrast.and yet the equivalent, and I said—It is the cypresses" (February 2, 1890).

The loaded brushstrokes and the swirling, undulating forms are typical of van Gogh's late work. Nevertheless, the subject posed an extraordinary technical problem for the artist, especially with regard to realizing the deep, rich green of the tree: "It is a splash of *black* in a sunny landscape, but it is one of the most interesting black notes, and the most difficult to hit off that I can imagine" (June 25, 1889).

Rogers Fund, 1949

49.30

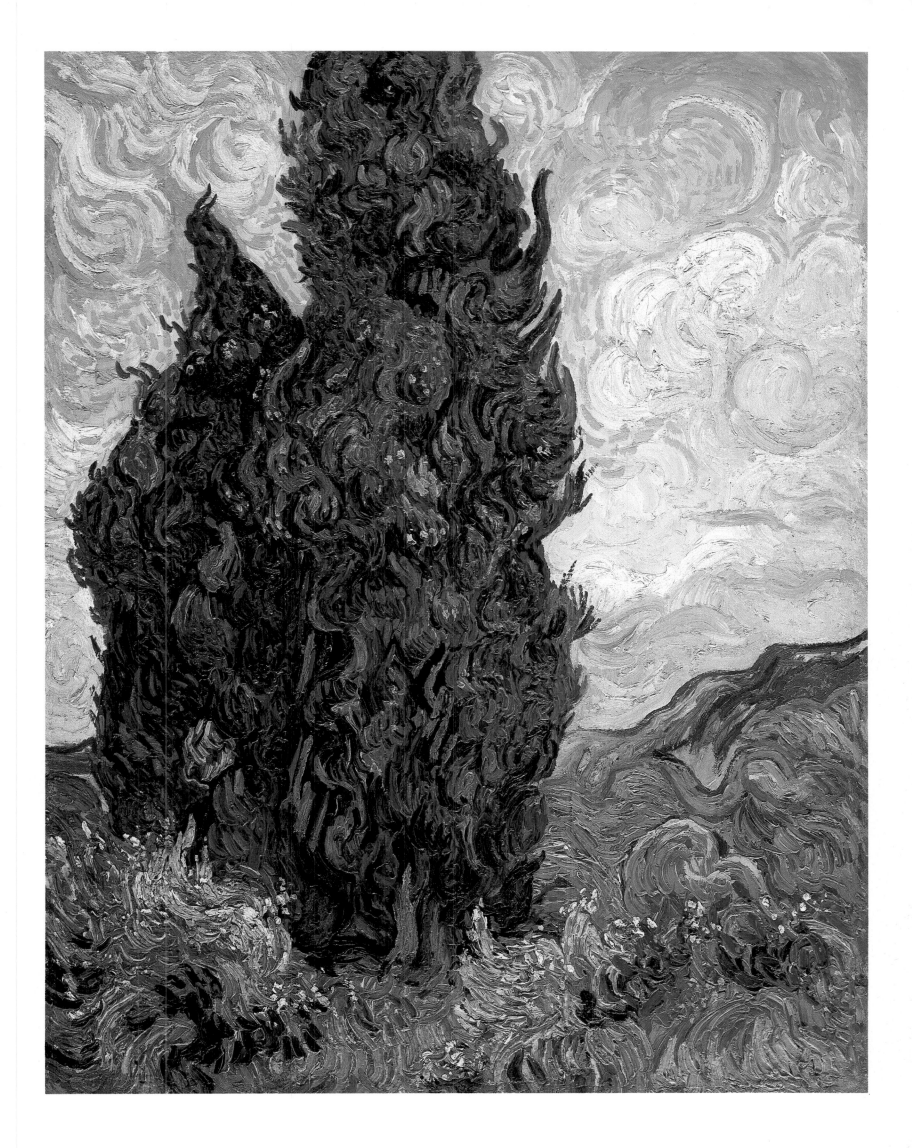

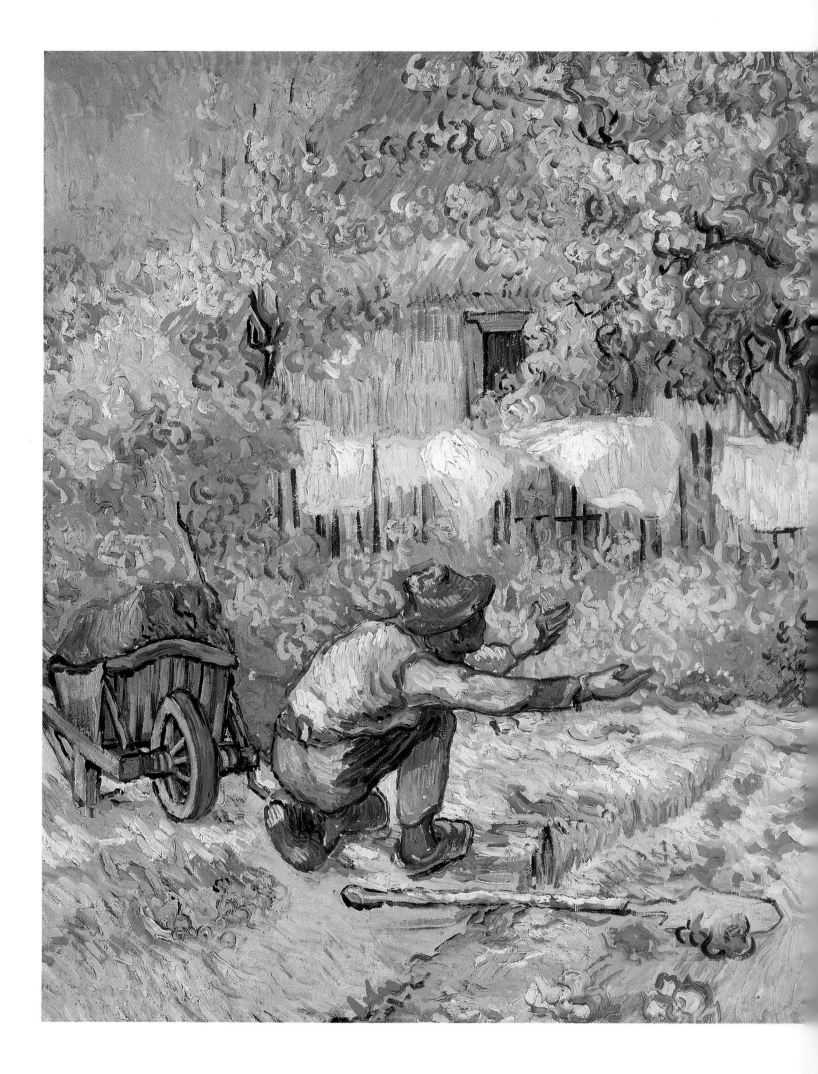

VINCENT VAN GOGH

Dutch, 1853–1890

First Steps

Oil on canvas, 28½ x 35⅞ inches

DURING THE LAST week of October 1889, Theo van Gogh sent reproductions of the work of Millet, paint, and canvas to his brother at the Asylum of Saint Paul in Saint-Rémy. Vincent wrote to thank him immediately: "Thank you for a package of paints, and finally, last night the canvas arrived and the Millet reproductions, of which I am very glad." The day that the letter was written van Gogh had begun a painting based on a reproduction of Millet's *The Diggers,* but a reproduction of another work immediately caught his eye: "How beautiful that Millet is, 'A Child's First Steps'!"

In a letter written the following January, van Gogh explained the purpose of the many copies after Millet that he made while in the hospital in Saint-Rémy: "The more I think about it, the more I think there is justification for trying to reproduce some of Millet's things which he himself had no time to paint in oil. Working thus on his drawings or woodcuts is not purely and simply copying. Rather it is translating—into another language—that of color—the impressions of light and shade in black and white." A few paragraphs later he said that he was about to begin a copy of *The First Steps.* Millet made several drawings that, with minor variations, treat the theme of a child learning to walk. It is not known which was depicted in the reproduction that van Gogh received from his brother in October.

The peasant subjects of Millet had an especially strong appeal for van Gogh, and he made more copies after Millet than after any other artist. Among the others whose work he "translated" from black-and-white reproductions were Delacroix, Lavieille, Doré, Rembrandt, Hiroshige, and Hokusai.

Gift of George N. and Helen M. Richard, 1964 64.165.2

VINCENT VAN GOGH

Dutch, 1853–1890

Irises

Oil on canvas, 29 x 36¼ inches

IN MAY 1890 van Gogh was released from the Asylum of Saint Paul in Saint-Rémy. He had been there for about a year for the treatment of an illness characterized by seizures and bizarre behavior. During his last month in the asylum, he enjoyed a period of relative calm and productivity. He wrote his brother, "All goes well. I am doing . . . two canvases representing big bunches of violet irises, one lot against a pink background in which the effect is soft and harmonious because of the combination of greens, pinks, violets . . . the other . . . stands out against a startling citron background, with other yellow tones in the vase and the stand on which it rests, so it is an effect of tremendously disparate complementaries, which strengthen each other by their juxtaposition."

The first picture described is the Museum's *Irises,* the background of which has faded considerably; the second is *Still Life: Vase with Irises Against a Yellow Background* (Rijksmuseum Vincent van Gogh, Amsterdam). The entirely different effects achieved through slight alterations in his palette emphasize van Gogh's interest in the symbolic meaning as well as the formal value of color. As he wrote in another context, "I am always in the hope of making a discovery there, to express the love of two lovers by a wedding of complementary colors, their mingling and their opposition, the mysterious vibrations of kindred tones. To express the thought of a brow by the radiance of a light tone against a somber background" (September 3, 1888).

Gift of Adele R. Levy, 1958 58.187

GEORGES SEURAT

French, 1859–1891

The Gardener

Oil on wood, 6¼ x 9¾ inches

ABOUT 1881 SEURAT began to work out-of-doors like the Impressionists, but he developed his own working methods to pursue their goal of reproducing the appearance of colors in daylight. His lively, hatched brushwork clearly derives from the loose facture introduced by Monet and Renoir to suggest dappled lighting effects. But whereas the older Impressionists generally brought full-sized canvases to a chosen site, Seurat preferred to make small studies on wooden cigar-box lids that measure approximately six by ten inches. Easily portable, these studies in many cases served as notes for larger works executed later on canvas in the studio. The golden brown of the wood beneath these painted studies enriches the green tones that are predominant in the rural scenes that Seurat preferred. The Impressionists seldom worked on toned grounds.

By Impressionist standards, Seurat's studies lack spontaneity; he seems to have planned even such small-scale compositions as *The Gardener* in advance. The measured relationship between the rounded silhouettes of the figure and the basket, and the interplay between the slender tree trunks and their shadows suggest Seurat's admiration for such carefully composed pictures as Millet's idealized peasant subjects and Puvis de Chavannes's stately decorative allegories.

Bequest of Miss Adelaide Milton de Groot (1876–1967), 1967 67.187.102

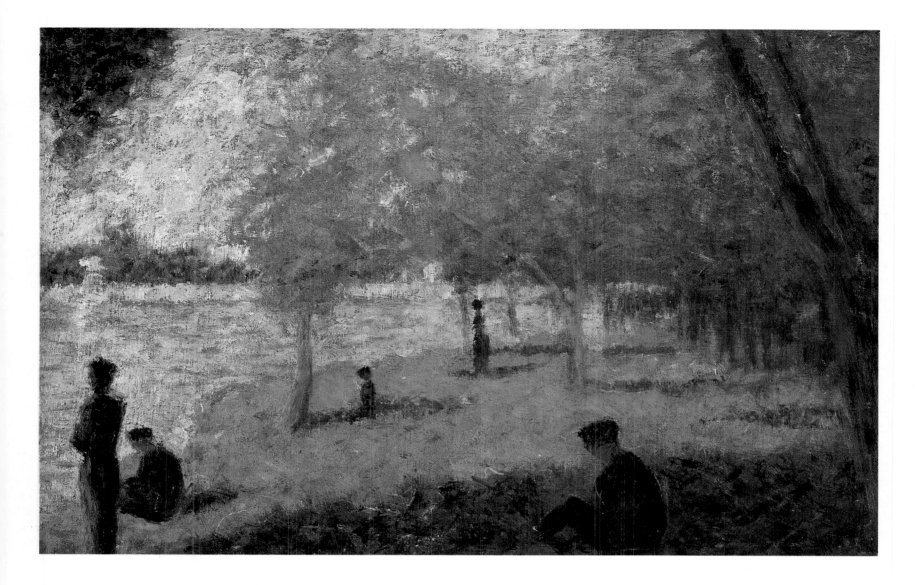

Study for
A Sunday on La Grande Jatte

Oil on wood, 6⅛ x 9½ inches
Inscribed (by Paul Signac, on reverse): Seurat #96

DURING JUNE AND JULY 1884 Seurat began a group of more than two dozen oil sketches on wooden cigar-box tops that relate to the composition of his monumental *A Sunday on La Grande Jatte* (Art Institute of Chicago), which he finished in 1886 and exhibited that year in the eighth and last of the Impressionists' group shows. The site depicted is the bank of an island in the Seine located between the Parisian suburbs of Neuilly and Courbevoie. The finished painting is often referred to as *A Sunday Afternoon on the Island of La Grande Jatte,* but during the artist's lifetime the painting was known only as *A Sunday on La Grande Jatte.* If the assumption that the painting depicts an afternoon scene is correct, Seurat placed his easel on the western bank of the island, looking toward Courbevoie.

This study, in the Museum's Lehman Collection, was painted relatively early in the sequence of oil sketches. It shows that initially Seurat considered accenting the right side of the painting with the trunk and branches of a tree, and that he had not originally intended to place the horizon line as high as he did in the final composition (pages 224–25). Nevertheless, here Seurat established the vantage point for the completed painting. Although later stages in the work's development include many more figures, this sketch shows that their eventual placement was a primary consideration as Seurat determined the composition of the landscape.

Robert Lehman Collection, 1975 1975.1.207

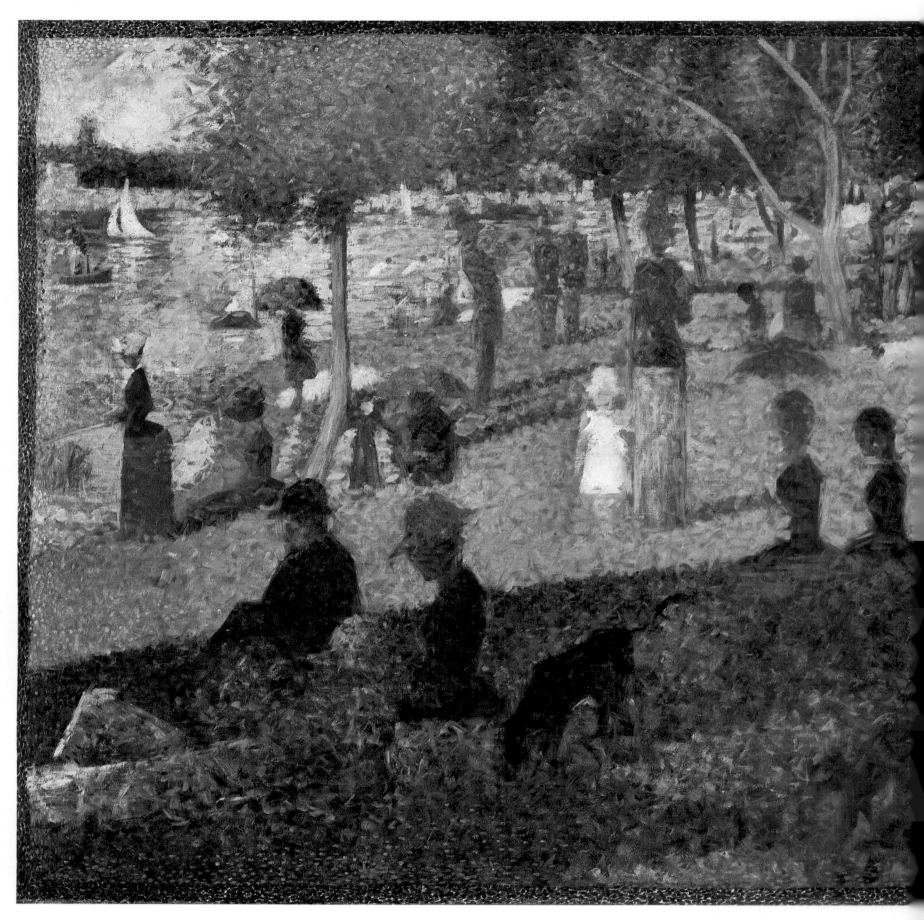

GEORGES SEURAT
French, 1859–1891

Study for
A Sunday on La Grande Jatte

Oil on canvas, 27¾ x 41 inches

THIS PAINTING IS Seurat's final sketch for his master-piece depicting Parisians enjoying their day off on an island in the Seine (Art Institute of Chicago), which was first shown in the eighth Impressionist exhibition, in 1886. About August 15, 1884, Seurat began work on the final canvas, which is ten feet high and over six feet wide, after having studied every detail painstakingly in at least thirty-two small preparatory drawings and oil studies. The Metropolitan's picture was presumably ex-ecuted shortly before mid-August. Although there are only minor differences in compositional detail between this study and the final work, the pictures represent distinct stages in the development of Seurat's color theory. For the study he prepared the canvas with a red ground, upon which he applied layers of saturated colors in hatched strokes. He may have begun the large version in a similar fashion, but eventually he chose a white ground and applied his paints in small, discrete dabs. Later, in 1885, following Pissarro's advice, Seurat re-painted the large version, using pigments that had already begun to lose their brilliance by 1892. Conse-quently, the Metropolitan's study is an important record of the chromatic range that the artist intended to achieve in the full-scale picture.

Based upon optical mixture (the phenomenon that causes two tones seen at a distance to form a single hue), Seurat's ideas about color were indebted to the technical treatises of M. E. Chevreul (*La Loi du contraste simultané des couleurs,* 1839) and O. N. Rood (*Modern Chromatics,* 1879). If his concepts were to work successfully in a painting, Seurat had to weigh each color relationship precisely. About 1885 he began to add borders to his pictures in order to insulate them from the unrelated colors of frames and walls. These borders were painted in the tiny dotlike brushstrokes characteristic of his Poin-tillist technique. Presumably he added a border to this study because he intended to exhibit it as a finished work in its own right.

Bequest of Sam A. Lewisohn, 1951 51.112.6

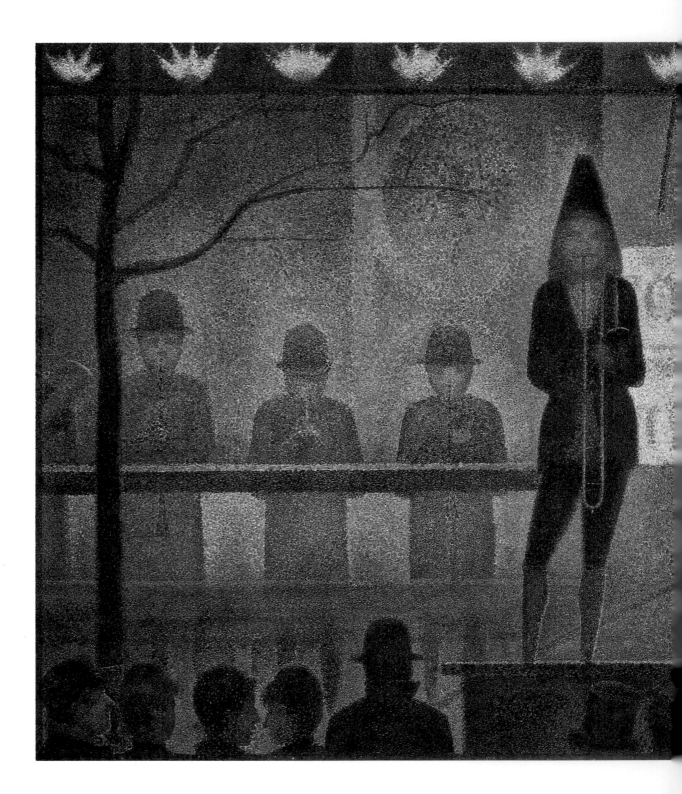

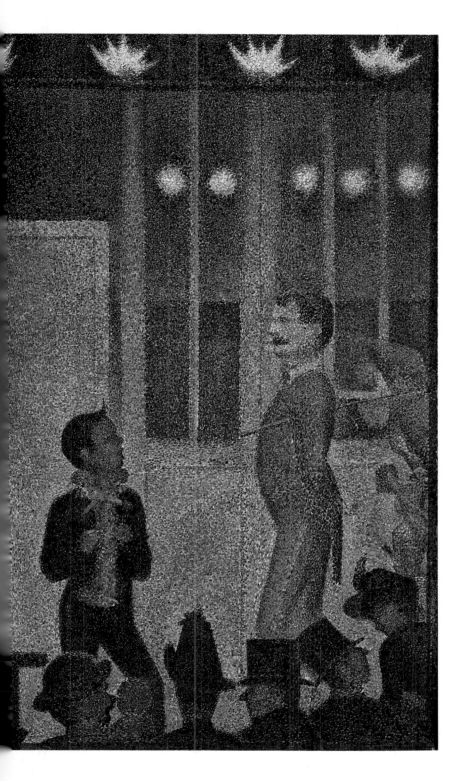

GEORGES SEURAT

French, 1859–1891

Invitation to the Sideshow (Parade de Cirque)

Oil on canvas, 39¼ x 59 inches

INCLUDED IN THE fourth exhibition of the Société des Artistes Indépendants, in 1888, this picture represents the *parade* of the Corvi Circus, which had set up in the Place de la Nation in Paris the previous spring. A *parade* is a sample entertainment performed on the street to entice passersby to purchase tickets. The onlookers at the far right are queued on stairs leading to the box office. Observed as if from the rear of the audience, magnifying our sense that we are part of the crowd, the entertainers include a trombonist isolated on a platform and four additional musicians lined up on a catwalk just behind him. Standing at the right, to oversee the performance, is Monsieur Loyal, the ringmaster, accompanied by a clown. Seurat was keenly interested in the effect of different types of light upon colors; this painting records the ashen shimmer produced by gaslights, here installed above the performers. Darkened and silhouetted by their glow, the circus players appear more sinister than merry. Perhaps derived from ancient Egyptian tomb paintings, their rigid poses add to the sense of exotic gloom, as does the leafless tree, its branches seeming to dance to the music like a charmed snake.

Using a fine brush, Seurat covered the surface of the painting with precise, interspersed, orange, yellow, and blue touches. Though his research in optics and perceptual psychology was highly scientific, the luminous shadows endow objectively observed facts with mystery. Forms seem to fade into or emerge from the moody light, and figures seem to levitate, since where they stand is hidden from view, and railings suggest ramps that lead nowhere. In this world where nothing is certain to the eyes, Seurat suggests a parity between fact and fantasy. To classify pictures like this one, in which light imbues commonplace appearance with poetry, Seurat's contemporaries generally used the term *féerique,* which means enchanted.

Bequest of Stephen C. Clark, 1960 61.101.17

PAUL SIGNAC

French, 1863–1935

The Jetty at Cassis

Oil on canvas, 18¼ x 25⅝ inches
Signed, dated, and inscribed (lower left): P. Signac 89;
(lower right): Op. 198
Inscribed and monogrammed (on stretcher): La Jetée de
Cassis–PS

SIGNAC PAINTED *The Jetty at Cassis* between April and June 1889, during a visit to the fishing village of Cassis, about ten miles from Marseilles. It was the third in a group of five paintings and one sketch that Signac made on this trip. In 1893 he referred to them in his journal: "I believe that I have never painted pictures as 'objectively exact' as those of Cassis. In this region there is only white; the reflected light everywhere devours local colors and gray shadows." The small dots that compose the painting are called Divisionist, or Pointillist, brushstrokes. The technique was developed by Seurat, Signac, and their associates to represent with scientific accuracy the oscillating appearance of light.

Until 1894 Signac inscribed each of his pictures with an opus number, as if it were to be considered as a musical composition. Like Whistler, who referred to some of his works as Symphonies, Signac sought a pictorial art based upon harmonious intervals and orchestrated colors. Such an art would be primarily evocative, as music is, and only secondarily representational.

Bequest of Joan Whitney Payson, 1975 1976.201.19

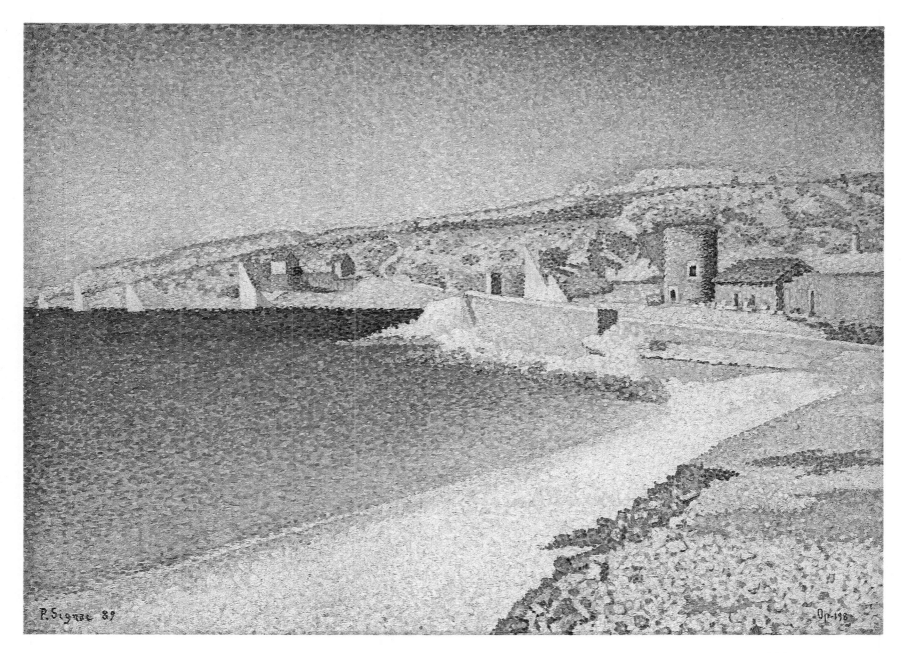

PAUL SIGNAC

French, 1863–1935

View of the Port of Marseilles

Oil on canvas, 35 x 45¾ inches
Signed and dated (lower right): P Signac / 1905

SIGNAC PAINTED IN the Impressionist style of Monet until he met Seurat and became interested in his theory of Neo-Impressionism and his technique of painting with tiny dots or "points" of color (which is called, for this reason, Pointillism). Signac went even further than Seurat in his methodical studies of the division of light into its component elements of pure color, and he arranged rectangular brushstrokes like tesserae in a mosaic. To achieve the utmost luminosity, he did not mix his colors on the palette but depended upon their blending in the spectator's eye. Signac's view of Marseilles, crowned by the church of Notre-Dame-de-la-Garde, seems to vibrate under the meridional sun like the broken reflections of boats in the harbor waters.

In 1901 Signac had painted a smaller version of this composition. Compared to the pale tonalities of the earlier work, the color in the Metropolitan's picture of 1905 is brilliant. Signac's changed attitude toward color was brought about by conversations with the young Fauve painters Henri-Edmond Cross and Henri Matisse, who were at Saint-Tropez during the summer of 1904, as was Signac. They, in turn, were influenced by Signac's Pointillist technique.

Gift of Robert Lehman, 1955 55.220.1

230

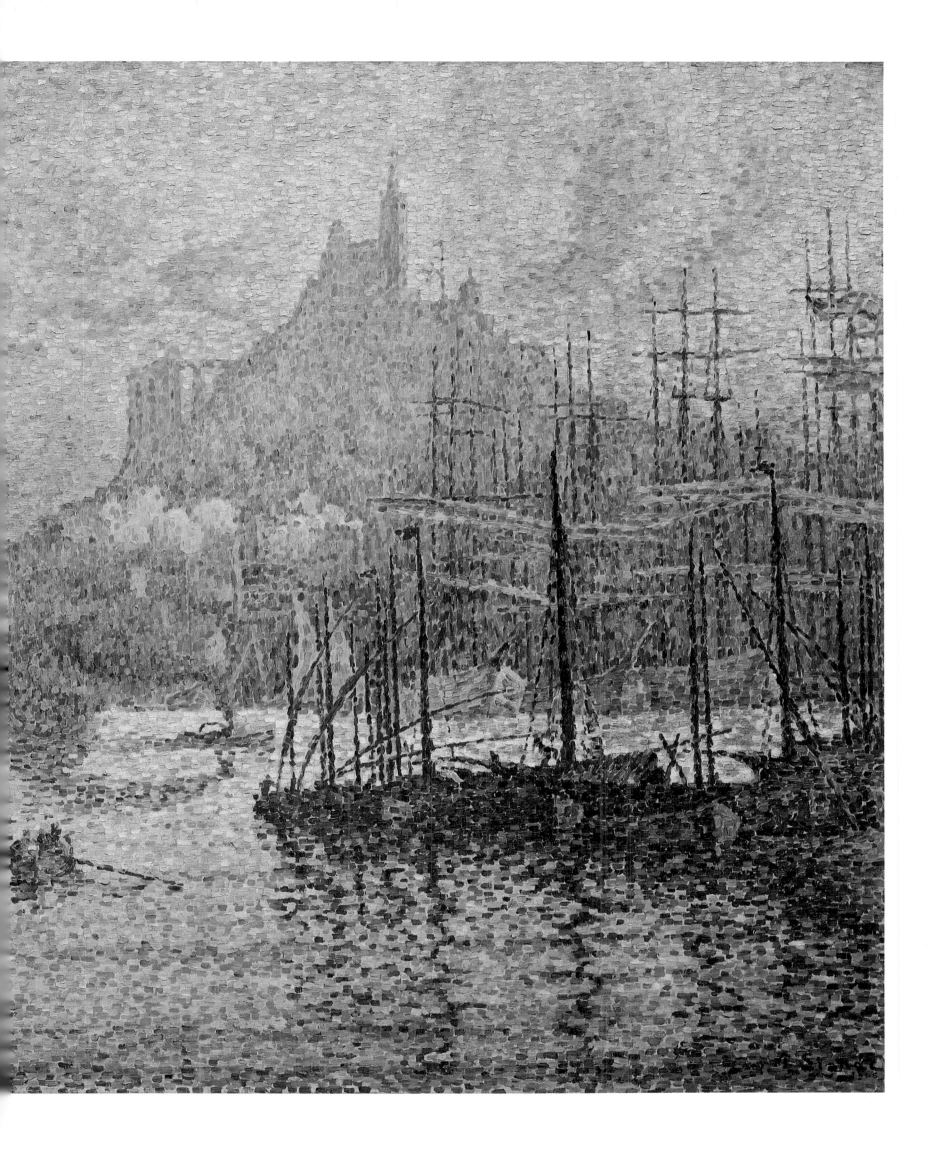

HENRI DE TOULOUSE-LAUTREC

French, 1864–1901

René Grenier

Oil on wood, 13⅜ x 10 inches
Inscribed (on reverse): Mon portrait par / Toulouse
Lautrec / en 1887 / atelier rue Caulaincourt / [Grenier?]

RENE GRENIER AND Lautrec were fellow students in the atelier of Fernand Cormon during the early 1880s. Before establishing his own studio in the Rue Caulaincourt in 1886, Lautrec lived with Grenier and his wife, Lili, an actress and model, both of whom occasionally posed for him.

Fascinated with so-called primitive portraits by Holbein, Cranach, and their contemporaries, Lautrec often preferred to work on colored supports, such as wood panels, and to use thin paints so that the underlying tone perceptibly enriched his final surface. For this portrait Lautrec carefully drew Grenier's features in pencil before adding the predominantly muted colors. For highlights he added accents in impasto. The result is a sensitive character study, dignified, yet at the same time informal, since Grenier has removed his coat. In effect, Lautrec's portrait closely resembles works by his favorite contemporary artist, Degas.

Bequest of Mary Cushing Fosburgh, 1978 1979.135.14

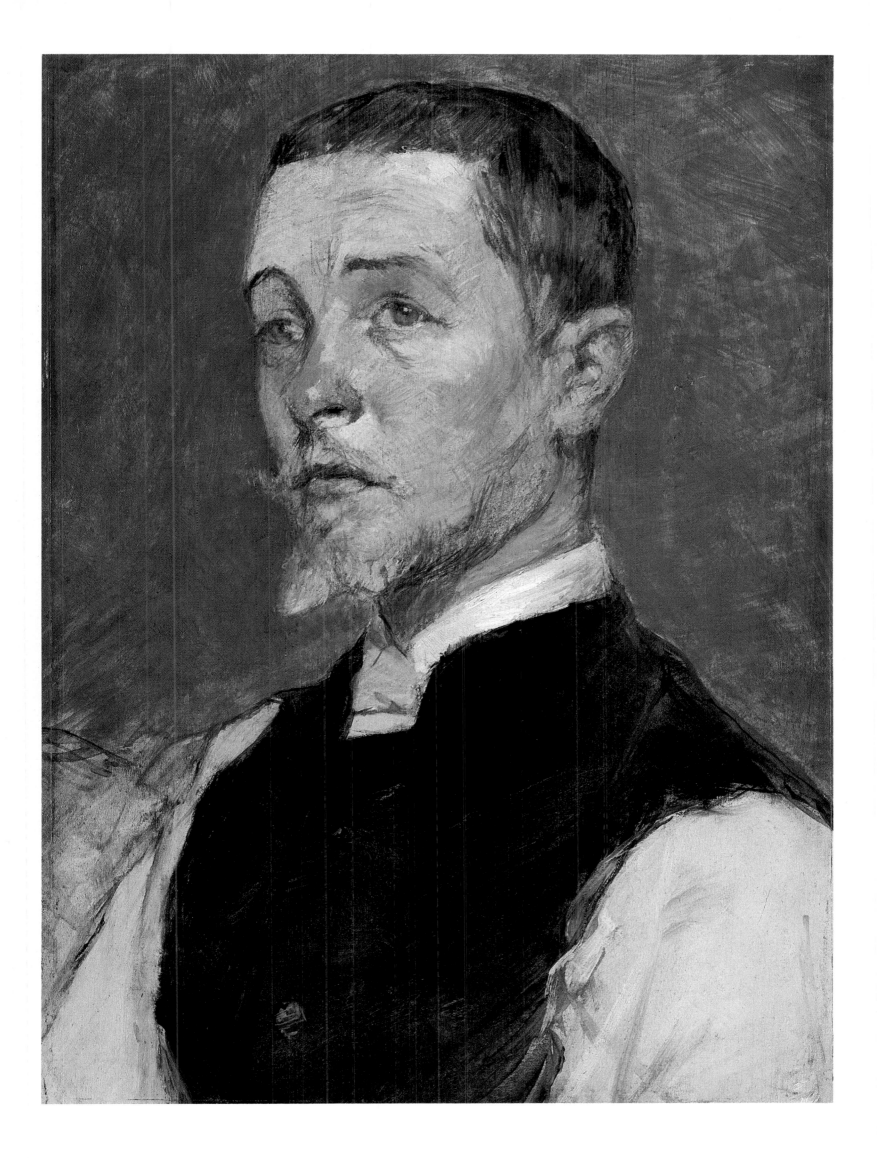

HENRI DE TOULOUSE-LAUTREC

French, 1864–1901

Woman in the Garden of Monsieur Forest

Oil on sized linen, 21⅞ x 18¼ inches
Signed (lower left): T-Lautrec

THE UNIDENTIFIED sitter for this portrait, like most of Lautrec's female models, is redheaded and belongs to the working class. Like van Gogh, Lautrec was fascinated by coarse features that express tenacity and blunt candor. Beginning about 1888, he often posed his subjects in the private garden belonging to a man called Forest, situated near his studio. Presumably the setting appealed to him because the green foliage provided a richly decorative background and because shadows out-of-doors are deeply colored. This latter phenomenon had been systematically studied by Seurat and Signac, whose theories intrigued Lautrec. Reflecting their ideas, he rendered the shadows on his model's neck in vivid green, the color complementary to the reddish tone of her hair and complexion. In addition, as if investigating current theories that complementary colors intensify one another, Lautrec posed the model in a deep pink smock, which the eye perceives as particularly vivid in conjunction with the green background. The interplay between line and color suggests the fluidity of light conditions out-of-doors.

Characteristically, Lautrec first sketched the outlines of the model and her surroundings and then added colors in thinned paints.

Bequest of Joan Whitney Payson, 1975

1976.201.15

234

HENRI DE TOULOUSE-LAUTREC

French, 1864–1901

The Englishman at the Moulin Rouge

Oil and gouache on cardboard, 33¾ x 26 inches
Signed (lower left): T-Lautrec

NO LATER THAN 1885 Lautrec began a series of pictures of Montmartre cafés and dance halls frequented by prostitutes and their clients. His candid, psychologically penetrating studies, which are comparable to episodes in Zola's novels, appealed immediately to artists and dealers who appreciated art based upon the realities of modern life. *The Englishman at the Moulin Rouge* is the preparatory study for a color lithograph commissioned by the Boussod & Valadon Gallery in 1892.

To heighten the illusion of intimacy, with all that the word implies, Lautrec chose a vantage point close to the shoulder of a seated woman with bright orange hair who wears a black choker and long black gloves. Her right hand is placed on the thigh of a top-hatted gentleman, whose chair has been pulled up to hers. He regards her advances with smug expectation. A second woman watches the open sexual advances. Lautrec drew her eyes in an exaggerated slant, like a cat's, and colored green the lock of hair falling over her brow, evoking the luridly gaslit interior of the Moulin Rouge, as well as the passions of lust and jealousy that bind the three figures together. The model for the man was William Tom Warrener, an artist and friend of Lautrec's.

Bequest of Miss Adelaide Milton de Groot (1876–1967), 1967 67.187.108

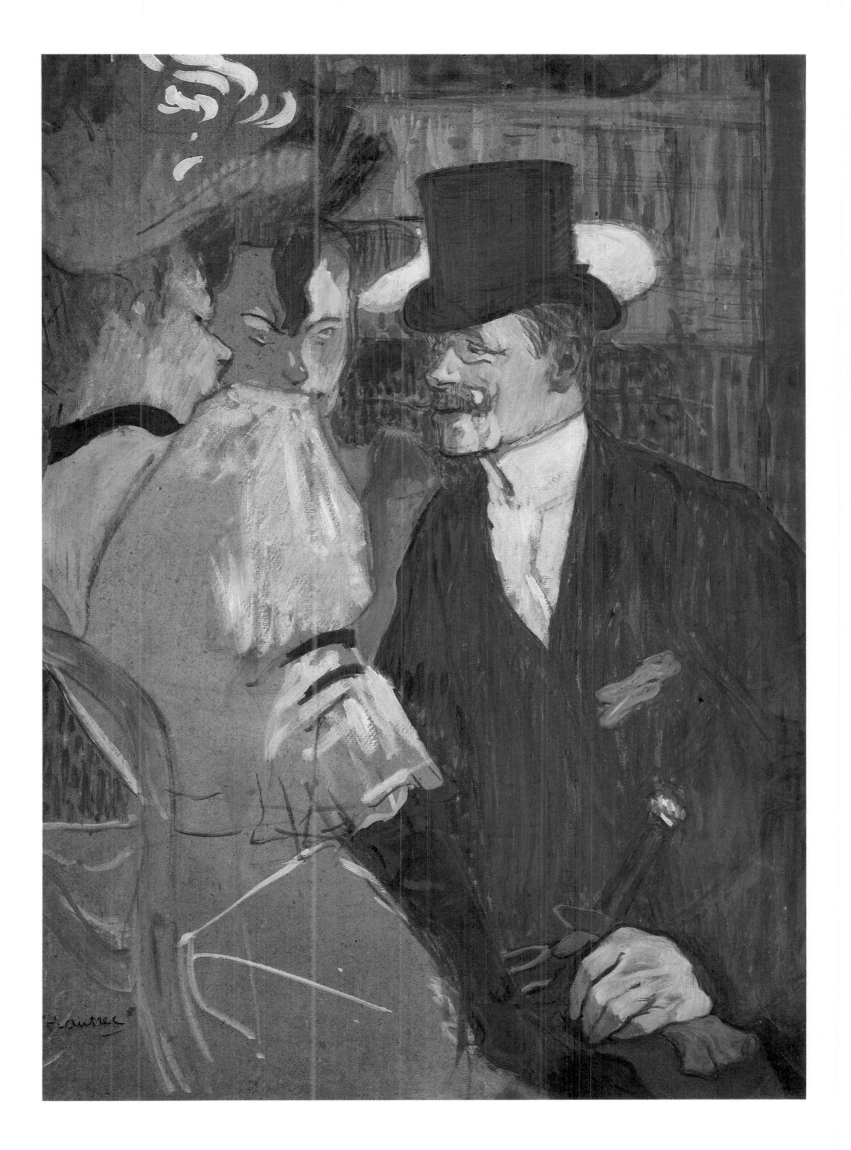

HENRI DE TOULOUSE-LAUTREC

French, 1864–1901

The Sofa

Oil on cardboard, 24¾ x 31⅞ inches
Stamped (lower left): HTL [monogram]

INTRIGUED BY EROTIC Japanese prints, as well as by Degas's small monotypes of brothel scenes (which were not intended for public exhibition), Lautrec set out to document the lives of prostitutes in a series of pictures executed between 1892 and 1896. Himself a social outcast on account of his grotesque physical deformities, Lautrec was accepted by the whores and keenly apprehended the dreary sadness of their lives. Since they were accustomed to being observed, the whores made unaffected models, never compromising Lautrec's commitment to utter candor. At first Lautrec made sketches in the brothels. Hampered by the insufficient lighting, however, he eventually had his models pose in his studio on a large divan. The writer Jules Renard was shocked to find the women there in 1894 when he visited Lautrec.

Bonded together by their occupation, and excluded from permanent relationships, the prostitutes often fell in love with one another. Lautrec was sympathetic to lesbianism, perhaps because he understood that the women's tenderness toward each other was a reality that transcended any feelings they might have for their male clients. This picture is closely related to two others (Dr. Peter Nathan Collection; Staatliche Kunstsammlungen, Dresden). Although the explicitly sexual theme is calculatedly shocking, Lautrec's characterization of the lovers was no less consciously intended to be deeply touching.

Rogers Fund, 1951 51.33.2

ODILON REDON

French, 1840–1916

Flowers in a Chinese Vase

Oil on canvas, 28⅝ x 21¼ inches
Signed (twice, lower left and at base of vase): ODILON REDON

A FIGURE OF GREAT importance to the Symbolist movement of the late nineteenth century, Redon championed an aesthetic ideal based on the primacy of the imagination. Nonetheless, the visionary character of his work is rooted in the observation of nature, as this painting of about 1906 demonstrates. His stated intention was "to place the logic of the visible at the service of the invisible." In his still lifes, most of which were painted during the last two decades of his life, he depicted the subject in great detail but placed it in a misty, undefined field.

Flowers in a Chinese Vase was exhibited in New York in 1906, seven years before Redon's work became familiar in the United States as a result of the Armory Show. It was included in the Metropolitan Museum's fiftieth-anniversary exhibition in 1920. The picture was owned at that time by the American lawyer and prominent art patron John Quinn, who assembled one of the first great collections of early twentieth-century European and American art.

Bequest of Mabel Choate, in memory of her father, Joseph Hodges Choate, 1958
59.16.3

240

ODILON REDON
French, 1840–1916

Madame Arthur Fontaine

Pastel on paper, 28½ x 22½ inches
Signed, dated, and inscribed (upper left): fait à St-Georges-de-Didonne / Septembre-1901- / ODILON REDON

THE WEALTHY INDUSTRIALIST Arthur Fontaine and his wife often entertained in their Paris apartment a circle of friends that included Claude Debussy, Paul Claudel, André Gide, Odilon Redon, and other prominent artists, writers, and musicians. In September 1901 the Fontaines visited Redon and his wife at the seaside resort of Saint-Georges-de-Didonne, and Redon executed a red-chalk portrait of Monsieur Fontaine as well as this remarkable pastel of Marie Escudier Fontaine.

The combination of real and imagined elements in this work seems perfectly natural. Madame Fontaine herself is portrayed relatively realistically, but her face is seen in a subtle half-light that lends her mystery and permits the colorful flowers around her to play a stronger role. The fictive garland suggests a personality that is colorful, vibrant, and gentle. Clearly these ethereal blossoms establish a context that is appropriate to the sitter, but it is impossible to assign them a specific meaning. One of the aims of Symbolism was to create statements about subjective truths and states of feeling for which there are no corresponding words. As this portrait demonstrates, Redon was particularly adept at fashioning images that function as metaphors and express otherwise incommunicable significances.

The Mr. and Mrs. Henry Ittleson, Jr. Purchase Fund, 1960 60.54

242

HENRI ROUSSEAU (LE DOUANIER)

French, 1844–1910

The Banks of the Bièvre near Bicêtre

Oil on canvas, 21½ x 18 inches
Signed (lower right): H Rousseau

ROUSSEAU'S SOBRIQUET "Le Douanier" refers to his career as a customs official. Self-taught as a painter, he began to exhibit at the Société des Artistes Indépendants in 1886. After his retirement in 1893, he devoted himself entirely to painting. His unique style, characterized by fanciful distortions of perspective and scale, simplification of detail, and an emphasis upon pattern, was appreciated by avant-garde writers and painters, including Apollinaire, Jarry, and Picasso.

Rousseau identified the subject of this picture (which on the basis of style can be dated about 1897) as the banks of a stream near Bicêtre, an area on the outskirts of Paris known for its asylum, workhouse, and prison. The Bièvre rises near Versailles and empties into the Seine after running, mostly underground, through Paris. Already in Rousseau's time it was contaminated with sewage. The picturesque simplicity of Rousseau's landscape, thus, should be understood as ironic.

Gift of Marshall Field, 1939 39.15

HENRI ROUSSEAU
(LE DOUANIER)

French, 1844–1910

The Repast of the Lion

Oil on canvas, 44¾ x 63 inches
Signed (lower right): Henri Rousseau

ROUSSEAU HAD BEGUN to paint imaginary scenes set in the jungle by 1891. The Metropolitan's picture, which shows a lion devouring a jaguar, was probably first exhibited at the Salon d'Automne of 1907. The vegetation in Rousseau's jungle paintings is evidently based upon exotic plants that the artist had studied at the botanical garden in Paris, but, disregarding their actual sizes, Rousseau invented forests that dwarf his figures of natives and animals. Reminiscent of Delacroix's studies of fighting lions, Rousseau's animals are often closely based upon photographs in a children's book that his daughter owned. Riding in a blue sky, the full moon partly visible beyond a hill in the background intensifies the incongruous, dreamlike character of the scene. It is as if the moon's influence has brought violence to the lush paradise.

Bequest of Sam A. Lewisohn, 1951 51.112.5

246

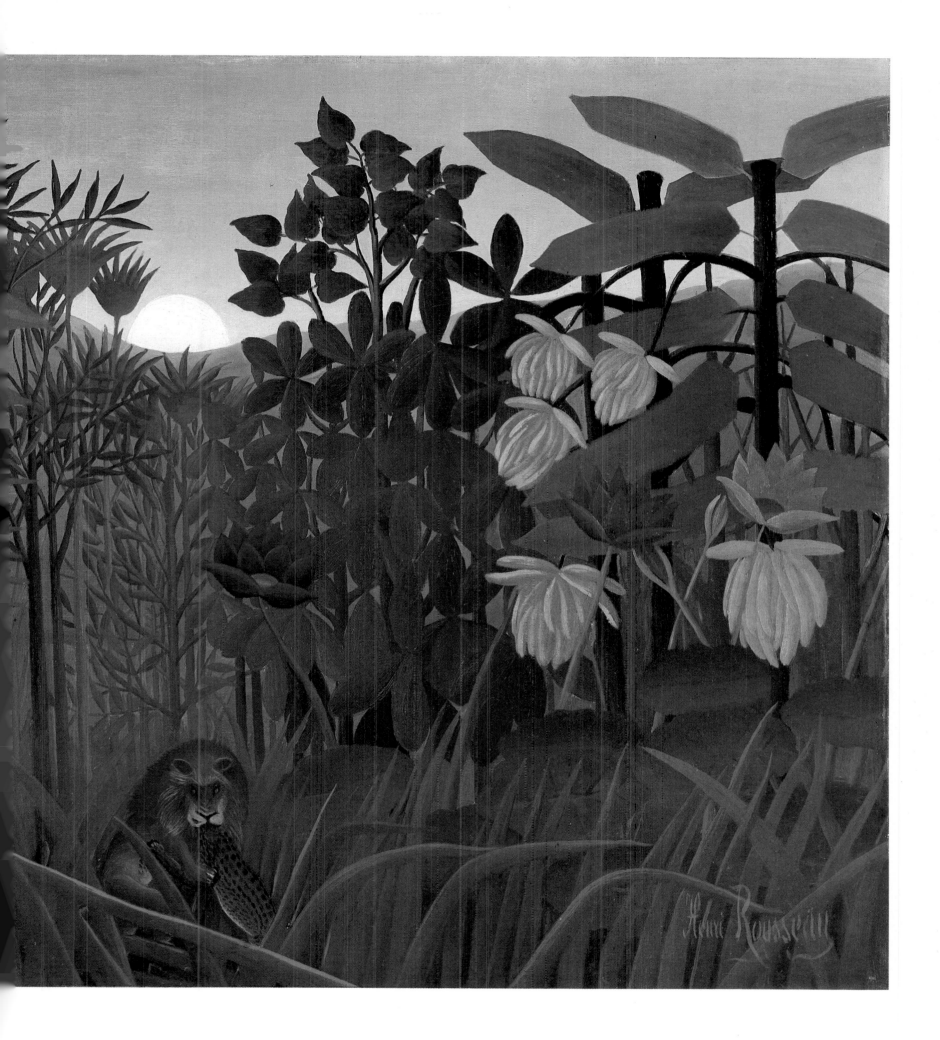

LIST OF ILLUSTRATIONS
AND SELECTED BIBLIOGRAPHY

ABBREVIATIONS OF WORKS FREQUENTLY CITED:

Moffett, *Impressionism*

Charles S. Moffett, in Anne Dayez, Michel Hoog, and Charles S. Moffett, *Impressionism: A Centenary Exhibition (Centenaire de l'impressionnisme),* Metropolitan Museum of Art, New York, and Grand Palais, Paris, 1974–75.

Rewald, *Impressionism*

John Rewald, *The History of Impressionism,* 4th rev. ed., New York, 1973.

Rewald, *Post-Impressionism*

John Rewald, *Post-Impressionism from van Gogh to Gauguin,* 3d rev. ed., New York, 1978.

Sterling-Salinger

Charles Sterling and Margaretta M. Salinger, *French Paintings: A Catalogue of the Collection of The Metropolitan Museum of Art,* 3 vols., vol. 2, *XIX Century,* New York, 1966; vol. 3, *XIX–XX Centuries,* New York, 1967.

Johan Barthold Jongkind
Pages 14–15: *Honfleur*
Sterling-Salinger, vol. 2, p. 133. Victorine Hefting, *Jongkind: sa vie, son oeuvre, son époque,* Paris, 1975, p. 166 (no. 344). Charles C. Cunningham, Susan D. Peters, and Kathleen Zimmerer, *Jongkind and the Pre-Impressionists,* catalogue of an exhibition at Sterling and Francine Clark Art Institute, Williamstown, Mass., and Smith College Museum of Art, Northampton, Mass., 1976–77, p. 40 (no. 9).

Eugène Boudin
Pages 16–17: *On the Beach at Trouville*
Sterling-Salinger, vol. 2, pp. 135–36. Robert Schmit, *Eugène Boudin,* 2 vols., Paris, 1973, vol. 1, p. 86 (no. 271).

Pages 18–19: *Village by a River*
Sterling-Salinger, vol. 2, pp. 134–35. Schmit, *Eugène Boudin,* vol. 1, p. 297 (no. 833), dates it about 1872–73.

Ignace Henri Jean Théodore Fantin-Latour
Pages 20–21: *Still Life with Flowers and Fruit*
Mme Fantin-Latour (Victoria Dubourg), *Catalogue de l'oeuvre complet de Fantin-Latour,* Paris, 1911, p. 40 (no. 288). Jacques-Emile Blanche, *Propos de Peintre: De David à Degas,* Paris, 1919, p. 47.

Pages 22–23: *Still Life with Pansies*
Mme Fantin-Latour, *Catalogue de l'oeuvre complet,* p. 80 (no. 735).

Edouard Manet
Pages 24–25: *The Spanish Singer*
George Heard Hamilton, *Manet and His Critics,* New Haven, 1954, pp. 24–31. Sterling-Salinger, vol. 3, pp. 27–30. George Mauner, *Manet: Peintre-Philosophe,* University Park, Pa., and London, 1975, pp. 155–59. Denis Rouart and Daniel Wildenstein, *Edouard Manet: Catalogue raisonné,* 2 vols., Lausanne and Paris, 1975, vol. 1, p. 50 (no. 32).

Pages 26–27: *Boy with a Sword*
Sterling-Salinger, vol. 3, pp. 30–33. Rouart and Wildenstein, *Edouard Manet,* vol. 1, p. 54 (no. 37).

Pages 28–29: *Mademoiselle Victorine in the Costume of an Espada*
Hamilton, *Manet,* pp. 43–52. Sterling-Salinger, vol. 3, pp. 33–35. Beatrice Farwell, "Manet's 'Espada' and Marcantonio," *Metropolitan Museum Journal,* vol. 2 (1969), pp. 197–207. John Rewald, "The Impressionist Brush," *Metropolitan Museum of Art Bulletin,* vol. 32, no. 3 (1973–74), p. 7 (no. 2). Rouart and Wildenstein, *Edouard Manet,* vol. 1, p. 66 (no. 58).

Pages 30–31: *Young Man in the Costume of a Majo*
Hamilton, *Manet,* pp. 42–51. Sterling-Salinger, vol. 3, pp. 35–36. Rouart and Wildenstein, *Edouard Manet,* vol. 1, p. 80 (no. 70).

Pages 32–33: *The Dead Christ, with Angels*
Hamilton, *Manet,* pp. 55–64. Sterling-Salinger, vol. 3, pp. 36–40. Mauner, *Manet,* pp. 111–14. Rouart and Wildenstein, *Edouard Manet,* vol. 1, p. 82 (no. 74).

Pages 34–35: *Peonies*
Adolphe Tabarant, *Manet et ses oeuvres,* Paris, 1947, pp. 94–95. Rouart and Wildenstein, *Edouard Manet,* vol. 1, p. 92 (no. 87).

Pages 36–37: *Woman with a Parrot*
Hamilton, *Manet,* pp. 114–22. Sterling-Salinger, vol. 3, pp. 40–43. Mona Hadler, "Manet's Woman with a Parrot of 1866," *Metropolitan Museum Journal,* vol. 7 (1973), pp. 115–22. Moffett, *Impressionism,* pp. 110–14 (no. 19). Mauner, *Manet,* p. 136. Rouart and Wildenstein, *Edouard Manet,* vol. 1, p. 112 (no. 115).

Pages 38–39: *Madame Edouard Manet*
Rouart and Wildenstein, *Edouard Manet,* vol. 1, pp. 112–13 (no. 117).

Pages 40–41: *Boating*
Hamilton, *Manet,* pp. 214–17. Sterling-Salinger, vol. 3, pp.

45–47. Rewald, "Impressionist Brush," p. 31 (no. 19). Moffett, *Impressionism*, pp. 124–26 (no. 22). Rouart and Wildenstein, *Edouard Manet*, vol. 1, p. 186 (no. 223).

Pages 42–43: *Mademoiselle Isabelle Lemonnier*
Sterling-Salinger, vol. 3, pp. 47–48. Rouart and Wildenstein, *Edouard Manet*, vol. 2, pp. 6–7 (no. 15).

Pages 44–45: *George Moore*
Sterling-Salinger, vol. 3, pp. 48–50. Rewald, *Impressionism*, p. 401. Rouart and Wildenstein, *Edouard Manet*, vol. 2, p. 4 (no. 11).

Pages 46–47: *The Monet Family in Their Garden*
Tabarant, *Manet*, pp. 246–57. Rewald, *Impressionism*, pp. 341–43. Rouart and Wildenstein, *Edouard Manet*, vol. 1, p. 190 (no. 227).

Pages 48–49: *George Moore (Au Café)*
George Moore, *Modern Painting*, London and New York, 1893, p. 31. Anne Coffin Hanson, *Edouard Manet: 1832–1883*, catalogue of an exhibition at Philadelphia Museum of Art and Art Institute of Chicago, 1966–67, pp. 158–59 (no. 145). Sterling-Salinger, vol. 3, pp. 50–51. Rouart and Wildenstein, *Edouard Manet*, vol. 1, pp. 234–35 (no. 296).

Hilaire Germain Edgar Degas

Pages 50–51: *Self-Portrait*
Paul André Lemoisne, *Degas et son oeuvre*, 4 vols., Paris, 1946–49, vol. 1, pp. 14, 20, vol. 2, pp. 6–7 (no. 12). Jean Sutherland Boggs, *Portraits by Degas*, Berkeley and Los Angeles, 1962, pp. 9, 87 (no. 36), 105. Sterling-Salinger, vol. 3, pp. 56–57. Charles S. Moffett, *Degas: Paintings in The Metropolitan Museum of Art*, New York, 1979, p. 5.

Pages 52–53: *A Woman with Chrysanthemums*
Lemoisne, *Degas*, vol. 1, pp. 55–56, 239 (n. 117), vol. 2, pp. 62–63 (no. 125). Boggs, *Portraits*, pp. 31–32, 37, 41, 59, 119. Sterling-Salinger, vol. 3, pp. 57–60. John Rewald, "The Impressionist Brush," *Metropolitan Museum of Art Bulletin*, vol. 32, no. 3 (1973–74), p. 8 (no. 3). Moffett, *Impressionism*, pp. 70–75 (no. 10). Theodore Reff, *Degas: The Artist's Mind*, New York, 1976, pp. 48–49, 62–65. Moffett, *Degas*, p. 6.

Pages 54–55: *Portrait of a Lady in Gray*
Lemoisne, *Degas*, vol. 2, pp. 64–65 (no. 128). Sterling-Salinger, vol. 3, pp. 60–61. Moffett, *Degas*, pp. 6–7.

Page 55: *Mademoiselle Marie Dihau*
Lemoisne, *Degas*, vol. 2, pp. 88–89 (no. 172). Boggs, *Portraits*, p. 106. Sterling-Salinger, vol. 3, pp. 61–62. Moffett, *Degas*, p. 7.

Pages 56–57: *The Collector of Prints*
Lemoisne, *Degas*, vol. 2, pp. 70–71 (no. 138). Sterling-Salinger, vol. 3, p. 61. Reff, *Artist's Mind*, pp. 98–101. Moffett, *Degas*, pp. 7–8.

Pages 58–59: *Jacques Joseph Tissot*
Lemoisne, *Degas*, vol. 1, pp. 56, 240 (n. 117), vol. 2, pp. 90–91 (no. 175). Boggs, *Portraits*, pp. 23, 32, 54, 57, 59, 106, 131. Sterling-Salinger, vol. 3, pp. 62–64. Moffett, *Impressionism*, pp. 76–79 (no. 11). Reff, *Artist's Mind*, pp. 101–10. Moffett, *Degas*, pp. 7–8.

Pages 60–61: *Portrait of Yves Gobillard-Morisot*
Lemoisne, *Degas*, vol. 1, pp. 57–58, vol. 2, pp. 110–11 (no. 214). Boggs, *Portraits*, pp. 27, 61, 119. Moffett, *Degas*, pp. 7, 8–9.

Page 61: *Joseph Henri Altès*
Lemoisne, *Degas*, vol. 1, p. 54, vol. 2, pp. 90–91 (no. 176). Sterling-Salinger, vol. 3, p. 65. Boggs, *Portraits*, pp. 92 (no. 40), 108. Moffett, *Degas*, pp. 7–8.

Pages 62–63: *Madame Gobillard-Morisot (Yves Morisot)*
Lemoisne, *Degas*, vol. 1, pp. 57–58, vol. 2, pp. 110–11 (no. 213). Boggs, *Portraits*, pp. 27, 31, 61, 119. Sterling-Salinger, vol. 3, pp. 65–66. Moffett, *Degas*, pp. 8–9.

Pages 64–65: *Sulking*
Lemoisne, *Degas*, vol. 1, p. 83, vol. 2, pp. 174–75 (no. 335). Sterling-Salinger, vol. 3, pp. 71–73. Reff, *Artist's Mind*, pp. 10, 90, 93, 116–20, 144–45, 162–64, 216, 228, 232, 272, 315 (nn. 74, 80). Theodore Reff, *The Notebooks of Edgar Degas*, 2 vols., Oxford, 1976, vol. 1, pp. 20–21, 110–11, 122, 151, vol. 2, notebook 25, pp. 36, 37, 39. Theodore Reff, "Degas: A Master among Masters," *Metropolitan Museum of Art Bulletin*, vol. 34, no. 4 (1977), pp. 22–23. Moffett, *Degas*, p. 10.

Pages 66–67: *The Dancing Class*
Lemoisne, *Degas*, vol. 1, p. 69, vol. 2, pp. 148–49 (no. 297). Ronald Pickvance, "Degas's Dancers," *Burlington Magazine*, vol. 105, no. 723 (1963), pp. 256–59, 265–66. Sterling-Salinger, vol. 3, pp. 67–71. Rewald, "Impressionist Brush," p. 23 (no. 13). Moffett, *Impressionism*, pp. 94–98 (no. 15). Reff, *Notebooks*, vol. 1, pp. 7 (n. 2), 9 (nn. 6, 7), 21 (n. 6), 115, 119–20. Moffett, *Degas*, p. 11.

Pages 68–69: *The Ballet from "Robert le Diable"*
Lemoisne, *Degas*, vol. 1, p. 68, vol. 2, pp. 144–45 (no. 294). Sterling-Salinger, vol. 3, pp. 66–69. Reff, *Artist's Mind*, pp. 221, 327 (n. 33), 329 (n. 88). Reff, *Notebooks*, vol. 1, pp. 7 (n. 2), 9 (n. 7), 21 (n. 6), 119–20, vol. 2, notebook 24, pp. 10, 11, 13, 15, 16, 17, 19. Reff, "Master among Masters," p. 26. Moffett, *Degas*, pp. 9–10.

Pages 70–71: *The Rehearsal of the Ballet on the Stage*
Lemoisne, *Degas*, vol. 1, pp. 91–92, vol. 2, pp. 218–19 (no. 400). Pickvance, "Degas's Dancers," pp. 259–66. Sterling-Salinger, vol. 3, pp. 73–76. Theodore Reff, "The Technical Aspects of Degas's Art," *Metropolitan Museum Journal*, vol. 4 (1971), pp. 151–52. Reff, *Artist's Mind*, p. 274. Reff, *Notebooks*, vol. 1, pp. 7 (n. 2), 9 (n. 7), 21 (n. 6), 115, 119–20, vol. 2, notebook 24, p. 27. Moffett, *Degas*, p. 12.

Pages 72–73: *A Woman Ironing*
Lemoisne, *Degas*, vol. 1, p. 87, vol. 2, pp. 188–89 (no. 356). Sterling-Salinger, vol. 3, pp. 77–78. Reff, *Artist's Mind*, pp. 166–68, 321 (n. 68). Moffett, *Degas*, p. 10.

Pages 74–75: *Dancers Practicing at the Bar*
Lemoisne, *Degas*, vol. 1, pp. 93, 239 (n. 118), vol. 2, pp. 224–25 (no. 408). Sterling-Salinger, pp. 78–81. Reff, *Artist's Mind*, pp. 277–78. Moffett, *Degas*, pp. 11–12.

Pages 76–77: *At the Milliner's*
George Moore, *Confessions of a Young Man* (1888), reprinted New York, 1959, p. 45. Lemoisne, *Degas*, vol. 2, pp. 382–83 (no. 682). Sterling-Salinger, vol. 3, pp. 81–82. Reff, *Artist's Mind*, pp. 168–70, 322 (n. 92). Reff, "Master among Masters," pp.

38–39. Moffett, *Degas*, p. 10.

Pages 78–79: *The Singer in Green (La Chanteuse Verte)*
Lemoisne, *Degas*, vol. 3, pp. 440–41 (no. 772). Sterling-Salinger, vol. 3, pp. 82–83. Reff, *Artist's Mind*, pp. 66–67, 69, 310 (n. 87). Moffett, *Degas*, p. 12.

Page 80: *The Bather*
Lemoisne, *Degas*, vol. 3, pp. 602–3 (no. 1031 *bis*). Sterling-Salinger, vol. 3, pp. 90–91.

Pages 80–81: *A Woman Having Her Hair Combed*
Lemoisne, *Degas*, vol. 1, p. 121, vol. 3, pp. 488–89 (no. 847). Douglas Cooper, *Pastels by Edgar Degas*, New York and Basel, 1952, pp. 22–23. Sterling-Salinger, vol. 3, pp. 86–88. Rewald, *Impressionism*, pp. 524–25. Reff, *Artist's Mind*, pp. 143–44, 274–76, 310 (n. 87), 319 (n. 165), 336 (n. 19). Moffett, *Degas*, pp. 13–14.

Pages 82–83: *Dancers, Pink and Green*
Lemoisne, *Degas*, vol. 3, pp. 590–91 (no. 1013). Sterling-Salinger, vol. 3, pp. 85–86. Theodore Reff, in *Edgar Degas*, catalogue of an exhibition at Acquavella Galleries, New York, 1978, n.p. (no. 45). Moffett, *Degas*, pp. 12–13.

Camille Jacob Pissarro
Pages 84–85: *Jallais Hill, Pontoise*
Ludovic Rodo Pissarro and Lionello Venturi, *Camille Pissarro: son art—son oeuvre*, 2 vols., Paris, 1939, vol. 1, p. 85 (no. 55). F. W. J. Hemmings and Robert J. Niess, *Emile Zola Salons*, Geneva and Paris, 1959, pp. 128–29. Sterling-Salinger, vol. 3, pp. 15–16. Rewald, *Impressionism*, pp. 158, 185–86. Moffett, *Impressionism*, pp. 171–75 (no. 33). *Pissarro*, catalogue of an exhibition at Hayward Gallery, London, Grand Palais, Paris, and Museum of Fine Arts, Boston, 1980–81, pp. 75–76 (no. 9).

Pages 86–87: *A Cowherd on the Route du Chou, Pontoise*
Pissarro and Venturi, *Camille Pissarro*, vol. 1, p. 116 (no. 260). Sterling-Salinger, vol. 3, pp. 16–17. *Pissarro*, exhib. cat., pp. 20–28.

Pages 88–89: *Barges at Pontoise*
Pissarro and Venturi, *Camille Pissarro*, vol. 1, p. 131 (no. 358).

Pages 90–91: *La Mère Larchevêque*
Pissarro and Venturi, *Camille Pissarro*, vol. 1, p. 153 (no. 513). Sterling-Salinger, vol. 3, pp. 18–19.

Pages 92–93: *Two Young Peasant Women*
Lionello Venturi, *Les Archives de l'impressionnisme*, 2 vols., Paris and New York, 1939, vol. 2, pp. 32, 34, quotes Camille Pissarro to Durand-Ruel, 13 and 19 January 1892. Pissarro and Venturi, *Camille Pissarro*, vol. 1, pp. 61, 192 (no. 792). Everett Fahy, *The Wrightsman Collection*, vol. 5, *Paintings, Drawings, Sculpture*, New York, pp. 151–57.

Pages 94–95: *Poplars, Eragny*
Pissarro and Venturi, *Camille Pissarro*, vol. 1, p. 208 (no. 920).

Pages 96–97: *Morning, An Overcast Day, Rouen*
Pissarro and Venturi, *Camille Pissarro*, vol. 1, p. 215 (no. 964).

Pages 98–99: *The Boulevard Montmartre on a Winter Morning*
Pissarro and Venturi, *Camille Pissarro*, vol. 1, p. 217 (no. 987). Sterling-Salinger, vol. 3, pp. 20–21.

Pages 100–101: *Rue de l'Epicerie, Rouen*

Pissarro and Venturi, *Camille Pissarro*, vol. 1, p. 225 (no. 1036). Camille Pissarro, *Letters to His Son Lucien*, ed. John Rewald, New York, 1943, p. 329 (letter from Rouen, 19 August 1898, and a photograph of the site). Sterling-Salinger, vol. 3, pp. 21–22. John Rewald, "The Impressionist Brush," *Metropolitan Museum of Art Bulletin*, vol. 32, no. 3 (1973–74), pp. 44 (no. 28), 54.

Pages 102–3: *The Garden of the Tuileries on a Winter Afternoon, II*
Pissarro and Venturi, *Camille Pissarro*, vol. 1, p. 233 (no. 1097). *Pissarro*, exhib. cat., p. 146.

Claude Oscar Monet
Pages 104–5: *The Green Wave*
Sterling-Salinger, vol. 3, p. 124. Daniel Wildenstein, *Claude Monet*, 5 vols., vol. 1, *1840–1881* (Paintings), Lausanne and Paris, 1974, pp. 35, 152–53 (no. 73).

Pages 106–7: *The Bodmer Oak, Fontainebleau Forest*
Sterling-Salinger, vol. 3, pp. 124–25. Kermit S. Champa, *Studies in Early Impressionism*, New Haven and London, 1973, p. 5. Wildenstein, *Claude Monet*, vol. 1, pp. 17, 29, 142–43 (no. 60).

Pages 108–9: *The Beach at Sainte-Adresse*
G. Poulain, *Bazille et ses amis*, Paris, 1932, p. 92. Sterling-Salinger, vol. 3, pp. 125–26. Champa, *Studies*, pp. 19–20. Wildenstein, *Claude Monet*, vol. 1, pp. 38, 47, 162–63 (no. 91). Joel Isaacson, *Claude Monet: Observation and Reflection*, Oxford and New York, 1978, pp. 16, 69, 199. Hélène Adhémar et al., *Hommage à Claude Monet*, catalogue of an exhibition at Grand Palais, Paris, 1980, pp. 80–81 (no. 16).

Pages 110–11: *Terrace at Sainte-Adresse*
Gustave Geffroy, *Claude Monet: sa vie, son temps, son oeuvre*, Paris, 1922, p. 98. John Richardson, *Claude Monet*, catalogue of an Arts Council of Great Britain exhibition at Tate Gallery, London, and Royal Scottish Academy, Edinburgh, 1957, p. 20. William C. Seitz, *Claude Monet*, New York, 1960, pp. 72 f. René Gimpel, *Diary of an Art Dealer*, New York, 1966, p. 152. *Important Impressionist and Modern Drawings, Paintings, and Sculpture*, special sale catalogue, Christie, Manson, & Woods, London, 1 December 1967, p. 23. Douglas Cooper, "The Monets in the Metropolitan Museum," *Metropolitan Museum Journal*, vol. 3 (1970), pp. 281, 284 f., 300, 302, 305. Champa, *Studies*, pp. 13 ff., 17 f., 20, 30. Rewald, *Impressionism*, pp. 152–54. Moffett, *Impressionism*, pp. 140–44 (no. 26). Wildenstein, *Claude Monet*, vol. 1, pp. 38, 47, 164–65 (no. 95). Grace Seiberling, "The Evolution of an Impressionist," in *Paintings by Monet*, catalogue of an exhibition at Art Institute of Chicago, 1975, pp. 24, 25, 60 (no. 6). John House, *Monet*, Oxford and New York, 1977, pp. 5 f. Robert Herbert, "Method and Meaning in Monet," *Art in America* (September 1979), pp. 100–101, 104, 108.

Pages 112–13: *La Grenouillère*
Sterling-Salinger, vol. 3, pp. 126–27. Champa, *Studies*, pp. 63, 65–66. Rewald, *Impressionism*, pp. 227–32. John Rewald, "The Impressionist Brush," *Metropolitan Museum of Art Bulletin*, vol. 32, no. 3 (1973–74), pp. 19, 21 (no. 12). Moffett, *Impressionism*, pp. 145–49 (no. 27). Wildenstein, *Claude Monet*, vol. 1, pp. 45, 48, 178–79 (no. 134), 427 (letter 53, 25 September 1869). Seiberling, "Evolution," pp. 25, 28, 73 (no. 19). House, *Monet*, p. 6. Isaacson, *Claude Monet*, pp. 17–19, 22, 77, 201 f.

Pages 114–15: *Landscape near Zaandam*
Wildenstein, *Claude Monet*, vol. 1, pp. 56, 200–201 (no. 186). George Szabo, *The Robert Lehman Collection*, New York (Metropolitan Museum), 1975, p. 98 (no. 88).

Pages 116–17: *Apple Trees in Bloom*
Sterling-Salinger, vol. 3, p. 128. Cooper, "Monets in the Metropolitan," pp. 287–88, 290, 302, 303, 305. Rewald, "Impressionist Brush," p. 25 (no. 15). Wildenstein, *Claude Monet*, vol. 1, pp. 65, 230–31 (no. 271). Herbert, "Method and Meaning," p. 108.

Pages 118–19: *The Parc Monceau, Paris*
William C. Seitz, *Claude Monet*, New York, 1960, p. 26. Sterling-Salinger, vol. 3, pp. 128–29. Remus Niculescu, "Georges de Bellio: l'ami des impressionnistes" (1964), reprinted in *Paragone*, nos. 247, 249 (1970), pp. 9, 11, 31, 57, 68 f., 88. Wildenstein, *Claude Monet*, vol. 1, pp. 82, 84 (n. 602), 286–87 (no. 398).

Pages 120–21: *Parisians Enjoying the Parc Monceau*
Sterling-Salinger, vol. 3, p. 129. Niculescu, "Georges de Bellio," pp. 15, 31, 57, 69, 88. Cooper, "Monets in the Metropolitan," pp. 288–90. Moffett, *Impressionism*, pp. 164–76 (no. 31). Wildenstein, *Claude Monet*, vol. 1, pp. 90, 316–17 (no. 466).

Pages 122–23: *Apples and Grapes*
Sterling-Salinger, vol. 3, pp. 129–30. Cooper, "Monets in the Metropolitan," pp. 296–97, 303, 305. Wildenstein, *Claude Monet*, vol. 1, pp. 100, 106, 350–51 (no. 545).

Pages 124–25: *Path in the Ile Saint-Martin, Vétheuil*
Sterling-Salinger, vol. 3, p. 132. Cooper, "Monets in the Metropolitan," pp. 302, 304, 305. Wildenstein, *Claude Monet*, vol. 1, pp. 104, 368–69 (no. 592), 440 (letters 188, 30 June 1880; 191, 5 July 1880).

Pages 126–27: *The Seine at Vétheuil*
Sterling-Salinger, vol. 3, p. 131. Cooper, "Monets in the Metropolitan," pp. 301, 304, 305. Wildenstein, *Claude Monet*, vol. 1, pp. 115, 370–71 (no. 599), vol. 3, *1887–1898* (Paintings), Lausanne and Paris, 1979, p. 66 (n. 1278).

Pages 128–29: *Vétheuil in Summer*
Sterling-Salinger, vol. 3, p. 130–31. Cooper, "Monets in the Metropolitan," pp. 291–92, 302, 304, 305. Wildenstein, *Claude Monet*, vol. 1, pp. 115, 372–73 (no. 605). Herbert, "Method and Meaning," p. 108.

Pages 130–31: *Sunflowers*
Vincent van Gogh, *The Complete Letters of Vincent van Gogh*, 2d ed., 3 vols., Greenwich, Conn., 1959, p. 108 (letter 563, early December 1888). Sterling-Salinger, vol. 3, pp. 132–33. Konrad Hoffman, "Zu van Goghs Sonnenblumenbildern," *Zeitschrift für Kunstgeschichte*, vol. 31, no. 1 (1968), pp. 28–29. Cooper, "Monets in the Metropolitan," pp. 292–93, 296–97, 302, 303, 305. Wildenstein, *Claude Monet*, vol. 1, pp. 382–83 (no. 628), vol. 2, *1882–1886* (Paintings), Lausanne and Paris, 1979, pp. 13 (n. 145), 44 (n. 465), 47 (n. 484). Robert Rosenblum, *Modern Painting and the Northern Romantic Tradition*, New York, 1975, pp. 86–87.

Pages 132–33: *Chrysanthemums*
Sterling-Salinger, vol. 3, p. 133. Cooper, "Monets in the Metropolitan," pp. 296–97, 303, 304. Wildenstein, *Claude Monet*, vol. 1, pp. 388–89 (no. 634), vol. 2, pp. 13 (n. 145), 44 (n. 465), 47 (n. 484). John House, "The New Monet Catalogue," *Burlington Magazine*, vol. 120, no. 907 (1978).

Page 134: *The Manneporte, Etretat, I*
Sterling-Salinger, vol. 3, p. 135. Cooper, "Monets in the Metropolitan," pp. 291–92, 302, 303, 304, 305. Wildenstein, *Claude Monet*, vol. 2, pp. 10, 12, 38 (n. 392), 44 (n. 465), 104–5 (no. 832).

Page 135: *The Manneporte, Etretat, II*
Sterling-Salinger, vol. 3, p. 136. Cooper, "Monets in the Metropolitan," pp. 291, 292, 294, 302, 303, 304, 305. Isaacson, *Claude Monet*, pp. 37–38, 132, 217. Herbert, "Method and Meaning," p. 108. Wildenstein, *Claude Monet*, vol. 2, pp. 43, 45, 184–85 (no. 1052), vol. 3, p. 66 (n. 1278). Grace Seiberling, *Monet's Series*, New York and London, 1981, pp. 65–68, 271.

Pages 136–37: *Rapids on the Petite Creuse at Fresselines*
Seitz, *Claude Monet*, p. 136. Daniel Wildenstein, *Impressions*, Lausanne, 1967, p. 51. Cooper, "Monets in the Metropolitan," pp. 292, 305. Wildenstein, *Claude Monet*, vol. 3, pp. 19, 20, (n. 820), 21 (n. 825), 128–29 (no. 1239), 301 (letter 136, 9 November 1900). Seiberling, *Monet's Series*, p. 77.

Pages 138–39: *Poplars*
Sterling-Salinger, vol. 3, pp. 136–37. Cooper, "Monets in the Metropolitan," pp. 291, 297–99, 302, 304, 305. Andrew Forge, "Monet at Giverny," in Claire Joyes et al., *Monet at Giverny*, London, 1975, p. 11. *Monet's Years at Giverny: Beyond Impressionism*, catalogue of an exhibition at Metropolitan Museum of Art, New York, 1978, pp. 60–61 (no. 16). Isaacson, *Claude Monet*, pp. 41, 151, 222. Herbert, "Method and Meaning," p. 108. Wildenstein, *Claude Monet*, vol. 3, pp. 42–43 (n. 1051), 47 (n. 1083), 66 (n. 1278), 152–53 (no. 1309). Seiberling, *Monet's Series*, pp. 116–17, 365 (no. 23).

Pages 140–41: *Haystacks in Snow*
Sterling-Salinger, vol. 3, pp. 137–38. Cooper, "Monets in the Metropolitan," pp. 298–99, 302, 303, 304, 305. Herbert, "Method and Meaning," p. 108. Wildenstein, *Claude Monet*, vol. 2, p. 34 (n. 355), vol. 3, pp. 13 (n. 745), 38, 142–43 (no. 1279). Seiberling, *Monet's Series*, pp. 93, 96, 358 (no. 23).

Pages 142–43: *The Thaw (La Débâcle)*
Sterling-Salinger, vol. 3, p. 138. Cooper, "Monets in the Metropolitan," pp. 295, 304, 305. Wildenstein, *Claude Monet*, vol. 3, pp. 49, 160–61 (no. 1335), 292 (letters 1354, 23 November 1896; 1355, 30 December 1896; 1357, 17 January 1897), 293 (letters 1361, 20 January 1897; 1364, 22 January 1897).

Pages 144–45: *Rouen Cathedral*
George Heard Hamilton, *Claude Monet's Paintings of Rouen Cathedral*, London, 1960, p. 26. Sterling-Salinger, vol. 3, pp. 138–40. Cooper, "Monets in the Metropolitan," pp. 297–301, 304, 305. Rewald, "Impressionist Brush," p. 43 (no. 27). Wildenstein, *Claude Monet*, vol. 3, pp. 44–46, 52, 66 (n. 1278), 156–57 (no. 1325). Seiberling, *Monet's Series*, pp. 155–56, 160–61, 271, 365 (no. 4).

Pages 146–47: *Morning on the Seine near Giverny*
Gustave Geffroy, *Histoire de l'impressionnisme: la vie artistique*, 3d ser., 8 vols., Paris, 1894, vol. 1, p. 170. Sterling-Salinger,

vol. 3, p. 141. Cooper, "Monets in the Metropolitan," pp. 299, 300, 302, 304 305. Wildenstein, *Claude Monet*, vol. 3, pp. 79, 84 (n. 1440), 212–13 (no. 1482). Seiberling, *Monet's Series*, pp. 189, 225.

Pages 148–49: *Bridge over a Pool of Water Lilies*
Sterling-Salinger, vol. 3, pp. 141–42. Cooper, "Monets in the Metropolitan," pp. 297–300, 302, 304, 305. Robert Maillard, in Denis Rouart and Jean-Dominique Rey, *Monet Nymphéas*, Paris, 1972, p. 154. *Monet's Years*, exhib. cat., p. 82 (no. 31).

Pages 150–51: *The Houses of Parliament*
Seitz, *Claude Monet*, p. 148, quotes Monet to Durand-Ruel, 1903. Sterling-Salinger, vol. 3, pp. 142–43. Cooper, "Monets in the Metropolitan," pp. 299, 301, 302, 304, 305. Seiberling, *Monet's Series*, p. 375 (no. 41).

Alfred Sisley
Pages 152–53: *The Bridge at Villeneuve-la-Garenne*
François Daulte, *Alfred Sisley: catalogue raisonné de l'oeuvre peint*, Lausanne, 1959, no. 37. Sterling-Salinger, vol. 3, pp. 119–20. Moffett, *Impressionism*, pp. 201–4 (no. 41).

Pages 154–55: *View of Marly-le-Roi from Coeur-Volant*
Daulte, *Alfred Sisley*, no. 208.

Pierre Auguste Renoir
Page 156: *A Road in Louveciennes*
As of this date, this picture is apparently unpublished.

Page 157: *A Waitress at Duval's Restaurant*
Jean Renoir, *Renoir: My Father*, trans. Randolph and Dorothy Weaver, Boston and Toronto, 1962, p. 232. Linda Nochlin, *Impressionism and Post-Impressionism, 1874–1904: Sources and Documents*, Englewood Cliffs, 1966, p. 5, quotes Edmond Duranty, *La nouvelle peinture*, 1876. Sterling-Salinger, vol. 3, pp. 147–48. François Daulte, *Auguste Renoir: catalogue raisonné de l'oeuvre peint*, vol. 1, *Les Figures (1860–90)*, Lausanne, 1971, no. 101.

Pages 158–59: *Young Girl in a Pink and Black Hat*
Sterling-Salinger, vol. 3, pp. 148–49. Daulte, *Auguste Renoir*, no. 595.

Pages 160–61: *Madame Georges Charpentier (Marguerite Lemonnier) and Her Children, Georgette and Paul*
Ambroise Vollard, *Tableaux, pastels et dessins de Pierre-Auguste Renoir*, 2 vols., Paris, 1918, vol. 2, p. 91 (n. 362). Sterling-Salinger, vol. 3, pp. 149–52. Daulte, *Auguste Renoir*, no. 266. Moffett, *Impressionism*, pp. 190–94 (no. 38).

Pages 162–63: *Marguerite (Margot) Bérard*
Sterling-Salinger, vol. 3, pp. 152–153. Daulte, *Auguste Renoir*, no. 286. Lucy Oakley, *Pierre Auguste Renoir*, New York, 1980, pp. 10–11.

Pages 164–65: *View of the Seacoast near Wargemont in Normandy*
Sterling-Salinger, vol. 3, p. 153. Oakley, *Pierre Auguste Renoir*, p. 11.

Page 166: *Still Life with Peaches and Grapes*
Maurice Bérard, *Renoir à Wargemont*, Paris, 1938, pp. 12–13. Sterling-Salinger, vol. 3, pp. 153–54.

Page 167: *Still Life with Peaches*
Bérard, *Renoir à Wargemont*, pp. 12–13. Sterling-Salinger, vol. 3, p. 154.

Pages 168–69: *By the Seashore*
Sterling-Salinger, vol. 3, pp. 155–57. Daulte, *Auguste Renoir*, no. 448. John Rewald, "The Impressionist Brush," *Metropolitan Museum of Art Bulletin*, vol. 32, no. 3 (1973–74), p. 37 (no. 23).

Pages 170–71: *In the Meadow*
Jean Renoir, *Renoir*, p. 248. Sterling-Salinger, vol. 3, pp. 158–59. Daulte, *Auguste Renoir*, no. 610. Oakley, *Pierre Auguste Renoir*, p. 14.

Pages 172–73: *Young Girl Bathing*
Renoir, Centennial Loan Exhibition, Duveen Galleries, New York, 1941, pp. 87, 153 (no. 65). François Fosca, *Renoir*, trans. Mary I. Martin, New York [1970], p. 205. Elda Fezzi, *L'Opera completa di Renoir nel periodo impressionista 1869–1883*, Milan, 1972, p. 119 (no. 669). George Szabo, *The Robert Lehman Collection*, New York (Metropolitan Museum), 1975, p. 92 (no. 92).

Pages 174–75: *Two Young Girls at the Piano*
Jean Renoir, *Renoir*, pp. 389–90. Michel Robida, *Renoir Children*, trans. Diana Imber, Lausanne, 1962, p. 35. Szabo, *Robert Lehman Collection*, p. 92 (no. 93).

Paul Cézanne
Pages 176–77: *Dominique Aubert (Uncle Dominic)*
Lionello Venturi, *Cézanne: son art—son oeuvre*, 2 vols., Paris, 1936, no. 73. John Rewald, *Cézanne*, Paris, 1939, pp. 167–68. Sterling-Salinger, vol. 3, pp. 96–97.

Pages 178–79: *Bathers*
Venturi, *Cézanne*, no. 265. Lawrence Gowing, *An Exhibition of Paintings by Cézanne*, Arts Council of Great Britain, Tate Gallery, London, and Royal Scottish Academy, Edinburgh, 1954, no. 14.

Pages 180–81: *Still Life*
Venturi, *Cézanne*, no. 213. Meyer Schapiro, *Cézanne*, 3d ed., New York, 1965, pp. 17, 60. Sterling-Salinger, vol. 3, pp. 98–99.

Pages 182–83: *Madame Cézanne in the Conservatory*
Gerstle Mack, *Paul Cézanne*, New York, 1935, pp. 169–72. Venturi, *Cézanne*, no. 569. Schapiro, *Cézanne*, p. 82. Sterling-Salinger, vol. 3, pp. 100–102. John Rewald, "The Impressionist Brush," *Metropolitan Museum of Art Bulletin*, vol. 32, no. 3 (1973–74), p. 41 (no. 26).

Pages 184–85: *Still Life: Apples and a Pot of Primroses*
Venturi, *Cézanne*, no. 599. Sterling-Salinger, vol. 3, pp. 102–4.

Pages 186–87: *Near the Pool at the Jas de Bouffan*
Venturi, *Cézanne*, no. 648. Sterling-Salinger, vol. 3, pp. 104–5.

Pages 188–89: *The Gulf of Marseilles Seen from L'Estaque*
Venturi, *Cézanne*, no. 429. Sterling-Salinger, vol. 3, pp. 105–6. Rewald, "Impressionist Brush," p. 38 (no. 24). Moffett, *Impressionism*, pp. 59–63 (no. 8). Paul Cézanne, *Letters*, ed. John Rewald, 4th rev. ed., New York, 1976, pp. 145–46.

Pages 190–91: *Gardanne*
Venturi, *Cézanne*, no. 432. Sterling-Salinger, vol. 3, pp. 106–7.

Pages 192–93: *Mont Sainte-Victoire*
Venturi, *Cézanne,* no. 452. Cézanne, *Letters,* London, 1941, p. 114 (letter to Zola, 14 April 1878). Schapiro, *Cézanne,* p. 66. Sterling-Salinger, vol. 3, pp. 107–8.

Pages 194–95: *Madame Cézanne in a Red Dress*
Venturi, *Cézanne,* no. 570. Schapiro, *Cézanne,* p. 94. Sterling-Salinger, vol. 3, pp. 109–11.

Pages 196–97: *Still Life with a Ginger Jar and Eggplants*
Venturi, *Cézanne,* no. 597. Schapiro, *Cézanne,* p. 10. Sterling-Salinger, vol. 3, pp. 111–12.

Pages 198–99: *The Cardplayers*
Venturi, *Cézanne,* no. 559. Kurt Badt, *The Art of Cézanne,* Berkeley and Los Angeles, 1965, pp. 94–97, 117–22. Sterling-Salinger, vol. 3, pp. 112–15.

Page 200: *Still Life: Apples and Pears*
Venturi, *Cézanne,* no. 502. Sterling-Salinger, vol. 3, p. 109.

Page 201: *View of the Domaine Saint-Joseph*
Venturi, *Cézanne,* no. 660. Sterling-Salinger, vol. 3, pp. 115–17.

Pages 202–3: *Rocks in the Forest*
Venturi, *Cézanne,* no. 673. Schapiro, *Cézanne,* p. 118. Sterling-Salinger, vol. 3, p. 117. *Cézanne: The Late Work,* catalogue of an exhibition at Museum of Modern Art, New York, 1977, p. 389 (no. 8).

Paul Gauguin
Pages 204–5: *Ia Orana Maria*
Georges Wildenstein, *Gauguin,* Paris, 1964, pp. 167–68 (no. 428). Sterling-Salinger, vol. 3, pp. 170–71. Richard S. Field, *Paul Gauguin: The Paintings of the First Voyage to Tahiti,* New York and London, 1977, pp. 54, 58–74, 78, 301, 306, 315, 360. V. Jirat-Wasiutynski, *Paul Gauguin in the Context of Symbolism,* New York and London, 1978, p. 276. Rewald, *Post-Impressionism,* pp. 466, 476, 477.

Pages 206–7: *Two Tahitian Women*
Wildenstein, *Gauguin,* p. 246 (no. 583). Sterling-Salinger, vol. 3, pp. 176–78. Françoise Cachin, *Gauguin,* Paris, 1968, pp. 301 ff., 349 (n. 24).

Vincent van Gogh
Page 208: *The Potato Peeler*
Vincent van Gogh, *The Complete Letters of Vincent van Gogh,* 2d ed., 3 vols., Greenwich, Conn., 1959, vol. 1, pp. 77 (letter 299, about 11 July 1883), 370 (letter 403, last week of April 1885). J.-B. de la Faille, *The Works of Vincent van Gogh: His Paintings and Drawings,* Amsterdam, 1970, pp. 106 (no. F 365 recto), 624. Charles S. Moffett, *Vincent van Gogh,* New York, 1979, pp. 5–6. Jan Hulsker, *The Complete Van Gogh,* New York, 1980, pp. 145 (no. 654), 150.

Pages 208–9: *Self-Portrait with a Straw Hat*
Van Gogh, *Complete Letters,* vol. 2, p. 462 (letter 441, 19 December 1885), vol. 3, p. 445 (letter W 8, about 26 August 1888). De la Faille, *Works of van Gogh,* pp. 171 (no. F 365 verso), 625. Moffett, *Vincent van Gogh,* p. 7. Hulsker, *Complete Van Gogh,* pp. 300, 302, 304–5 (no. 1354).

Pages 210–11: *Sunflowers*
Sterling-Salinger, vol. 3, pp. 181–82. De la Faille, *Works of van Gogh,* pp. 174 (no. F 375), 626. Moffett, *Vincent van Gogh,* p. 8. Hulsker, *Complete Van Gogh,* pp. 292, 298–99 (no. 1329).

Pages 212–13: *Oleanders*
Van Gogh, *Complete Letters,* vol. 3, pp. 47 (letter 541, about 23 or 24 September 1888), 158 (letter 587, 25 or 26 April 1889). Sterling-Salinger, vol. 3, pp. 183–85. De la Faille, *Works of van Gogh,* pp. 242–43 (no. F 593), 634. Moffett, *Vincent van Gogh,* p. 8. Hulsker, *Complete Van Gogh,* pp. 356, 358–59 (no. 1566).

Pages 214–15: *L'Arlésienne: Madame Joseph-Michel Ginoux (Marie Julien)*
Van Gogh, *Complete Letters,* vol. 3, pp. 100 (letter 559, November 1888), 128 (letter 573, 23 January 1889), 182 (letter 595, 19 June 1889). Sterling-Salinger, vol. 3, pp. 185–88. De la Faille, *Works of van Gogh,* pp. 219 (no. F 488), 630. V. Jirat-Wasiutynski, *Paul Gauguin in the Context of Symbolism,* New York and London, 1978, pp. 101–2. Rewald, *Post-Impressionism,* pp. 238–40. Moffett, *Vincent van Gogh,* p. 10. Hulsker, *Complete Van Gogh,* pp. 372, 374 (no. 1624). Bogomila Welsh-Ovcharov, *Vincent van Gogh and the Birth of Cloisonism,* catalogue of an exhibition at Art Gallery of Ontario, Toronto, 1981, pp. 142–44 (no. 30), 188, 189 (n. 4).

Pages 216–17: *Cypresses*
Van Gogh, *Complete Letters,* vol. 3, pp. 185–86 (letter 596, 25 June 1889). Sterling-Salinger, vol. 3, pp. 188–89. De la Faille, *Works of van Gogh,* pp. 246–47 (no. F 613), p. 635. Hulsker, *Complete Van Gogh,* pp. 398, 404 (no. 1746).

Pages 218–19: *First Steps*
Van Gogh, *Complete Letters,* vol. 3, pp. 224–25 (letter 611, about 25 October 1889). Sterling-Salinger, vol. 3, pp. 190–91. De la Faille, *Works of van Gogh,* pp. 262–63 (no. F 668), 637. Charles Chetham, *The Role of Vincent van Gogh's Copies in the Development of His Art,* New York and London, 1976, p. 190. Moffett, *Vincent van Gogh,* p. 13. Hulsker, *Complete Van Gogh,* pp. 432–33 (no. 1883).

Pages 220–21: *Irises*
Van Gogh, *Complete Letters,* vol. 3, pp. 26 (letter 531, 3 September 1888), 269 (letter 663, 11 or 12 May 1890). Sterling-Salinger, vol. 3, pp. 191–92. De la Faille, *Works of van Gogh,* pp. 266–67 (no. F 680), 638. Rewald, *Post-Impressionism,* pp. 354, 355, 368. Moffett, *Vincent van Gogh,* p. 13. Hulsker, *Complete Van Gogh,* pp. 448, 450, 452 (no. 1978). Welsh-Ovcharov, *Vincent van Gogh,* p. 158.

Georges Pierre Seurat
Page 222: *The Gardener*
Henri Dorra and John Rewald, *Seurat,* Paris, 1959, p. 47 (no. 48). C. M. de Hauke, *Seurat et son oeuvre,* 2 vols., Paris, 1961, vol. 1, pp. 62–63 (no. 101).

Page 223: *Study for A Sunday on La Grande Jatte*
Dorra and Rewald, *Seurat,* p. 120 (no. 113). De Hauke, *Seurat,* vol. 1, p. 72 (no. 117). André Chastel and Fiorella Minervino, *L'Opera completa di Seurat,* Milan, 1972, p. 99 (no. 115). George Szabo, *The Robert Lehman Collection,* New York (Metropolitan Museum), 1975, p. 93 (no. 98).

Pages 224–25: *Study for A Sunday on La Grande Jatte*
Daniel C. Rich, *Seurat and the Evolution of "La Grande Jatte,"* Chicago, 1935, pp. 24–25 (no. 49). Dorra and Rewald, *Seurat,*

pp. 150–51 (no. 138). De Hauke, *Seurat,* vol. 1, pp. 94–95 (no. 142). Sterling-Salinger, vol. 3, pp. 194–97.

Pages 226–27: *Invitation to the Sideshow (Parade de Cirque)*
Dorra and Rewald, *Seurat,* pp. 225–27 (no. 181). De Hauke, *Seurat,* vol. 1, pp. 150–53 (no. 187). Sterling-Salinger, vol. 3, pp. 197–200. Robert L. Herbert, *"Parade de Cirque* de Seurat et l'esthétique scientifique de Charles Henry," *Revue de l'Art,* no. 50 (1980), pp. 9–23.

Paul Signac
Pages 228–29: *The Jetty at Cassis*
Françoise Cachin *Paul Signac,* Paris, 1971, pp. 41–42.

Pages 230–31: *View of the Port of Marseilles*
Signac, catalogue of an exhibition at Musée du Louvre, Paris, 1963–64, pp. 74–75 (no. 66). Sterling-Salinger, vol. 3, pp. 201–2. Cachin, *Paul Signac,* p. 91.

Henri Raymond de Toulouse-Lautrec-Monfa
Pages 232–33: *René Grenier*
François Gauzi, *Lautrec et son temps,* Paris, 1954, pp. 27, 58. M. G. Dortu, *Toulouse-Lautrec et son oeuvre,* 6 vols., New York, 1971, vol. 2, p. 138 (no. P.304).

Pages 234–35: *Woman in the Garden of Monsieur Forest*
Dortu, *Toulouse-Lautrec,* vol. 2, p. 172 (no. P.344). Naomi E. Maurer, in Charles F. Stuckey, *Toulouse-Lautrec: Paintings,* catalogue of an exhibition at Art Institute of Chicago, 1979, pp. 152–53 (no. 40).

Pages 236–37: *The Englishman at the Moulin Rouge*
Dortu, *Toulouse-Lautrec,* vol. 2, p. 256 (no. P.425). Charles F. Stuckey, in Stuckey, *Toulouse-Lautrec,* pp. 24, 26.

Pages 238–39: *The Sofa*
Sterling-Salinger, vol. 3, pp. 204–5. Dortu, *Toulouse-Lautrec,* vol. 3, p. 370 (no. P.370). Naomi E. Maurer and Charles F. Stuckey, in Stuckey, *Toulouse-Lautrec,* pp. 251–53.

Bertrand Jean (called Odilon) Redon
Pages 240–41: *Flowers in a Chinese Vase*
Klaus Berger, *Odilon Redon—Fantasy and Colour,* New York and London, 1965, p. 204 (no. 308). Sterling-Salinger, vol. 3, pp. 8–9.

Pages 242–43: *Madame Arthur Fontaine*
Roseline Bacou, *Odilon Redon,* 2 vols., Geneva, 1956, vol. 1, p. 153, vol. 2, p. 54 (no. 76). Roseline Bacou [?], *Odilon Redon,* catalogue of an exhibition at Musée de l'Orangerie, Paris, 1956–57, pp. 49–50 (no. 89). Berger, *Odilon Redon,* p. 211 (no. 393). Sterling-Salinger, vol. 3, pp. 7–8. *From Realism to Symbolism,* catalogue of an exhibition at Wildenstein & Co., New York, and Philadelphia Museum of Art, 1971, pp. 118–19 (no. 120). Richard Hobbs, *Odilon Redon,* Boston, 1977, pp. 145, 148, 183.

Henri Julien Félix Rousseau (Le Douanier)
Pages 244–45: *The Banks of the Bièvre near Bicêtre*
Sterling-Salinger, vol. 3, pp. 167–68. Giovanni Artieri, *Rousseau il Doganiere,* Milan, 1969, p. 102 (no. 162).

Pages 246–47: *The Repast of the Lion*
Sterling-Salinger, vol. 3, pp. 166–67. Artieri, *Rousseau,* p. 105 (no. 193).